JACQUES DE CASO

David d'Angers

Sculptural Communication in
the Age of Romanticism

Translated by Dorothy Johnson
and Jacques de Caso

Princeton University Press · Princeton, New Jersey

Library of Congress Cataloging-in-Publication Data

De Caso, Jacques, 1928–
[David d'Angers. English]
David d'Angers : sculptural communication in the age of romanticism /
Jacques de Caso ; translated by Dorothy Johnson and Jacques de Caso.
p. cm.
Translation of: David d'Angers
Includes bibliographical references and index.
ISBN 0-691-04078-8
1. David d'Angers, Pierre-Jean, 1788–1856—Criticism and interpretation.
2. Portrait sculpture, French. 3. Romanticism in art—France.
4. Public sculpture—France. I. Title.
NB553.D3D413 1992 730′ 730′.92—dc20 91-10881

Publication of this book has been aided by the
French Ministry of Culture and Communication

This book has been composed in Adobe Janson

Princeton University Press books are printed on acid-free paper,
and meet the guidelines for permanence and durability of the
Committee on Production Guidelines for Book Longevity of the
Council on Library Resources

Printed in the United States of America by Princeton University Press,
Princeton, New Jersey

10 8 6 4 2 1 3 5 7 9

First published in France by Flammarion, 1988

Designed by Laury A. Egan

IN MEMORY OF

Hans Bellmer and Hans Schaetz

Who can understand all the torments and agonies the artist experiences, especially at night when sleep abandons him; then, the thought of his work comes to his mind, everything seems worthless to him. At the moment when his heart seems to be seized by an aneurysm, the artist despairs of the success of his work; but when the beneficent daylight rises to calm his anxieties, he works with ardor and illusion comes to comfort him, only to abandon him when night comes again. This is the history of my entire life as an artist; none of my work has escaped this cruel ordeal.

—David d'Angers
Notes, Private Collection

CONTENTS

[ix]

LIST OF ILLUSTRATIONS

INTRODUCTION

THIS BOOK will argue that David d'Angers' oeuvre expresses, with a unique degree of coherence, originality, and power, the Romantic conception of sculpture, particularly monumental, commemorative sculpture. The structure of the book is provided by a synthesis of diverse and neglected issues and problems in David d'Angers' oeuvre and in French Romantic sculpture. This was preferred to a more traditional, analytical approach based on a narrative presentation of his life and works. Although such a method often proves useful, it usually results in a misleading and incomplete reconstruction of an artist's life and oeuvre. A principal objective of this study will be to examine pertinent aspects of the art and ideas of David d'Angers. A second objective will be to elucidate salient yet neglected works, issues, and problems in the art of French sculpture of this period, as aesthetic, social, and political contexts of late 18th- and early 19th-century sculpture are still not well defined or understood.

The present study is the revised, English version of a book first published in French in 1988—*David d'Angers: l'Avenir de la mémoire*—which was based on a series of lectures given at the Collège de France in Paris, 1981–1982. Several types of revisions have been made. A small number of historical and critical citations have been added to the footnotes. A discussion of three additional works (David's statuette of *Liberty*, his project for a *Monument to Emancipation*, and aspects of the history of Napoleon's Tomb), which would have made the footnotes cumbersome, has been placed in appendixes. Also, for the English edition, a fourth appendix has been added. This consists of a hitherto unpublished and, indeed unknown, exchange of letters between David and the German physiologist and landscape painter, Carl Gustav Carus. Revisions of the text were related primarily to questions of presentation rather than to content. Whenever possible, the author and the translator transformed the rhetoric of the lecture format, which the French edition preserved, in order to render the English text more direct and concise. Of course, it was not possible to transform completely the oral nature of the book's first presentation. To do so would have considerably lengthened the present text. It should also be noted that the translations of 19th-century quotations have been kept as literal as possible. Only a small number of changes and minor corrections were made in content, none concerning substantive issues. A few illustrations have been added to the English edition: an unpublished drawing by David for the Chambre

des Députés pediment replaces the better-known drawing published in the first edition; a neglected caricature of the Pantheon's pediment now accompanies the discussion of its critical reception; and a recently rediscovered sculpted terracotta sketch for David's *Monument to Emancipation* has also been reproduced.

This book could not have been written without the help of many institutions and individuals. The John Simon Guggenheim Foundation and the Humanities Institute of the University of California at Berkeley have supported my research over the years. I would like to thank those curators of Parisian and French provincial museums who kindly gave me access to their collections and archives. I would especially like to thank Viviane Huchard, Head Curator of Angers' museums, who generously gave me complete access to the collections during a difficult period, indeed, for the renovation of the Musée des Beaux-Arts, including the Galerie David, had already begun. Isabelle Battez, former Director of the municipal library of Angers, also greatly facilitated my work. I am indebted as well to numerous descendents of David's family and friends who gave me access to their archives and collections—enabling me to publish certain works for the first time. In addition, I would like to thank my many students and friends who drew my attention to aspects of the art of David d'Angers and of French sculpture of the 18th and 19th centuries. Last, but not least, I would like to express my gratitude to Dorothy Johnson, who did the lion's share of the translation. She worked assiduously with an intelligence and attentiveness that few authors are fortunate enough to encounter. Jack Johnson read the manuscript carefully and made numerous valuable suggestions. John Cameron provided a critical reading from the point of view of a non-specialist in 19th-century art. Erika Naginski prepared the index.

David d'Angers

CHAPTER 1

The Signs of Sculpture

DAVID D'ANGERS occupies an important and unique position in French art from 1820 to 1850 because of the significant works he produced and the cogent ideas he expressed concerning the art of his time. Until the end of the 19th century and beyond, David and his oeuvre were included in the great debate concerned with a committed art, a debate associated with Republican politics made possible by the downfall of the Second Empire. During the Second Empire, David was justly perceived as an individual who had been a conspicuous, irritating, and obstinate opponent to the July Monarchy. He had been a mayor of one of Paris' administrative districts during the Second Republic, and one among a small group of elected representatives who, on May 11, 1849, had signed, along with former 1848 Interior Minister Ledru-Rollin, a petition requesting the indictment of Louis-Napoleon Bonaparte and his ministers for their advocacy of the French military intervention in Rome in support of the pope. David died in 1856, having been proscribed for more than a year. The press reported that his statue of General Drouot had been inaugurated in Nancy in 1855 without the artist's name being mentioned. David's funeral, like those of so many opponents of diverse regimes during the course of the 19th century, turned into a political demonstration. His disciple, the sculptor Etex, was prevented from reading the speech he had prepared to give in the cemetery, which, being both a private and public ground, was an ambiguous site in the 19th century. Protected from government interference, the cemetery was nonetheless under surveillance as a potential political arena. Etex, however, published his speech in the press the following day and arrests were made. The report made to the Imperial prosecutor dealing with David's funeral questioned Etex's "transparent call to the political passions of youth" and recommended that the government adopt a repressive attitude. The Republican press recorded the circumstances and the significance of the event: "Behind this coffin which, unfortunately, none of us could follow, walked long lines of young people who were neither the pupils nor the friends of the man, nor the colleagues of the representative, but the students and friends of the revolution."[1]

David was well-known for one overtly political work that can still be seen in Paris—the pediment of the Pantheon. This work apparently only narrowly missed being taken down in 1851. It was probably saved by Fortoul, a friend of David's, who signed the decree reconverting the Pantheon into a church dedicated to Saint Genevieve. David's other works are not very accessible. Few can be found either in public places in Paris or in Parisian museums. Some are located in cemeteries in or near Paris but most are to be seen in the provinces. In spite of this inaccessibility, David's public renown was great in his own time. He was supported to some extent by the opposition press, especially during the July Monarchy, when conservative critics treated him harshly and often harassed him. But even after the fall of the Second Empire the French establishment had reservations about David's oeuvre and legacy. After 1859 the Louvre brought back the *Philopoemen* from the Tuileries Garden (fig. 1), but one wonders if this was merely a way of removing it from the public domain. In any case, this was David's only monument to enter the Louvre before the painter Jean Gigoux's gift in 1896 of the marble *The Child with Grapes* (fig. 2). During this period the national museums purchased few of David's works, sometimes refusing gifts from the artist's family or accepting only minor works such as plaster casts which were sent to museums in the provinces.[2] The city of Paris itself, however, was more receptive.

The official evaluation of David's artistic and ideological fortunes at the end of the century can be assessed by Courajod's statements in his *Leçons professées à l'Ecole du Louvre* which are related to the long offensive Courajod led against the ideas, functions, and styles of "classical" art: "a brochure recently appeared entitled *La Statue de Racine à la Ferté-Milon. Essai sur les statues à l'antique.* The honorable author of this small book . . . wrote to ask me to reclaim for the Louvre this *masterpiece* [Courajod's emphasis] of David d'Angers which appeared to him to be destined for placement in the Gallery of Modern Sculpture (fig. 3). I answered, thanking him, that I did not judge this grotesque statue worthy of the Louvre."[3] The author of the brochure, in fact, wanted to rid La Ferté-Milon of David's work and replace it by another statue of Racine, which, he said, would be made of a more resistant material and would be characterized by a "less metaphysical" conception.

The Third Republic initiated an ideological revision of David's political involvement and aesthetics and made several decisions regarding his legacy. Thus, in 1879, Viollet-le-Duc, chairman of the commission discussing the budget for the fine arts of the city of Paris, revived an idea that David, among others, had proposed in 1848—namely, to decorate the Champs-Elysées with statues of illustrious Parisians.[4] Neither the city nor the state, however, initiated an homage to David, one which would have been either Parisian or national in scope. Because he was not Parisian David was not represented in any form on the newly reconstructed Hôtel

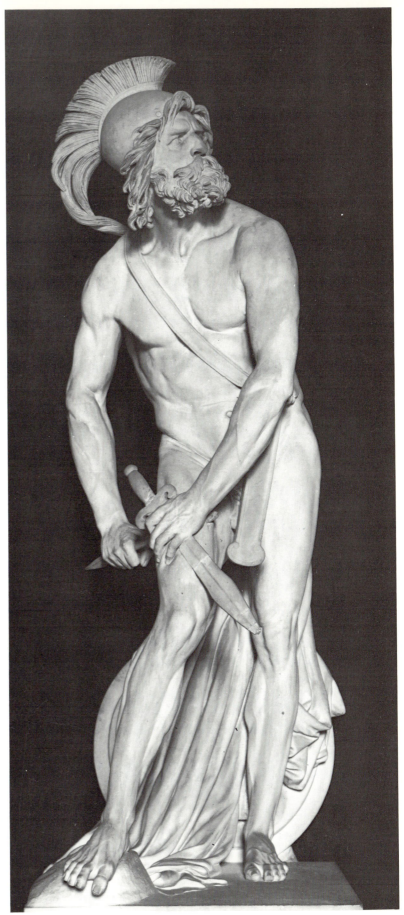

1. *Philopoemen*, statue, marble, Paris, Louvre

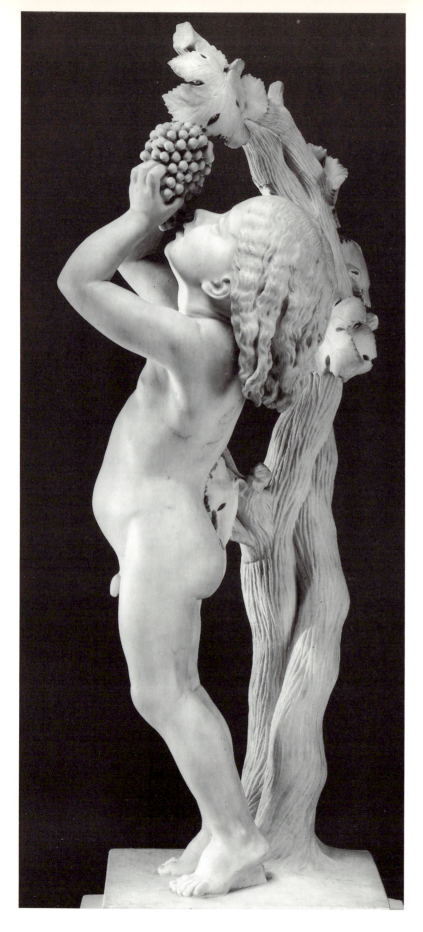

2. *The Child with Grapes*, statue,
marble, Paris, Louvre

3. *Racine*, statue, marble,
La Ferté-Milon

>

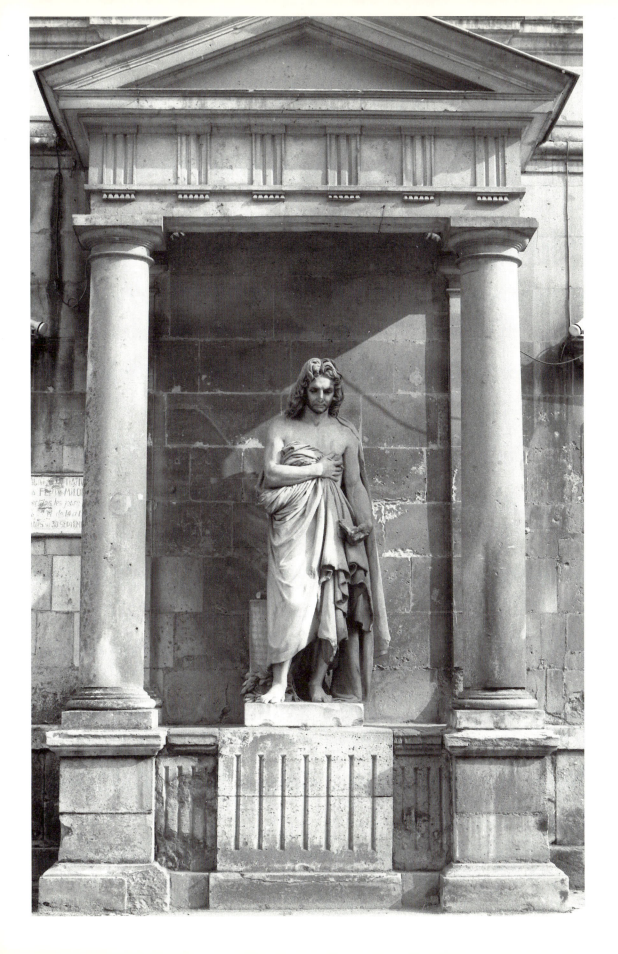

de Ville. But in 1877 a street in the 19th arrondissement of Paris was named after him and his bust appeared with those of Houdon, Barye, Rude, and Pradier in the mini-Pantheon of modern masters on the facade of the Luxembourg Museum in the 1880s.[5] Angers, his native town, was the only city to erect a statue in his honor.[6]

This limited public homage was, however, compensated for by a private homage from those who wanted to commemorate David's ideas and commercially exploit his oeuvre. David's widow Emilie David, a Republican protestant and the granddaughter of La Révellière-Lépeaux, a member of the Convention, was well-educated and cultivated. She immediately liquidated David's cumbersome ateliers which did not contain sculpted works that could be sold (according to David's will, numerous works in plaster were sent to Angers, Saumur, and Marseille) and kept only a few personal, private works which were difficult to sell.[7] She hired Eugène Marc to undertake the lithography of what she called the "complete works" of David, a publication that would "commemorate the works" and serve as a substitute for the dispersed ateliers. She confided one day to Madame Victor Hugo that she had done this at the price of "great pecuniary sacrifices" and that "the work is greeted with very moderate enthusiasm: it is too serious for many people, too compromising for others."[8]

During the Second Empire, the efforts of the family to acquit a moral debt went hand in hand with their difficult struggle to compete with a speculative art market. David's posthumous glory, in fact, as perceived by the public even today, is due in large part to the sustained promotion of his works by art industrialists and merchants, and, above all, to the institutions—museums and libraries—which acquired his now well-known, extensive series of medallions.

After 1838, David permitted the engineer Achille Collas to engrave a series of portraits of contemporaries (fig. 4).[9] This same Collas, even before the period of his association with the industrialist-editor Barbedienne, had made reductions of several of David's busts and medallions, as had other founders, but on an artisanal scale (fig. 5). The most significant factor in the orchestrated promotion of David's name was the founder Thiébaut's reproductions of the collection of almost five hundred medallions which were promulgated by thinly disguised publicity in the art press. In the early 1860s, Thiébaut had purchased this vast collection from his colleagues Eck and Durand, David's previous founders. He then exploited this purchase despite the efforts of David's family to stop him. Emilie David wrote: "My husband, who dreamed above all of making accessible to everyone the features of the illustrious men, of whom he had been so happy to form his collection of contemporaries, and who wanted at the same time to be helpful to his founder, gave him the models without reserving any legal rights himself, and asked him only to sell them at a price low enough to fulfill his intentions. This founder is dead, his

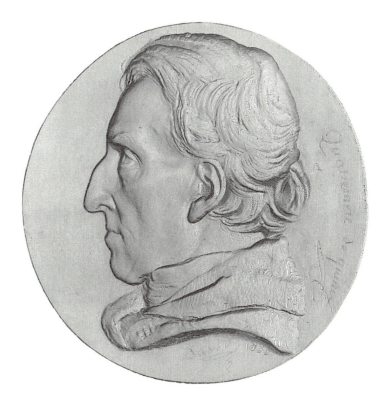

4. *Quatremère de Quincy*,
medallion, print, Private
Collection

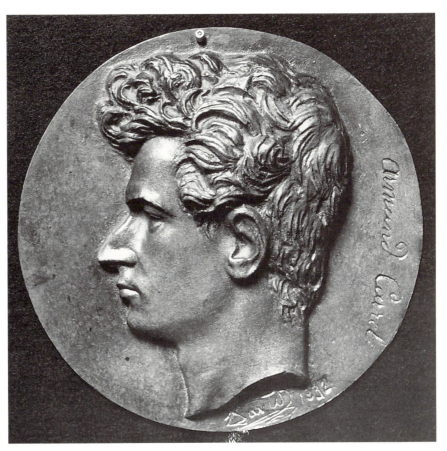

5. *Armand Carrel*,
medallion, bronze, Private
Collection

successors have found things in this state; they did not ask M. David to formalize his contract with them; David himself, strongly indifferent to business affairs, did not take enough notice. When we had the misfortune of losing him in 1856, that which was only an apparent right had become, considering the time that had passed, almost an actual right. To convince Monsieurs Eck and Durand would have necessitated the undertaking of a suit before which I, my children and their tutor recoiled."[10]

One last factor which has helped to transmit the image of David to our time should be mentioned: it concerns a private homage that had public resonance— Henri Jouin's publication in 1878 of more than a thousand pages on the life and works of David d'Angers. Since every historian of David depends, perforce, on Jouin, David's only careful biographer, it is necessary to discuss briefly the history of his project.

The project was developed with difficulty, punctuated by near-conflicts with David's widow, which can be sensed between the lines of Jouin's book. Brother of the well-known, conservative Abbot Jouin, David's biographer was a socialist Catholic from Angers. In 1870 he launched the *Revue des associations catholiques*; he also had a curious epistolary relationship with Bishop Dupanloup. Jouin was a scholar, a collector, and a fairly competent historian of French sculpture, but he also aspired to be the great critic of the sculpture of his time—which he was not. Charged with writing the catalogue of the Museum of Angers, he formed a collection of David's sculpture and drawings (several thousand works) bequeathed by the sculptor and his family to the museum. David's widow lent Jouin part of her husband's archives so that he could write his monograph. Today these documents are dispersed, not all having been preserved. Jouin, in fact, seems to have been privy to Emilie David's highly selective remembrances of the past; she did not confide in him completely. He worked on his book in the early 1870s, a period when the ideological rehabilitation of David had begun. Jouin, a stern, conservative Catholic, was hesitant to discuss forthrightly the political aspects of David's art and ideas. This phenomenon can possibly be explained by the conjunction of Jouin's own personal reticence with that of Emilie David who was probably uncertain of Jouin's attitude towards her husband's political beliefs and actions. The result was that in this book, as in Jouin's later publications on David, one finds emollient commentaries, omissions, and, in certain cases, outright censorship of David's reported ideas and writings. It is difficult to determine whether these factors were due to Jouin himself, to Emilie David, or to friends of the artist. Taken as a whole, however, Jouin's work is irreplaceable, because many of the sources he depended upon are lost.

Since its publication, Jouin's monograph has remained important for its biographical and critical sections, as well as for the second volume which presents its

ideological justification. He composed the second volume as an anthology of David's writings (unpublished for the most part) but he acknowledged in the preface that texts of a political nature were not emphasized. In fact, Jouin rewrote much of David's writings, including the sculptor's voluminous correspondence. Sometimes he made a compilation based on the many drafts that had been preserved, in other cases he consciously revised David's texts. This imposing ensemble of largely reworked sources became the basis for the construction of David's image over the years, the image that the most attentive historians and critics accept today, including, among the foremost, Louis Aragon.[11] This image in general should be accepted but with certain reservations. The present study will reconsider several aspects of Jouin's work, and David's writings cited by Jouin will be, whenever possible, transcribed from the original source.

David's image in the late 19th century is conveniently presented in summary form in Henri Delaborde's long and nuanced commentary on Jouin's book for the 1878 *Revue des Deux Mondes*. This text is a book review as well as an important theoretical statement concerning sculpture at the end of the 1870s, when Rodin, who was almost forty, was beginning to be known. Like Charles Blanc,[12] Delaborde emphasized the importance of David's image and public fortunes which he related, to a large extent, to the posthumous promotion of his work by the media and serial reproduction:

> Through what exceptional circumstances did David alone, or almost alone among contemporary sculptors succeed in remaining important and creditable with everyone? Even after his death the celebrity he had acquired lost none of its prestige, which even seems to have increased in proportion to the number of biographies and collections of lithographed and photographed works which have followed. Could it be thus that David's talent imposed itself on everyone with this irresistible influence that all great discoveries or sovereign inspirations of genius bring with them? Certainly, this talent, considerable in more than one respect, is of high pedigree and of strong character. Several of the principles from which it proceeded, and the merits that characterized it would certainly suffice to assure David of the votes of sound judges. But all of this could not suffice to explain how he could have succeeded so well with the mass public and to interest it so extraordinarily in his cause. One must look elsewhere for the cause of this phenomenon. One will find it in the nature of the subjects themselves usually treated by David, in the memories, exclusively modern and familiar to everyone that were awakened or supported by the chosen themes and the individuals he represented; contemporaries themselves furnished him with types that he popular-

ized by preference rather than the customary images of the heroes of fable or of antiquity. There are scarcely any artists, writers or politicians of our time, more or less famous, or even men known by whatever claim they may have upon posterity of whom David has not made a statue, a bust or a medallion, according to the relative importance of each of them. Beyond the inherent merit of most of his works, it is from this that the artist's reputation has profited."[13]

What did Delaborde mean by "mass public"? Did he mean the popular masses, those whom David, as we know, wanted at any price to reach through his art and his writings during his own lifetime?[14] Certainly he enjoyed great popularity with the cultivated middle class, particularly in the 1840s. And his popularity was sustained through engravings and the populist literature of the almanachs to which he often contributed. Thus, after he died in 1856, the *Magasin pittoresque*, which was managed by his political friends, singled him out from all other artists of his time. It remains difficult, however, to evaluate the extent to which David's art reached the masses. In 1848, when the political clubs were preparing the April elections, the Club of the Union of Saint-Denis asked him for his statuette of *La Liberté* (figs. 6, 7) in these terms: "At the moment when Liberty was not particularly popular, you made a statuette of Liberty that awesomely resembles her mother, the Republic. Our poor club has only a poor bust of the latter for our ornament, our family portrait. . . . I will take it upon myself to present [your statue] to my fellow citizens, to remind them of the date of the statuette; I will also remind them of the date of the beautiful, timeless page you wrote for the Pantheon. I will make them understand that the arts could not have a more dignified representative of a more deeply felt patriotism at the next assembly." This passage is, however, preceded by: "But, it must be said that in our brave city of Saint-Denis, whose population is in large part made up of workers, works of art, whatever their brilliance, are not as generally known and appreciated as they could be; to such an extent that the name of the citizen David (d'Angers) is a new name for many among us."[15] A terracotta example of the statuette that belonged to the collection of the politician Ledru-Rollin bears an incised inscription not always used in other examples and casts. This consists of the dates of the two past revolutions ([17]89, 1830) and that of a third to come, which is left incomplete (18..) to emphasize its proleptic nature. The dates associate David's meditation on the past and the present with a future that history will soon realize (fig. 8).[16]

Jouin's and Delaborde's judgments of David's art should be discussed briefly, for their observations summarize an important aspect of the detailed history of the sculptor's critical fortune. Both authors depended on a normative position inspired

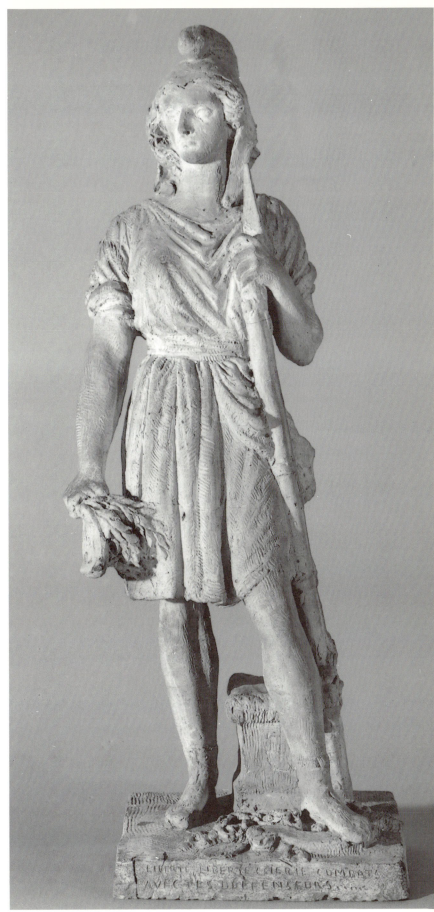

6. *Liberty*, statuette, terracotta, Paris, Musée Carnavalet

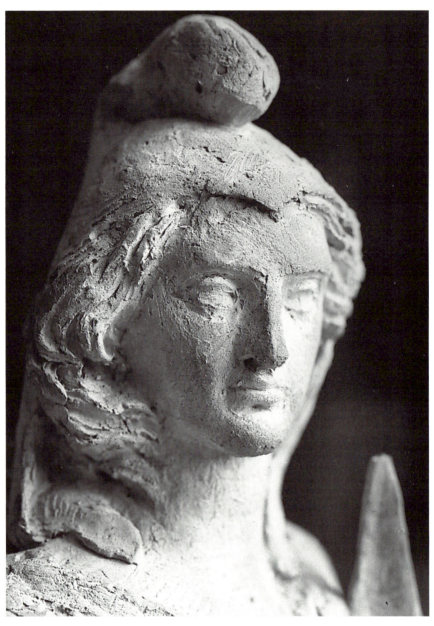

7. *Liberty*, statuette, terracotta, Paris, Musée Carnavalet, detail

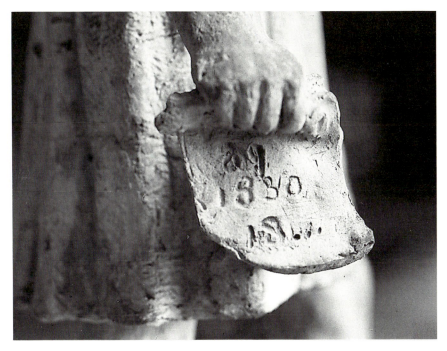

8. *Liberty*, statuette, terracotta, Paris, Musée Carnavalet, detail

by the classical aesthetic that was revived throughout the 19th century, in a continuous and often original discourse concerned with the modalities of imitation. This discourse consistently reinforced the notion of the pre-eminence of taste in conjunction with the sharp divisions maintained between the respective merits and expressive effects of the arts in the hierarchy of genres. In his 1878 review, Delaborde was infinitely more clever and subtle than Jouin in his handling of the theoretical discourse. In 1855 he had applied this theoretical discourse to the sculpture of his time in a long and important study of the sculptor Bartolini, "the only man who continued in our time the glory of Italian art."[17] It is important to note that even as late as 1878, Bartolini's art continued to be a central element in the informed criticism of sculpture for observers of differing critical viewpoints. (Baudelaire, for example, an attentive observer of sculpture, had described a work by Bartolini as the "capital piece" of the Salon of 1845.) Seen in the light of his study of Bartolini, Delaborde's views on David are very revealing:

David himself resolutely acknowledged at every opportunity his intention to liberate art from the former conventions of the school; but it would be a great mistake to attribute to these attempts at freedom the significance of a revolt

against higher and more general laws, a war declared against the ideal. On the contrary, the ideal is David's dominant preoccupation, the object of his studies and his continual efforts. Nothing is less materialist than art as he understands it, nothing more closely tied to the function of thought than the work he demands that the hand accomplish. By subordinating to the particular means of his art the intentions that he must translate, and by considering his subject from the point of view of sculpture and with the sentiment of a sculptor, David conceives each composition and combines the elements in them. It remains to be seen whether, in the execution itself, he succeeds in saving himself as well from divagations and if, even while avoiding the domain of writers and poets, he always abstains with the same prudence from invading the domain of the painter. . . . It will suffice to cite as examples such strange mistakes as the statue of Larrey (fig. 9), placed in the courtyard of the Val-de Grâce, and the group that stands above the Tomb of General Gobert (fig. 10) in the cemetery of Père-Lachaise. How does one explain these almost deformed exaggerations which, when one looks at these two works, or others of the same genre, leap to the eyes of even the least perceptive. How is it that these outrageous interpretations of stature or individual physiognomy were made by a man so deeply and well-informed in the laws of his art and so capable—as he has proved elsewhere—of putting them into effect? If one follows the development of David's talent from his first steps to the period when, because of his compulsion to act, he no longer took the time to reflect, or, because he hurried, he lost his breath, one can explain the progressive divagations or, at least, one sees them succeed one another with a type of fatal logic. . . . Through a singular lack of knowledge of his true aptitudes and a progressive deviation he appears, towards the end of his life, to have had the ambition to become what he never became—the Delacroix of his art.[18]

David's art can be most effectively studied within the context of several late 18th- and early 19th-century ideas concerning the nature, objectives, and impact of sculpture in France. During this period sculpture was omnipresent. And modern sculpture was expected to emulate what were believed to be the objectives of ancient sculpture, which was seen as the means of regenerating modern art. Sculpture was understood as a sign of the beliefs, ambitions, and accomplishments of men but the sculpted image was considered to be a manifestation of the grandeur of nations as well as an indicator of their errors and defects. Sculpted works were divided into two distinct categories: that of public sculpture (whose origin and financing could be collective or individual) and private sculpture. These two options for the desti-

9. *Monument to Larrey*, statue, bronze, Paris, Val-de-Grâce

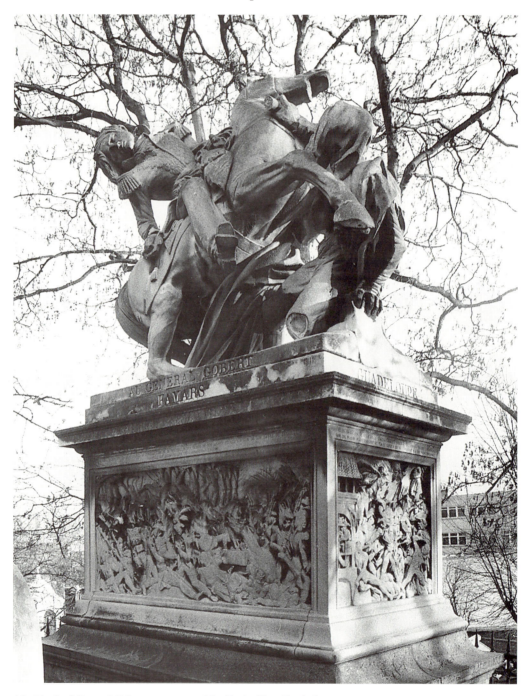

10. *Tomb of General Gobert*, group, marble, Paris, Père-Lachaise

nation, markets, and consumption of sculpture were important to the extent that they implied a precise choice of imagery, as well as expressive parameters or "style." The artist developed his ideas about a subject according to options concerned with a choice of elements based on appropriateness, the relationship of a work to its site, the support responsible for its placement (the base or pedestal), the dimensions of the monument, its material, the costume (according to the principal meaning of the word) of a figure, and expression. The sculpted monument, which usually depicted the public image of a man, sometimes consisted only of a single figure, but it could also be associated with architecture. It was, therefore, often submitted to both the prescriptions of architects and governments. The statue and the sculpted monument, what we might call the statue-monument or the edifice-statue, offered to the city or to surrounding nature what was perceived to be a meditation on origins, permanent features, and posterity—an ensemble of ideas that linked a present based on the past to a hypothetical future.[19] These are, certainly, traditional, atavistic uses of sculpture. Around 1770, however, these uses expanded and underwent spectacular transformations in two privileged genres. One was the traditional genre of the dynastic monument, while the other, innovatory and transformative, promoted the role of the statue as a sign of public homage to a contemporary—to an ordinary man whose genius made him a beacon to and a benefactor of humanity.

Two examples bear witness to the extent of these changes. The first is Pigalle's monument at Reims erected to Louis XV (fig. 11). Two figures on the pedestal offer, in a diptych, a lesson in civics in the form of two colossal allegories (a traditional usage in this type of monument). One figure, *Benevolent Government*, a personification accompanied by its emblem is, in fact, a true allegory. The other, *The Citizen*, is also an allegory but one which would be called in the 19th century, "a real allegory." Diderot, referring to this very figure by Pigalle called it "the thing itself "[20] and opposed it to true allegory. The *Citizen* offers an image of modern man relaxing after a day of labor (this was an idea valued by the Enlightenment). Voltaire wrote about this subject to d'Alembert: "[Pigalle] honored me by telling me with his naïveté free from all self-love that he conceived of the design of the accompaniments of the king's statue which he made for Reims based on these words which he read in the *Siècle de Louis XIV*: It is a former practice of sculptors to place slaves at the feet of the statues of kings: it would be better to represent free and happy citizens."[21] It is important to note that the figure of *The Citizen* (fig. 12) is presumed to be a self-portrait of Pigalle;[22] it is, therefore, both a form of signature and at the same time a fairly bold assertion less related to personal vanity than to the sculptor's claim to intellectual and social prestige—a distinction rarely accorded to sculptors during this period.

The second example, Pajou's *Buffon* (fig. 13), introduces a group of issues that are directly related to one of David's obsessive preoccupations with the nature,

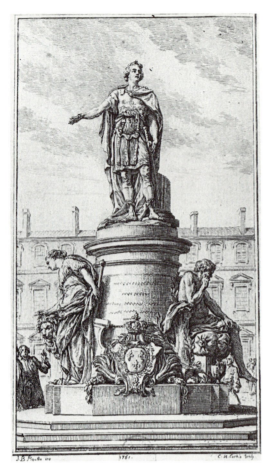

11. Pigalle, *Monument to Louis XV*, etching
by Cochin, Paris, Bibliothèque nationale

goals, and means of homage in sculpture, either through private or national initia-
tives. Pajou's *Buffon* was erected during Buffon's lifetime in 1776 in the *Garden of
the King*, which was open to the public. Pajou represented the naturalist partially
draped, "in the costume of a philosopher," with the upper part of the body nude.
This work constitutes a significant reversal of a former national custom which lim-
ited the public monument to depictions of royalty (exceptions were rare). In 1765,
the architect Pierre Patte recalled: "it is not customary in France to erect monu-
ments to great generals and to famous men: kings alone obtain this distinction."[23]
Buffon's statue is closely related to Pigalle's depiction of the nude *Voltaire* (fig. 14),
a private homage offered to the philosopher by his friends while he was still alive.
During the period in which these two works were executed, modern *statuomanie*
was inaugurated on a large scale with d'Angiviller's series of *Grands Hommes* com-

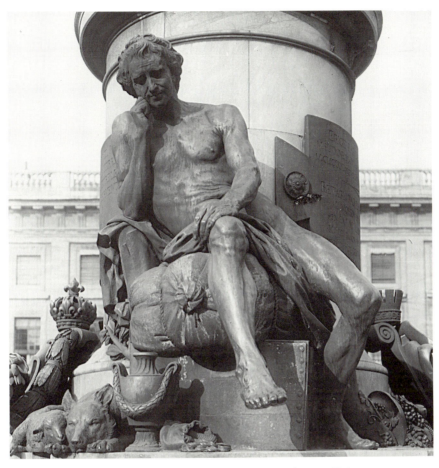

12. Pigalle, *The Citizen*, detail of *Monument to Louis XV*, bronze, Reims

missioned for the Grande Galerie of the Louvre (which was in the process of becoming a museum).[24] To complete the early history of *statuomanie*, several examples remain to be examined. These examples define the casuistry of the modern period which determined the sculptural methods employed to render figures heroic or monumental. These examples were influenced by diverse factors which include ideas concerning the limitations of homage, those related to a measurable hierarchy of values that the work expressed through size, and a tenacious notion of the durability of the historic testimony embodied in the statues. It was of equal importance to discern in representation what pertained to the public and to the private realms in the accomplishments of the hero.

In his works and in his writings, David would take these ideas to the extreme, by analyzing the artistic methods that the sculptor must employ, the choice of ar-

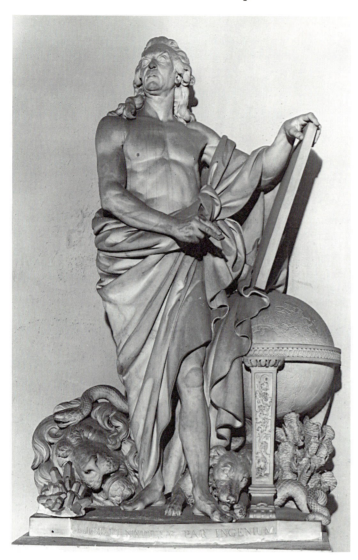

13. Pajou, *Buffon*, statue, marble, Paris, Museum d'histoire naturelle

chitectural support and decoration, of material, of the moment represented, of the costume and, finally, of the style of execution. These issues can be observed in Bouchardon's project in Rome around 1730 for the statue of the Prince of Waldeck (at this time the model was still alive). The figure was to be depicted "nude and life-size" (fig. 15).[25] Equally interesting was Segrais' project in Caen, at the end of the 17th century, to honor the poet Malherbe by commissioning a statue from Postel, which was to be placed in a niche on the facade of his hotel.[26] Questions concerning the function of sculpture were discussed after 1750 in an abundant dis-

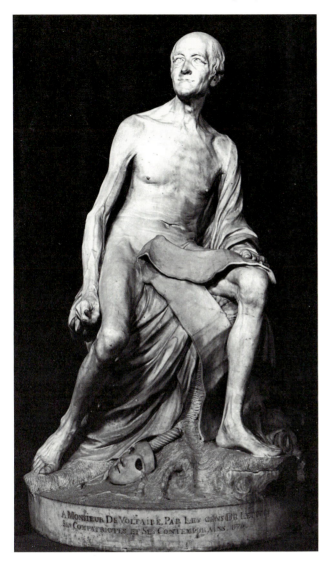

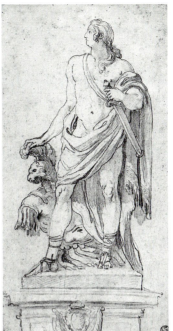

15. Bouchardon, *Project for a Statue to the Prince de Waldeck*, drawing, Louvre

14. Pigalle, *Voltaire*, statue, marble, Paris, Louvre

course in which widely debated ideas concerning the nature, history, and forms of homage and honors, genius, the hero and the notion of heroism, and the artist's reflections on posterity were conflated. This discourse expressed widely held beliefs concerning the moral and reformatory role of responsible art, which was found, above all, in sculpture. Strict lines of division were drawn in the choice of subjects and images and the issue of the moral responsibility of the artist was emphasized. In 1750 Rousseau wrote: "Our gardens are decorated with statues and our galleries with paintings; what do you think that these masterpieces of art, exposed to the

[23]

public admiration, represent? The defenders of the country? Or these men, even greater still, who enriched it through their virtue? No, these are images of all the deviations of the heart and of reason."[27] Diderot wrote: "Whatever talent there is in a dishonest work, it is destined to perish either by the hand of the severe man or by the hand of the superstitious or devout man. What! You would be barbarous enough to break the Venus with the beautiful buttocks? If I would catch my son masturbating at the feet of this statue, I would not fail to do it. Once I saw the key of a watch imprinted on the thighs of a voluptuous plaster-cast."[28] Falconet's memorable formulation in a remarkable article written for the *Encyclopédie* was particularily well-known to artists: "Sculpture, after history, is the most durable repository of man's virtues and weaknesses. If we have in the statue of Venus the image of an imbecilic and dissolute cult, we have in that of Marcus Aurelius a celebrated monument of the homage rendered to a benefactor of humanity. This art, in showing us deified vices, renders even more putrid the horrors that history transmits to us. . . . Caesar saw the statue of Alexander; he fell into a profound reverie, let several tears escape and cried: What happiness you had! At my age you had already subjugated a part of the earth: And me, I have done nothing for my own glory. What glory is his! He was bound to tear apart his country."[29]

Diderot's well-known maxim that revives the discussion of the *paragone* expresses more clearly these ideas concerning sculpture: "I look at a painting, I must converse with a statue."[30] We see here a discursive relationship, forcefully emphasized and extended temporally, between the spectator and the statue. This relationship, however, would soon be challenged, or at least rendered more subtle, by the radical theorists of Neoclassicism in the name of a primal, instantaneous, and comprehensive perception of the sculpted image.[31]

Another facet of the discourse on sculpture during this period (concerned with its private uses) is more traditional and is related to the function of "decorative" and "charming" sculpture. Falconet specifies that sculpture, in this case, is less useful in appearance, but, he adds, "[it] is no less appropriate to lead the soul to good or evil."

The ideas and beliefs about sculpture during this period were widely popularized in a curious work that survived in the 19th century (David owned a copy of it). This is the 500 page treatise that Octave de Guasco, the Count of Clavières, published in 1768, *De l'usage des statues chez les anciens*, . . . an essay on idolatry as it was perpetuated in history by means of the statue. This book offers a remarkable compilation of antique sources on sculpture but it is also a sociological reflection; the author was not concerned at all with questions pertaining to sculptural aesthetics. The work is polemical and derives its impetus from multifarious sources— history, geography, and linguistics—in order to denounce, and, at the same time,

to demonstrate that religion (idolatry) and politics used the unique and curious practice of making statues as weapons in their arsenal.

Two aspects of Guasco's book are of interest to this investigation: the first is its documentary and retrospective aspect. The book yields an extraordinary harvest of pagan marvels, a fascinating inventory of characteristics and customs noted by authors, travelers, and ethnologists. Guasco reminds his reader of many things concerning the usage of statues. He includes humorous, long-forgotten facts, such as, for example, that "fever" had its own statue in Rome, or that the inhabitants of the city of Golconde erected a statue to smallpox. He recalls, giving numerous examples, the respect that statues inspired. He recounts, for example, how Martial asked Jupiter to force the comic actor Athonte to dine with him [Martial] for three days "because he farted in the presence of a statue on the Capitoline."

However, the most profitable lesson on the usages of statues to be learned from Guasco's thesaurus (and this is due in part to the number of cases he recorded) concerns the fascination that the statue exerted on the ancients and the moderns, on the civilized man as well as on the primitive, non-western man. This fascination is due to the statue's forms, material, and diverse dimensions, to its nature as an object that unites and concentrates ideas. The statue is a simulacrum, a sign, destined at the same time for public communication and private manipulation. The author relates that if the statues manifest, for the historian, the social and historical ideas that brought them into being, if they are "treasures" for the antiquarian, they also are, he insists, *dolls* [my emphasis][32] for the rich and ostentatious man. Later, Baudelaire would rediscover this image and usage in one of the most penetrating analyses of sculpture written in the 19th century.[33] We can imagine that Guasco's work influenced artists, commissioners, and the public in their ideas concerning sculpture, the statue, the monument, and the honors that reaffirmed the values of ancient traditions.

The rapid development in the production of statues and in critical discourse (with the aberrations and exaggerations this produced) offers a unique perspective on the significance and uses of sculpture circa 1800 and later. The political, commemorative, votive, prophylactic, and erotic meanings ascribed to sculpture during this period merit historical investigation. This vast and fascinating material should be studied comprehensively. For example, the statue and other "genres" of sculpture created during the 19th century, namely the completed architectural monument and the projects and works destined for an ephemeral goal such as ceremonies and festivals, should be studied in conjunction with one another. Sculptors usually planned works in collaboration with others—particularly for public programs. Falconet recorded this inter-dependence when he wrote: "I have executed a figure for the dairy of Crécy after a sketch by Boucher: Messieurs Allegrain and Vassé did the

same; but Boucher was Boucher and there were orders from higher sources: all things considered, this is not the most worthy action we could have performed in our life."[34] During the Revolution, Louis David perpetuated the tradition of Boucher and the first painters of the Ancient Régime by his quasi-dictatorial role in the artistic domain. In the 19th century, the architects (or the politicians and bureaucrats who directed them), to a greater extent than the painters, maintained a vigorous grip on sculptors and rigorously controlled their ideas and the execution of the works.[35] Thus, one of the most profitable domains for the study of sculpture is to be found in the confrontation between sculptors and architects, particularly in the joint projects for what was essentially architectural or decorative monuments, the typology of which was reestablished in the late 18th century and sustained throughout the 19th century: arches, fountains, columns, tombs, monuments, and memorials.

From the early decades of the 19th century it would be reiterated that sculpture and sculpture alone embodied what was essential in a monument because the statue depicted an image and, therefore, conveyed the meaning of the monument itself. The ambitious and often frenzied monuments planned during the Revolutionary epoch were frequently discussed during this period. Progressive critics acknowledged that sculptors should have the initiative in sculpted monuments in which architecture was an accessory. Often, however, architects had the final say. In 1840, for example, in the competition for *Napoleon's Tomb*, in which eminent sculptors competed with architects, the sculptors' projects were not retained (this monument will be discussed in appendix II). One must not, however, forget the works of Chinard, Chardigny (fig. 16), Petitot, and others, in which the statue characterized the monument and in which the architects' control over the program was denounced.

A well-known sculptural project which was frequently discussed in literature and historical writing during the 19th century was Louis David's colossal *Monument to the People*. The Convention voted to support the project thanks to the painter's encouragement. A competition was held for this permanent monument in bronze which would consecrate and memorialize the "people" in the format of Hercules triumphing over superstition and tyranny. Louis David saw it as a summation of "all [the] victories" of the Revolution. Its pedestal would consist of the truncated debris of the "idols" of tyranny and superstition which were gathered in Paris for this purpose.[36] Diverse works relate to this competition, one of which, still neglected, was the project designed by the sculptor Moitte (fig. 17), who, during the same period, was executing the pediment of the Pantheon (defined in its new functions by Quatremère de Quincy). Moitte's elaborate project, whose true destination has been recently identified,[37] was not retained. The reasons for the neglect

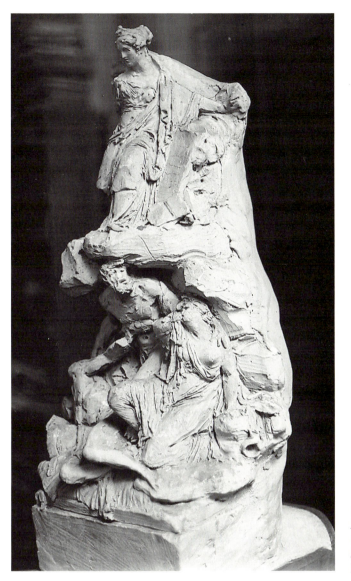

16. Chardigny, *Clergy and Nobility Vanquished at the Feet of the Third State Who is Protected by Law*, sketch in clay, Aix-en-Provence, Musée Granet

of this project are understandable. If the project was presented at the *Concours de l'An II*, after Robespierre's fall in July 1794 (no document exists to demonstrate this), when the second reconstituted jury was presided over by the conservative Quatremère de Quincy, it would have been too close to what were considered to be Louis David's radical ideas. Conversely, if it had been presented to the jury before Thermidor (Robespierre's fall), it would have been seen as too conservative to be acceptable. The projected monument emblematized, in a traditional mode, the

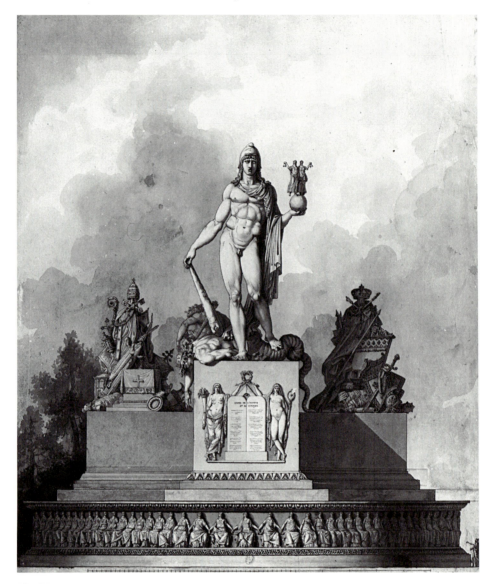

17. Moitte, *Project for a Monument to the French People*, drawing, Paris, Bibliothèque nationale

overturned insignias of royalty and the church, rather than use them as the real base of the monument, the true pedestal in which the reality of the colossal image of the People must take its root. In fact, late 18th- and early 19th- century theorists and critics asserted that the meaning inherent in a commemorative monument depends on the accumulated power that it draws from the site. The historical and topographical continuity and survival within the monument of the site on which it

is erected is of utmost importance, for the monument becomes the substitute for the site and affirms, almost magically, its transubstantiation.[38] The series of colossal monuments of this period that were intended to be erected on the ruins of the Bastille should be studied in this context. And, if we consider works executed on a small scale, such as the portable icon, the models of the Bastille carved from its ruins come to mind. This provides, in a sense, a form of almost derisive survival that was completely emblematic of the Bastille in all of its associations. This type of "popular" carved object that bears witness to a memorable event was accepted in the Pantheon program. This acceptance must have displeased Quatremère de Quincy, for his ambitious, though thwarted program of "heroisation" for the decoration of the original Pantheon had eliminated popular, representational art altogether. The politician Barère de Vieuzac in his report concerning the "pantheonization" of the Republican sailors of the ship *Le Vengeur*, on August 8, 1794, declared: ". . . a kind of warrior philosophy had seized the entire crew. . . . They deliberated their fate. . . . They would have preferred to drown rather than dishonor the country by capitulating. . . . Why should one not propose to you to suspend from the vault of the Pantheon a ship that would be the image of the Vengeur?" This proposition, in fact, was adopted by the Convention through decree: "a form of a warship will be suspended from the vault of the Pantheon. . . ."[39]

Let us return to Louis David's distinguished program for the *Statue of the People* and to questions discussed earlier that concern the significance of the statue, sculpture, and the monument (which could represent both individuals and objects), particularly in their public usage around 1800. These questions can be related to the influence that Louis David's program exerted during the 1830s, a period of intense *monumentomanie* and *statuomanie*. During this period, Thiers, for example, chose the subjects of four chapters from his forthcoming historical work and had them sculpted on the lower sides of the Arc de Triomphe, like four colossal frontispieces. And, in 1834, the polemist Godefroy Cavaignac, who was imprisoned for political misdemeanors, published a long study on "The Monuments" of the French Revolution (in the broadest sense of the term, that is, on the cultural achievements). He highlighted the Convention's decree proposed by Louis David, and spoke at length of David as pageant master of the Revolutionary festivals. But he gave a curiously slanted account of the aborted project of the *Statue of the People*: "The *Statue of the People* was not erected and this project failed with the grandeur of which it was meant to be the emblem; the popular colossus, like that of Rhodes, was overturned by tremors of the soil, and one can say that its debris, just like that of this marvel of the ancient world, was sold to vile pedlars. . . ." Cavaignac alluded to tremors of the soil, political soil, of course, but also to the destructive—or constructive—powers of politics and of nature herself who acts as architect and sculp-

tor (this was a persistent *topos* in the discourse on sculpture during this period). Cavaignac offered a rather remarkable description involving the sculptural and architectural possibilities of natural phenomena. He recorded a correspondence, that he described as fictitious, between two of the most politically active artists of the Revolution—the sculptor Ceracchi and the painter Topino-Lebrun. In this passage these artists realize David's projects in words and images: "Yes," writes Ceracchi, "I will build a colossal statue of the People. The Seine will open its waves before its pedestal, the head will be higher than the highest summits; it is this statue that, above the domes will announce, from afar, the great city to the proscribed, so they may recognize their refuge, and I want my statue to cast its shadow all the way to the Louvre palace, where its shadow alone will terrify the phantom of royalty. This program has so stirred my imagination that it does not seem to be gigantic enough. I would like to make the block of the colossus from a mountain, like the one Quintus Curcius speaks of, and place in its hand a cup from which the rivers flow, and carve its face from rocks crowned by high clouds. The task alone of its historian would be more colossal than its sculptor. . . ."[40] This phrase, inspissated with meaning, will be of interest in a later context.

CHAPTER 2

"Statue Bravache"

SINCE his work was produced in a relatively short period of time—about thirty years or so—a selective, chronological study of the development of David d'Angers' career is justified, one that will highlight typical, significant examples or important moments of his artistic production. A strict separation of his oeuvre into artistic categories dictated by themes or images does not seem desirable given the idiosyncratic and restrictive nature of David's ideas concerning art and sculpture. In his writings he obsessively expresses an almost exclusive preference for the genre of iconic sculpture. His belief in this privileged, unique, austere genre is associated with his completed public monuments. At first glance this might appear to represent a conservative and retrogressive approach to art, since iconic sculpture does not lend itself to spectacular transformations and revivals. A study based exclusively on David's iconic sculpture, however, would be misleading; it would make uniform and consistent the complexity and diversity of his art and ideas. Finally, a study of works based on changes in political regimes does not seem to be the best approach either, in spite of the prominent political character of David's oeuvre and the major impact politics exerted on all forms of public art during the 19th century. Such a study, it is true, would emphasize the originality of David's works and the provocative power and social impact of his most accessible public images. But a study based on political concerns would have disrupted the surprising continuity (in the midst of consistent fluctuations) of his artistic development, which is of critical interest here and which will be considered in a later chapter.

In this and subsequent chapters, several selected works, writings, and attitudes of David from the period of 1815 to 1850 will be investigated; they help to elucidate his fascinating and original ideas about, and approaches to, the making, viewing, and communication of sculpture. This examination will be accompanied by parenthetical observations and digressions which will serve a double purpose: first, to examine elements of the social and cultural contexts of the diverse milieus in which sculpture was made (such an examination is necessary in order to understand the art of Romantic sculpture) and, second, to help clarify the Roman-

tics' ideas about sculpture, by analysing the writings of David and several of his contemporaries.

We know little about David's early years when he was studying at the Ecole des Beaux-Arts in Paris and we are only slightly better informed about the studies that followed at the French Academy in Rome.[1] (Little documentation exists related to the Roman sojourn of students before 1824.)[2] We know for certain, however, that this entire period is characterized by the extraordinary burden of academic and governmental sanctions imposed on the education of sculptors and on their subsequent careers. Students at the Ecole des Beaux-Arts were compelled to submit to these sanctions if they wanted to succeed. They often received important commissions during the last stages of their student careers in Rome. When they finally became full-fledged academicians and professors at the Ecole des Beaux-Arts they continued to sustain the artistic policies of the government through the authoritarian, consultative role of the Académie des Beaux-Arts which directly influenced the Ecole.

Within this system, David, beginning with his Parisian studies, followed a direct route to success. He adhered to the prescribed time schedule, as did his exact contemporary Pradier, a sculptor who may be defined as David's artistic and intellectual antipode. David and Pradier differed in almost every way except in the quality of their unique faculties of invention; yet each had a comparable, significant impact on 19th-century sculpture.

In the 1810 competition for the Prix de Rome, David (who was 22 years old) received Second Prize for his *Othryades Mortally Wounded* (fig. 18), a work in the round. The following year he won the First Prize with a similar subject, *Epaminondas after the Battle of Mantinea* (fig. 19), a relief. As might be expected, these two works, based on assigned subjects, are entirely in keeping with the academic curriculum. Academic expectations would be reiterated in the judgments and criticisms of the works executed for the competitions. In the figure in the round these expected characteristics included a forceful pose, strong and thick contours in drawing, an "appropriate" character, strength, feeling, and an anatomy that was "easy to read."[3] The relief, in addition to these characteristics, was expected to display a harmony of composition in the depiction of multiple figures which was also required for the painters. These requirements were developed from the aesthetics of Greek sculpture, a subject of contemporary debates that revolved around whether the mimetic character of Greek art was based on observed nature or on idealized forms. Moreover, the style in which the subject was executed was also based on contemporary interpretations of classical aesthetics. For example, energy, accentuated surfaces, and an emphasis on physiognomic detail were particularly pronounced in examples David and his fellow students executed for the figure of "char-

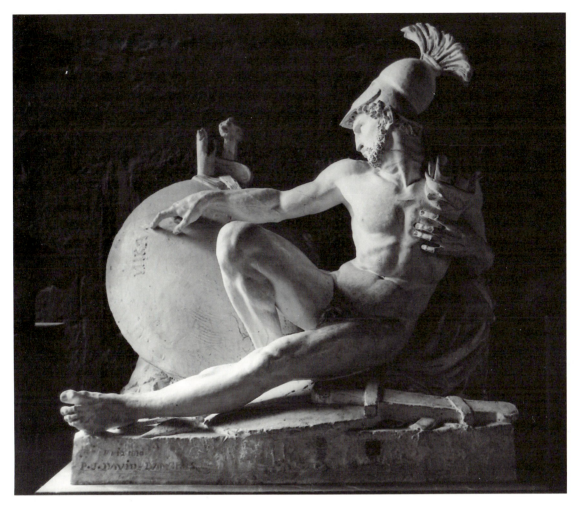

18. *Othryades Mortally Wounded*, statue, plaster, Angers Museum

acter." Style, however, would differ according to the choice of subject. For exam-
ple, a figure depicting a "youth,"[4] which represented a bucolic, mythological, or
allegorical subject, required a style that differed considerably from the heroic style.
The Ecole demanded that the students conform to this discipline of mind and
hand, this set of rules in which invention was restrained and reduced to basic essen-
tials. Quatremère de Quincy declared that artistic education "could not begin too
early: [because in the act of drawing] the work of the physical organ plays a large
part, one cannot utilize too early the period of life when everything is flexible in
us."[5] It is interesting to note that among David's contemporaries the average age
for Prix de Rome winners was at its lowest point in the history of the competition

19. *Epaminondas after the Battle of Mantinea*, relief, plaster, Angers Museum

(the winners were from nineteen to twenty-three years old). Rude, however, was the exception—he received his at age twenty-eight.

Certainly it is difficult to discern in the Parisian prize-winning works clear evidence of individualized talent. In Rome, however, the sculptors were compelled to produce works of a different nature. Through a series of exercises, they continued to refine their Parisian studies, but they also directed their efforts towards the conception of a more original work which would reveal to some extent the nature of an individual's talent. The last Roman "envoi," a work sent back to Paris for the scrutiny of the Academy, was restricted in the choice of subject, style, and execution—elements that were largely dictated to the sculptors. In spite of these limitations, however, the envoi is of interest, because the figure had to be a nude, and the nude, throughout the 19th century, remained the essential subject of sculpture.

A study of the nudes executed by student sculptors in the early 19th century can be particularly revelatory, especially if we look at the figures produced by a triad of Parisian laureats and coevals—David, Rude, and Pradier—who won the Prix de Rome in three consecutive years: 1811, 1812, and 1813. These are the three great artists of the first generation of Romantic sculptors, who all died shortly after 1850. One can appositely compare Rude's prize-winning *Aristeus Mourning the Loss of his Bees* (fig. 20) of 1812 (although it was not executed in Rome) with David's *Young Shepherd* (fig. 21), executed in 1815 during the third year of his Roman sojourn (Pradier's Roman works, his *Bacchante* and his *Niobid* cannot be compared

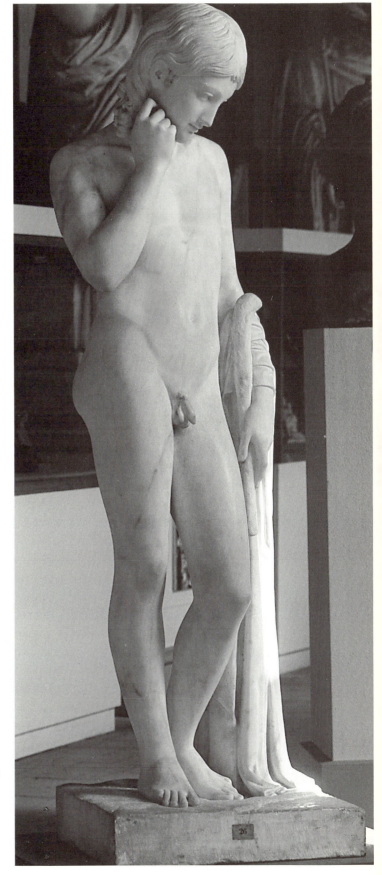

20. Rude, *Aristeus Mourning the Loss of his Bees*, print

21. *Young Shepherd*, statue, marble, Angers Museum

with those of Rude and David because of the type of subject). A comparison be-
tween the *Young Shepherd* and *Aristeus* is, nevertheless, difficult, because David's
marble must be contrasted with a late bronze cast based on a reworking of the 1812
plaster which is known only through a neglected engraving.[6] The accuracy of the
engraving is subject to certain reservations but the affectation of the pose and the
insistence on mannered details are sufficient to allow us to reconstruct the original
work and to understand better the attitude of Rude during the 1840s towards a
youthful work of which he no longer approved. His first attentive biographer re-
called that "one of the first things Rude did upon his return from Italy [in 1843]
was to break his *Aristeus Mourning his Bees* . . . a long time ago he had left behind
the mistakes of the school to which the [composition] and the style of the figure
belong . . . but after his trip, the sight of this too academic work was hateful to him
and it disappeared."[7]

The *Young Shepherd* (fig. 22), "a youthful figure," expresses something very
different from the *Aristeus*, although the subject, represented like a Narcissus at the
water's edge, belongs to the same bucolic mode as Rude's figure. David minimizes
the expression of movement by presenting a figure with solid volumes, almost com-
pletely devoid of accessories, in a regular compositional format with pronounced
vertical thrusts. Enthralled with his "very beautiful" model, David had initially
thought of a more specific subject, perhaps an Apollo, a youthful hunter with "a
little goat at his feet that he killed by mistake." He appears to have abandoned this
idea on the advice of his teacher Roland.[8] His final choice emphasizes the pro-
nounced psychological dimension of the figure who is absorbed in profound medi-
tation: nothing could be further from Canovian art. The work, in fact, is manifestly
opposed to the aesthetics of Canova. Later in his career, David would publish his
views on Canova and Thorwaldsen, his two great predecessors whose works he saw
in Rome. The early Roman works of these sculptors reveal a simplicity of pose and
an expressive reserve that is akin to that of the *Young Shepherd*. David's response to
the critical assessments of Canova and Thorwaldsen during the first half of the
19th century will not be analyzed here, but his preference for their Roman works
is clear. In 1816, before he left for Rome, he recorded what Louis David had said
to him about Canova: "See him for his way of working the marble but not for his
way of imitating nature."[9] David d'Angers appears to have had sustained contact
with Canova (we know nothing about the contact he may have had with Thor-
waldsen) and his criticism of Canova largely follows that of Quatremère de Quincy
who saw in Canova, at his worst, "an antique Bernini." Later David would express
serious reservations about Canova's lack of political involvement: "Why didn't
Canova erect a monument to the generous Rienzi or to Dante. . . . He did not
know the philosophy of art."[10] David's short study of Canova, published in 1840,

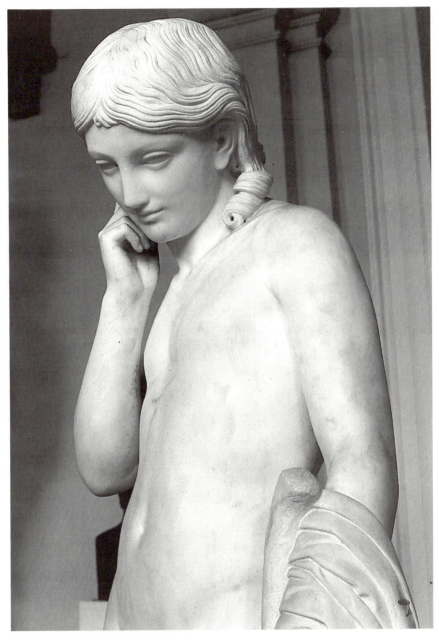

22. *Young Shepherd*, statue, marble, Angers Museum, detail

is full of praise, although the syntax he uses abounds in negative constructions.[11] The essay he wrote in 1844 on Thorwaldsen for Charles Blanc, however, was more reserved in its praise and stronger in its scathing condemnations. In his personal notes David repeated that Thorwaldsen's sculpture was "worthless" but he deleted this from the published version because of his belief in the political and timely pedagogical importance of his essay. All in all, the reservations concerning Thorwaldsen that he expressed publicly were less severe because he believed that students of sculpture could learn from this artist: "[Canova] has clearly more of the ideal, more composition, in the highest sense of the word. Thorwaldsen, it seems to me, lacked inspiration and verve: his works rarely produce emotion and it is only after long study that one discovers in them eminent beauty."[12] It is important to note that for David, the modern masters were French, and he wished to write about them.[13] In particular, he wrote a long and penetrating study of his teacher, Roland, in whose productions he discerned "an incredible truth to nature."[14] He also wrote about several representatives of radical Neoclassicism in sculpture (today neglected) who worked at the turn of the century—Caillouette, Massa, and Espercieux. He contrasted these French artists and their works to modern Italian sculpture: "The Italian sculptors concern themselves more with the *primo aspetto*, with exterior effect, with charlatanism of form, if I may use the term; they are extremely impressionable and they speak to a people who understand so quickly even a simple sign, provided they be struck by it suddenly, that they do not feel the need to emphasize very much the study of anatomy and physiology . . . the French sculptors differ in as much as the impression of the soul, although it has an immense influence on them, does not exclude the analytical power that is the indispensible condition of any work apt to resist the popular fashions of any period."[15]

Before concluding our examination of the artistic beginnings of David, Rude, and Pradier, let us examine briefly an aspect of David's career that has already been mentioned and which will be of critical importance to this study—namely, the question of his writings. A great deal of his written oeuvre was published during his lifetime, and, although frequently attacked by critics of his time and more recently by others, this published work was nonetheless noticed by several perspicacious intellects. Delacroix, for example, after having read David's articles on Canova and Thorwaldsen, wrote to him: "The truth of such a judgment should not be surprising coming from you, but the manner in which it is expressed and the style of your letter proves, once again, that the *only true writers* are those who are not professionals."[16]

David left a considerable body of writing—articles on art published during his lifetime, unfinished articles (in some cases a number of versions exist), a long "intimate journal" in which he recorded, in fragmentary form, his thoughts on art and

other subjects, and, finally, a vast correspondence. From a very early date he was simultaneously involved with these three types of writing—articles, the personal journal, and the letter—which fused with one another and were confluent since often an image or idea was transposed from one genre to another. His writings should not be studied separately because, when read as a unified corpus, they reveal the remarkable cohesiveness of his ideas. Curiously, David was obsessed by the word and the image that it evokes, but also by the phenomenon of writing itself and by the deficiencies he found in himself with regard to writing. "What a misfortune that I cannot write,"[17] he confided repeatedly to his friends and to himself. His texts, for the most part, are scattered. A large number, today inaccessible or lost, were seen by Henri Jouin who, as noted earlier, made selections, arranged, and often rewrote texts with the intention of establishing what he hoped would become David's aesthetic code and artistic legacy. This constitutes the second volume of Jouin's work of 1878. In 1958, an erudite Angevin, André Bruel, transcribed in chronological order nearly all of David's fifty-four preserved notebooks which had been utilized in part by Jouin and others. Bruel restored a more exact text but one based on criteria that should have been more critical and scholarly. In the present study, quotes have been transcribed and translated from the manuscripts of the notebooks, since Bruel's transcriptions are not always faithful to the original texts.

If we return to art from the domain of the text, James Pradier should be the next sculptor to be discussed since, along with David, he was seen as the great rising force in sculpture of the 1820s. In a sense, Pradier's art, to a much greater extent than the art of David, was clearly defined in his earliest works, which prefigure the course of his entire career. His official career follows David's almost exactly. He was elected to the Academy in 1827, one year after David, and, like David, he received very quickly a professorship at the Ecole. It is significant that Pradier, whose Roman sojourn seemed more fructuous than David's, chose a female nude for the first statue he was required to execute in marble at the end of his stay.[18] This was his *Bacchante* (fig. 23), which he viewed as a work with popular appeal and a sustained market value. The *Bacchante*, certainly a seductive work, enabled Pradier to be associated with related erotic themes in sculpture as soon as he returned to France. The erotic female mythological figure, depicted in the nude, would become Pradier's principal subject throughout his long career. In contradistinction, the nude female, with a pampered, seductive body, an object of desire, would have no place in David's public art and this eschewal constitutes a remarkable exception in 19th-century French sculpture. Pradier's *Bacchante* or *Nymph*, which marks the beginning of a long series of female nudes, reveals what is unique and innovatory in his art—a sensual art which was the object of a specific type of criticism throughout the first half of the 19th century and whose very existence was a thorn in

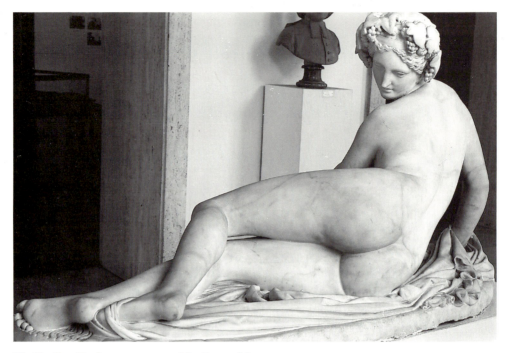

23. Pradier, *Bacchante*, statue, marble, Rouen Museum

David's side. Pradier developed a type of sculpture that David and others called "licentious," sculpture which brought to mind the art of the 18th century associated with private patronage.

Occasionally, this genre was tolerated in the small format of the statuette, but many denounced it when it escaped its boudoir environment and invaded the public domain, particularly the Salons, which were considered the showcase for the morality of various regimes. Pradier's art provoked conflicts related to the debate on social and moral art—the great issue at the end of the 18th century which social Romanticism adopted when it examined the modalities of the encounter between morality and modernity. Nothing could be more foreign to the art and views of David than the art of Pradier, and nothing could be more worthy of condemnation from a "responsible" criticism whether it be Christian, liberal, socially oriented, or conservative in inspiration. Nothing could be more desirable, however, for another type of criticism, one that was penetrated by the necessity of eulogizing the body, the corporal sign of the survival of the beautiful throughout history and, therefore, of the heritage of antiquity. The critical discourse is surprisingly extensive. David refers to it incessantly in his writings with uncompromising intensity up until his final years. For David, sensual art was the art of an elite unworthy of that name, an art of the privileged, an art whose very basis should be condemned because it de-

rives from oligarchic governments. And Pradier provided the perfect expression of this art.

The historical importance of his *Bacchante* in the context of sculptural ideas circa 1820 needs to be clarified. Certainly this figure belongs to a lively tradition of large female nudes which were frequently plagiarized from antique models and which were found in great numbers in 18th-century sculpture. The more general depictions of the female body, however, should be distinguished from those figures that depict the female reclining in an inviting position with an expression that can be read immediately in sexually explicit terms. At a time in which the antique Hermaphrodite was in vogue, one finds these recumbent figures of partially dressed women, often on a bed, in a pose that suggests a modern context which was confirmed by their portrait-like character. The dimensions, also, were important. Antecedents in the 18th century immediately come to mind, such as Mignot's *Reclining Venus*, which still conforms to the dimensions of the antique Hermaphrodite. One thinks of Pajou's alleged portrait in smaller dimensions of Madame du Barry (fig. 24), asleep on a quilted mattress,[19] or the large sleeping nude, whose head is on an embroidered pillow, attributed to Deseine.[20] The taste for this genre of sculpture did not disappear during the first two decades of the 19th century. The works are most often smaller than life-size but some were executed in larger dimensions which indicated more important placements. Landon had Lemot's marble *Reclining Woman* (fig. 25), a portrait of Ida de Saint-Elme, engraved for his *Annales* of 1812. In his commentary, Landon makes a precise reference to the dimensions of the work: "This woman lying on a couch leans her head on her left hand while she inclines her head slightly in the opposite direction. With her right hand resting on her breast, she pulls up a fold of her tunic whose upper part is entirely removed and reveals more than half of her body. . . . The pose indicates that instant of abandonment preceding sleep. . . . The nobility of style, the elegance of the forms and the lightness of the draperies which distinguish this pretty statue make us regret that Monsieur Lemot, accustomed to large works, did not make this one life-size."[21]

A series of captivating works of this type were produced during the Romantic period. Foyatier's so-called *Siesta* (fig. 26) (the variant that appeared in 1848 is reproduced here), for example, which depicts an undressed but bejeweled, contemporary woman, inspired extensive commentary at the Salon of 1834. The critic Théophile Thoré denounced in it, as he did in Pradier's works, "filthy thoughts and detestable actions."

Pradier's *Nymph*, in its canon of proportions, its heavy, almost vulgar power, thick contours, and the crudeness of its effects, seems, like David's *Young Shepherd*, to be a major component of the French attack on Canovian art. At its exhibition at the Salon of 1819, the eminent archaeologist, Emeric-David, took particular notice of it. He first examined the subject of the work which he corrected by identifying

24. Pajou (?), *Reclining Woman*, statue, marble, Paris, Louvre

25. Lemot, *Reclining Woman*, print

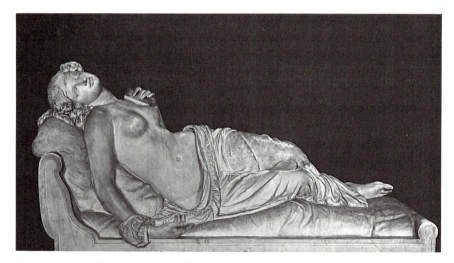

26. Foyatier, *A Siesta*, statue, marble, Paris, Louvre

the nymph as a Bacchante. And, in an analysis in which he attended closely to anatomical characteristics, Emeric-David highlighted the manner in which the figure expresses complacency about and absorption in the discovery of her own eroticized body: "M. Pradier has ingeniously varied the archetype of the Callipygian Venus. He has represented in marble a Bacchante entirely nude, lying on her side, raising her right arm and turning her head back to see the object to which her coquettishness attaches a high opinion of its beauty. The left hand, in a contrary movement, hides the breast almost involuntarily. This contrast is doubly felicitous because in this young inhabitant of the woods, a feeling of modesty seems to be allied with the admiration that she has conceived for her secret beauties and, at the same time, the breasts do not at all rival the buttocks which the artist has made a point of emphasizing."[22] Emeric-David's ideas were well-known to French sculptors during the first half of the 19th century since they all used the section on the practice of sculpture found in his remarkable *Recherches sur l'art statuaire. . . .*, published in 1805. In the theoretical section of this book that deals with the mimetic nature of Greek sculpture, Emeric-David described the Greek experience of the body as the singular cause of the perfection found in Greek sculpture. Like his contemporaries during this period, he recognized the role of taste in defining formal beauty but, in contrast, his perception of form was linked to the communicative functions he related above all to corporal awareness. His apparent rejection of 18th-century sensualism was, in reality, only a strategy to make it more intelligible:

> Eros has become for us the supreme judge of beauty. Rich in technology which chance or science has given us, we have neglected the principal agent of our will, the majestic, sensitive, agile, robust body with which nature has endowed the being that it destined to rule the earth; the irresistible attraction that forces the two sexes to seek each other out and unite; this imperative drive for pleasure that does not choose; in which friendship, vanity, hope, and admiration, disguise or beautify the faults that otherwise would thwart desire; this drive . . . by whose power nature, merging the races and mixing and regenerating forms, repairs its errors and keeps the human species perfect, but which for these very reasons, only brings isolated, evanescent, illusory judgments. We mistake taste for judgment. It is said that the body of man was only made to obey the law that dictates that we must reproduce . . . it is necessary to see in the form of man the instrument of his particular pleasures and, at the same time, the instrument of the pleasure and happiness of each of his fellow beings.[23]

The rapidity with which David made a name for himself in Paris after his return from Rome in 1816 is nothing short of remarkable. He returned to Paris after visiting London, a city that attracted him for a variety of reasons. He wanted

to meet Flaxman in whom he perceived, before knowing his sculpture, "one of the great men of the learned world under whom one can study." The other great man, for David, was his mentor and teacher, Jacques-Louis David. After having seen the works of Flaxman he was convinced of Flaxman's "extreme weakness in sculpture." The architect and archaeologist Coquerell, whom David had often encountered in Rome, urged him to settle in London. The overriding reason for the trip was to study the marbles of the Parthenon which had just arrived. After David's return to Paris, the death of his teacher Roland brought him to center stage as he received the offer to replace Roland in one of the most important collective programs of this period—the decoration of the Pont Louis XVI (the Pont de la Concorde). David was offered the commission for the colossal statue of the Grand Condé that Roland had been asked to execute.

With this program a privileged site was created which, like a large avenue bordered with statues, became the extension of another unique site, the Place Louis XVI (the Place de la Concorde). The government wanted to compel public sculpture to serve ideologies and regimes by expanding the Place Louis XVI into a large scenographic complex where projects and realized programs were to intersect and merge for more than half a century. A great number of images were consistently suggested for this site; only a few were ever realized. But these images, taken as a group, reveal the public meanings of the buildings and of the space of the site itself. Their value as signs, like their designations, was well understood. Chateaubriand wrote of this vast ensemble in the early 1830s: "In the middle of the Place Louis XV [the 18th century name of the Place] I will make a great fountain of perpetual waters gush, received in a black marble basin, which will indicate clearly enough what I want to cleanse. . . ."[24] A Saint-Simonien writer during the following decade specified the meaning of the now-decorated site:

This square is one of the most mysterious, most sacred places on earth. It is here, in the center of this square, that the world of the Middle Ages came to expire, immolated on the scaffold of the Revolution, and it seems to me that at the sound of its last sigh on this square, all the people that our world had oppressed and who had appeared effaced from the world of the living, emerged from the depths of their tombs and made an appointment to build a home. Look, he [one of the protagonists] said, showing the Madeleine church, the genius of Greece has rebuilt its Parthenon and it has again dedicated it to a woman. Before you, the genius of Rome has restored, by increasing its height, the Arc de Triomphe consecrated to its warriors. There, on the pediment of the Palace of Legislature, Judea has engraved its tables of law and on the site of the scaffold, on a block of granite from Brittany, Egypt has come to plant its indestructible obelisk. Athens, Rome, Judea, I cried to my-

self, our three mothers, our three initiators! Those who have given us the Arts, Law, and Religion, and Egypt, our grandmother, the mother of our mothers. Was it necessary that Athens, Rome, and Judea came to rebuild the monuments of their faith and grandeur on the very ruins of the world which Egypt had nurtured and that the others had crushed beneath their feet? Here the mysteries of life . . . are revealed.[25]

During the First Empire one of the most spectacular programs for the glorification of dignitaries arose from the decision to erect on the bridges of Paris, colossal, full-length or equestrian effigies of generals recently killed in campaigns. Twelve standing statues and four colossal trophies were envisaged for the Pont Louis XVI. The reestablished monarchy had energetically addressed the question of the proliferation and control of public homage in sculpture by submitting the erection of commemorative statues to governmental censorship. Politically, it was concerned with "curbing the spirit of partisanship."[26] It replaced the Empire's program for the bridge with its own. This program revived, to a certain extent, d'Angiviller's project for the decoration of the Grande Galerie of the Louvre. By the end of the 18th century, it was hoped that several of the Louvre statues honoring the great servants of the monarchy would be used for the decoration of the bridge.[27] The new program emphasized an homage to several men of the cabinet and, above all, to military leaders rather than to intellectuals, writers, or artists. The 17th century was particularly well represented by these men of war, including, among others, the Grand Condé placed beside Turenne. The two great captains of the century of Louis XIV had already been conjoined in a proleptic monumental program executed at an early date—1771. At Montpellier, when the decoration of the Peyrou Promenade was anticipated, Clodion had been asked to execute a colossal group (fig. 27) which, along with three other groups of illustrious men who had honored his reign, would be assembled around the statue of the king. Condé was to be depicted according to the following specifications: "Leaning on the Maréchal de Turenne, raising his right hand and arm, his gaze fixed on Louis as though to receive his orders . . . and every detail of the warrior's attire will be executed according to the costume of 1648."[28]

David's complex and captivating *Grand Condé*, now destroyed, is known only through the model which is one half the size of the original (fig. 28). It differs dramatically from the other twelve figures made for the bridge, in which the significant moments chosen for representation generally indicated repose or restrained action. The commissions were distributed to the "senior sculptors"—Bridan, Dupasquier, Espercieux, Gois, Lesueur, Marin, Milhomme, Moutoni, Ramey, Roguier, and Stouf—whose average age was over sixty. David was the exception— he was only twenty-eight years old. The commission was prestigious and very well

27. After Clodion, *Project for a Group*, drawing, location unknown

paid. We do not know if David chose the "significant" moment from the life of Condé, since this moment had become canonical. Dardel had represented it in 1781 and, in 1783, Roland completed a statue for d'Angiviller, in which Condé was depicted "in the action of throwing his general's baton into the trenches of the enemies at Fribourg in 1644." For the Pont Louis XVI, Roland had planned a different representation depicting the soldier at rest "near a post surmounted by the royal crown; a lily branch crosses his feet. Condé shields it with his threatening sword, as if to defend this emblem."[29] The moment represented in David's work is described in detail in the booklet of the Salon of 1817 when the model was exhibited in plaster. The description is taken from a passage in the popular *Vie des*

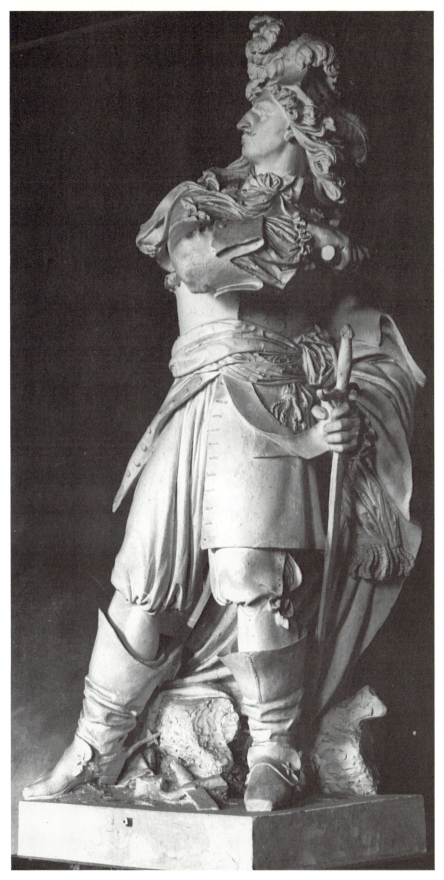

28. *Grand Condé*, statue,
plaster, Angers Museum

hommes illustres: "The duke of Enghien, seeing his men engaged between the woods and the camp of the enemy, made a resolution worthy of his courage. With the 2,000 men he had left he undertook to rout 3,000 well-entrenched men. This rashness was necessary in order to free those who had crossed the first entrenchment and, at the same time, to divide the forces of the enemy who could have reunited against Turenne. He dismounted, threw his general's baton into the trenches, marched at the head of the volunteers and of Conti's regiment in order to reclaim it."[30]

The *Grand Condé* is an audacious study of movement; nothing comparable can be found in the sculpture of this period. David chose to depict the beginning of an unfurling action within the space of an expansive eristic gesture. In this respect the work differs as much from the composition chosen by Roland in 1783 (fig. 29) as from the restraint that characterizes the most gesticulative of the warriors represented on the bridge: Roguier's *Admiral Duquesne* (fig. 30). The gesture anticipates the principal action by representing the instant that precedes it and predicts it, thereby directing the perception of the spectator. But whereas the illusion of movement in Roland's figure is understood as the discursive explication of two contradictory and simultaneous gestures, those in which the two arms are engaged, David's unified representation expresses the effect of a passion in a simplified pantomime. The work exalts the emotional aspect of the incident and, paradoxically, minimizes it because it represents in the figure an amaranthine, permanent character. Condé emerges and imposes himself in the heroic moment that the statue narrates, but even further, he is conflated with the idea that the image symbolizes. In other words, in the *Grand Condé*, David represents the superhuman quality that transcends the individual at the summit of heroism. This quality is manifested by "genius" as defined at the end of the 18th century (a definition that prevailed during the Romantic period). As Diderot stated: "Thus, during war and in counsel, the genius, similar to Divinity, examines, in the blink of an eye the multitude of possibilities, sees the best and executes it, but he should not be involved over a long period of time in affairs that require attention and perseverance; Alexander and Condé were masters of events and appeared inspired the day of battle, in moments when there was not time to deliberate and when it was necessary that the first idea be the best. . . ."[31] Incidentally, David pondered the notion of genius as applied to artistic creation. Curiously, he described his own methods as being characterized by the workings of artistic genius, although he refused to acknowledge himself overtly as its beneficiary.[32]

One can easily explain the fanatical admiration of the generation of the 1830s for the *Grand Condé*, which had become once again accessible (the plaster had been exhibited originally in 1817). Executed in 1827, the completed statue was erected in 1828. The figure is characterized by extraordinary verve, energy, and multiplic-

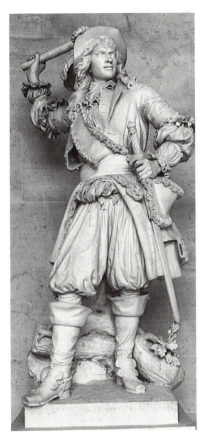

29. Roland, *Grand Condé*, statue, marble, Versailles, Musée du Château de Versailles

30. Roguier, *Duquesne*, statue, marble (destroyed), formerly Brest, Ecole d'application de la marine

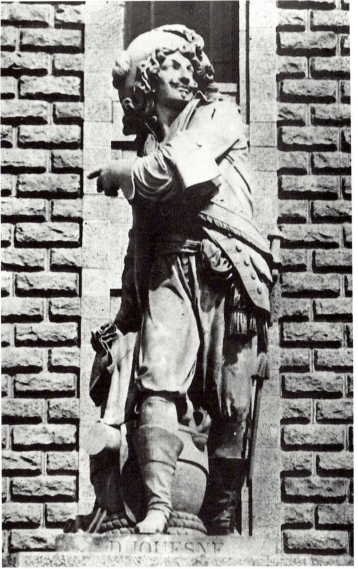

ity of profiles (David had created the statue for a specific site—the bridge—where the spectator, of necessity, had to move from one side to the other and could thus view it from different angles). Noteworthy, also, is the attention David paid to surface effects in spite of simplified planes. All of these characteristics can be seen as part of a "classical" conception. During this period, following the ideas of Lessing and Hemsterhuis, many reiterated that a statue, like a painting, must renounce the temporal and strike the spectator in a brief instant. This forces the artist to repre-

[49]

sent only human figures which, in their poses, either suggest a continuous action or no action at all. In the *Grand Condé*, the temporal quality of the gesture unfurling in space and time paradoxically coexists with the idea of instantaneous communication. This paradox is confirmed in a preparatory sketch, a first idea for the work, which caricatures the principal idea. For, in the sketch, David reduced the expression to a silhouette (fig. 31). Indeed, in 1817, at the exhibition of the plaster model, the *Grand Condé* was not perceived as a revolutionary work, artistically speaking. The reservations expressed were moderate and were concerned with aspects of the figure which were then considered important to the theoretical discourse—i.e., a certain "exaggeration of action" and exactitude in anatomical construction.[33] Conservative critics expressed reservations about an "inferior" genre of sculpture—the historic statue—which represented (as a painter did in a portrait), scenes where "the artist is sometimes forced to reproduce bizarre costumes."[34] The costume of the *Grand Condé*, as much as its unusual expressive power, defined it as "Romantic" and led to its success and popularity over the years. "Statue bravache," Michelet would later say.[35] The evocative power of costume—traditionally associated with the art of painting—constitutes a sign that activated the historic romantic imagination. Small troubadour sculpture (fig. 32) would make use of this powerful sign.[36] Costume belongs to a hierarchy of meanings and stylistic effects in sculpture to which David, in his art and his writings, devoted a profound reflection.

The *Grand Condé* manifested several of the objectives of Romantic sculpture. But one can get a good idea of the number and complexity of the objectives imposed on sculpture by considering the works exhibited at the Salons (unfortunately a great number of works were excluded by the juries). Increasingly, projects for prestigious enterprises were exhibited that involved architectural sculpture for public buildings. David, for example, was slightly involved in the renovation of the site of the Bastille, whose vicissitudes were numerous. A project for the embellishment of the square of the Bastille during the Restoration was designed to exorcize from the site tenacious Revolutionary associations. To do this, the construction of a monumental fountain was proposed whose base would consist of a curious belt of allegorical reliefs that would depict—to use the phrase of the architect Alavoine—"the sum of human knowledge."[37] Alavoine evidently felt ill at ease. Although forced to accept a horizontal circular placement of images in a consecutive series for the belt at the base of the fountain, he wanted nevertheless to reconcile this type of composition with his concept of a vertical placement of images which would be arranged in a hierarchical order of importance from top to bottom. David, who was employed to work on the project for the fountain with thirteen other sculptors, exhibited the composition he planned for it—a model of *Military Architecture*—at the Salon of 1822. Now lost, this work survives only through a drawing (fig. 33).

31. *Grand Condé*, drawing, Angers Museum

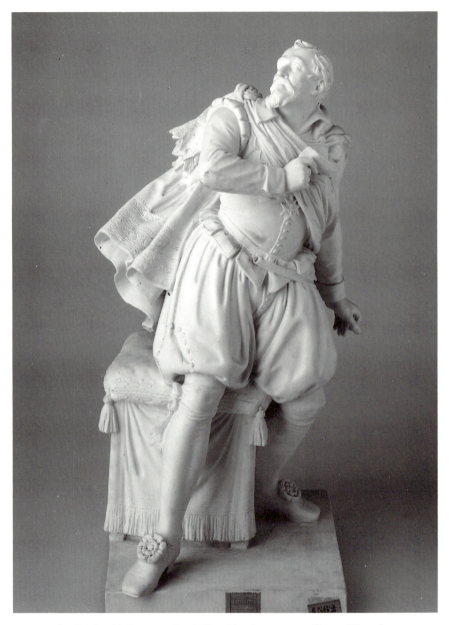

32. Brachard (after E. Fragonard), *Crillon*, biscuit statuette, Sèvres, Manufacture nationale

David's modest participation indicates clearly the difficulties young sculptors experienced in receiving important commissions for the large programs of the period; these were generally given to well-known, established artists.

The Restoration witnessed the creation of vast numbers of sculpted works characterized by a great variety in subject and style. At the Salons of 1817, 1819, and 1822, close to five hundred were exhibited. The images were divided into traditional categories whose hierarchy of importance was upheld almost unanimously in the critical discourse. Mythology and legendary history were at the top of the hierarchy of genres and still dominated these Salons. One is led to wonder whether these subjects were gratifying, intellectually or in any other way, to the artists and the public. The issue is noteworthy because it relates to prevailing ideas about the nature and goals of sculpture, ideas that David consistently and obstinately opposed. Mythology and fable have no place whatsoever in his public art.

One can wonder, thus, about the values that inspired an artist of great talent, such as Baron Bosio, when, in 1817, he exhibited the marble of his appealing *Hyacinth* (fig. 34), "represented half-reclining, leaning on his pallet, and appearing to watch the game while awaiting his turn." Bosio was then at the height of his fame—he was nearly fifty—but this aspect of his art which can be qualified above all as "Neoclassical," was, paradoxically, still appreciated by progressive Romantic critics a quarter of a century after it was made.[38]

This work conjoins the depiction of a myth which, for varying reasons, fascinated painters and sculptors circa 1800,[39] and offers principally a visual enjoyment of the forms, a sensuous indulgence which might be characterized as intellectually indolent.[40] Bosio represents a moment in the narrative before Eros appears. The dramatic, fatal outcome for Hyacinth is well-known, but this narrative element plays a minimal iconological role in the work. The myth, evoked anticipatorily, is emptied of its dramatic content in favor of its symbolic meaning. This is due to the recumbent position of Hyacinth, who seems pleased with his evocative languor and passivity. His pose prefigures the historically distant denouement. The "imbecilic" expression of the face is not surprising (critics of this period frequently use the term "imbecilic" to describe works of this type). Artists such as Bosio did not want to renounce the subject completely but wished instead to subordinate it to a formal idea of beauty. Bosio's work provides an early example of this in the privileged vehicle of the nude, a genre that did not accord well with physiognomic effects. One can understand how a significant aspect of the Hellenic dream of the Romantics of 1830 and 1840 would be realized in this type of languor and contemplative "morbidezza."

Mythology, whether considered in relation to the Hellenic dream or to a caprice of the historical imagination, should not necessarily be viewed as a refuge of

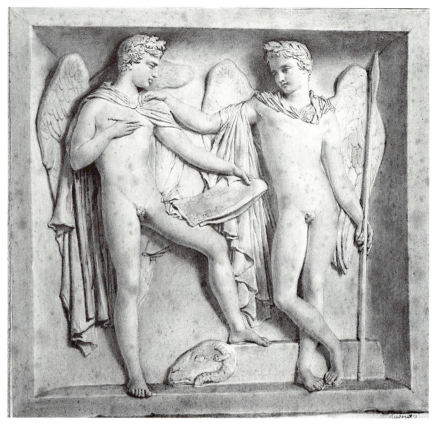

33. After David, *Military Architecture*, drawing, Saumur Museum

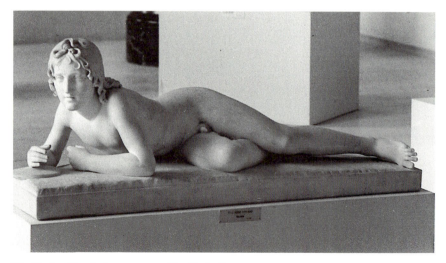

34. Bosio, *Hyacinth*, statue, marble, Paris, Louvre

artists in the received conventions of the past. The power and complexity of De-
lacroix's mythological art reminds us of this salient fact. For David, mythology was
an aspect of art linked to luxury and complacency rather than to ideas. It would
have no place in his meditations that would lead to precise and practical applica-
tions in his realized works. On rare occasions he refers to mythological themes in
which a symbol clarifying the human condition can be clearly seen as transcending
the narrative itself: "[Goethe] gave his approval to the idea of my doing a Prom-
etheus unbound, the vulture dead at his feet, an expression of scorn with a nuance
of past sufferings on his face as he looks towards the sky."[41]

In the early decades of the 19th century, the reinterpretations of myth in ar-
chaeological discourse, the personal exegesis of antique myths by poets, as well as
scientific explanations and meanings occasionally imposed on myth in regard to
political situations, created subtle affiliations that influenced artists. Their positive
responses, as interesting as David's total eschewal, merit attention. A paradoxical
situation, however, should be noted: namely the eagerness of artists in evoking
Hellenic myths and the simultaneous "mediocrity" (to cite the caustic term Renan
used later, in 1853) of French erudition in explicating them: "It was the epoch in
which M. Petit-Radel lectured gravely on the adventures of the cow Io and listed
in a paper the synoptic table of the lovers of Helen, showing their ages compared
to that of 'this princess'."[42] This remark was careless and not entirely just because
Renan's scientific criticism led him to ignore the work of mythologists and iconol-
ogists from the beginning of the century: Emeric-David in particular comes to
mind with his neoplatonic analysis of beliefs and symbolic structures of Hellenic
religion in which "the [real] gods [that is to say, the elements and the stars], objects
of a [direct] cult," are distinguished from "[fictive] gods, objects of a [symbolic]
religion" which, like fictitious characters, have taken their place.[43]

It is beyond the scope of this study to investigate the numerous examples of
mythological and heroic statuary in both the single figure and the group whose
golden age in France occurred between the Salons of 1812 and 1822. Many of
these works have disappeared and others that have survived are not well-known.
Generally executed in a colossal style, the most successful realizations of these sub-
jects answered the joint aspirations and viewpoints of classicism as well as Romanti-
cism. This group of works includes depictions of a variety of heroes such as Ajax,
Theseus, Aristeus, and Orestes. The figures are not necessarily represented in dra-
matic action and are frequently distilled into a symbolic form which conveys beliefs
about the nature and destiny of man or expresses an intense meditation on passion.
A typical example can be found in Dupaty's *Philoctetes* (fig. 35), a figure extended in
space which displays an uncommon understanding of the play of opposing move-
ments. The model was exhibited at the Salon of 1810. Espercieux's *Philoctetes* (fig.

36), which renders the drama subjective, provides another example of this type. David analyzed this work at length and praised it as a "magisterial study."[44]

This genre of sculpture, which for the sculptors of David's generation culminated in Pradier's *Prometheus*, lost none of its fascination for the perspicacious critics, who later examined the "magical vocation" of sculpture. Here one must cite Baudelaire first and foremost. In 1855, when he wrote about the paintings of Louis David (whom he called "this cold star"), he conjured up the images of his youth in which sculpture must have been omnipresent (although he does not refer to it directly): "I recall very distinctly the prodigious respect which, during my childhood was accorded to all these figures, who were fantastic without trying to be, all the academic spectors; and I myself could not contemplate without a type of religious terror all these heteroclite dummies (flandrins hétéroclites), all these thin and solemn 'handsome men'. . . . But the masters, formerly too famous, today too scorned, had the great merit, if one does not want to be too preoccupied by their processes and bizarre systems, of bringing French character back to a taste for heroism; . . . but they were not always as Greek and as Roman as they tried to appear."[45]

A final work to be examined is Théophile Bra's heroic figure of *Ulysses on the Isle of Calypso* (fig. 37), which is comparable in its ambitions to the images discussed in the framework of the transformations in sculpture of the 1820s. Bra is an important and much neglected artist. His spiritual experiences, which he recorded in his voluminous writings, are among the most remarkable of all Romantic sculptors. His *Ulysses* was first exhibited at the Salon of 1822, the Salon in which David made a striking impression with a dozen important works (more than half of them were portraits). It was exhibited again in marble at the Salon of 1833.

Bra was nine years younger than David and the two artists encountered one another several times. He was one of several important sculptors, including Barye, Etex, and Préault, who did not receive the first prize for sculpture at the Ecole des Beaux-Arts, and therefore did not go on to the French Academy in Rome. The ways in which the careers of non-prize-winning artists succeeded or failed would be of great interest to a sociologist. Bra's *Ulysses* is a colossal, unornamented work. Its only emblem is nature—the rock, near to shore, on which the hero, a prisoner seduced by Calypso, is absorbed in meditation. The subject, precisely defined in the Salon booklets of 1822 and 1823, is based on Homer: "Ulysses passed his days sitting on the rocks at the edge of the sea; there, his eye wandering over the waves, his soul prey to the most profound pain, he would give his life to see for only an instant, smoke rising from his cherished isle."[46] This work manifests a "classical reserve" which is completely within the prevailing artistic norms of 1822. It is important to note that, in spite of its classicism, certain individuals perceived in it singular qualities when it was exhibited again, slightly reworked, in 1833, in a Salon

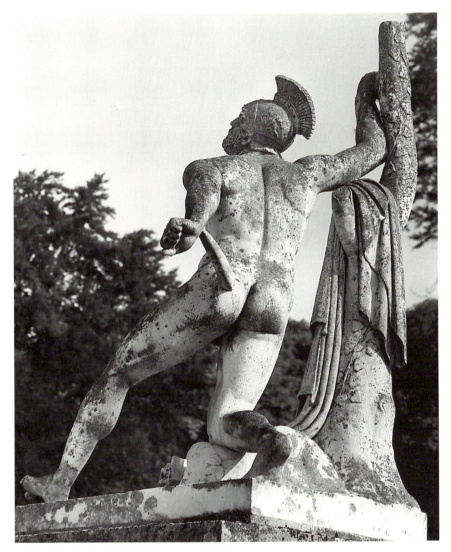

35. Dupaty, *Philoctetes*, statue, marble, Compiègne, Parc du Château

in which both artists and Romantic critics vehemently challenged antique subjects, outdated, anachronistic meanings, and moderation in expression.

Thus, in his criticism of the Salon of 1833 which treats sculpture first (for perhaps the only time in the 19th century), the social thinker Jean Reynaud, whom one could not at this date charge with conservatism, distinguished among the sculptors "those who have already felt the fecund influence of the first heat that modern philosophy is beginning to radiate. . . . [These artists] understand that

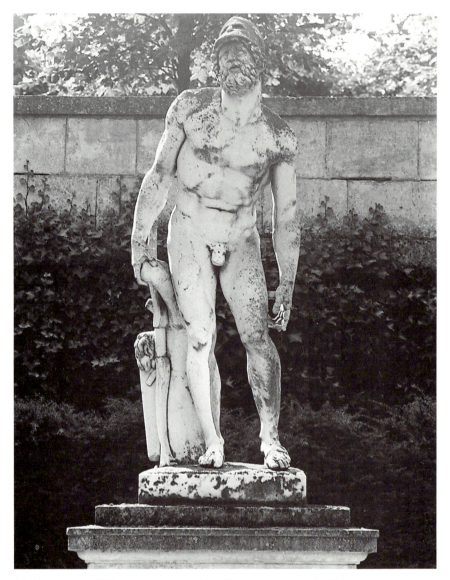

36. Espercieux, *Philoctetes*, statue, marble, Compiègne, Parc du Château

form only has value inasmuch as it is the manifestation of an idea. . . . They tried to extend art further, beyond the domain of the senses, and, by passing through the imagination, they wish to go directly to the mind through vision."[47] In his review, Reynaud disregarded most sculptors, including Pradier, Foyatier, Desboeuf, and others, such as Moine and Triqueti, who were then considered "Romantic." He briefly mentioned Rude and Duret but commented at length on Bra's *Ulysses*, be-

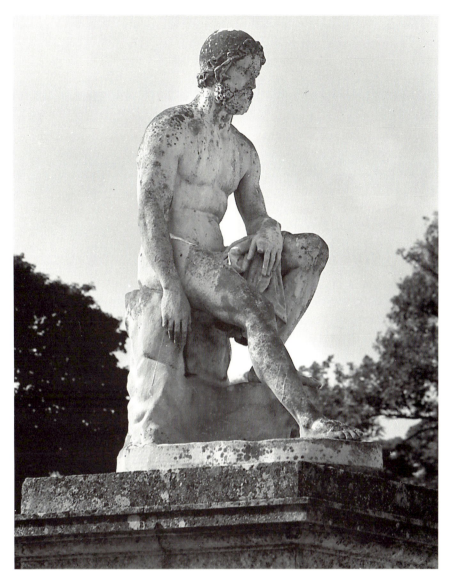

37. Bra, *Ulysses on the Isle of Calypso*, statue, marble, Compiègne, Parc du Château

fore moving to Etex, Préault, and Barye (David only exhibited one bust in 1833; he virtually withdrew from the Salons during the July Monarchy).

Ulysses, an iconic figure, is the summary of a type just as Bra intended it to be and just as the philosophers Vico and Ballanche understood it thematically, as Reynaud reminds us. Ballanche wrote: "This is man himself, striding towards successive imitations. . . . Ulysses' mistakes, to use the mythical word, are the trials

through which the primitive plebeian elevates himself to primitive heroism, in other words, to the humanity of a primitive epoch. . . . Thus the fable of the *Odyssey* is nothing but a vast tableau of human initiation. . . . This antique epic is a book analogous to Aristotle's *Politics*, the one occupies its poetic and symbolic sphere, the other its philosophical and political sphere."[48]

The discourse that includes the writings of Reynaud, Leroux, Fortoul, and Thoré can only be briefly alluded to here. In the political and moral climate of the 1830s, these authors (then close friends of David) combined humanitarian aspirations and poetic symbolism to challenge irresponsible art, regardless of the style that embodied it. It is important to emphasize this discourse which echo's David's dogmatic and unyielding determination to repudiate the seductions of mythology, symbolism, and poetry (in other words, in his effort towards creative abnegation) in his public, exhibited works, in favor of a collective "committed art," in which the hero is part of history. Symbolism, certainly, does play an important role in David's art. At every stage of his artistic development he bases his art on an intensely personal, allegorical reading of quotidian reality. His ideas, however, always return to the useful, reformatory meaning of history.

From the 1820s onwards, therefore, we see this religion, this "idée fixe," evolving in David's art and ideas. Certain individuals will find it impoverishing and limiting. For more than thirty years David obdurately adhered to the idea of a modern, "iconic" statuary, accessible to all. Sometimes commissioned and completed, sometimes dreamed or imagined, David's pantheon, which unites both Racine and Bichat, reveals an idea of sculpture that Baudelaire later developed in a long, superb passage of 1859 in which he meditated on the primary vocation of this art in terms strangely similar to those that David employed:

> Cross any great ancient city grown old in the civilized world, which contains some of the most important relics of the life of man, and your eyes are drawn upward, *sursum ad sidera* (upwards to the stars). In the city squares, at the angles of intersections, motionless figures larger than the ones that pass at their feet tell you stories in a mute language of lofty legends, of glory, of war, of science, of martyrdom. Some point to heaven to which they have ceaselessly aspired, others point down at the soil from which they sprang. They brandish or contemplate that which was the passion of their life and which has become the emblem of it: a tool, a sword, a book, a torch, *vitaï lampada* [the lamp of life]. Were you the least thoughtful of men, the least fortunate or the vilest, whether be you beggar or banker, that stone phantom takes possession of you momentarily and commands you in the name of the past to think of things that are not of this world.
>
> Such is the divine purpose of sculpture.

Can anyone doubt it takes a powerful imagination to realize a program of such magnificence? What a singular art, which emerges from the obscurity of time and which was already in primitive ages producing works before which the civilized spirit stands amazed! . . . Here in sculpture more than in any other medium, beauty imprints itself in the memory in indelible fashion. With what prodigious power Egypt, Greece, Michelangelo, Coustou and some others have imbued these motionless phantoms! What a look in those pupilless eyes! Just as lyric poetry ennobles everything, even passion, sculpture, the truth, solemnizes everything, even movement. It gives everything human something of the eternal, partaking in the duration of the matter employed. Anger becomes calm, tenderness, strictness. The undulating and illuminated vision of painting is transformed into solid, unyielding meditation.[49]

CHAPTER 3

The Throne and the Altar

IN HIS representation of the *Grands Hommes*, David would make manifest, in the public sphere, the mythology of the modern world. He set himself the task of erecting a Pantheon for the *Grands Hommes* with an obstinacy that bordered on monomania. He chose to depict famous individuals as well as those who were not well-known (his mission would be to rescue the latter from obscurity). In the approximately thirty completed, monumental statues few variations can be found in David's objectives and "styles." Most of the statues depict "moderns" or contemporaries—architects of contemporary civilization and of social and intellectual progress. David also celebrated the *Grands Hommes* in about one hundred busts (surrogate statues). Added to these are about seven hundred medallions of remarkable men and women, most of which depict contemporaries (several still to be identified) associated with notable events and accomplishments. This fascination with the outstanding individual constitutes a principal interest of the 19th century. David thought very carefully and at great length about the issue of homage, in order to discover artistic and intellectual solutions. Evidence for this is to be found in his writings, as well as in his sculpted works. In his diaries, notes, letters, and published articles he categorizes elements and ideas related to homage and places them into distinct hierarchies. He explains the appropriateness and limits of homage. He questions his own ideas and sometimes hesitates about alternatives. He ponders his choices and attempts to predict the manner in which posterity will discover and understand the work of sculpture. Much of the historical details of his sculptural programs are not extensively known. Most are in the public domain—the street, the square, the cemetery, and the museum. These sculpted images of individuals whose inventions and accomplishments have provided the foundations of modern society and thought punctuate the nation's landscape and function as signposts or buoys that mark or distinguish the significant legacy of the *Grand Homme*.[1] David was able to finance the construction of his Pantheon over the course of his career through both public and private funding. The realization of his projects often spanned many years and the mishaps, failures, and accidents associated with their

completion (problems usually linked to financial constraints) can be interpreted today as significant indications of the capriciousness of political life.

This chapter will examine a few of these programs from the beginning of David's career to around 1830. The first project to be studied, David's *Monument to Bonchamps*, may be considered either a monument or a sepulchre (fig. 38). It was inaugurated in 1825 when David was thirty-seven years old. A remarkable work in many respects, the *Bonchamps* provides a rare example in David's oeuvre in which detailed evidence exists of the diverse artistic alternatives envisaged by the artist and the commissioners of the monument. The project constitutes the most remarkable provincial program completed during the Restoration to commemorate both a hero of the counter-revolutionary insurrection and the political party with which he was associated, as well as a site. Bonchamps, in fact, had become the object of lasting cults and rites.[2] The statue was exhibited in plaster at the Salon of 1824. The initiative for the project, inspired by the extraordinary prestige of Bonchamps, was given impetus by both local and Parisian political strategies. The monument was intended to glorify the monarchical government's assertion of its legitimacy, as well as to express its desire to be conciliatory and national. The *Monument to Bonchamps*, which celebrates a vanquished individual's plea for clemency, appeals to party reconciliation and expresses a momentous political encounter through the depiction of the character and magnanimous gesture of the hero. David represents Bonchamps in the last heroic moment before he dies, when he cries "Pity for the prisoners!" and thereby saves his Republican prisoners from being put to death.

During the Restoration many lavish provincial and Parisian programs that aspired to national acclaim were inspired by the prevailing climate of contrition, edification, and expiation, and were often funded through subscription or donation. An outstanding example of this type of expiatory monument can be found in Paris in the monumental *Chapelle expiatoire*.[3] We still have an imperfect knowledge of a large group of comparable, fascinating programs found throughout the provinces—in Quiberon, Rennes, Lyon, and Orange. Some were nearly completed during the Restoration, others were realized after the establishment of the July Monarchy.

The development of David's initial project for the *Monument to Bonchamps* is of interest for both its art and politics. He began with simple ideas for the tomb, including that of a sarcophagus decorated with trophies and one relief, surmounted by a bust.[4] This developed into an ambitious monument in which a large figure in the round dominates the program. We can follow the major stages in the transformation of this project, the completion of which was assured by a successful, well-organized, and intense subscription campaign—evidence at this early date of the strength of initiatives for public homage undertaken in the provinces. Interestingly,

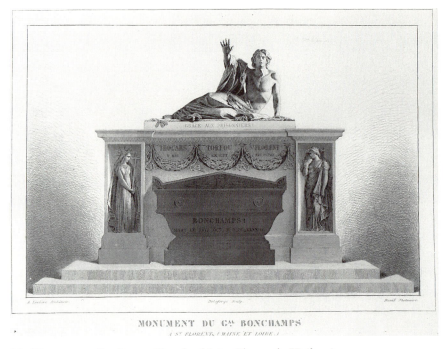

MONUMENT DU Gᵃˡ BONCHAMPS
(Sᵗ FLORENT, (MAINE ET LOIRE))

38. *Monument to Bonchamps*, Church of Saint-Florent-le-Vieil, print

David, for a variety of reasons, refused to accord Paris intellectual or even political preeminence over the provinces. He was, of course, personally attached to his birthplace in the province of Anjou, but was also profoundly concerned with the question of artistic decentralization; this interest contributed to a great degree to his artistic survival during the July Monarchy: "The provinces have freedoms that Paris does not have. I am surprised that the provincial cities are permitted to conse-crate their public squares to the erection of statues of illustrious men; it is true that what is done in the provinces is deemed inconsequential."[5] This was written around 1840, at the very moment when David was to be proven wrong because the munic-ipality of Angers refused to execute one of the projects dear to him, the statue of General Beaurepaire (fig. 39). For some it represented an homage to the courage of soldiers from Angers who, in 1792, marched towards the border; for others, it constituted an unacceptable apology for Beaurepaire's possible suicide—a philo-sophical act in the context the Enlightenment gave to it. During this period, a friend of David's, François Grille, who knew well the Angevin milieu, wrote: "At Angers, the people voted for a statue of Beaurepaire. Hateful and retrogressive fac-tions have banded together against this great figure and the most generous sacri-fices have only been paid by calumnies."[6] There was, certainly, nothing comparable

39. Moll, *David's Project for a Statue to Beaurepaire*, drawing, Private Collection

to this episode in the history of the *Monument to Bonchamps*. The Prefect, governor of the region, directed the operations at Angers with an iron hand. He selected the committee, appointed himself as head, and chose the Bishop of Angers, the Duke of Brissac, the Count of Autichamp, and other notables "attached to the legitimist government."[7] The statue was completed in six years, which is not a very long time

for a project of such importance. The court contributed a great deal and the king "wished that it be constructed in the abbey of Saint-Florent and that he be kept informed about the artistic decisions made by the committee."[8] It is important to note that, at one point, a project to represent, in relief, the imminent massacre of Republican prisoners that (according to history and legend) Bonchamps had prevented at the last moment was apparently abandoned for lack of funds (fig. 40). The commission returned to the more ambitious initial project suggested by David which consisted of placing "a half-reclining statue on the tomb."[9] David was, however, forced to submit to the demands of the commission and to place beside the figure of Bonchamps two personifications instead of the figures of Fame he had projected: "We propose that you substitute for these two figures of fame, two allegorical figures which would make this mausoleum a monument both Christian and French; on one side, one would see *Religion Weeping* (fig. 41), without any attribute other than the cross on which she is leaning, and on the other side *France in Mourning* (fig. 42), holding in her hands the banner decorated with the fleur-de-lis."[10]

After 1830, David's enemies would remind him of his monument to Bonchamps in an insistent, acidulous tone. David himself spoke of the monument with an earnestness that implied a desire to emphasize the moral imperative which drove him to undertake it. This work, after all, associated him with a political regime that he would soon afterwards denounce vehemently in his notes (as he would all monarchical regimes): "This man [Bonchamps] gave a lesson in generosity to all the groups that devoured one another in the civil wars. My father owed his life to him because he was one of the Republican prisoners locked up in the Church of Saint-Florent."[11] In his notes and letters, David would single out the great figures of the insurrections in Vendée to whom he would refuse a monumental homage. And he explained his reasons: "David [the artist frequently wrote of himself in the third person] refused to do statues of Charette, Cathelineau, and Stofflet; the first was a good leader of the partisans, but the chisel could be more honorably used for the millions who died for the cause of liberty. The second is a fanatic full of heroism whom I esteem but who doesn't have my sympathy and the third was courageous, bloodthirsty, fighting like a bull-dog on the orders of his master; he was a zealous servant but I scorn him."[12] In fact, the generals from Vendée were rarely represented in sculpture. At the end of the 1820s, Molknecht obtained through Foyatier (who had recommendations from Paris) the execution of a monumental statue of Cathelineau and one of Charette. According to the Parisian administration, Molknecht's parents "had taken a very active part in the Vendée affair." These statues were destroyed by the army following the legitimist insurrection of 1832. In 1826, however, David completed for the Church of Verneuil the delicate relief of a small expiatory monument which commemorated Bonaparte's execution of the

40. *Project for a Monument to Bonchamps*, drawing, Archives départementales de Maine-et-Loire

Count of Frotté and his six companions in 1800 (fig. 43). He depicts this image of ill-fated collective heroism with great subtlety and variety of pantomime in a severe frieze in which the conspirators stand together and face the firing squad.[13]

One could develop at length a study of the diverse aspects of the *Monument to Bonchamps*: the political circumstances as well as the artistic and personal objectives that led to its conception, the choice of a functional, Christological site for the monument (which was located in the choir of the abbey church behind the altar until 1891), the local and national goals it responded to, and the history of its execution. In the composition of the figure, David revived a traditional pose of funerary sculpture: it is reminiscent, for example, of Vassé's *Saint Etienne Lapidated* (fig. 44), executed for the choir of the Cathedral of Auxerre. But David enframed the figure in a simplified geometrical format. David represents the athletic, wounded Bonchamps in heroic demi-nudity, half-covered by his cloak, raising himself on a stretcher made of cloth and oak branches (fig. 45). The gesture is authoritative, and appears to carry the body forward with an expression of power tempered by kindness. As the chairman of the committee remarked when the sketch was approved and described (in anticipation of the desired effect of the monument), the image expressed "the supernatural effect of the soul on weakened muscles. Bonchamps will not support himself with his left hand, as the resigned prisoner, dying [knight]

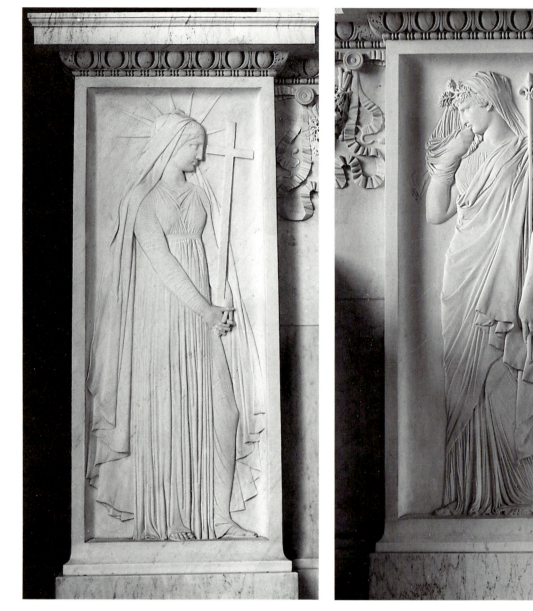

41. *Religion Weeping*, detail of *Monument to Bonchamps*, relief, marble, Church of Saint-Florent-le-Vieil

42. *France in Mourning*, detail of *Monument to Bonchamps*, relief, marble, Church of Saint-Florent-le-Vieil

43. *Monument to Frotté*, relief, marble, Church of Verneuil

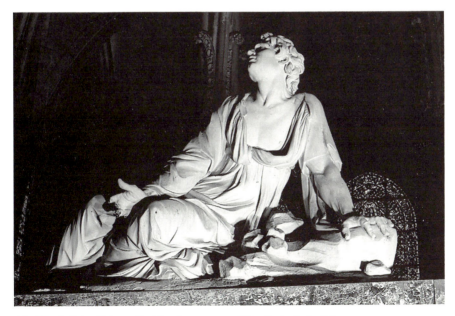

44. Vassé, *Saint Etienne Lapidated*, statue, marble, Cathedral of Auxerre

Bayard, could have. We recognize in his weakened pose something proud and as-sured that befits an adored leader, certain of being obeyed even until death. He does not reject the thought of a massacre that he fears to witness, he does not im-plore the compassion of an angry troop. Alone he still commands; alone he can grant pardon and he grants it to five thousand Frenchmen who will one day in the future be touched by this magnanimity."[14] Bonchamp's pose is balanced; his ges-ture of clemency is both circumstantial and symbolic. David gave him the features of Alexander, with large twists of wavy hair and an open mouth (fig. 46). The exe-cution demonstrates a mastery in the handling of the portrait that few of David's contemporaries possessed. And the observation of specific anatomical and physiog-nomic features are combined with elements that generalize and idealize (or, to re-vive an expression that was commonly employed at the time, that "ennoble" the model).

The proportions of the figure (which David posed like Phidias' *Ilyssos* of the Parthenon), its athletic canon, and its elegance correspond to a treatment of ana-tomical masses as broadly distributed geometrical elements, simplified into planes and strongly articulated in the contours that separate them. In certain areas, myol-ogical details are heightened, such as in the veins of the forearm. This attests to David's adherence to an anatomical theory based on observation of the model, which he had seen confirmed in the example of the figures from the Parthenon pediment. In 1816, when he was returning from Rome, David stopped in Paris very briefly before going to London to study the marbles brought back from Greece by Lord Elgin. This was before Jean-Baptiste Giraud secured plaster casts of the ped-iments and exhibited them in his "museum" at the Place Vendôme in 1818 (thereby enabling archaeologists and artists to study and criticize them). And this was the moment when the sculptors Cartellier, Dupaty, and Ramey were discussing with the archaeologist Emeric-David the limitations and merits of Phidias' naturalism.[15] This very moment witnessed an important debate in France concerning the nature and means of imitation in the arts, a debate that led to innovative effects in the execution of sculpture, principally in three domains. One domain was that of the representation of nude figures which assumed new, imitative characteristics in a more attentive, pronounced, massive, and geometric rendering of anatomical masses and textures. Another was a graceful, ornate inflection given to wet drapery, an aspect of sculpture that was beginning to interest artists again.

A third avenue for innovative effects in sculpture was that of the relief. The two figures of *Religion* and *France* in the *Monument to Bonchamps* provide evidence of this. Their style prefigures the development of the relief in David's art, which he considered as significant as sculpture in the round. Certainly his style in the genre of the relief, after the *Monument to Bonchamps*, underwent remarkable transforma-tions, but the theoretical positions that inspired David remained largely unchanged

45. *Monument to Bonchamps*, statue, marble, Church of Saint-Florent-le-Vieil

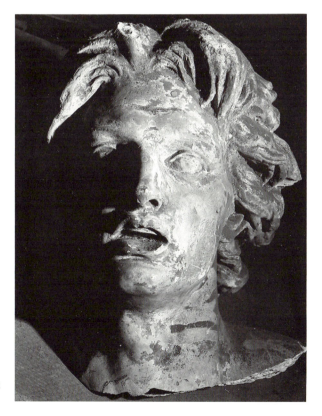

46. *Head of Bonchamps*,
model in plaster, Rouen
Museum

throughout his career. The "flat" style David employed at this date was character-ized by a conflation of drawing and the low relief. He often addressed these isssues in his writings and his art. After 1828, he explained: " . . . the principle is the same, because the relief must be rendered on a flat surface . . . Phidias used this very method for sculpture in the round on the pediment of the Parthenon; behind the two legs of one of the women there is drapery that is barely engraved on the seat, this in order to give greater relief to the legs. . . ."[16] For David, low relief served to highlight and make more pronounced the principal areas of high relief. The spe-cific illusion produced by the relief, paradoxically, owes more to drawing than it does to sculpting. In historical examples of relief sculpture that he closely exam-ined, David denounced the misconception illustrated by a figure executed in the round that was attached to the background of the relief. Thus, in the genre of the relief, he rejected an approach that he believed informed sculpture in the round, namely the modeling of a three-dimensional form that privileges the construction originating with the figure's center. For David, relief sculpture was an art form akin to writing. The relief's thickness is projected, as letters are, on a single plane. Its flat execution alone ensures that the relief will capture light uniformly and will be fixed in its legibility through the solidity and firmness of its contours.

David offered an exemplary demonstration of his ideas on the relief and its expressive character—perhaps even more systematically than in the *Monument to Bonchamps*—in a work that he produced for the interesting program of the large, decorated oculi in the Cour Carrée of the Louvre. The best examples of this pleas-ing, although somewhat insipid, group of works in the Cour Carrée present moral and political allegories in which the personifications of the works of man and his virtues are related to the declared moral principals of the regime. Between 1820 and 1825, two generations of sculptors worked together at this important site. The most notable, to name but a few, include Gérard and Lange, of the older genera-tion, and David, Cortot, Debay, Matte, and Ramey, of the younger generation. This program offers interesting variations on the art of Jean Goujon, who was con-sidered during this period to be the founder of French sculpture. Goujon's mastery of the relief was almost unquestioned for the younger sculptors perceived simi-larities between his style and the wet and naturalistic effects of Phidias' draped figures. However, even though the "styles" of David's young colleagues share com-mon characteristics in analogously complicated surface effects, David's *Innocence Imploring Justice* (fig. 47), in the conception of the figures and in their execution, has virtually nothing in common with the other reliefs of this group. In his figures we observe a rather squat canon of proportions and a contrast in drapery folds which are heavy and vertical in Justice and more irregular in Innocence. It is sig-nificant that although Innocence is an allegory it is perhaps the only female figure

47. *Innocence Imploring Justice*, relief, stone, Palais du Louvre

in David's art that expresses an undeniable sensualism. The flat execution of the volumes in this sculpture is remarkable and illustrates clearly the privileged role David assigned to flatness. It is important to understand that the ultimate justification for David's choice of low relief can be found in the destination of the image— it was to be contained within an architectural support. In his works in relief, David's artistic objective was to promote the iconological function of the image to the utmost degree. He considered this to be essential; in order to achieve it, he had to ensure the totality and luminous integrity of the sculpted image. Flatness alone preserved the relief from picturesque, pictorial, illusionistic deformations that would weaken the meaning of the image if a lateral or other type of shift in light occurred, or if the spectator changed his position. Thus, transitory effects could not affect figurative stability in the low relief.

The *Monument to Bishop Fenelon* (fig. 48), contemporaneous with the *Monument to Bonchamps*, is of equal significance. The work honors the thought and the teaching of a great individual rather than his participation in an heroic act, and presents aesthetically a more complex, more complete type of monument to a "Grand Homme." David often achieved similar results in his most accomplished public works. Inaugurated in Cambrai in 1826, this work belongs to the same category of lavish constructions that combine the commemorative monument, the tomb, and the cenotaph, and in which an elaborate base supports a colossal statue.

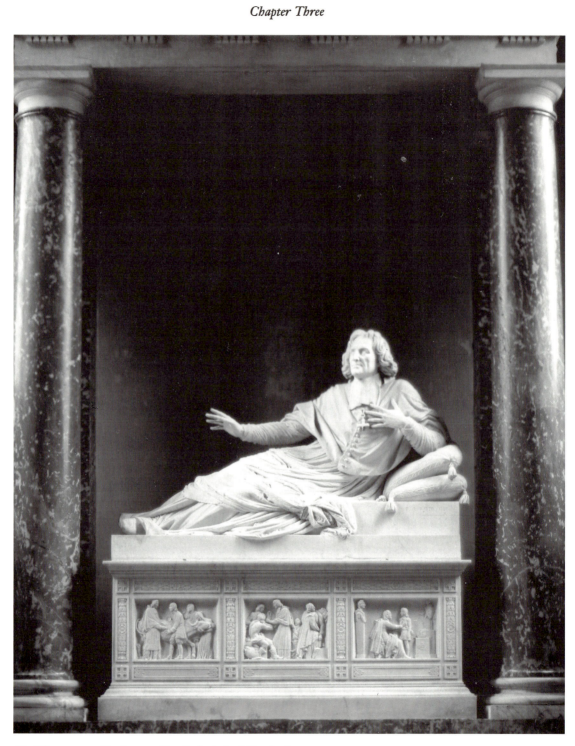

48. *Monument to Fenelon*, marble, Cathedral of Cambrai

As in the case of Bonchamps, the history of the *Monument to Fenelon* is related to commemorative and expiatory decisions. Its completion brings to a close a long history that highlights a "civic" figure and that credits the Restoration with a project that it did not inaugurate. Unlike the generally practical, realistic attitudes towards public statuary that characterized Napoleonic programs, this monument embodies ideas related to the cult of the "Grand Homme" as conceived during the Ancien Regime and the Revolution. It is also a sepulchre whose avatar must be called to mind. Fenelon died in 1715. He was buried in the vault of the archbishops of the cathedral of Cambrai, where a modest mausoleum decorated with a bust was constructed. In 1793, a confusing concatenation of events occurred. An exhumation took place that apparently was incomplete. This was followed by a profanation of the burial vaults, their destruction, and the leveling of the cathedral. After 1801, incidents redolent of gothic novels occurred in Paris and Cambrai. In 1804, one month after the proclamation of the Empire, Fenelon's ashes, which were believed to have been scattered to the winds,[17] were claimed to have been rediscovered. A tense and bitter polemic between the clergy in Cambrai, as well as local notables, and the Parisian administration concluded in favor of the clergy. This was not an isolated case in matters involving commemoration. During the same period a similar affair was taking place at Marseille regarding projected monuments to honor Bishop de Belzunce.[18] At Cambrai and Paris, opinions differed, certainly, about Fenelon's personality and the type of homage he merited. These conflicts were concerned, in part, with public, secular celebrations, such as the translation of the ashes. Archbishop Belmas refused to associate himself with this and claimed it was a "type of triumph, ceremonies that do not make mention of any religious idea and only offer mythological allusions." Other issues were related to a permanent monument that was planned. In accordance with the program he had received, the architect planned to erect, in a public square, a two-storied monument composed of an underground chapel in which Fenelon's remains would be placed and, above it, a *tempietto* with columns that would shelter a statue. The archbishop obstinately rejected the project. The reasons he offered express singularly articulated ideas related to the merits of the homage and the artistic means proposed to perpetuate it. A few excerpts from a long and remarkable document should be noted:

> . . . His remains belong to me as his [Fenelon's] successor and the head of the clergy who owned them in the past. They belong to me because they were not part of the ancient, alienated church where they were placed; custom and law require that whenever a change in location makes necessary the transport of the ashes of the dead, their bones must be taken to another place of the same nature as that in which they were received. . . . Religion, it is true, con-

cedes to gratitude or sometimes concedes to vanity which borrows it as a mask, in order to erect monuments to the memory of great and virtuous men; she accepts them even in her temples. But this admittance and the monuments themselves, by their form, are an homage to the divinity. Man, in these cenotaphs, is represented in the attitude of a suppliant, or the pose, even more humble, that death has given him. These postures attest to the justice and holiness of God whom the just themselves must implore for clemency. . . . They attest to the grandeur and power of God, before which any other grandeur is reduced to the level of dust. . . . In our temples God alone is great. Religion, it is true, admits into these same temples statues and images of saints. She offers them a type of public cult; after having established the proof of their holiness, the Church bestows honors upon them. But these images never occupy the principal place. We do not consecrate our temples to the saints (this was the error of idolatry); but to God alone, under their invocation. . . . Between their cult and that which we offer to the Divinity, we place the incommensurable distance that separates the Creature from the Creator: in our temples, God alone is great. In the projected monument, grandeur is revealed in the inverted sense. It belongs entirely to Fenelon. It is only by means of the aid offered by optics that the religious man, astonished to have need of it, will discover there some attribute of the Religion to which the Archbishop was honored to be but the Minister. . . . I do not know if the costume and the mode of the statue, if the inscription that is supposed to be placed on the pedestal, will not add to a triumph already too insulting for Religion and for Fenelon himself: a triumph that I reject in His name, as His Successor and His trustee. I expect that the statue and the inscription will be submitted to my scrutiny, for the statue can only be erected in this place by my initiative. For the monument to be continued to be considered religious, it would suffice for me to read on the most legible part the inscription: TO FENELON, for me to refuse to consent to a project that consecrates a religious edifice to a man in this manner and would tend to associate irreconcilable ideas in the management of the Religion; and which already presents contradictions which must then be effaced, if it is not even better not to do them. . . .[19]

Fenelon was, thus, an ambiguous figure, the "New Orpheus" as the philosopher Ballanche called him in 1820. Similar questions were asked ten years later when David represented Fenelon, the only man of the Church, in the Pantheon pediment. As a privileged figure of the prelate-philosopher, it is not surprising that his legend and his cult continued virtually without eclipse from the age of Enlight-

enment to Romanticism. In his monument, David retained the traditional posture of the half-reclining figure (fig. 49). The left hand is placed on the heart, the extended right arm seems to evoke the image of the teacher. In the official correspondence it is difficult to determine the extent to which the decisions concerning the subjects chosen for the sculpture express choices suggested by the architects, rather than by the administration or by the sculptors who could have themselves proposed the subjects first. We know in this case, however, that in July 1829 the architect Gauthier wrote to the mayor of Cambrai that he had "convinced M. David to make the change you desired . . . the prelate sees now only the heavens to which he seems to address himself to ask for the prosperity of his diocese."[20] Did David choose alone or in consultation with the architect what the latter called "the principal phases of Fenelon's life" that decorate the stylobate? Three miniscule reliefs (fig. 50), similar to three small paintings in their ornamental frames, represent, from left to right, three episodes from Fenelon's life which were emphasized by his biographers. The first two celebrate his evangelism. Precursor of Victor Hugo's Bishop Myriel in *Les Misérables*, Fenelon returns a lost cow to a poor family of peasants in Cambrai. This was a popular episode (perhaps invented by d'Alembert) during this period, and then depicted in diverse ways. Hersent made it famous in a painting exhibited in 1810.[21] In the second image, Fenelon dresses the wounds of Spanish prisoners after the battle of Malplaquet. The third depicts him in a scene that has

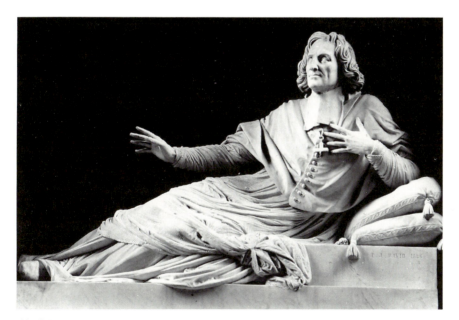

49. *Monument to Fenelon*, marble, Cathedral of Cambrai, detail

a long political history, i.e., in the act of educating the "good monarch"—the Duke of Bourgogne. This is also an illustration of the didactic literature in a period in which the putative dialogues of the Abbot Millot between Fenelon and the grandson of Louis XIV, the "hope of his country,"[22] were very popular.

The conception of these images is remarkable in many respects. Their choice is dictated by simple if not new ideas in commemorative monuments.[23] David, and the architects associated with his works, remained faithful to a type of relief instituted earlier, even though the dimensions of the works expanded and enlarged the monumental character of the pedestal or the stylobate that supports them. At Cambrai, the modest character of the reliefs is balanced by the importance still given to long inscriptions in *monuments somptuaires* at the beginning of the century (a practice that David condemned), and to sculpted ornament. In essence, David believed that the decoration of the pedestal, the element of the monument that serves to isolate the statue and elevate it to an apotheosis, should not be subtle. The most significant episodes of the life of the figure, those that project the image of the great man and his accomplishments and establish them in history, are those already well-known in popular culture—in the edifying biography, the song, or the anonymous print. In the monument to Fenelon, David condensed three episodes in the manner in which a vignette summarizes a chapter. This helps to explain their unexpected exiguity—they are about 50 centimeters long—and their high placement. Their

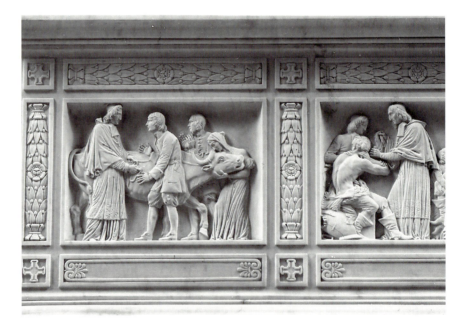

50. *Monument to Fenelon*, marble, Cathedral of Cambrai, details

very presence on the pedestal is as important as what they represent. The reliefs constitute a type of collective ex-voto, images whose meaning is already known to the spectator. An enlightened viewer, however, interested in their aesthetic quality, would have to examine them at close range.

More important, the execution of these reliefs is truly remarkable (fig. 51). Nothing in the sculpture of the 1820s approaches their expressive characteristics. The bodies of the figures, flatly modelled, are accentuated in several places through incised surfaces. Separated from the background by a frame that makes little use of a deep compartment, the figures that fill the space are thick and squat. The expressions are reinforced by abbreviated yet accentuated physiognomic effects. In each relief the composition is based on a vertical, triparite division and a pattern of squares. Here we see David employ a compositional format that student painters and sculptors utilized during this period as sketches in competition works at the Ecole des Beaux-Arts. In David's reliefs at Cambrai, the profile view dominates in the figures and groups which are characterized by extraordinary stylistic effects of imbalance, compression, elongation, and the flattening of forms. These effects necessitate a great effort on the part of the spectator attempting to read the image, unless she or he decides—as when looking at any of Ingres' *Bathers*—that the complete expressive effect of the whole image outweighs the convincing—or unconvincing—rendering of the anatomy. This was a completely unique conception in

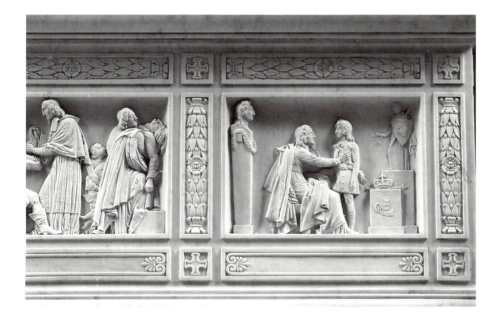

51. *Monument to Fenelon*, marble, Cathedral of Cambrai, detail

sculpture of this period, and one which David emphasized by advocating the primacy of the contour. A precedent for certain of these elements can be found in reliefs executed in England during the early decades of the century. In addition to considering the works David could have seen in London in 1816 and again in 1828, one must examine his ideas about the sculpture of Flaxman and Chantrey, whose oeuvre he judged very severely. French examples are, perhaps, more pertinent, since at an early date David distinguished in them promising pedagogic qualities which would influence greatly his ideas and judgments about sculpture. These include the works of several French sculptors at the beginning of the century whose art is still neglected (if not denounced entirely), and which can be described as "Attic." The most notable characteristic of this group of works is an attempt to disassociate the style of execution from all contamination of Italian sculpture made after the Renaissance and, above all, from Canova. Roland, Moitte, Cartellier,[24] and Chaudet are the artists most involved. Espercieux, another artist who followed this direction, was well-known to David.[25] Espercieux's reliefs, which decorate the delicate fountain of the market of Saint-Germain (fig. 52) and which are characterized by a clarity of conception and a remarkable freshness, were exhibited at the Salon of 1810. Towards 1825, David recalled examples of the historiated relief which likewise manifest pronounced contours and a flattening of forms.

David was not the only artist to question the expressive possibilities both of the relief and of another genre, the sculpted group, in which painting and sculpture

52. Espercieux, *Agriculture*, fountain, Paris, Marché Saint-Germain

are placed in a situation of aesthetic rivalry. During a period of about ten years—from 1825 to 1835—the various conceptions of the relief demonstrate the vitality of the genre. Certain sculptors favored an execution in moderate relief separated from a flat ground, a very conservative approach compared with David's radical formulations. Jean-Baptiste Debay provides but one example from the group of up and coming young sculptors associated with the Ecole. In 1829, Debay made a name for himself in a significant manner (a year before winning the first Grand Prix de Rome) with his *Jesus among the Doctors* (fig. 53), executed for the main altar at Saint-Sulpice. In this work, he adheres to the prevailing rules of classical theory. These rules are described in detail in Griffoul-Dorval's *Essai sur la sculpture en bas-relief*, . . . published in 1821, in which the author acknowledges the debt he owes in particular to the teaching of Cartellier: "Low relief, without having the form and the projection of figures in the round, represents figures nevertheless by means of a certain elevation above the background; an elevation always very moderate, some-times reduced to an eighth of the real projection."[26] Griffoul-Dorval's theory of the low relief, "a genre of work against nature," proscribed extensive foreshortenings and a perspective view, but admitted the bolstering and the support of projected planes by secondary planes and proposed the placement of the diverse planes of each figure in harmonic correspondences, as well as the elimination of objects in the background. This theory provides but a faint precedent for David who would make the propositions more extreme.

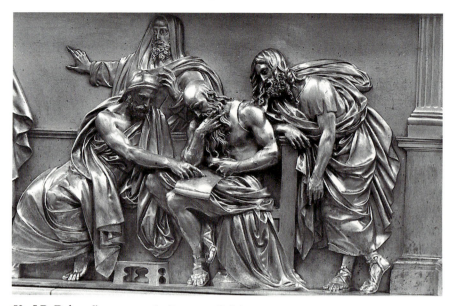

53. J.B. Debay, *Jesus among the Doctors*, relief, bronze, Paris, Church of Saint-Sulpice, detail

In the domain of the relief we can examine further the engaging personalities who belonged to the generation younger than that of David—Moine, Félicie de Fauveau, Triqueti, Maroquetti, Duseigneur, and Préault. Born during the first decade of the century, for the most part, several were trained at the Ecole des Beaux-Arts, but most left it of their own accord or were rejected. They emerged in official artistic circles during the last years of the Restoration and the first years of the July Monarchy before being brutally excluded from the Salons after 1834. The relief style of these artists reveals how the genre became transformed. In their works, the relief becomes independent from its architectural support and forms a category of sculpture the values of which assume a new identity: this will be the "relief-painting," which is portable, usually of modest dimensions, and autonomous in its effects. It is intended for the personal museum, the collection, or the apartment. Because of its private, intimate function, this type of small relief naturally favors the subjects and styles of painting.

This genre experienced an extraordinary vogue around the 1830s when Romantic criticism celebrated the disruption of the former theoretical and critical compartments and hierarchies. The most characteristic work of this period was one that was singled out by Stendhal: *Christina of Sweden Refusing to Give Mercy to Her Squire Monaldeschi* (fig. 54), one of the most popular subjects of the modern novelistic chronicles. It was executed by a remarkable woman, Félicie de Fauveau (who would soon become a celebrated legitimist activist and would go into exile

54. F. de Fauveau, *Christina of Sweden Refusing to Give Mercy to Her Squire Monaldeschi*, relief, plaster,
Louviers Museum

after being condemned). She treats the narrative seriously, and in a traditional
manner, for she brings the incidents of the plot to bear on the significant moment
and displays great reserve in the depiction of "local color," that is, in the pictur-
esque trappings dear to French Romantics. There is no background setting. The
figures, however, almost completely detached from the background, assume, be-
cause of their volume, imitative authority comparable to that of figures seen from
a distance in a marionette theater or in a miniature tableau vivant. Félicie de
Fauveau's relief was noticed by many and seen in various ways as a renovation of
the genre. Its critical reception is revelatory. Some critics spoke of a "revolution,"
others used the term "preliminary sketch" which had become a privileged category
of the discourse on art.[27] Stendhal went further: "I would be certain of appearing
extravagant if I confessed that I found more merit in this poor, small low relief,
several inches high, than in the equestrian statue extolled in *Le Moniteur* . . . in
the fine arts, the importance of the genre is nothing, it is the perfection of the
execution, in other words, it is the pleasure the spectator experiences that decides
everything." And Stendhal, for the pleasure of his readers, transcribes the chronicle
in manuscript by Père Lebel, which documents the scene in its most moving
details.[28]

Several significant factors inform the flowering of the relief around 1830. These include the growing number of artists and an increase in personal exhibitions marginal to the Salons, modifications in the structure of the markets for art, and the appearance in greater numbers at the Salons of works executed in perishable materials (which prevented many works from surviving). Finally, an extremely important factor profoundly affected the strategies of production—namely, the efflorescence of the periodical press which made a massive investment in the discourse on art provided by all types of writers.

Préault was a key figure in the transformation of the relief. His major works—reliefs and groups—which assured him of a spectacular arrival on the art scene around the 1830s are not known. These were executed before his remarkable *Tuerie* (fig. 55), subtitled "Episodic Fragment of a Low Relief." He exhibited this work at the Salon of 1834 but he could not cast it until the Second Empire. Having noted Stendhal's interest in historical narrative, we should keep in mind the enigmatic brevity of the title of *Tuerie*. In 1834, Préault was twenty-five years old. He had worked in David's atelier at the Ecole des Beaux-Arts (we will not be concerned with the personal rapport between David and Préault, which is quite detailed in David's correspondence). A note by David (that Jouin, if he knew of it, chose to neglect since he was writing during Préault's lifetime), reveals understandable reservations, but also expresses an unexpected and very eloquent homage—both frank and intimate—by an artist who was severe in his judgments concerning the art of his contemporaries:

All the reactions are exaggerated and almost always unjust: in 1827, when the Romantics rebelled, one saw the young artists giving themselves passionately to the cult of the ugly, thus the young Duseigneur produced his group of Quasimodo. . . . Préault also produced his group of the Pariah who embraces a young girl, both wallowing on the ground and presenting misery in all of its ugliness: At least there was life and a terrifying animation in this production of a young man who, if the jury had not always rejected him, would have been restored by the public to a more reasonable path without losing the precious qualities with which nature endowed him. France would have been assured of having a new Puget, he would have inevitably listened to the advice of a public who is always a good judge, whereas he saw that the jury was jealous of him, and he had been killed by the praise of the men of letters who often only write what they see in their imagination, rather than what they see before their eyes, and who, moreover, used this young man as a means of battle.[29]

In the *Tuerie* we admire a work that is as startling as it is troubling. It is remarkable that its subject was in some ways occluded by Préault himself, who never

55. Préault, *Tuerie*, relief, bronze, Chartres Museum

spoke of it in his known correspondence. The identification of the subject, which certain of his contemporaries saw as "dantesque," was never deciphered by his critics. Moreover, the subtitle proposed by the artist—"episodic fragment of a low relief"—is crucial since it demonstrates that Préault, by engaging the spectator in the discovery of a work putatively completed at an early date, confirms the indivisible authority of the fragment. Certainly, the evocative power of the fragment was not ignored in classical aesthetics as Winckelman's remarks *ex pede Herculem* attest. In the *Tuerie*, Préault transforms the fragment into a category of expression that conceals its literal and literary meaning. During this period, when every work of painting or sculpture at the Salon was accompanied by textual support in explanatory booklets (most frequently the source of the subject was cited at length), *La Tuerie* remained deliberately incomplete. It was exhibited without a "subject," as certain perspicacious viewers well understood: "*La Tuerie*, . . . a low relief whose meaning appeared obscure to several people, seemed to us the clearest thing in the world. The idea that presided in this composition is of the same nature as that which dictated to Decamps his large page of the *Battle of the Cimbrians*, which he named no doubt in this manner to give it greater importance and which should have been simply called the battle, as Rome was called *Urbs*—that is, the battle par excellence. These are unknown combatants . . . Préault's *La Tuerie* is in some way the epilogue of Decamps's mêlée."[30] This type of image, which manifests the fasci-

nation of the Romantics for full-fledged *terribilità* in subject as well as in style, can be found in other reliefs of this period. Several utilize the partial or total dislocation of figures, the multiplication of planes, and flickering surface effects. It is surprising that such effects are accepted by the Salon juries before 1834. For example, they can be recognized in a relief exhibited by Théophile Caudron at the Salon of 1833, *Childebert Attending the Games* (fig. 56). Caudron was educated at the Ecole des Beaux-Arts, which he entered in 1827. In 1830, along with Ramus, he was at the head of the group of student artists competing for the *concours de composition* (a modeled sketch). He did not win the Prix de Rome but he received a second class medal for his *Childebert*, a scene of a massacre, when he exhibited it at the Salon. Other examples of this nature could be cited.[31]

Préault's *Tuerie*, to a greater extent than Caudron's *Childebert*, juxtaposes areas treated in low relief with other elements that are more violently and completely detached from the background. This relief, which combines different stylistic modes, manifests a more polemical and clearly anticlassical conception of the genre. But this conception is still related to a certain tradition because antecedents can be found in the reliefs of Algardi and Puget. *La Tuerie*, similar to these earlier examples in its expressive power, is more intense, for Préault substitutes a much broader meaning for the simple narrative that an image traditionally conveys. The spectator is thus confronted with what might be considered a bold, figurative writing that conveys the incoherence of violence. Paradoxically, in its dense, oppressive, telescopic effects in the volumes and in the surfaces of the figures, the *Tuerie* provided an exacerbated transformation of effects already identifiable at an earlier stage of development in David's reliefs for the *Monument to Fenelon*.

Let us return to David and look at his works that date from the final years of the Restoration. Several programs indicate that three avenues were open to him to ensure effectively the impact of sculpture on the public; and at this moment David definitively chose three privileged "genres" to serve a common cause. One was the edifying image of modern man in iconic public sculpture, the character of which was commemorative or funerary. Another was the depiction of the great individual's accomplishments, sometimes fulfilled in the relief. The third was the portrait bust or medallion. David's approach to sculpture was thus considerably restricted in both choice of subjects and objectives. This self-imposed limitation implies an intense activity of the mind; the artist is compelled to question, choose, and constrain himself concerning hierarchies of decorum and merit. For David, public art was the only art that was consequential. He did not exclude, however, the contribution of written discourse—thoughts recorded in a fragmentary form—which became the material for a daily, continual meditation. He consistently thought in terms of works that were realizable and those that were impossible to execute—

56. Caudron, *Childebert Attending the Games*,
relief, bronze, Amiens Museum (frontal and side
view)

projects as well as visions. His meditations flourish in words and in drawings with
an unexpected richness.

In the 1820s, David executed a monument to honor Racine (fig. 57). This was
not a novatory idea for, as early as 1783, the sculptor Boizot had asked d'Angiviller
to give him a commission for a Racine as part of the series of the *Grands Hommes*
for the Louvre's Grande Galerie. This project was not entirely abandoned during
the Revolution. In 1819, the Ministry of the Interior commissioned several statues
of writers from the century of Louis XIV: "six feet high [and to be placed] in the
cities where the great men that they represent were born or in the cities closest to
their place of birth."[32] This was an interesting commission because of its "decen-
tralization" and because it bears witness to a comprehensive, official homage to
17th-century "classicism," a response to an enduring longing that characterized the
age of the Enlightenment.[33] The Parisian administration monitored the artists as-
siduously—both in the conception of their works and in the progress towards real-
ization—by inspecting their sketches (fig. 58). Fine arts officials were punctilious
concerning the representation of psychological veracity in the moment that David

57. *Racine*, statue, marble, La
Ferté-Milon

58. *Racine*, sketch,
plaster, Angers Museum

had chosen: namely, the instant when Racine has just composed the interjection of the third scene of the fifth act of *Andromaque* when Hermione reproaches Orestes for the death of Pyrrhus. The famous phrase reads: "Barbarian, what have you done! . . . Why did you assassinate him? What did he do? By what right? Who had told you of it? . . ." If David actually adhered to the representation of this instant it led him to express a sustained moment of reflection when the melancholy, almost feminine poet is self-absorbed, his right hand pressed against his heart. One wonders, however, if David actually accorded importance to this precise literary moment since there is no inscription on the scroll in Racine's left hand.

Government art officials reminded him of the inappropriateness of this pose when they examined his sketch for Racine: "in writing this play [Racine] had to

have, as Voltaire said, his whole being enflamed. All the passion, the hatred and the despair of Hermione had passed through his soul. The physiognomy and gestures should depict this agitation, ... but if you persist in representing him at the moment when he is supposed to have found the 'Qui te l'a dit?' (Who told you this?) [continued the censor], then you must, I believe, indicate in another way the state of his mind."[34] David ignored this advice.

In the subsequent years, David meditated upon this work whose pronounced physiognomic effects and pose embodied, in their tenderness, characteristics that could be considered "classic" as well as "gothic" (in terms of pose and drapery as well as emotion). He justified at length his choice of heroic or poetic nudity, a decision explained by diverse motivations and which diverged from his colleagues' unanimous decision to choose the costume of the time (witness, for example, Cortot's *Corneille* in Rouen) (fig. 59). The question of heroic nudity versus contemporary costume, a central issue debated throughout the 19th century, contributed to the numerous contradictions David's critics noted in his artistic development. Ten years later, when he worked on his own statue of Corneille for Rouen (fig. 60), David wrote concerning this subject: " . . . I congratulate myself greatly for having gotten rid of all of the frippery of the epoch, already several people whose taste I value have applauded this idea." Critics from Gustave Planche to Courajod wrote that the use of contemporary costume in the depiction of Racine was a mistake. One should view David's *Racine* as the thoughtful result of the sculptor's judgment concerning this essential idea of decorum, of matching the style to the character of the subject represented. David believed that in genius, invention, and style, Racine was an ancient and Corneille was a modern. The perspicacious Romantics perceived that Racine was an ancient who spoke their language.[35] David could not hesitate, therefore, about the costume. (Stendhal had perceptively understood the issue of costume in the modern sculpted representation of Racine).[36] If the sculptor seemed somewhat to have disregarded verisimilitude in his *Racine*, by depicting him *all'antica*, wearing the "hairstyle of the [antique] *Tragic Muse*" (as David recalled in his notes), the statue's coiffure, nevertheless, resembles that of the 17th century.

The placement of David's statue is another important issue. After having been exhibited twice at the Salon, as a plaster model in 1822 and executed in marble in 1827, it was supposed to be erected at La Ferté-Milon, a small provincial village, at a site that was uniquely arranged. The placement foreseen for the statue in 1828 appeared in a drawing by David's friend, the architect Moll. Inserted in a somewhat archaic ensemble, with notable commemorative and funerary associations, it forms the central element of a memorial (fig. 61). The architect wrote: "The site where the monument will be erected should offer a meeting place; an exedra with a bench for repose has been placed there. . . ."[37] Later a sheltered site had to be found for the statue, a much needed, protected placement, was imperative given the friable

59. Cortot, *Corneille*, statue, marble, Rouen City Hall

nature of the marble that had been used, whose deterioration (very noticeable today) could not have been anticipated. The initial placement that was planned was more interesting for it offered an example of a type of monument, rarely built, that united the garden, the public promenade, and the antique Elysian Fields (the cemetery) in one of the ensembles that were meant to signal the sites, in cities or elsewhere, where the *Grands Hommes* were born or where they worked. The most complete monument of this type, which was probably known to Moll and David, was one that was contemplated throughout the 19th century to honor Poussin in the Andelys (fig. 62). The architect Harou Le Romain wanted to place a replica of Julien's statue of Poussin in the midst of nature in a *sacellum* surrounded by a number of accessories and mementos, to be experienced with the "aid of optics." Julien's work is a direct antecedent of David's *Racine*, in the "nocturnal" instant of artistic creation that it represents and in its costume which justifies the moment (Poussin has wrapped himself in his bedsheet and thus wears a costume that is both contemporaneous and *all'antica*). The frame offered by nature is of prime importance in both cases. Harou had stipulated that "the author of the project wanted to be able to create a painting with the surrounding objects that would recall the beautiful landscapes of Poussin...."[38] David would develop in his reflections the organic analogies he discovered continually between the character of Racine and the

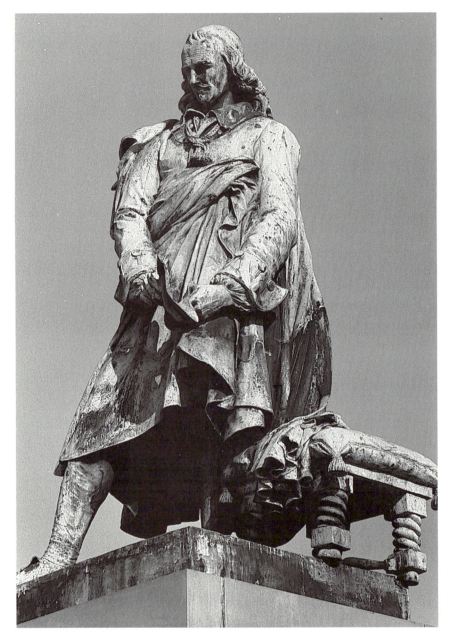

60. *Corneille*, statue, bronze, Rouen

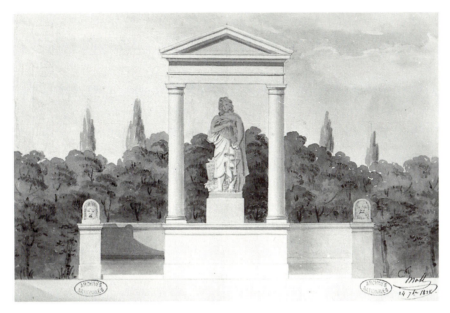

61. Moll, *Project for the placement of David's Racine*, drawing, Paris, Archives nationales

62. Harou Le Romain, *Project for a Monument to Poussin*, print

type of nature that had nourished his art: "[At La Ferté-Milon] everything is calm, large, the soul must withdraw into itself in this country. This was not a thoroughfare, especially in Racine's time. The first impressions of children are imprinted for their entire life. Corneille, on the other hand, lived in the heart of a tumultuous commercial city, and, consequently, had in his heart images of a working class eaten away by unhappiness; all this must have struck his energetic mind. I believe that if a view could be given of the land where a great individual was born, one would not be surprised by the evolution of his ideas."[39]

As we have seen, in the *Racine* David was concerned with the question of costume. He would deal with this issue in a completely different manner in the remarkable *Monument to General Foy* which was begun in 1826 and completed under the July Monarchy. The word costume is used here as defined during this period by Quatremère de Quincy: "By this is meant every manner of being."[40] General Foy is represented nude (as if in "a swimming school," the poet Petrus Borel acerbically wrote). In this statue other aspects of David's art are articulated and, if we believe his contemporaries, including Etex, this work signals the beginning of his "decline."[41]

CHAPTER 4

Saint Voltaire

D AVID'S WORKS sometimes manifest a disconcerting plurality of "styles."
("Style" is used here in its most comprehensive sense, to denote both tech-
nique and idea.) Expectedly, the differing styles of David's works are related to a
considerable extent to the specifications of the commissions, which, in part, help to
account for their diversity.

The commission that David received in 1826 for the sculpted decoration of
the colossal funerary monument to General Foy (fig. 63), erected at Père-Lachaise,
followed by several months the inauguration of the monument commemorated to
Bonchamps. When one looks, however, at the reliefs of this monument, one is led
to wonder how the Foy monument could be virtually contemporaneous with works
so different in conception that David exhibited in 1827, such as *The Young Greek
Girl Placing a Wreath on the Tomb of Botzaris* or *The Grand Condé*, among others.

In the *Monument to General Foy*, a work in the public domain, David openly
expressed his political commitment. He utilized a mode of representation that in-
vests public sculpture with a political function based on contemporaneous politics,
and therefore offered monumental sculpture as a rival to polemical literature and
the press, making it an instrument that influences public opinion and therefore
society. During the Restoration, General Foy was recognized as a leading figure of
parliamentary insurrection and was adulated by the liberals. Indeed, he was consid-
ered in public opinion as one who was certainly a measured apologist for regicidal
regimes. He was less violent, however, in his provocation of the monarchists than
many and less compromised than others in the numerous plots that punctuated the
Restoration. His death gave rise to an extraordinary spectacle of liberal solidarity
and to a popular legend promulgated and sustained for months in literature, po-
etry, prints, and medallions. Nearly thirty years later, the critic Villemain still
spoke of the talents of Foy as an orator, comparing him to Demosthenes. Foy had
been given a standing ovation by Villemain's students when he visited his course at
the Sorbonne. Villemain recalled "the extraordinary spectacle of his truly national
funeral." This was a great lesson, he concluded, "too soon lost on our forgetful

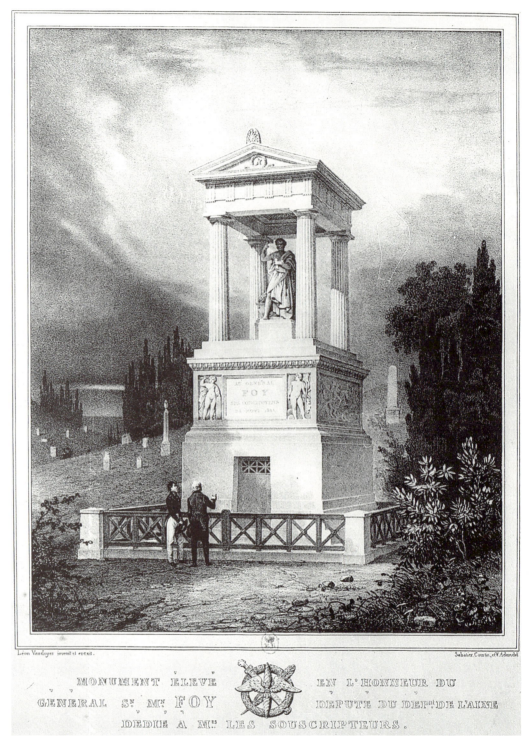

63. *Monument to General Foy*, print

nation."[1] A procession of ten thousand people followed Foy's coffin for seven hours. The opposition press in numerous and lengthy accounts noted that "the remains were carried by some young people who had asked to render him that homage." A national subscription was immediately initiated for the erection of a monument on an upper level of Père-Lachaise. David wrote in his diaries that "100,000 citizens voted a million francs for his family and a monument to the orator." He continued, "at the burial of Foy one was struck by the formidable silence that reigned; each individual, through this action, fought against the government, while at the funeral of the [politician] Benjamin Constant there were no longer any battles, to the contrary, people only wanted to be seen there."[2] This remembrance, which expresses a clear disenchantment with the political commitment of certain individuals, was written in December of 1830 when David was returning from the funeral of Benjamin Constant.

The circumstances which gave rise to the *Monument to General Foy* are unclear. Questions remain concerning the nature of the decisions made by the commission, the family, the architect, and David regarding the choice of images and forms. The architect Léon Vaudoyer, winner of the contest for the monument to Foy (which he and others found "weak"), judged in April 1826, seemed to have control of the enterprise. This occurred immediately prior to the competition in which Vaudoyer won the Prix de Rome. We do not know precisely how and when David, who had been chosen unanimously by the commission, came to an understanding with them concerning the choice of the subjects and figures to be represented, in particular the gallery of contemporary portraits represented full-length in the large reliefs and the "costume" of the effigy. The initiative appears to have been Vaudoyer's. Three months after having been chosen, he wrote that he had "been invited to make some changes. . . . They have asked for a grille . . . some bas-reliefs. M. David (d'Angers) is making the marble statue six feet and six [thumbs] high and three bas-reliefs eight feet long and four feet high, one of which will represent General Foy as an orator at the tribune, another one, a battle, and a third will represent his funeral procession which is a very memorable historical event. Is it not extraordinary to see a whole population accompany a deputy to Père-Lachaise, in spite of a torrential rain, and argue among themselves for the honor of carrying him to his tomb?"[3]

The theoretical aspects of the debate concerning the suitability of heroic nudity (fig. 64), although attenuated here by the use of partial drapery, in the celebration of a modern, indeed contemporary, individual, are clearly implicit in this monument. It is not known whether Vaudoyer and David together or separately decided in favor of heroic nudity during a second stage in the development of the conception of the monument.[4] This decision was denounced very quickly and on

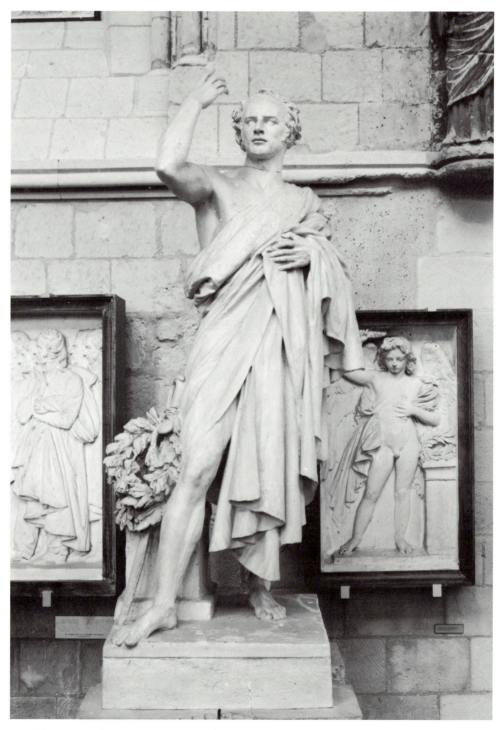

64. *Monument to General Foy*, statue, model in plaster, Angers Museum

every possible occasion, by virtually everyone who commented on the monument in the 19th century and since. Pétrus Borel's comments made in 1832 have already been noted; he also pointedly raised the question of David's political and artistic integrity, a question often debated between 1830 and 1840. Borel's condemnation was supported in a more nuanced form in 1856 by Gustave Planche.[5]

It is necessary to examine fully the architectural setting in order to understand the reasons for David's final choice of heroic nudity—that mode then called *recomposition* or metaphorical nudity (it is scarcely disguised by the drapery). An antique-like construction of large dimensions with pronounced horizontal divisions (traditional in funerary architecture) was to be placed on a prominent site in Père-Lachaise. Solely by reason of their placement, these divisions emphasize iconological functions which are hierarchical, simple, and easily legible. The lowest level refers to the terrestrial realm where the body is placed. The inscriptions and the reliefs make explicit the meaning of the middle level which is related to biographical narrative. Finally, at a higher level, one that is privileged and inaccessible, the statue stands as the sign of an apotheosis placed within a type of *tempietto*. This hierarchy necessitates a vertical reading of the monument which proceeds in tiered stages in which diachronic depictions of the heroic are specified. A statue in modern costume, placed at the summit of this edifice, could only have been seen as inappropriate. Several years after the completion of the monument, when modern costume was accepted in lavish and elaborate funerary architecture, the compositions of the architects involved were simplified and the funerary monument with a statue evolved in the direction of a representation closer to the familiar aspects of the figure observed in his own century. The figure was, therefore, rendered more accessible. One sees an intermediate stage in the development of the portrayal of figures in modern costume in a work comparable to that of the *Monument to General Foy*, namely, the *Monument to Casimir Périer* (fig. 65) in Père-Lachaise, completed by the architect Achille Leclère and the sculptor Cortot in 1837. Périer is not represented in modern clothing but rather is depicted in civic dress which, like military uniform, remains a costume, that is, a convention—the sign of a conferred duty or honor. This work is still far from portraying what was then understood in the critical debate as "modern costume." David and others referred to modern costume as a rag, or the "glorification of the [modern] boot." Nevertheless, in 1839, David chose modern costume for the admirable funerary statue erected to the polemicist Armand Carrel (fig. 66) in the small cemetery of Saint-Mandé.

The critical debate and decisions of the sculptors concerning costume during this period remain extremely significant because they involve fundamental choices in the representation of the *Grand Homme*, choices pertinent to the nature of homage and the notions of posterity. Interesting precedents can be found in the works of David's contemporaries which, certainly, nurtured his ideas concerning the pos-

[99]

65. Leclère and Cortot, *Monument to Casimir Périer*, Paris, Père-Lachaise

sibilities of *recomposition* (the term he employed) of the nude and the use of drapery in the idealization of the modern *Grand Homme*.[6]

It would be interesting to investigate precedents in encomiastic English sculpture that David had studied carefully in situ. For the purpose of this study, however, the discussion will be limited to France, where a few exceptional works of private and public sculpture (works called aberrations at the time) were created during the First Empire. In general, sculptors were encouraged to dress the dignitaries of the regime in civil or military costume, "after having posed them in an antique manner." David described this practice as "a misinterpretation, shocking beyond all words." These characteristics are found in their extreme manifestation in the commemorative effigy of General Leclerc that Dupaty exhibited at the Salon of 1812 (fig. 67). One can see that anatomically important parts of the figure are "forgotten" under the sitter's providential, thin sword. This work, nonetheless, can be appreciated as a type of pleasing, monumental cameo with graceful contours. In

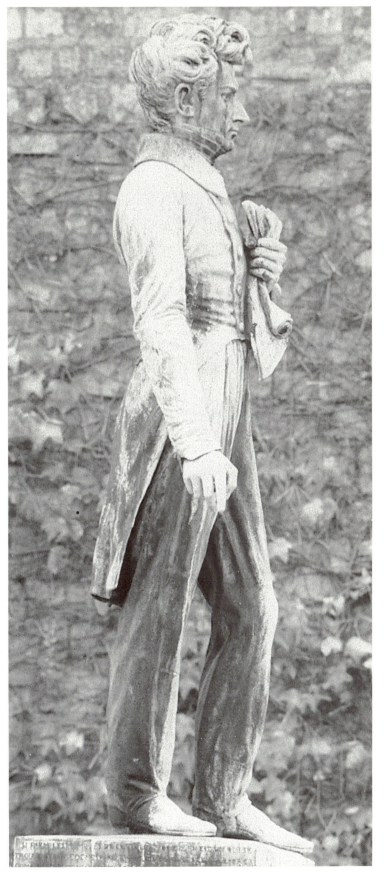

66. *Armand Carrel*, statue, bronze,
Saint-Mandé, Cemetery

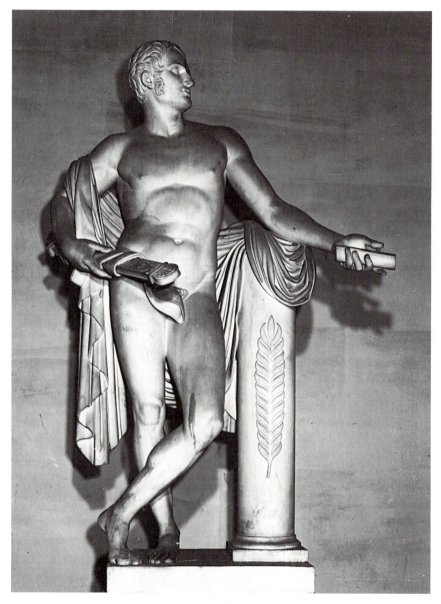

67. Dupaty, *General Leclerc*, statue, marble, Versailles, Musée du Château

68. Cartellier, *Vivant Denon*, statue, bronze, Paris, Père-Lachaise

contradistinction to these solutions, in 1826, the very year when David was thinking about the "costume" of General Foy, Cartellier placed a life-size effigy on Vivant Denon's tomb (fig. 68), depicting Denon seated in an intimate pose, pencil in hand, wearing the clothing of his time. This pose, certainly appropriate in an intimate and familiar monument, enhanced its potential for a subsequent reduction into a statuette-portrait, a genre that would become extremely popular in the 1840s. David imposed on his own works strict criteria related to the merits of the model and the didactic meaning of the homage. He carefully distinguished in his sculpture and in his writing the *sculpted portrait* from the statue. The sculpted portrait, an inferior genre, consecrated an abused and often unmerited democratization of the homage. For David, the portrait was the antithesis of the statue because it glorified the common and the mediocre. The statue alone could express the apotheosis befitting the great man.

Preparatory stages, which also corresponded to diverse levels of merit, led to this apotheosis. These levels of merit determined whether the homage took the form of a medallion or a bust (the bust itself was executed in either natural or colossal dimensions according to David's evaluation of the importance of the individual). In addition to the human figure, David celebrated the expressive possibilities of the engraved name. The inscription alone could suffice to represent the *Grand Homme*.

Thus, after meditating at length on the nature of representation, David transferred imitation from the figure to an expressive sign. In so doing, he extended the distinction made by a Salon critic in 1783 who had suggested that in the statue of the hero the distinction be maintained between word and image: "When a Hero who has never ceased to be important to his country is represented, why should one choose a single moment of his life? It would suffice to engrave his name on the base of his statue; just by seeing it, all that he had done for his fellow citizens would be remembered." David claimed that "the inscription of a name on a monument is the equivalent of a statue."

If we return again to the *Monument to General Foy* (fig. 69), we observe a remarkable innovation in the images of the second level, which David's contemporaries immediately perceived. The three reliefs resemble three large paintings, two of which portray the contributions of the great man. One depicts an episode from Foy's military life—a spirited battle scene (fig. 70). Another represents him at the Assembly where, surrounded by his peers, he appears in an image devoid of picturesque effects (fig. 71). The figures to the right and left are placed on a single plane and serve as a frame for the pantomime of the orator. Even more interesting is the third relief—Foy's funeral procession (fig. 72). This was being completed at the end of 1829 and was the first to be finished in stone, in August 1830.[7] Vaudoyer

69. *Monument to General Foy*, Paris, Père-Lachaise

may have furnished the idea for this composition, if not the choices concerning its execution at the beginning of 1826.[8] But one wonders if this idea should be credited to Vaudoyer alone. The work depicts a moment in the long cortege in which the body of Foy was carried by young men—a very unusual subject in monumental sculpture. Although David does not indicate the specific location, the image is composed as a close-up profile view, similar to a modern snapshot. The family and

70. *Monument to General Foy*, relief, plaster, Angers Museum

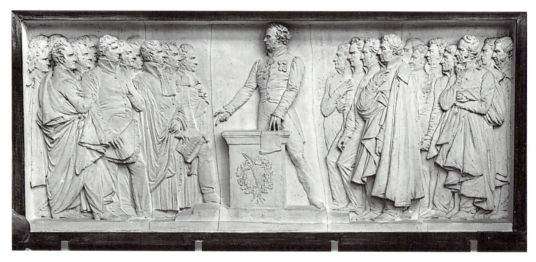

71. *Monument to General Foy*, relief, plaster, Angers Museum

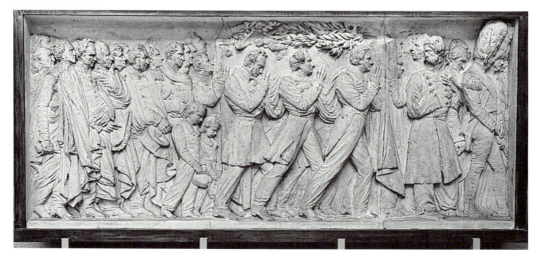

72. *Monument to General Foy*, relief, plaster, Angers Museum

the relatives of the general as well as the portraits of famous figures in front of and behind the coffin are depicted in extremely precise detail (fig. 73). These include Foy's companions in his political struggles, sympathizers, members of the committee of the monument, intellectuals, writers, and artists. Significally, David included himself among the pall-bearers. In short, this is a fascinating group portrait. One wonders if the final choice of characters was due to a last-minute decision on David's part related to the political commitments of several personalities during the few months that preceded and followed the Revolution of July 1830. Because of his political sympathies one does not, expectedly, see Chateaubriand represented in the cortege, even though it seems that he was present.[9] David had been very close to Chateaubriand between 1826 and 1830. After July 1830, however, the writer professed his overt attachment to the elder branch of the Bourbons. On the other hand, we do not know if Victor Hugo attended the funeral but his prepotent position as a pall-bearer is remarkable and puzzling.[10] If David had intended to include Hugo in his ideas for the project in 1826, one wonders what reasons he could have had for doing so. In 1826 Hugo was politically conservative (although his literary reputation as a Romantic was growing).[11] Remarkably, in the completed relief, David unites liberals representing multifarious elements of society. The metaphorical eloquence of the image is more significant than the depiction of the historical event (which can be commemorated in sculpture as a type of document). The relief, however, is not exclusively political and is even politically moderate. The subscription and the monument were supported by high finance. The monument was certainly liberal in spirit but it was not understood as a provocation to the regime.[12] Rather, the work depicts, on a colossal scale, a powerful, realistic image with symbolic relevance. This accounts for its polemical human and prophetic value—a march of diverse, modern individuals side by side, bent in a common effort, brought together by a common respect for a spokesman.

In the relief, David did not hesitate to adopt modern costume. Its use at this level of the monument, near the mortal remains, alludes to terrestrial necessities, to the impediments caused by infirmities, to the caprices of physical organizations, and the constraints that costume exerts on the gestures and attitudes of the body. In other words, modern costume signifies the defects and restrictions imposed on man by physiology, fashion, and milieu. David, in his writings, reflected at length on these questions.

It is therefore necessary to see in this relief an exceptionally bold vision which makes it unique in the sculpture of this period. This panathenaic procession of liberalism commemorates an idea of intellectual and political solidarity. David confronts the Restoration with this symbolic image of solidarity before the advent of

the July Monarchy which first accepted these ideas, but later denounced them. This unusual and perhaps unique subject may be seen as a response that functions contrapuntally, or even paradoxically, to a similar event with a completely different signification—namely the funeral of Louis XVI and Marie-Antoinette depicted on the Chapelle Expiatoire in 1826. David's response would have been difficult to execute in any place other than a cemetery. While the Chapelle Expiatoire was being completed, the sculptor Gérard decorated it with its only large historiated relief, a long central frieze that represented, with a typical combination of antique and modern elements, the translation of the royal remains to Saint-Denis on the 23 of January 1825 (fig. 74). As was then often noted, this ceremony was paid for by the state treasury. Incidentally, in 1848 David opposed the proposals made to destroy the chapel.

We are thus led to ask a number of questions that can only be debated profitably by examining detailed evidence. Such questions are related to the limitations, stability, and reversals of David's political convictions, to the artistic means by which he linked them to sculptural objectives, to his personal mission and morality. These questions also concern David's role as a sculptor and his commitment to writing. David's descriptions of political events and their justification intersect with past, present, and prospective moral considerations. It sometimes seems as if he edits his autobiographical reflections because he anguishes over the anticipatory judgment of posterity.

Much could be written on David's political ideals and his concern with posterity. Only his principal political ideas, however, can be considered here. As he often repeated, his democratic propensities appeared very early. They are evinced in an episode from his Roman years which remains obscure. He conspired with his companions in Rome—the artists Pallière, Dejuinne, Picot, and Dupré—to join the Carbonari who tried to liberate King Murat in Naples at the time of his landing in Calabria.[13] He refused, however, to honor Murat later with a statue. During the final years of the Restoration, he sculpted the royalist hero Bonchamps and agreed to participate in the large collective projects that openly celebrated the glory of the Bourbons. Among other works, he executed a large relief for the Arc de Triomphe of the Carrousel representing the Duke of Angoulême returning from his campaigns in Spain and being greeted by Louis XVIII (fig. 75). He participated in a program of the same nature with Ramey. Two months before the July Revolution, he finished the drawings of three colossal reliefs for the Arc de Triomphe of Marseille, which celebrated the Spanish victories of the Duke of Angoulême (fig. 76). Under the new regime, he proposed a modified program for the same monument which was finished at the end of the 1830s. Under the Restoration he was also

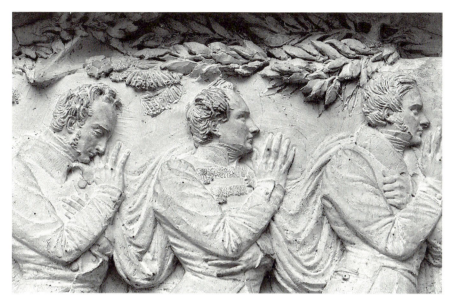

73. *Monument to General Foy*, relief, plaster, Angers Museum, detail

74. Gérard, *Translation of the Remains of Louis XVI and Marie-Antoinette*, relief, marble, Paris, Chapelle Expiatoire

preoccupied with Parisian monuments: in 1828, he proposed to the Minister of the Interior a statue of Peace to crown the Vendôme Column.[14] The Revolution of 1830 saw him on the barricades, a fact recorded by Republican historians who were his friends.[15]

After 1830, the progressive direction of his thought was very clear and he began to live and act according to the ideas of the First Republic. If his "professions of faith" to the voters of Maine-et-Loire did not openly call into question the principle of constitutional monarchy (no one could reproach him for this in 1834, in an electoral campaign in this conservative district), his personal notes and his actions condemning it are numerous: ". . . and one tells us that Republics are states of anarchy and atrocities. The royal annals are everywhere, and at all times, written in blood."[16] His disenchantment with the regime of Louis-Philippe increased as conflicts arose that placed in opposition the liberal circles and the government. His remarks in his notebooks and correspondence are brief but penetrating when they evaluate political situations. His articles published on art, too numerous to be mentioned here, transcend their ostensible subject and are always based on vigilant social ideas that systematically and relentlessly question any threat to individual liberty. Through his reactions to events, David's political ideas can be followed in detail more easily than those of any other "committed" artist of the epoch. The commission of the *Monument to General Foy* and the first medallions and busts of political personalities that he executed suggest that from 1825–1826 the sculptor was accepted by those who demanded electoral reform. For many years the lengthy, radical, essential program to establish electoral reform was the principal aim of David's political activity. He recorded his efforts for this cause, beginning in 1830, with a particular insistance: ". . . We were twelve reunited citizens. We appointed ourselves as the representatives of the twelve [Parisian] districts. The objective of this meeting was to put forth an idea which had an important result, namely electoral reform, but I requested that this measure be applied to all members of the National Guard of France. I was supported by Dornès and my proposition was adopted. From this effort came this outstanding reform which served in February of 1848 to make this republic blossom, which in spite of numerous enemies is the only government possible."[17]

In 1837, David was a member of the Central Committee of the Constitutional Opposition and became vice president in 1839. He was a member of numerous opposition committees and attempted several times to obtain both municipal[18] and national mandates: in 1834, 1837, 1846 (he withdrew his candidacy in Paris in 1839); in 1848, beaten in Paris, he won finally in Maine-et-Loire.[19] His name appears in police surveillance reports due to his presence at political banquets.[20] He

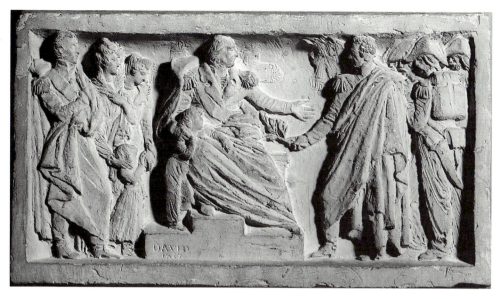

75. *The Duke of Angoulême Greeted by Louis XVIII*, sketch in clay, Paris, Louvre

76. *The Fall of Trocadero*, drawing (counter proof), Cambridge, Fogg Art Museum

collaborated at this time with diverse journals and toward the end of the 1830s he tried to exert influence through the liberal press which supported his candidacies.[21] In 1838 he founded, with his political friends, *La Revue du progrès*.[22] With his friend Hippolyte Carnot, he edited the *Mémoires* of Barère de Vieuzac, former Convention president. He advised E. Arago's gathering of information for his publication on the atrocities committed by royalists during the Vendeen Wars. David himself also wrote on this subject.[23] His personal involvement increased with the erosion of his confidence in the constitutional government. In 1840, he gave shelter to the anarchist Blanqui (fig. 77), who was being hunted by the police.[24] In his writings, portrait busts, and medallions, he honored members of the Convention whom he revered,[25] and he depicted and wrote about large numbers of contemporary individuals who resisted and conspired against repressive regimes.

He judged obsessively and ineluctably the conduct of the moderns. He recorded things seen and heard in which he discerned signs of the moral grandeur or, conversely, the turpitude of his contemporaries. He questioned their political and moral tergiversations and renunciations. This attitude helps to explain the sometimes eldritch tone of prophylactic confession found in his notes. Thus, in writing of the politician Félix Barthe, he states: "Among all the disagreable memories that rush and crowd together from my tenure at the City Hall of the Eleventh District [of Paris], I see a hideous figure, always sidling in the streets, like a reptile. This man is the former lawyer Barthe whom I had seen one night in Drolling's studio swearing his hatred of kings on a sword held by Godefroy Cavaignac. The elite of the Republican party were there. So, this filthy man, this senator, had himself brought to the City Hall nearly dying of fear, trembling while asking me to protect his life, threatened, he said, by the Republicans. . . . I sent him away with an order for the commissioner of police to protect him. The commissioner told me that there was no reason to be concerned because it was only his guilty conscience that made him conjure up his fear."[26] David's vigilant propensity to pass moral judgment on his contemporaries influenced his ideas concerning artistic responsibility in the depiction of historic and human actions. His reflection on this issue was important in view of his artistic activities during two political regimes that he repudiated—the Restoration and the July Monarchy. Because of his unwavering belief in the perfectible character of institutions, David thought that the artist should act as a witness and dispassionately record the spectacles offered by history.

He was therefore confronted with a mission which, as a sculptor, he was required to fulfill, but he arrogated to himself the right to ignore this mission. David, in fact, separated the event from the individual and we find in his ideas and his art a clear distinction between what belongs to the realm of history and what belongs

77. *Auguste Blanqui*, drawing, Paris, Carnavalet Museum

to the realm of the individual. As a result, two major, contiguous genres in his art can be distinguished. One is the genre of historical relief which records an irreversible, albeit perhaps regrettable, event that must be preserved because it has become archival and therefore part of the record of history. The other is the statue, an apotheosis, an unconditional homage rendered to an individual and, through the individual, to an idea. This homage morally involved the artist and was related, as we might expect, to questions of merit and of hierarchy, notions that consistently informed his ideas and his art. His ideas on this subject are described in a comprehensive way in a letter to his friend, the poet Victor Pavie: "The people are very wrong to destroy monuments that depict individuals who are the object of hatred; these are pages of history. What is exasperating is the type of apotheosis that sculptors give to figures they represent. Certainly if a sculptor rendered his figures with the naïveté of a Charlet, the people would laugh at the great Charles X and the [false] hero Angoulême [Duke of Angoulême] and he would expose these heroes to *la naïveté des hommes*" (the naïveté of the [credulous/discerning?] populace).[27] His analysis of his own behaviour (in intimate meditations) allowed him to resolve contradictions and duplicities that his critics had denounced at a very early point in his career. David did not develop his thoughts concerning these conflicts either publically or in detail.

The final years of the Restoration and the early years of the July Monarchy offered ideological objectives and opportunities for monumental sculpture, in both private and public initiatives. These monumental works, like sculptures of the same period exhibited at the Salons and elsewhere, manifest a remarkable reinvigoration of traditional imagery and styles, and attest to an overturning of the accepted hierarchy of genres, as has been emphasized earlier. David's monumental art of this period, conceived for the public sphere, and its refraction in his intimate writings and drawings, also called into question traditional values and hierarchies.

Two projects of this period for monumental works (which always have political content), stand out among the important programs. One was the completion of the Pantheon—to be realized according to the ideological principles of 1791—that many thought possible and even immanent in July of 1830. The other project was related to modifications of the vast, monumental urban complex whose center was the Place de la Concorde. A vast scenographic site was being constructed around two key buildings that faced one another—the Chamber of Deputies, which was being decorated, and the Church of the Madeleine, which was being completed. In connection with these programs a series of conspicuous dynastic monuments, conceived in an allegorical mode, were planned during the final years of the Restoration. These include Bosio's projected *Monument to Louis XVIII* (fig. 78), which was to have been surrounded by traditional personifications

78. Bosio, *Project for a Monument to
Louis XVIII*, drawing, Paris, Carnavalet
Museum

of Religion, Justice, Force, and Law, and placed in front of the Palais-Bourbon, facing the Pont de la Concorde.[28] Another was the projected *Monument to Louis XVI* (fig. 79), given to Cortot, destined for the center of the Place de la Concorde. The king was to be represented as a martyr accompanied by the personifications of his virtues. In 1829 this monument was about to be cast and erected on the site. In this vast complex, however, the most important program was for the Church of the Madeleine, the huge pediment of which, thirty-five meters at its base, was to be decorated with an image that would make clear the significance of the building. On the eve of the July Revolution, the Church of the Madeleine had been restored to its former status as a royal church but its interior decoration, funded by the government and rich in sculpture, became a type of public, national "branch" of the Chapelle Expiatoire. A series of colossal expiatory monuments offered to Louis XVI, the royal family, and the defender of the king were to be placed

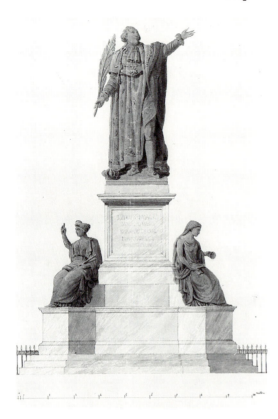

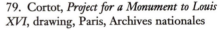

79. Cortot, *Project for a Monument to Louis XVI*, drawing, Paris, Archives nationales

in a series of lateral chapels. An emphatic lesson in contrition and repentance was thus planned which was justified by the patronage under which the church had been placed.

The competition for the decoration of the pediment with acroteric figures, one of the most significant episodes in the history of French religious sculpture in the 19th century, was rapidly concluded and executed because, as Guizot recalled, the government feared the Napoleonic party's desire to reconvert the church into a Napoleonic Temple of Glory.[29] The competition that took place in two stages has left few traces, with the exception of several losing entries. It was denounced for a variety of reasons, including the sculptors' perception of governmental pressure. In 1828, the architect Huvé had been chosen to complete the monument because, according to official correspondence, "he was committed to execute the ideas that would be proposed to him by the administration."[30]

Several of the sculptors who competed asked interesting questions concerning the program because no subject was assigned. According to the announcement of the competition, the artists were free to choose "an episode from the life of St. Magdalen, or a completely different subject appropriate to call to mind the pious

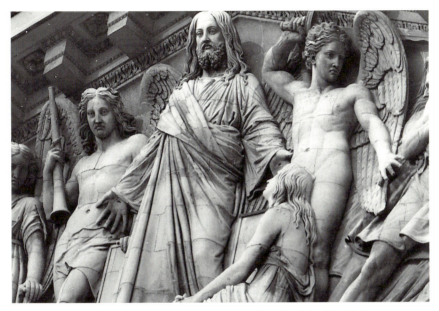

80. Lemaire, *Last Judgement*, relief, stone, Paris, Church of the Madeleine

function of the building." Several competitors would therefore understand the image in its literal sense, as a simple hagiographic illustration, while others would ignore this meaning and transform it. The laureat Lemaire, for example, transformed the literal meaning by depicting Magdalene at the feet of Christ in the *Last Judgment* (fig. 80); he thereby turned the image into an expiatory metaphor of the collective repentance of the nation.

David did not compete for the Madeleine program, although, according to Rude, he considered doing so at one point.[31] Among the submitted sketches were a range of subjects and interpretations related to the three canonical episodes from the life of Mary Magdalen. Pradier, for example, in his two exhibited variants, chose to depict her conduct at the house of Simon the Pharisee. Some sculptors chose a simple apotheosis of the saint. Others, including Barye, de Bay the Elder, Gérard, and Petitot the Younger, related the saint's apotheosis, with varying degres of specificity, to the apotheosis of Louis XVI and his family, who were thereby canonized in advance (this issue was vehemently discussed in the discourse of the time). The most remarkable image was conceived by the fascinating sculptor Bra, who envisaged an ambitious composition. He wanted to represent Louis XVI offering himself and his family as sacrificial victims near an executioner's block and a hatchet (that he depicted, as his contemporaries remarked, "still smoking"). He juxtaposed this image with episodes of the *Noli me tangere* and the *Meal at Simon's House*—a juxtaposition he publically justified as being a metaphorical image of

Charity. These issues were being discussed on the eve of the July Revolution, along with others concerned with what was called the "frontispiece" of public buildings—the pediment: this large image on the facade where public architecture and sculpture were expected to clarify didactic goals. Such issues and objectives were passionately disputed during this period. The expressive possibilities of this type of public sculpture were being rediscovered. The theological and political significance of famous antique examples of this kind continued to be discussed and it was thought that in the "genre" of pediment sculpture a rapid and economical means had been found to communicate an ideology.

In order to capitalize on this effective form of ideological communication, the July Monarchy, just several weeks after the July Revolution, commissioned David to execute the colossal pediment of the Pantheon—the Republican "Basilica of Saint-Denis" (fig. 81). David completed it in 1837. Guizot later described the decision to give a new purpose to Soufflot's church as a political "mistake" for which he was responsible. He recalled the government's efforts to mitigate the consequences and explained the action by the government's willingness to concede to factional pressure: "It was, in the midst of our general resistance to Revolutionary claims, an act of complacency towards a high-minded but rhetorical fantasy, which misunderstood the means leading to the goal to which it aspired."[33]

In a rather unusual way David became associated with the history of what was already the third conversion of the church during the final years of the Restoration. According to an administrative report of 1833, when the building was returned to the Archbishop of Paris in 1821, it was subjected to "destructions similar to those committed at the beginning of the Revolution."[34] These attacks had resulted from what was judged to be the intolerable presence in the church of the remains of Voltaire and Rousseau which were removed from the sacred site and placed in the vault beneath the large porch. The five reliefs of the Republican program designed by Quatremère de Quincy for the facade were taken down. At one stage, however, those in charge considered preserving Moitte's 1792 pediment by proposing to submit it to the most fanciful transformations known in the long list of political reconversions in monumental sculpture of the 19th century. The sculptor Gaulle, and later the architect Baltard the Elder, had prepared projects after 1820 that would bring about "slight structural changes." Utilizing former elements from Moitte's pediment they would either represent *Religion Crowning Saint Geneviève and the City of Paris*,[35] or a figure of *Immortality* (fig. 82) giving palms to the evangelical virtues with one hand and with the other giving palms to the evangelized continents presented to Immortality by a personification of the Génie du Christianisme.[36]

In 1823 the Archbishop of Paris demanded the removal of Moitte's pediment which was almost destroyed in the procedure. It was reported in 1833 that he gave

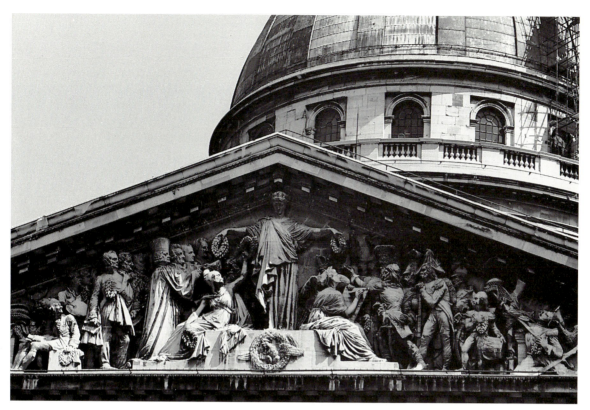

81. *Pediment of the Pantheon*, relief, stone, Paris

the order at the church and that the demolition was completed "with a rapidity that is difficult to imagine."[37] Moitte's pediment was replaced by a cross inscribed in a Glory [une Gloire], the motif of Coustou's original 18th-century pediment.

It is surprising to learn that in 1826, when he was about to work on his monument to General Foy, David became involved in the Restoration's efforts to restore the porch of Saint Geneviève, the large religious sculptural program that pre-dated the French Revolution. With his colleagues Gayrard and Walcher, he sat on a commission presided over by the clergy to decide subjects for a series of reliefs illustrating the life of the saint. He was asked to execute the principal part, three reliefs; apart from a few drawings, only a sculpted sketch survives.[38] He was thus already involved in this project when he received the commission for the pediment. It seems that the archaeologist Charles Lenormant, an acquaintance whom he met at the Salon of Mme Recamier during the final years of the Restoration, had negotiated the commission with Guizot, who gave him a certain latitude in the choice of the program. The re-establishment of the inscription on the frieze, *Aux Grands Hommes La Patrie Reconnaissante*, provided the idea for the iconography.[39]

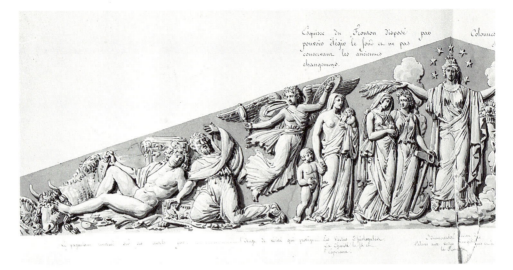

82. Baltard The Elder, *Project for a Pediment for the Church of Saint-Geneviève*, drawing, Paris, Archives nationales

Once again, the artistic and political history of this prestigious commission (figs. 81 and 87), which demonstrates the Revolutionary sympathies of the July Monarchy, proceeded in stages that can only be reconstructed with difficulty by employing the scarce archival sources. One wonders, for example, if Lafayette, the president of the Commission for the Honors of the Pantheon after the July Revolution, was consulted about the program.[40] The terracotta sketch (fig. 83), the only one known today, dated 1830, corresponds to the final composition, although it is impossible to identify most of the "actual" figures depicted. This was perhaps the sketch that David (after he sent it to the museum at Angers) described in 1838 in terms that indicate that he had submitted it twice to the government: "I have sent you a sketch of the pediment, it is perhaps rather unusual, politically speaking, because it is the one that the government approved in 1830 and in 1834, and which caused me so much anguish in 1837."[41] In spite of the date inscribed on it (1833), this sketch can perhaps be associated with the series of drawings preserved at Angers which demonstrate numerous hesitations concerning the choice of figures. Can it be dated, along with the drawings, to the first two years of the genesis of the pediment, that is, before the summer of 1833 when the sculptor received his first payment for the execution?[42] David's notes, written during the period when he encountered difficulties with the government in 1837, seem to confirm this hypothesis:

> In 1830 the minister Guizot commissioned me to do the pediment of the Pantheon. He approved my sketch, but after d'Argout replaced him, with

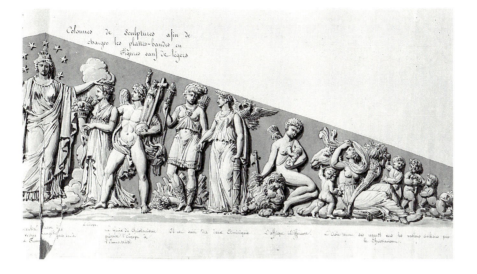

political events turning towards despotism, I received a counter-order and it was only in 1834 that the minister Thiers told me to continue my work and to follow my sketch exactly, keeping all the historic figures. After I had completely finished my work, when Montalivet was at the Ministery, he [Montalivet] went to see it with the Duke of Aumale. They complimented me very much, and the minister gave the order to pull down the scaffolding right away so that the relief could be seen for the July celebrations. But when the scaffolding was half-way taken down, the Archbishop was at the court in order to influence the queen and during the night the order was given to the architect to rebuild the scaffolding. I opposed this formally, engendering a battle that lasted nearly two months. During this time I cannot count the number of pressures put on me to get me to change the figure of Liberty, as well as that of the [Assemblyman] Manuel, and if I had conceded on this point, I would have had to change all of the figures. I had been commissioned to make a sketch for the pediment of the Chamber of Deputies, I had represented the Oath of the Tennis Court. While the battle was going on they implied that they had approved my composition, but since the constant battle in the journals and my relentless persistance forced them to submit to public will, the sketch of the pediment of the Chamber of Deputies was returned to me and they told me that I was making myself impossible.[43]

This project, known only in a drawing (fig. 84), reveals the development of David's conception for he openly appropriates Louis David's large, uncompleted painting

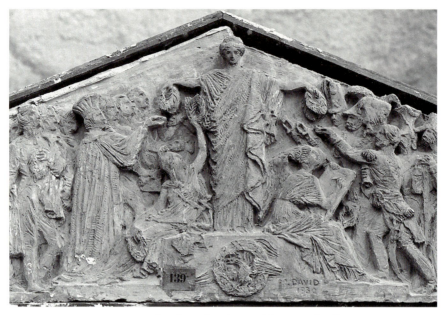

83. *Pediment of the Pantheon*, sketch in clay, Angers Museum, detail

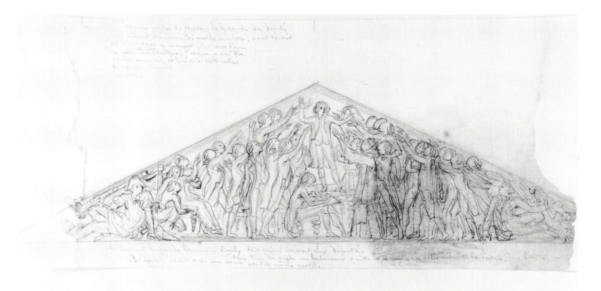

84. *Project for a Pediment for the Chambre des Députés*, drawing, Paris, Carnavalet Museum

of the same subject.[44] Louis David is the only artist depicted on the Pantheon pediment and, during this period, the government continued to oppose the repatriation of the painter's ashes despite David d'Angers' efforts to the contrary. David took the historical subject and legacy from the painting, the collective event that served as a prelude to the Revolution. He represents it, however, not as an illustration of an event but as a didactic composition. And he adopts the hieratic triangular format chosen by the painter which made the painting a type of pediment with Bailly in the central position. Here the question of artistic appropriation is straightforward and disarming in its simplicity. For David d'Angers, this composition was the only one possible and could not be replaced—it had been irrevocably established and offered to posterity by an artist whom he considered to be the greatest painter of the modern period. Furthermore, political regimes had rejected and occluded both the historical subject and the painting itself. David restored both in a type of double homage to the subject and to the artist which can be directly tied to his public and personal admiration and reverence for the great painter of the Revolution.

Drafts of several diverse texts reveal David's strained rapport with the government in 1837 when he finished the pediment. Jouin, who seems to have been acquainted with these texts through a résumé edited by David's wife, Emilie,[45] mentions them briefly.[46] They are significant documents because they recorded specifically the unprecedented resistance of a major artist to governmental interference concerning the iconography of a program of monumental sculpture of singular importance. One should keep in mind that this action took place at the moment when David's candidacy for the elections was made known.[47] Furthermore, documents bring to light the prescient use on that occasion that David made of the press,[48] which he understood and used as a weapon to counteract governmental pressure. One document is worth citing at length. David recorded in narrative form the conversation he had "at noon" with Montalivet, Minister of the Interior, on July 27, 1837. This was an interview whose tenor he anticipated. He announced to Montalivet that he intended to communicate excerpts of it to the press.[49]

(M): . . . Why haven't you done for the military side what you have done for the civil side? On the civil side you have placed leading people whereas [on the military side] you have placed simple soldiers. D [David]: I have already told you, I had no other way of generalizing the idea of the army, many great generals have begun as simple soldiers . . . I know that the idea that presides over the conception of my relief is completely populist, it is to the people that I have dedicated my life as an artist . . . I have made this work for the people and not for the Government. . . . As a patriot I wanted us to take possession of the Pantheon which will never belong to Saint Geneviève. Understand it

well, Monsieur le Ministre, this is what the Nation wants. . . . M: The opposition uses every available means, I myself have been part of the opposition and I then used means that I knew well were not based on the truth. D: Thus you were part of a systematic opposition and that is very bad, because one should only use means that one will not be obliged to disavow later, an opinion should be the result of a profound conviction. . . . M: You know that I am in charge of distributing paid commissions, we still have important deeds to illustrate, we are going to consult you about the pediment of the Chamber of Deputies, we will speak about it. . . . Many touchy individuals in the military are concerned; the son of Marshal Lannes is very angry not to see his father there, you have represented the army, the people. . . . You are in good standing with the journals, you have many friends, they help you. D: The journals are engrossed in this completely politically question which is political to the highest degree: I must tell you that I have informed and will inform the patriots of everything that happens. . . . We patriots are not men with two faces . . . I must therefore tell you that I will report our conversation, and that all the journals that render and make known with precision and gravity my frank opposition will be acknowledged by me, I cannot answer for the pleasantries of the small journals. M: But, Sir, I am speaking with you in confidence, this is a minister who speaks with an artist. I cannot understand how it would be appropriate to make our conversation known. . . . D: You have just stated the motive yourself. . . . This is a political question, it must be made known. . . . I believe you have spoken to me of military touchiness. Monsieur le Ministre, you circumvent the question, tell me frankly that Liberty, Manuel, Lafayette and perhaps other figures have disturbed several susceptible individuals too highly placed for me to name them. M (with a very pronounced embarassment): No, but I confess that, myself, I would have preferred to see the great citizen Casimir Périer. Manuel was a generous man, a powerful tribune who could demolish anything, but Casimir Périer was a conservative and we want only men like that. D: Well, Casimir Périer was not yet dead when I made the reliefs and I acknowledge that even if he had been dead at the time I would not have hesitated a minute between these two men. . . .[50]

Like two pages of an immediately legible book of history, the Pantheon pediment raises issues that involve the birth of the Republican era. These issues are vast and it is easy to understand how debating them in 1837 could have served as a springboard for an artistic and political controversy that was beginning to evolve. The principle of the 1789 Revolution was called into question along with the history of its causes, its historiography, as well as the politics of the day, and many

other questions debated during this period concerning Romanticism in the arts. After the 1830s, the significance of the image on the pediment was often questioned, the men and the principles they represented or symbolized were reassessed, always in a violent tone, which is not surprising considering the breadth of the conflicting ideologies involved. Proudhon later denounced the "nonsensical" inscription *Aux Grands Hommes*, . . . reestablished in 1830—the very theme of the program: "In the thinking of the Revolution and in the perspective of the Republic, the idea of the 'grands hommes' is nonsense: their passing is a gauge of our deliverance. Those of the Constituant [Assembly] who decreed the Pantheon, and those of the Convention that carried Lepelletier and Marat there, were frank aristocrats. . . . What! Is the Country now grateful to its men, towards its children! I would have thought it should be precisely the other way around. . . . But David [d'Angers] was a Republican, and, like his homonym, a partisan of Robespierre. Lacking a superior intelligence in art, why was he not warned by his conscience as a democrat? . . . I repudiate Rousseau; this cracked head is not French and we could have done well to bypass his lessons. . . . Fenelon: Come on! This quietist, this feudalist, this friend of the Jesuits. . . . Why forget the Bishop of Meaux [Bossuet], ten times greater than the Archbishop of Cambrai? . . . "[51] The reaction of the Catholic polemicist Louis Veuillot, during the same period, is just as vehement: "On the pediment of the Pantheon, amongst many others, one sees Voltaire, Rousseau, Mirabeau, that is to say improbity, avarice, defamation, revolt, felony, debauchery, atheism, suicide, bad behavior, all the capital sins and all their categories. Poor gods poorly established in their transient immortality, unknown to the majority, scorned by those who recognize them, and of whom even those who adore them begin to erase modestly their biography."[52]

David's intellectual and artistic development in the evolution of the Pantheon pediment is difficult to follow. One wonders what motifs and views of history and its influence on the present led him to choose these figures, particularly the group to the left of the spectator, whom he wanted to enlarge into "popular" icons so that they could be recognized by all. As in the pediment by Moitte and in well-known painted examples from around 1800—i.e., Louis David's *Oath of the Tennis Court* and Girodet's *Apotheosis of the French Heroes*, David placed his figures ascendently in profile on either side of three central allegorical figures, The Country, Liberty, and History (fig. 85). To the left, in a gallery of full-length portraits, entirely visible and clearly outlined in the foreground, are the following figures: Bichat, Rousseau, Voltaire, Louis David, Manuel, and Malesherbes. Also on the left-hand side, one sees Cuvier and Lafayette, Carnot, Berthollet and Laplace, Mirabeau, Monge and Fenelon depicted in medallion form, because their bodies are partially occluded. To the right are Bonaparte and the legendary drummer from Arcole. This presentation, which indicates a visual hierarchy, corresponds to a hierarchy of

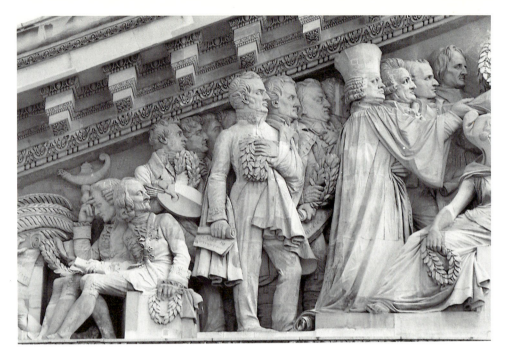

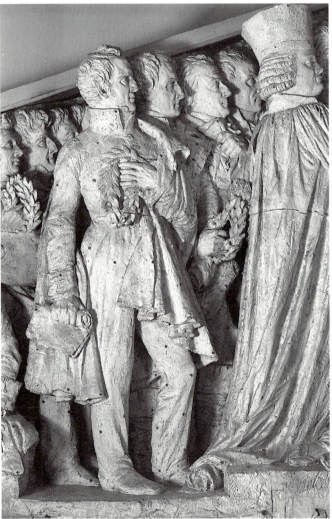

85. *Pediment of the Pantheon*, Paris, detail

< 86. *Pediment of the Pantheon*, model in plaster, Angers Museum, details >

merit and was perceived as such.[53] To the right one sees Bonaparte, full-length, and "types" of soldiers of the Revolution and the Empire that are found frequently in popular art and literature of the time. Added to these are several names engraved on the tablet that History holds: three are military (Hoche, Bonaparte, and Kléber) and one is a civilian (Lavoisier).

Is this the specific program of the sculpted sketch dated to 1830 that David implicitly, and Emilie David more categorically, recognized as the choice for the final composition?[54] The composition is difficult to read as a gallery of portraits with the exception of the figures in the foreground, Malesherbes and Manuel. It is

difficult to ascertain how the fluctuating reputations of the individuals represented in the pediment related to David's own intellectual and political evolution during the first half of the 19th century. Did he intend to include Lafayette in the background or even Cuvier as early as 1830 (fig. 86)? Both were still alive at this time and he would have chosen them in spite of his frequently avowed reluctance to depict living individuals in an apotheosis. The few drawings that can be related to the genesis of the pediment sometimes include inscriptions such as: "I will insert the painter David. There will be a surgeon of the army, one should represent the young Barra. Poussin and Lesueur will be on a plane further away; they will already have a wreath on their heads."[55] In another drawing only the names of the Generals Kléber, Desaix, Hoche, the scientist Berthollet, and Napoleon appear inscribed. Rumors later circulated concerning the inclusion of Bonaparte who is difficult to recognize in the sculpted sketch and in several drawings.[56] Finally, David's notes and his correspondence reveal very little about his preferences and nothing at all about the elaboration of the program. It is hard to imagine that he was interested primarily in the expression of historical truth. When he hesitated about the authenticity or priority of merits of great individuals in other works he asked his friends for advice. In the Pantheon pediment, the variety of individuals that he thought about including or finally did represent seems above all to express personal preferences. In 1837, those who condemned the pediment were unanimous in emphasizing the "incoherence" of the image and they stressed with equal vigor the errors of David's judgment concerning his selection of the individuals represented. His notes attest to his instinctive and often overzealous admiration for great individuals. For example, he did not speak of the Malesherbes whose memory was honored prominently by the Restoration government. In the pediment he depicts the pre-Revolutionary advocate of individual liberty during the Enlightenment, rather than the septuagenarian defender of Louis XVI. One wonders if he at one point considered representing Bossuet on the pediment. He mentions once in his notes a project for a statue of Fenelon and Bossuet "enlightened by Religion." He speaks of Fenelon as a "kind man" who could be brought "closer to people."[57] Sometimes there were personal reasons for his choices, inspired by relationships he had with his friends, the sons of several figures he honored such as Carnot or Larrey, "the surgeon of the army."

As a result of numerous visits to former members of the Convention who confided in him and whose medallions he made, he formed judgments which he later recorded about their past. What he learned of these individuals influenced his judgments. For example, around 1831, he noted that Levasseur de la Sarthe told him that he perceived in Carnot, "the most honorable man of his time,"[58] a judgment with which David would concur.

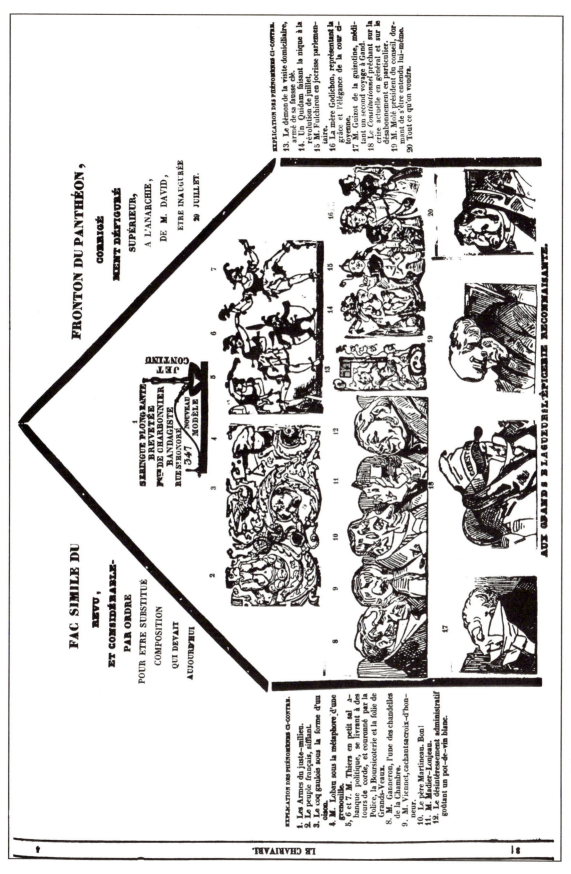

87. Caricature of the *Pediment of the Pantheon*, from *Le Charivari*, July 29, 1837

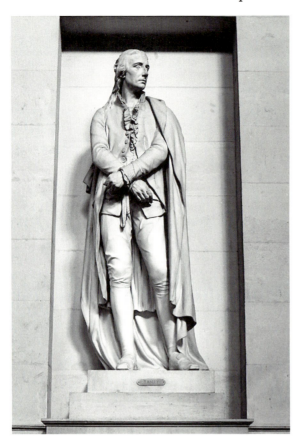

88. Jaley, *Bailly*, statue, marble, Paris,
Chambre des députés

With the exception of Fenelon, all the figures of the pediment belong to the 18th century. Voltaire and Rousseau are judiciously presented as predecessors. Back to back, their effigies are brought together Janus-like. As for the others, most had sat in the Revolutionary Assemblies and by this act their genius or virtue contributed to the service of the nation—this fact unites them. Two, however, died on the scaffold. How far did David go in his apology for the Jacobin government? This was the period in which his colleague Jaley completed a governmental commission for the Chamber of Deputies in which he depicted Bailly as Christ, with hands tied, being led to his death (fig. 88). But what did David think of violence in politics? He did not condemn the excesses of Jacobin radicalism, for he placed the necessity of action and the moral virtues of men above these excesses. He remarked that Jean de Bry had told him that "... Danton who was said to be so cruel, after having decided on his great coup of September [1793], gave passports to men who were nevertheless his enemies, including Etienne Dupont."[59] In 1832, David noted:

"A powerful plough is necessary to fertilize long uncultivated earth in which, consequently, an infinity of useless plants have grown with deep roots. It breaks, cuts and pulls out all these plants; sometimes young, beautiful, modest flowers are victims sacrificed to general interest. Robespierre, Marat, Danton, etc. have acted as a plough."[60] Certain drawings have survived, sometimes in a very advanced state, which depict scenes that would later interest sculptors, such as *Robespierre Wounded*, "in the room of the Committee for Public Safety" (figs. 89, 90). Other drawings record ideas for statues, especially for Carnot and Danton (fig. 91). These were projects that David knew he could never realize during his lifetime, no matter what changes might occur in political regimes (such monumental programs would only be realized at the end of the 19th century). He executed several portraits of these figures, however, in medallion form which did circulate.

In concluding the discussion of this project, an emphasis should be placed on the general meaning David wanted to convey in the Pantheon pediment which adheres to an allegorical structure. The pediment composition does not constitute a completed, axiomatic apotheosis. Rather, it remains imprecise in its didactic functions because it is difficult to discern the identity of the individuals depicted in the background. The meaning of the composition is rather to be found in the effigies depicted in the foreground. These individuals, a few representatives of the architects—thinkers and men of action—who prepared and realized the revolution that regenerated France, are reunited in a clear, simplified, synoptic vision. David achieved this clarity through the choice of individuals who, by virtue of their passions and meritorious commitments, teach a civic lesson. Many considered intolerable the presence of several "undesirables" on the pediment of a church, others expressed reticence concerning the worthiness of those depicted, and the image of the compact group of cohorts of the Revolution united around the Motherland (La Patrie) led to a widespread general outcry. This denunciation was often supported by the Church which demanded an expiation.[61] Many also denounced what they perceived to be the incoherent, incomprehensible conception of the work, which did not depict a specific vision of history. Added to this was a coarse, disconcerting, primitive style, and an unacceptable juxtaposition of allegorical and historical figures (a subject of much debate in the theoretical discourse throughout the 19th century). All these objections and observations demonstrate that David had reversed the traditional means of representation in monumental sculpture.

In order to explore fully the personal, poetic resonance of this work, and in so doing to complete the study of its function as an important public image, it would be necessary to take into account David's personal life which his writings (the corollary of his realized art) help to clarify. As has already been observed, David's actions were motivated by his obsession to live and think in the proximity of the

89. *Robespierre Wounded*, drawing, Angers Museum

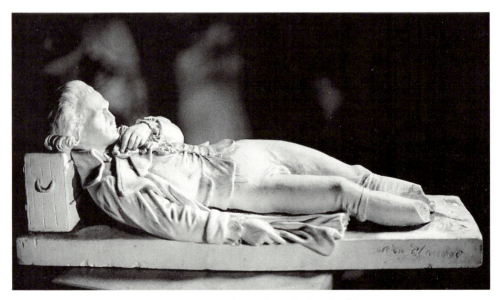

90. Claudet, *Robespierre Wounded*, statuette, plaster, Lons-le-Saunier Museum

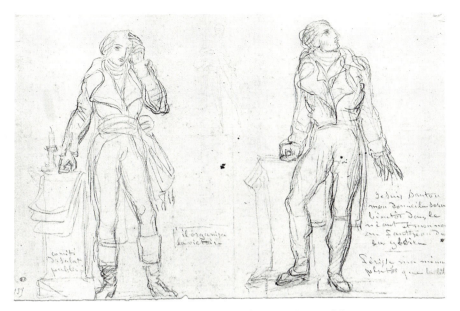

91. *Project for a Statue to Carnot and to Danton*, drawing, Angers Museum

example of the "great man." This obsession led him, both personally and artistically, to consider successive "great individuals" as role models. These individuals, for David, made up the fabric of history, and occupied every moment of his daily existence. His anguish concerning the judgment of posterity about his work and his conduct led to an extraordinary meditation on artistic creation.

An excerpt from a text gives a clear idea of the tone and the content of his rich reflections. Known through diverse drafts, this excerpt recounts an episode that David dates to the genesis of the Pantheon pediment (the multiple versions suggest that David was not merely interested in recording a simple biographichal incident):

> One night when I was working in my atelier, my lamp projected on the ceiling the shadows of busts of the great men of Antiquity, which decorated it. My eyes closed. Little by little my imagination identified itself so completely with them that I believed I saw them descend into my atelier. I saw the virtuous La Revellière-Lépeaux, he smiled at me with kindness, he spoke to me about the good he would have wanted to do if circumstances had not distanced him from the government. What nobility in his features! How his energetic and calm soul was well portrayed there. . . . Boulay de la Meurthe came with his scowling look. He circled around La Revellière who gazed at him with the calm of a man whose conscience is pure. Boulay tried to explain his political conduct through specious arguments. I saw La Revellière who

went off solemnly, making a gesture with his hand that seemed to say, I am sorry for you, but leave me alone, our minds were not made to understand each other. He went to take the arm of General Hoche of whom he had always spoken with great admiration. Then Grégoire appeared—this handsome, great, noble old man, the Las Cases of our epoch. He was conversing (with the warmth for which he was well-known) with Merlin de Douai, Merlin de Thionville, Barère, Sieyès, Danton, and Robespierre. The conversation was so animated that Goethe, the Hercules of modern literature, and Chateaubriand, whose powerful head brings to mind the Revolution, with its grandiosity, storms and heartbreaks and whose face bore all the moral physiognomy of our epoch—and Hugo, Lamartine, Béranger, Fenimore Cooper, and a crowd of others, felt obliged to form a circle around them. All these men of the first Revolution appeared to me to be of gigantic stature. What all these great men said to me seemed sublime, seemed to clarify many obscure points, but to record them here would necessitate the pen of Lord Bryon.[62]

CHAPTER 5

Indirections and Directions

T HIS concluding chapter will address varied and unexpected facets of David's
oeuvre and will focus on his ways of thinking about and making sculpture
that reside principally in the interstices of his commitment to public art. Thus, to
complete his artistic profile, a lesser known David will be considered. With regard
to these new points we will continue to consider the way in which David's ideas on
art and on sculpture concur with or diverge from those that were current during
his epoch, and whether they emanated from the artists of his generation or from
those of the younger generation whom he encountered during the final years of his
career.

After his commission for the pediment of the Pantheon, David pursued and
reaffirmed the meaning of his public art in the large images of the *Grands Hommes*
which were destined for the education of the masses. It appears that he felt the need
to restate his ideas, a quest that resulted in a rich series of about fifteen monumental
works commemorating the *Grands Hommes* (most are dispersed in the French prov-
inces). These works, in which major aesthetic, political, and social ideas were at
stake, revive earlier formulas for the statue and historiated reliefs—whenever fund-
ing was possible.[1] David obstinately sought and often solicited the commission for
these works (he was consistently reproached for this) as if this initiative sanctioned
the first stage of an urgent social mission he had to fulfill. He refused to commem-
orate certain individuals and sometimes was unable to erect monuments to those he
wanted to honor (he often recorded his efforts in this domain). For example, he did
not succeed in erecting monuments to Eustache de Saint-Pierre, Louis David,
Denis Papin, Lafayette, or Geoffroy Saint-Hilaire. In his completed monuments,
he employed diverse stylistic modes in order to represent the manias and passions
that animated the great individual. His idiosyncratic emphasis on expressivity of
pantomime and physiognomy are virtually unique in monumental sculpture of the
1840s and 1850s, and can be likened only to a very few examples in the works of
Rude and Préault.

In addition to his innovations in the monumental figure, David transformed
the genre of the relief. In the relief, he composed remarkably ample yet simple

images. He employed a multiplicity of figures to express the visual opulence of an event, yet with a simplicity of form akin to folk art. David considered the relief to be an "image d'Epinal" transposed into sculpture. He admirably united the principal narrative with subsidiary events by emphasizing simple compositional solutions and employing accentuated contours and flatness. These images express an indelible and hieratic vision of history.

The compositional formula is admirably realized in the large relief that David completed in 1835 for the vault of the Arc de Triomphe at the Gate of Aix (fig. 92) in Marseille. David was responsible for the iconography of the monument, a commission that he shared with E. Ramey. Work on the program was begun in 1831. Ramey executed the *Return of the Soldiers after the Victory* and David was responsible for *The Motherland Calling her Children to the Defense of Liberty* (figs. 93 and 94).[2] In David's composition it is the children of Provence who answer this call. This constitutes a civic variation of the subjects Moitte proposed in 1799 for the decoration of the Senate, namely, the representation of the Law of Conscription of 1798, a heroic step for the nation.[3] In the Marseille relief, David chose the popular, Revolutionary origins of the subject, thereby prefiguring Thiers' program of the 1830s for the Arc de Triomphe de l'Etoile.

Even though David's relief was related to contemporary genre painting and military painting in terms of format, dimensions, and subject, its style was antithetical to the illusionism of painting. In fact, David repudiated what he called the "lie of art," that is, a scenographic and perspectival vision. The sculptor denounced Renaissance perspective in pictorial representation as a screen that impedes vision and prevents the viewer from perceiving nature directly. He understood perspective as a violation of naive vision, a strait jacket imposed by force on nature and on sight. Perspective for David was a formatting device that was perhaps a paradigm for art itself. But in relief sculpture, perspective makes the viewer's immediate, unimpaired apprehension of the object impossible. And this immediate apprehension of the object was, for David, the essence of the art of sculpture. Thus, by eliminating the representation of illusionistic space, as well as the source and effects of light in the relief, David consciously deprived this genre of the intellectual and optical refinements that he believed sculpture could not tolerate. He severed it, in fact, from the attenuations of expression that he believed resulted from pictorial illusionism.

The majority of David's monuments of the 1840s represent the apotheosis of the *Grands Hommes*, with images of their accomplishments depicted in relief on the pedestals in a consistent style. Even the most favorable critics viewed the stylistic canon of these monuments as an aberrant and obdurate deviation from the norms of verisimilitude and taste. The artistic originality of these works results from

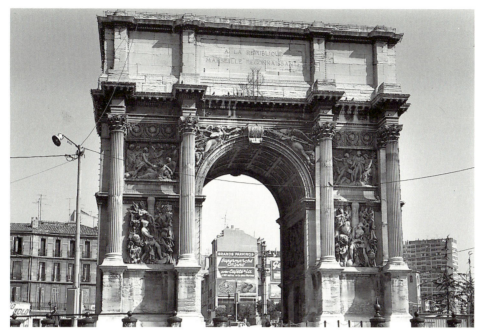

92. *Arc de Triomphe*, Marseille, Porte d'Aix

David's pronounced efforts to take expression to its ultimate limit. He rejected the ornamental and the superfluous and developed a style that borders on caricature in the broadest sense of the term, i.e., an acute observation of the essential. The elements of its artistic syntax can be easily identified. For example, in the statue of Cuvier for the Museum of Natural History (figs. 95 and 96), the naturalist probes with his finger the large open crevice on the surface of the globe. One is not surprised to see that his finger is placed in the center of Africa. While the raised right hand signifies discourse and communication, the simultaneous, pronounced gesture of the left hand that leans on the globe makes specific the meaning of the discourse. Another example is provided by the *Monument to Pope Gerbert* at Aurillac (fig. 97). In this work, three elements contribute to the iconology: the figure, the pedestal, and the inscription. This is a traditional formula, certainly, but one that is strengthened by the hierarchical clarity of the elements. The pedestal for *Pope Gerbert* was particularly significant for David. He studied the proportions and placement of the monument on the specific site with the architect, Achille Leclère. From two sides the monument is seen against the virginal nature of the mountains of the Auvergne. The pedestal is more prominent visually than the statue itself, which appears to be almost an ornament. In the order of expressive priorities, the inscription follows the pedestal in importance. David wrote startling comments

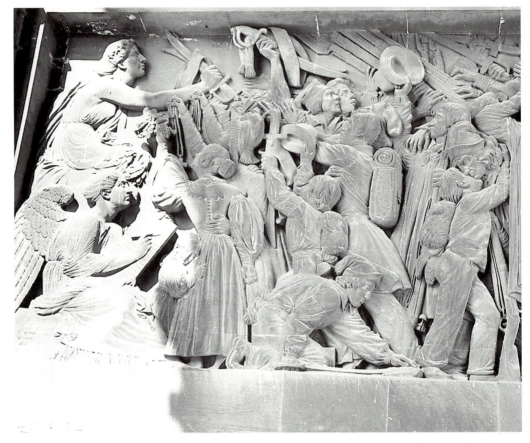

93. *The Motherland Calling her Children to the Defense of Liberty*, relief, stone, Marseille, Porte d'Aix

concerning the nature and function of these distinct elements of the sculpted monument. In the 1840s, during one of his frequent trips to the Pyrenées, he wrote: ". . . the statue of Geoffroy Saint-Hilaire comes to mind, in seeing these majestic mountains that appear to be pedestals erected to naturalists. I thought that it would perhaps be good to compose the pedestal of G. Saint-Hilaire in this manner—four sphinxes for the base, in memory of the Egyptian campaign—and also the symbol of the art of divining; above this, the antediluvian animal fossils and tropical plants that through their shapes could represent types of capitals; finally I should give an idea of creation in the composition of the pedestal, it is an idea to seek, in order to get rid of these eternal moldings that express nothing; the true monument is the representation of the man; I believe that in analyzing this idea of the pedestal one could attain plastic poetry. At the present time I must find the idea that will make specific the great and profound system of analogies that recommends the naturalist to the admiration of men."[4]

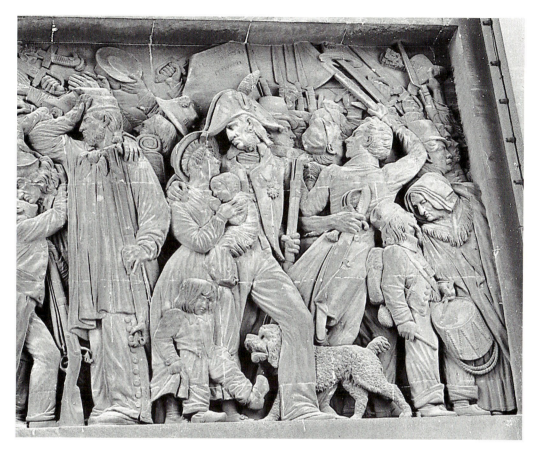

We have already seen that the inscription of a name on the monument is an important sign whose meaning involves the profound, unitary reading of the work. David often questioned the mimetic function of writing, relating it at times to actual experience: "Very often in copying writing and the forms of the letters, seeking to make a facsimile, *I have felt the impressions* [crossed out] of a woman whom I loved, I have felt the sensations of happiness that it is impossible for me to express."[5]

David's choice of expressive effects in a statue are dictated by diverse factors that vary according to the individuals being commemorated. The figure of Pope Gerbert (fig. 98), for example, is characterized by a grandiose gesture and deep drapery folds in the costume. In other cases, simplicity, equipoise, and reserve constitute the principal characteristics. In all of the colossal figures and portraits the expression of physiognomic traits is pronounced. David, it seems, wanted to summarize the character of the individual represented by exaggerating the elements of

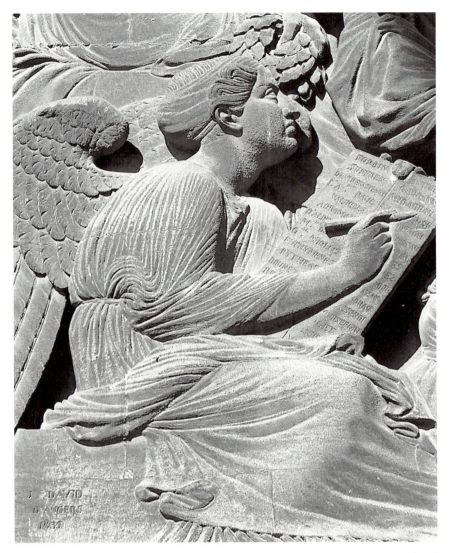

94. *The Motherland Calling her Children,* . . . relief, stone, Marseille, Porte d'Aix, detail

facial structure. An avid proponent of physiognomy, David constantly alluded to this subject in his writings and in his criticism. To a greater extent, perhaps, than any other artist of his generation, David practiced what he called "the language of phrenology." He used phrenology as one of the foundations of a vast semiotic system, based on his artistic response to the morphology of man and nature. This led him to esteem Humbert de Superville's important *Essai sur les signes inconditionnels dans l'art*, which he described as an "admirable work. . . . It is a work filled with new, profound, and philosophical ideas; the erudite world must certainly register it

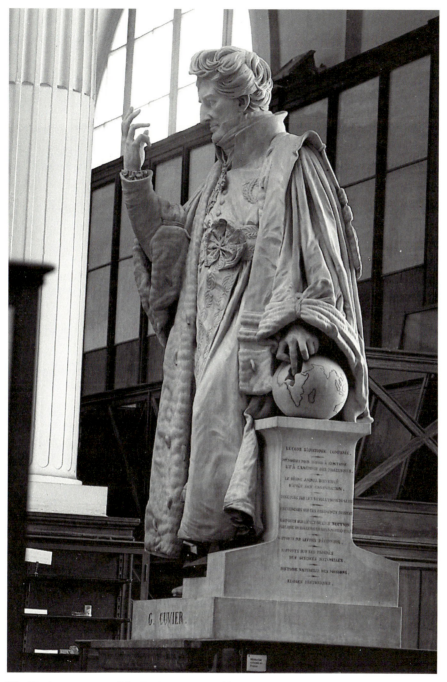

95. *Cuvier*, statue, marble, Paris, Museum d'histoire naturelle

with the small number of those works about which there can be no dispute, your luminous system depends on too decisive grounds."[6] In David's time phrenology provided a unitary explanation of the phenomena of universal life, as well as a privileged means of educating and guiding the artist to essences. In the 1840s, David's historiated reliefs emphasize phrenology and thereby give renewed importance to the visage of man.

Other aspects of the *Monument to Gerbert* are of interest. In composing this work David confessed that he first looked to images that he found in populist literature,[7] images transmitted in popular biographies and in street pamphlets (canards), and through the oral tradition of populist laments:

> It was a poor shepherd
> Born of poor parents
> Who, barefooted on our mountains
> Guarded cattle and sheep
>
> One evening it was beautiful
> There in the darkening night
> Wrapped in a long cloak
> He was watching the moon
> When an abbot passed by
> Who, without a sound, accosted him.[8]

In one of the reliefs from Gerbert's monument, David depicts a remarkable image of a landscape with mountains and of a tree sculpted in minute relief with splendid details of its foliage (fig. 99). One would expect that David would only tolerate in sculpture the representation of the human figure. In his writings he condemns outright French landscape painting of his time. It is remarkable that David was the only Frenchman in the 19th century who owned paintings by Caspar David Friedrich (three landscapes) and by Carl Gustav Carus (at least one).[9] He recorded enthusiastically, and in detail, his perceptive impressions of the drawings and paintings of Friedrich after he visited him in 1834. This visit alone was a mark of interest unique for a French artist of the 19th century. Before this revelation of "the tragedy of landscape" that he experienced in Germany, he recorded in his notes the blot-like effects that he recreated in a description of painted landscapes. None of the French landscape painters of his time would depict the elements of nature he described or the emotions that animate them: "A brisk air, penetrating, like a piece of steel that is applied to your skin, a pale sky, of a color which does not resemble any color and which it is impossible to compare to anything, impossible to define, clouds that do not have the shape of clouds that one is used to seeing, they resemble

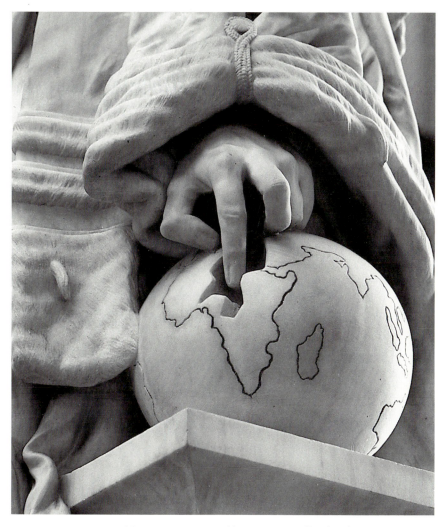

96. *Cuvier*, statue, marble, Paris, Museum d'histoire naturelle, detail

strokes of a brush given by chance by a *barbouilleur* to clear his brushes, a light red line at the horizon, a sluggish vegetation, trees without leaves whose black branches will make one think that a fire has been there; how this painting would render well the epoch when the world will grow cold again, like an old man dying little by little. Near *La Flèche*, 15 February 1831."[10]

Although landscape elements do appear in David's reliefs, the human figure certainly predominates. The extraordinary canon of proportions David employed in his reliefs in the representation of the human figure cannot be explained through deformations dictated by optics, as might be seen in a sculpted pediment viewed *da*

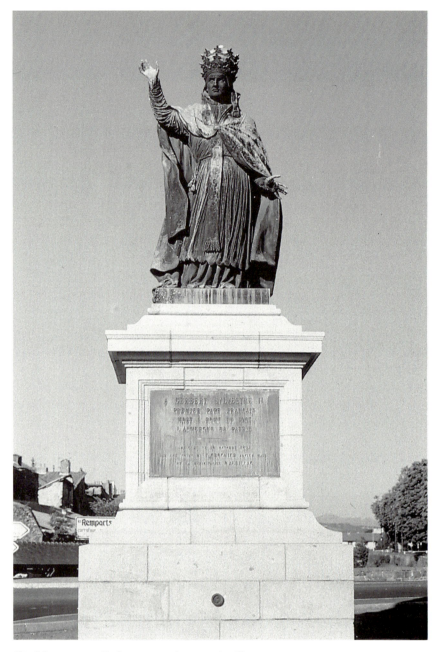

97. *Monument to Gerbert*, statue, bronze, Aurillac

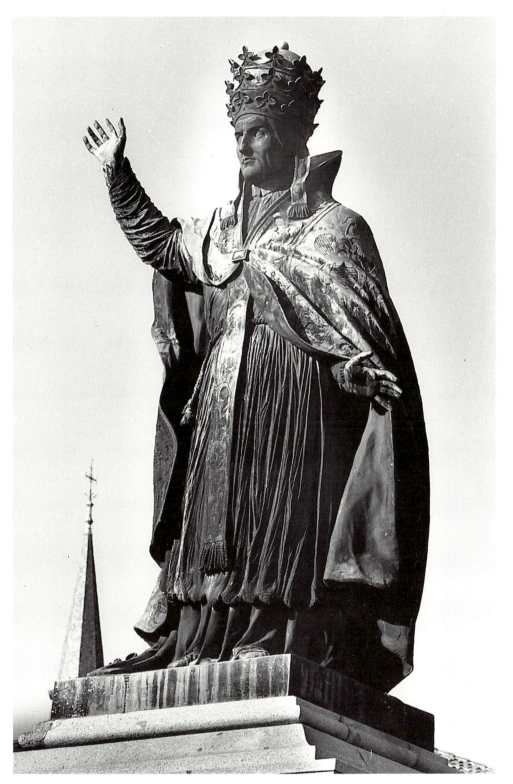

98. *Monument to Gerbert*, statue, bronze, Aurillac, detail

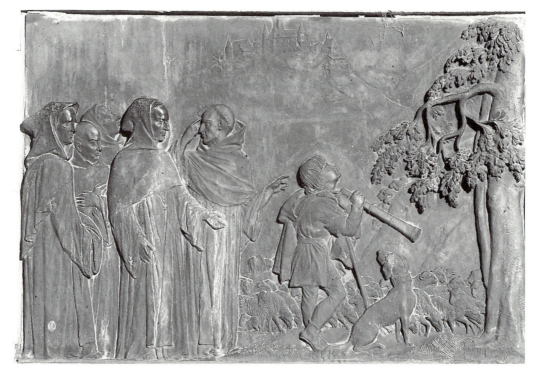

99. *Monument to Gerbert, Gerbert as Shepherd*, relief, bronze

sotto in su. The reliefs of *Pope Gerbert* (fig. 100), composed as a Panathenaea and characterized by a great hieratic dignity, reveal a remarkable reconstruction of the human figure. The critics of David's time consistently confess an inability to understand such depictions. In this relief, David rejects completely the anthropometric theories of the archaeologists and theoreticians of art of the period who asserted that the ideal human type, in the northern climate, was identical to that found in the most harmonious antique statues. He follows instead the ideas of modern physiologists (whom he had read closely) concerning organic growth. Thus, for David, the child and the nubile woman were objects of privileged observation. And the rapport between the size of the head and that of the body accepted by his contemporaries, which was based on a geometric given, was repulsive to David. Sculptors oscillated between a canon of proportions based on seven-and-a-half to nine times the size of the head. David sometimes reduced this canon, in his reliefs, to an remarkable module close to five.

David's historiated reliefs and heroic battle-reliefs completely disconcerted his contemporaries. The *Monument to the Military Surgeon Larrey*, erected in the middle of Paris at the Val-de-Grâce, presented such a seditious example that it was

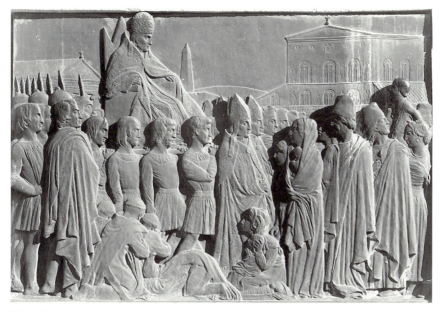

100. *Monument to Gerbert, Gerbert Pope*, relief, bronze

forbidden, as the critic Gustave Planche stated, "for criticism to remain silent."
One can easily see what was denounced. In the figure of Larrey (fig. 9), David
exaggerated the physiognomic traits, not respecting the traditional canon in the
representation of the body—in this case, the body is six-and-a-half times the size of
the head. In the reliefs, which represent landscapes, he used multiple planes in
compositions that appear to be sketched rather than completed. The four reliefs,
depictions of battles in which Larrey distinguished himself, are filled with multiple
actions composed of small groups that are distributed in a loose manner. The irreg-
ularity of the topography determines the irregularity of the composition and the
groups within them. The relief representing the *Battle of Somo Sierra* (fig. 101), for
example, is legible only if it is read as a series of fragments. In this relief, David's
contemporaries noted that the spectator experiences one of the great themes of
Romantic *terribilità*, a variation of the story of Count Ugolino, whose vengeance is
eternalized in *The Inferno*. This vision of hatred, presented in the relief in abbrevi-
ated form, provides but one of the numerous permutations of the Dantesque epi-
sode that haunted the artistic imagination in the 19th century. Two figures, like fat
insects, couple monstrously; the Spanish soldier devours the neck of the French-
man fallen beneath him in the dust (fig. 102). The representation of space is just as
remarkable as the heightening of the dramatic effects. David does not use Renais-
sance perspective space, instead he uses views or vistas through "aspective" vision;

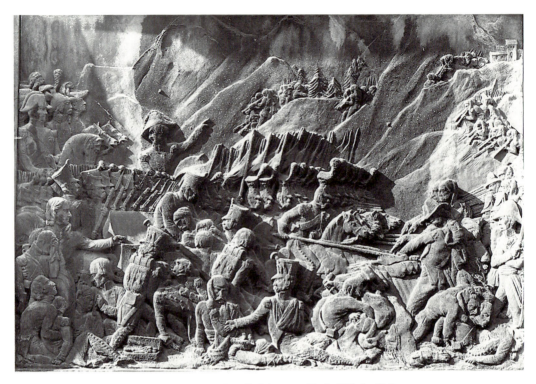

101. *Monument to Larrey, Somo Sierra Battle*, relief, bronze, Paris, Val-de-Grâce

102. *Monument to Larrey, Somo Sierra Battle*, relief, plaster, Angers Museum, detail

that is, he stacks the principal planes one on top of the other and overlaps figures and objects without reducing them according to their scale. David attempted to create a naive, brutal vision whose simplicity would strike the eye and the memory and whose conventions the child, the illiterate, and the working classes could understand. This primary, elemental system of representation is the vector of the social and didactic functions that David assigned to sculpture. Few examples of such innovations in the relief can be found in the works of other sculptors who were interested in this genre in the 1840s. One must turn to those rare artists who accepted caricature and were indirectly inspired by it in works of "high art." One example can be found in the surprising polychrome decoration that Dantan the Elder executed in incised, depressed relief in the *Tomb of Admiral Dumont d'Urville* (fig. 103) (the composition was drawn by Constant-Dufeux). The artist's intentions were certainly serious for the work concerns the commemoration of the salient episodes of the life and death of the great navigator. It is definitely comparable to David's vision in its crude effects, in its use "of images that speak to the eyes." One might think that Dantan, in his attempt at simplification, actually impoverished the illustration. This is certainly not the case, for he monumentalized the episode by making it into a large picturesque epigraph.[11]

David's writings demonstrate that he had reflected at length on the forms of this "primitive" vision. He drew examples from a wide spectrum of possibilities. Thus, he chose historical, well-known works as well as those that were marginal.

103. Dantan The Elder, *Tomb of Admiral Dumont d'Urville*, relief, stone, Paris, Montparnasse Cemetery, detail

He used Assyrian, Egyptian, Roman, and Romanesque relief, as well as other forms of sculpture, writing, or "crude" graphics—namely, the drawings of children and the insane, in addition to graffiti. He copied excerpts from his readings and investigated the sculpted monuments of Easter Island and the sculpted prows of Tahitian canoes. He looked closely at the ancient sculpture of Brittany and at the Christs "dressed in muslin" in Spain. He praised at length the art of contemporary artists who incised in alabaster or ivory or modeled in clay small "realist" subjects, such as those executed by Graillon in Dieppe (fig. 104) (he accepted this artist into his atelier in 1837). David saw in Graillon's works: ". . . almost all small masterpieces of naïveté, these are scenes from the private life of the people. . . . Everything is reminiscence for this man, he makes a portrait of a being without the subject's awareness of it, that is what makes him find the fortuitousness of nature; it is an intellectual daguerrotype; he says that if his model would pose for him it would confuse his ideas and he would not be able to do anything. . . ."[12]

In order to understand better David's ideas, it is necessary to read closely multiple passages from his writings, his correspondence, and his notes. These recursive writings are characterized by a profound self-reflexion; they reveal a complex nexus of interwoven ideas which form a captivating design of rephrasing and reiteration. David's obsessions, his anguish about the artist and art, can be found amidst many remarkably perspicacious perceptions and judgments. There is not one important question related to European Romantic ideas concerning art that David has not touched upon, directly or indirectly, in his writings. Personal experience is always present. In addition to observation or the notation of an anecdote, David posits personal experience as the foundation of his discourse. The following example can serve to illustrate this method (as noted earlier, David sometimes writes of himself in the third person): ". . . while making the model of the trophies of the Arc de Triomphe at Marseille, a spider who seemed to have taken his residence behind a helmet that was part of this bas-relief, came near him for hours on end when he [David] was singing. Well, when it came to cast this model, he made unheard of efforts so that it [the spider] would not be suffocated by the plaster and when the attempts to find it had been unfruitful he experienced a veritable sorrow. This man is brusk, irascible, but he has a very loving heart. And yet, he was found *almost dead* (crossed out) one night in Paris, *bathing* (word crossed out) bathed in his own blood, because of a cowardly jealousy caused by art."[13]

It is important to insist on the interest of this type of commentary. David accumulated these notes in vast quantities; he did not rule out the possibility that some of them might be published posthumously.[14] In the course of more than a quarter of a century this dense discourse moves in various directions which, nevertheless, intersect. For David repeats and recapitulates the elements in diverse modes: the journal article; the letter; the isolated note concerning a fact, a memory,

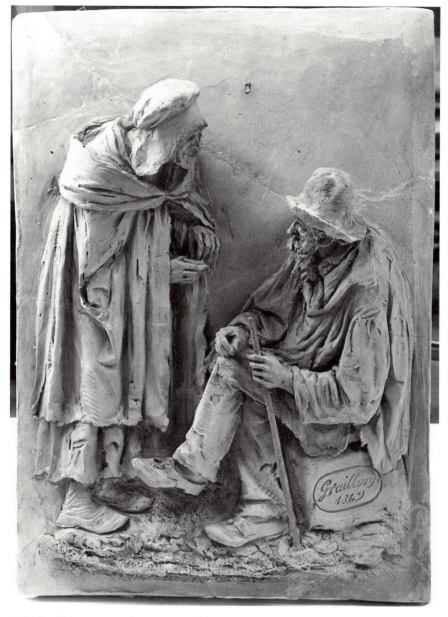

104. Graillon, *Peasants from Dieppe*, relief, clay, Dieppe, Musée du Vieux Château

or a trip; and the intimate diary, which developed over an identifiable length of time. In spite of their fragmentary nature and variety of subjects addressed (narrative fiction, biography, etc, . . .), these writings constitute a singularly unified discourse, a discourse concerned primarily with questions related to art.[15] This ensemble of texts, whether or not David published them, whether or not he even wanted them to be published, reveals a remarkable objective, for everything is related, directly or indirectly, to artistic creation. Today these texts offer to the critical discourse on Neoclassicism and Romanticism, an eminent example of what many artists shared—namely, a sustained meditation on art, realized in the practice of writing, which becomes, without interruption, the transposition of artistic praxis in a complementary register. David's writings, like those of Delacroix, are singularly distinguished from the written meditations of artists during the Romantic period through the quality of his perceptions. But other sculptors, like David, who were recognized early as "thinkers," also understood the importance of writing to their reflexions on art. In this context one sculptor in particular comes to mind— Théophile Bra. The voluminous manuscripts he left and his extraordinary drawings are of great interest. To mention David and Bra together is not fortuitous. Toward the end of the 1820s, David and Bra were seen by contemporaries and circumspect critics as the two sculptors of their generation who sought to think anew about sculpture. They belonged to very different milieus but their efforts to make the art of sculpture express useful, collective values are comparable. Both wanted to return sculpture to moral and religious values. They met one another, incidentally, in the most unexpected manner. Various indications suggest that Bra attempted to assassinate David in 1828. As we have seen, David wrote about this incident. His notes (which were not published by Jouin), as well as Bra's notes, reveal Bra's peculiar state of mind at the end of the 1820s, when he apparently competed with David for the commission of the *Monument to General Foy*. Bra's aberrant mental state, which was well-known, accounts for his murderous intentions.[16] Thus, he wrote: "Here I found myself for the second time in 1838, at the point of killing M. Cartellier—and I could not do it. I have family."[17] The inscribed date of this note—1838—corrects another date that can be read underneath it— 1828. Both dates may be apocryphal. The note concerns the sculptor Cartellier (who died in 1831) and is particularly instructive for what it reveals about Bra's manipulations of his own manuscripts, drawings, and disturbing fantasies, over a long period of time: the sculptor apparently was interested in reconstructing a mythic chronology of his personal history. His manipulations both illuminate and, paradoxically, obscure what his confused manuscripts and drawings reveal. In 1826 Bra was suffering from a nervous affliction and was undergoing a mystical crisis. In the 1830s he was friendly with Balzac, who acknowledged having conceived *Séra-*

phita at Bra's home.[18] During this period the sculptor was affiliated with Parisian circles in which magnetism was practiced. It is important to remember that in the 1830s the theory of animal magnetism was of major interest to the perceptive analysts of Romantic art. Together with phrenology, magnetism was perceived as one of the principal means by which man could recapture the knowledge of himself and of nature; it could, therefore, help to renew art and did so in a fundamental way. Magnetism explained "the mysterious communications of universal life" and phrenology explained "the conciliation of spiritualist and materialist disputes by envisaging man as a unity."[19] The written reflexions of both David and Bra were consistently involved with these two primordial issues. David's involvement is evinced in his obsessional pursuit of an inclusive, unitary understanding of man to which his portraits and medallions attest. Similar concerns are apparent in Bra's development of a religious art (religious in the broadest sense of the term). Towards 1826, Bra recorded the details of his personal and artistic experiments with magnetism by describing, in a prophetic way, the cathartic functions that "automatic" writing and drawing fulfilled for him: "My somnambulism, or, if you wish the spirit that bears this name, works on history, politics, religion. I arise, thus, and mechanically seek pen, ink, paper, place my hand on the page and watch it draw, write. . . . I sense the movement that follows and obey the received impulse. . . ."[20]

Remarkably, Bra's experience of "automatic" expression is recorded in a system of representations. His written discourse—a word or a phrase—which often conveys unexpected incidents from his personal history, unfolds on the page and penetrates drawn motifs; words and patterns combine into a non-figurative sign that is at the same time regulated and obscure (figs. 105, 106). The representation manifests intellectual and emotional experiences and involves, as well, artistic choices concerned with temporal sequence in the depiction of past, present, and future events. This adoption of the procedures of representation for the experience of the self through signs is not, in fact, limited to its use in drawing by writers and artists. One thinks, for example, of the manner in which Stendhal "illustrated" certain of his manuscripts (fig. 107).[21] A striking example is seen in a letter the social thinker Charles Duveyrier addressed to one of his friends in 1832. In it he explains, through a sign, his rupture with the Saint Simonien leader Père Enfantin. The "drawing" (fig. 108) places the proper names (and the individual's political predicaments) in a position of attraction and repulsion and represents the dynamic that results from it. This is a representation, however, that becomes complex, because it is duplicated in two simultaneous projections. On the left-hand page of the opened letter, the sign is superimposed on Duveyrier's letter itself, on the right-hand page it is represented in space, separated from the words of the letter. Duveyrier explains: "Here is my opinion on the dissidents: I am going to draw it for

105. Bra, *Self-portrait as Christ*, drawing, Douai, Bibliothèque municipale

106. Bra, *Drawing*, Douai, Bibliothèque municipale

greater clarity. I do not know why I have this idea of solid cones and why the fantasy comes upon me to trace this figure, but I like very much the one which is next to it."[22]

David's writings and drawings in their goals and impact are very different from those of Bra. In following the meanderings and repetitions of David's discourse, which is fragmentary in nature, one perceives a remarkably persistent reflexion on art. His meditations are founded on an apprehension of the real which is, in itself, unique (and here David diverges from both Delacroix and Bra). This leads the sculptor to a fascinating, holistic, metaphorical reading of specific moments in the spectacle of the visible world that involve man and nature. To cite but one example: "I saw a young child cleaning the lichens that were on the tomb of a woman; it is perhaps a son who seeks to preserve from the injuries of the air the monument that contains his mother's remains, or else a son from a second marriage who effaces the name of the first wife of his father."[23] David's propensity to give free imaginative rein to such narrative developments of a story are certainly confusing. But texts of this nature provide a unique demonstration in the history of the visual arts during the Romantic period, of the way in which images, surging forth from reality, strike the eye of the artist. These images signify their proper object but simultaneously provoke a metaphorical interpretation: they thus provide the source of enriched artistic interpretation and of art itself.

A great deal can be said about David's drawings: his contemporaries knew them to be countless.[24] The great variety of their subjects and styles can be explained by their diverse functions and objectives. Many, for example, are preparatory sketches for executed sculptures, and others record ideas for subjects not necessarily related to sculpture (these are often more difficult to decode). A small number of this latter group belong to an unexpected domain which is alien to sculpture, but which is very close to the fantastic "morbid" imagery of French and European Romantic poetry that David read attentively. These drawings are inspired by strange texts that David recorded in abbreviated form (often in brief jottings) in his writings and his notes, often narratives of obsessions, terrors, premonitions, and dreams. He was apparently interested in such evocations of the macabre. Several annotated drawings are inspired by these images, such as "a man holding the hand of a cadaver. Vampire," a dog digging up a cadaver in a moonlit landscape in the presence of what seem to be spectral witnesses (fig. 109), or the subject found recorded in his notebooks, clarified by an inscription on the drawing: "the assassin and his victim on their coffin. An owl."[25] He represents them as eternally awakened neighbors (fig. 110).

Other drawings belong to a domain adjacent to that of realizable sculpture; these are works of which he dreamed, projects that did not have a commission and which could acquire one only with great difficulty. Here one finds David's ideas

107. Stendhal, *Manuscript of Henry Brulard*, Grenoble, Bibliothèque municipale, detail

108. Charles Duveyrier, *Letter*, Paris, Bibliothèque nationale

expressed in images that evoke projects (if one can call them this) for political statuary, such as those often mentioned in his notes and his correspondence. Thus, the history of the Revolution haunts him. Among other subjects in a series of drawings, he returns to the project of the Convention to commemorate the collective heroism of the sailors of the *Vengeur* (fig. 111) and notes: "Does one believe that the people would not understand the sublime story of the *Vengeur* if they saw it in a public square reproduced in its colossal proportions; this boat almost completely engulfed by waves, and in this spectacle of devotion unique in history, Liberty, leaning on a gun, presses to her heart the nation's flag."[26] He does not specify whether this great idea could be realized in a relief or a group, but it becomes linked to numerous suggestions that he speaks of publicly in his mandate of 1848. This project would be echoed in the more modest works of young sculptors during the 1840s. Auguste Poitevin depicted it in a group in plaster (fig. 112) that he exhibited at the Salon of 1849 (he was unable, however, to ensure it a lasting future by executing it in durable material). At this particular Salon, which was held at the Tuileries, David exhibited only one work—the bust of the Revolutionary thinker Saint-Just.

These drawings lead us back to the issue of the commission of the sculpted work, the ensemble of conditions necessary for the existence of a work destined for a public audience. David thought at length about what this implied for the goals of social art. When it was a question of works that mattered most to him—monumental works—destined for collective experience, David advocated the initiatory role of the democratic State or of groups which, if necessary, would circumvent the State by acting through the powerful means of subscription.[27] He violently denounced as

[157]

109. *Dog Digging up a Cadaver*, drawing, Angers Museum

110. *The Assassin and his Victim*, . . . drawing, Angers Museum

111. *Le Vengeur*, drawing, Angers Museum

frivolous the principle of the private, elitist commission, because it favored an art of the same nature, one linked to the interests of individuals. He thought also that the artist must take the initiative and become his own commissioner. He chose to become one of the sculptors of the time to fulfill this goal which he thought of as a mission. Throughout his career he urged municipalities and associations to undertake the monumental commemoration of their great individuals. His repeated offers for these projects were made known and often denounced. Documents establish that, even when successful, they were not economically advantageous. David's disinterestedness was made possible thanks to the relative ease of his financial situation which was due to his marriage.[28] His strategies occasionally resulted in the public failure of works with political resonance, non-commissioned works, executed in a durable material and then rejected, such as the *Young Drummer [Barra]* (fig. 113) of the Salon of 1839; he had hoped to see this figure exhibited permanently in the Pantheon. These strategies also explain, in part, David's intense desire to create a sculpture gallery at Angers that would duplicate his complete oeuvre in plaster. In addition to personal satisfaction and his undeniable sentimental attachment to his hometown, one can discern more ambitious intentions in this project. As might be expected, David denounced incessantly in his writings the contradiction on which, according to him, the institution of the museum was based. The museum denatures the work of art, especially the public work, by separating it from the natural milieu for which it was created and outside of which it becomes impotent and meaningless. How could David justify, therefore, the creation of a collec-

112. Poitevin, *Le Vengeur*, . . . model in plaster, Fécamp Museum

tion of plaster casts which he recognized as surrogates rather than originals? David considered the collection to be primarily an archive. He could, thus, demonstrate the benefits that result from the democratic commission although the works were artificially concentrated in the restricted space of the museum. David deemed the space of the museum unnatural and, in a sense, absurd, but his own museum at Angers was important because its role was pedagogical. It provided the model of an exemplary municipal institution, not only of art but of civic virtues.

The David museum at Angers was enriched after the death of the sculptor by a large number of drawings that one hesitates to qualify as "projects" for sculpture because they depict works beyond the range of possible realization. Several can be associated with the genre of visionary images, many of which border on pictorial delusion. Throughout the century professional artists, or, more frequently, amateur artists, proposed such ideas to the public mainly through privately published pamphlets, and to the government through correspondence. These ideas were presented as drafted or drawn projects of commemorative monuments and statues of a political nature. To take but one central image from this period, David thought of diverse ways of representing Napoleon. His opinions about Napoleon are very nuanced and changeable, but his notes attest that he had reflected at length on Napoleon's character, on his role, and his image. Thus, after 1832 he imagined

him on the ship *Bellérophon* ". . . leaning on the mast, his head inclined on his hand, in the deepest reflexion."[29] In the examples shown here he depicts him exiled, seated, as though enframed by the stars of an apotheosis, or, alternatively, standing on a cannon (fig. 114). Elsewhere his condemnation of Napoleon is unequivocal: "To paint the epoch of Bonaparte, would it not be provocative to represent the Despot seated on a gigantic mountain, cadavers of soldiers and caissons heaped up beneath him to justify his right to distribute a constellation of thrones for his family; one would see at the base soldiers of the Republic showing him their fists."[30] David was one of three artists who sat on the jury of a commission that judged the competition for the Tomb of the Emperor in 1841. But, along with Ingres,[31] he resisted the decision of the majority to retain from approximately eighty submitted projects (of which twenty-six were submitted by sculptors), those that placed the tomb in an open crypt. In this important debate on the political manipulations of Napoleon's image and of the public monument, he expressed himself straightforwardly and angrily about the meaning of the decision: "The great Napoleon, with all his glory, could not choose his tomb. . . . they chained him at Saint-Helena, on a rock in the middle of the oceans; one had to wait until a small man, very small (Thiers), and the Tartuffe, Louis-Philippe, to have him returned, with the permission of the English, to plunge him into a hole at the Invalides under marble blocks unworthy of modern art, and all of this to satisfy a shabby political idea."[32]

In his assessment of works of art David was concerned principally with the significance of ideas and the immediacy of artistic impact. He reproached Debay for his blunder at Montpellier—Debay had represented Louis XIV, in the open plaza of the Peyrou Parade, pointing with his finger to the neighboring Cévennes mountains "where so much blood and tears [of the persecuted Protestants] had run." He was critical of Rude's *Resurrection of Napoleon* (the original title given to the work), a "private" monument erected to Napoleon at Fixin (fig. 115): ". . . unfortunately, he was not very inspired. The Emperor is lying on a rock enveloped in his cloak in the clumsiest manner. . . . He rests his head (rendered in the most trivial manner), on his right hand and at the same time raises a fold of the cloak above his head, this has the overall effect of a hood of a coach; there are no masses in this figure in the round, it is like a poor bas-relief."[33] In spite of David's criticism, the two artists conceived of their monuments to Napoleon in a similar manner, as blocks, fragments of the world (David also developed his ideas about this composition in his writings). They linked the representation of the effigy to that of its natural pedestal—the celebrated rock at Saint-Helena—in terms of a comprehensive mineralogical and botanical understanding of nature. In Rude's monument the pedestal involves the materiality of the site in history, for the sculptor offers a generous sample of nature; this constitutes a striking innovation in Romantic monu-

113. *Young Drummer [Barra]*, model in plaster, Saumur Museum

114. *Napoleon*, drawings, Angers Museum

115. Rude, *The Resurrection of Napoleon*, group, bronze, Fixin

mental sculpture. Barye, likewise, depicted captivating evocations of nature by representing an animal attached to the earth which determines its behavior. In his *Napoleon*, Rude represents the natural world in a different way because he contrasts real and allegorical elements, including man-made and natural objects such as the rock, the chains, the waves, the air, and the fallen eagle. In several of his sculpted works, David, surprisingly, would value such elements. One is led to wonder how

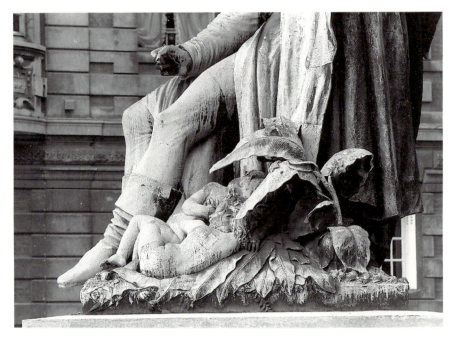

116. *Monument to Bernardin de Saint-Pierre*, statue, bronze, Le Havre, detail

the artist who claimed to restrict sculpture to the human figure alone, could depict the intertwined children, Paul and Virginie, at the feet of the writer Bernardin de Saint-Pierre in a luxuriant and tropical vegetal decor (fig. 116). Similarly, in the *Child with Grapes* (fig. 117), he placed his three-year old son Robert near the grape-vine from which he sucks, and he represented the vine, in the variety of its forms and details of its texture, larger than the child! These sculptures of plants and trees would seem to be aberrations in David's art but they must be understood in terms of their relationship to David's long meditations on the child and childhood in the context of a vast vitalist understanding of the objects of nature. Diverse meanings are blended in the *Child with Grapes*, this complex work that he kept in his possession but which he nevertheless wanted to make public by exhibiting it at the Salon of 1845. Here the exclusive historian of the virtues of the *Grands Hommes* stands aside and entrusts to sculpture a remarkably personal message. This work is related to an observed episode that he transposed.[34] David enriched the episode by evoking ideas debated by contemporary physiologists and theorists of sculpture concerning the development of the being expressed through specific canons of proportions.[35] In this work, David conveyed human growth by associating it with the vine, a generative and fecund element of nature, strongly placed in a prominent position, whose Dionysiac symbolism stood for a vast allegory of the knowledge of nature

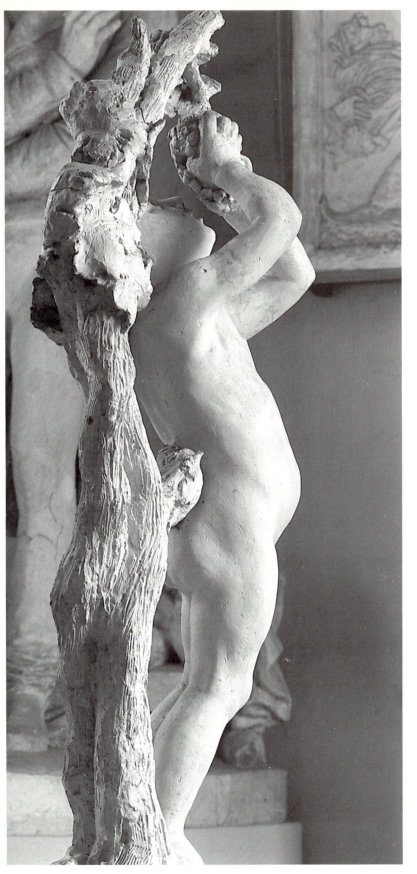

117. *The Child with Grapes*,
model in plaster, Angers
Museum

and its didactic role. Thus, through drawings and a small number of "personal" works, David's art—limited, if considered monolithic and reserved for the cult of the "Grand Homme"—becomes enlarged in an unexpected domain of intimate intentions which he also communicated to the public.

In addition to the surprising variety of important issues that inform them, David's writings present a remarkable cohesion of thought. His meditations on man (his principal subject), art, and history lead to reveries on the structures and behavior of the natural world (which is always close to man—and to art). Thus, he describes the analogies between a mountain and a colossal sculpture of which he dreams. David's writings abound in remarks that describe the organic similarities of beings, species, and the geological history of the globe. These analogies, certainly, are inscribed in the history of earlier mythological and geological meditations developed from Strabo to Nerval that equate the creative powers of nature with those of artists, sculptors of mountains. David envisages, therefore, anthropomorphic and humanitarian subjects. He revives visionary images of never-realized projects imagined by artists of the Revolutionary period; images of monuments erected not only to men but to ideas. David expanded these monuments into spectacular visions which are sometimes outlined in drawings (fig. 118): "Often when contemplating one of these mountains of marble, I sculpted, in my mind, a statue of Humanity. Her head in the sky would have stars for a crown, and this head would lean on a harp held by the left hand of the figure. . . . The great figure of Humanity would have a pen for an attribute which serves to write the code of emancipation. The feet of Humanity would touch the earth. Water would be represented by the torrents that water the mountains; fire by the forges that burn continually to make iron that is extracted from it; the clouds would veil her noble head and would be the symbol of human vicissitudes."[36] At times David respects the work that nature as an artist has created; the sculptor only completes her work: "On one of the mountains that surround Barèges, I saw a large granite rock, placed flatly like those that are on tombs in cemeteries. . . . I thought that this monument would be appropriate for one of those immortal Montagnards of the Convention and the idea came to me to trace the name of Robespierre that I surmounted with a Liberty cap with a star at the summit; several days later I saw that the hand of an enslaved man had effaced this great name. What man traces is too fragile, there are some names that can only be engraved in the mind of humanity. . . ."[37] These reveries of natural, colossal monuments evoke antique sources that inspired many initiatives for monuments planned during the Revolution. And these will not be isolated reveries during the course of the 19th century. In the 1860s, much was written about Préault's project for the transformation of a volcanic peak in the Auvergne into "an acropolis of Gallic civilization"[38]; this was to be a natural Pantheon, accessible by

118. *Humanity*, drawing, Angers Museum

a spiral ramp, with a representation of a colossal Vercingetorix at the summit. Michelet imagined another project that echoed Préault's (which perhaps he knew). He planned a colossal monument to be erected on the Place de la Concorde as evinced in a drawing (fig. 119) and a detailed description : ". . . A great monument of the People . . . it will be the rock of the People, an accumulation of the debris struck down from the towers of the Bastille . . . at the summit, an entrancing

119. Michelet (?) *Project for a Monument to the People*, drawing, Paris, Bibliothèque historique de la Ville de Paris

woman, holding her daughters to her breast, France! with God in her eyes . . . at her feet, seated on thrones, the kings of modern thought, Voltaire and Rousseau first of all. . . . Standing on the projecting promontories of the mountain . . . the two lions of the spoken word, Danton, Mirabeau. Finally, close to the People, the men whom the People loved, all united, holding hands, generals, artists, inventors, writers, soldiers, etc. . . ."[39]

Many aspects of David's art and thought that have been neglected in this study will now be discussed, such as his busts and his medallions—a major part of his production. Several drawings and sculptures the marginality and unexpected character of which require special attention will also be considered.

David's portrait busts are fascinating to study—about one hundred survive. To a greater extent than any other genre in the 19th century, the portrait depends upon paradoxical components of imitation. The paradoxical elements of the portrait—resemblance or imitation of nature combined with or opposed to the idealization of features—were issues widely debated in the discourse on art during David's period and by David himself. These issues involve simultaneous practical and intellectual considerations. For David, as might be expected, the nature of the homage, the personality and merits of the model, and the foreseeable function of the work (which extends from "private" to "public" and monumental usage) influenced style. These elements can only be profitably analyzed in the study of individual cases.

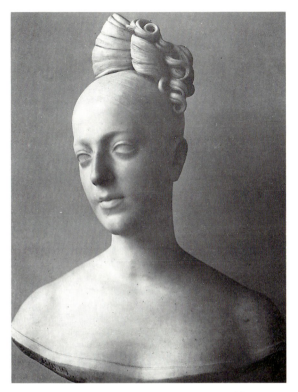

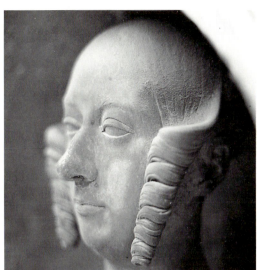

120. Bosio, *Marchioness de la Carte*, bust, marble, Private Collection

121. Dantan The Younger, *Mélanie Heudier*, bust, marble, Paris, Montmartre Cemetery

David eloquently conveys expression when he distinguishes in the model the momentous and accidental from broader, typical, and fictive characteristics. For these reasons his portraits can be linked to those of the most skillful portrait sculptors of the period, Bosio (fig. 120) and Dantan the Younger (fig. 121). David's private portraits are distinguished from those of his contemporaries through an acuity of representation. Lady Morgan (fig. 122) and Mademoiselle Jubin (fig. 123) provide outstanding examples in a variety of media, for the quality remains high even in the transformation of the work from plaster to marble or bronze. His male portraits, because more numerous, are more varied in their stylistic effects. They are more specific in nature and function and more ambitious in resonance. A comparison of two works executed ten years apart, the portrait of the philosopher Volney (fig. 124) and that of Paganini (fig. 125), demonstrates the versatility with which David manipulated diverse modes. *Volney* manifests the choice of generalized features of the model characteristic of Neoclassicism at the beginning of the century. The *Paganini* conveys the extraordinary fascination David felt for an artist without equal. He rarely took the portrait to such a pronounced degree of psycho-

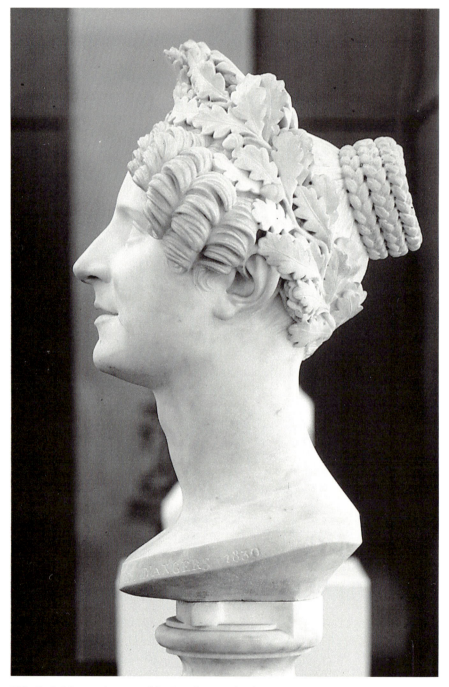

122. *Lady Morgan*, bust, marble, London, Bethnal Green Museum

123. *Mademoiselle Jubin*, bust, plaster, Angers Museum, detail

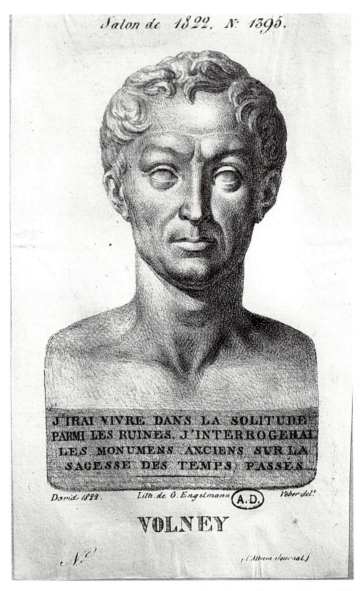

Salon de 1822. N: 1395.

J'IRAI VIVRE DANS LA SOLITUDE
PARMI LES RUINES. J'INTERROGERAI
LES MONUMENS ANCIENS SUR LA
SAGESSE DES TEMPS PASSÉS...

David 1822. Lith. de G. Engelmann (A.D.) Veber del.

VOLNEY

(l'Album Journal.)

124. *Volney*, bust, lithograph, Paris, Bibliothèque des Arts Décoratifs

logical expressivity: "... it seems to me that the soul has a tyrannical power over
this too weak body—he never laughs, he has too much genius.... When I told him
that I wanted to depict him in a bust with his head leaning forward, and to the side,
like a man playing the violin, he told me, yes, because I take from my interior to
impress my exterior."[40] The almond-shaped, inclined pensive head, and the agi-
tated treatment of the surfaces constitute a style that David extended from his me-

daillons to his portraits busts. Learning from his experience with medallions in bronze, he discovered with Honoré Gonon, a famous founder, the potential for incisive expression offered by casting in the lost-wax process.[41] The cast of *Paganini*, cut off at the neck like a study in plaster, appears to be the beginning of a larger bust. The shape and treatment of the face suggest a fragment taken from a portrait. Even more important, the cast provides a captivating evocation of Paganini's artistic creation and genius which is innovatively concentrated entirely in the face.

The medallions and the medals raise issues that are equally fascinating concerning David's intentions as well as the variety of methods he used. Of particular interest is the efficacy of the image achieved through the prophetic use of an extremely precise style of execution. The breadth of this program—more than seven hundred medallions executed during several decades—is as interesting as the sculptor's choice of models and his omissions. The genre of the medallion was popular during this period, but, as one might expect, David placed it at a low level in the hierarchy of genres of sculpture: "Since I have produced several medallions immediately a group of sculptors began to do them, they did not understand that this type of work is nothing for the artist except light chronicle, and that art must be studied in the grandiose; that these are nothing but notes taken from the human face."[42] At first David made these medallions solely for the private use of his models whom he patiently sought out. He quickly expanded his quest to include a great number of his contemporaries (fig. 126) usually whom he knew, and also to a few older, more venerable individuals (fig. 127). Thus, he built a pantheon of mini-homages where the profile view dominates. For David the profile view was the most expressive because it was comprehensive,[43] a summary, as it were, of the individual found equally in the model's signature, which was added to the image. In the model's reproduced signature, David saw an analogue of physiognomy and therefore of character. David left his founders in bronze free to disseminate his medallions, but he attached an importance to this enterprise that led him to deposit regularly examples in bronze at Angers. He also gave to the Bibliothèque nationale in Paris plaster samples from his collection. In the medallion he saw a unique auxiliary of democratic art, a prefiguration of the homage to the *Grand Homme*, such as would be promulgated through currency and postage-stamps: "A long time ago I recorded in one of my writings an idea that struck Goethe's imagination when I communicated it to him: this would be to engrave the features of the illustrious men of France on our currency; thus, money would be ennobled and the biography of the great men would become popular."[44]

David's political medals and medallions, like his political statuettes—for example, *Liberty* (figs. 6, 7, and 8)—are few in number. He wanted them, however, to be available to the public, to such an extent that he authorized an edition of them, published several in the press and allowed engravings of them to be sold.[45] The

125. *Paganini*, bust, bronze, Angers Museum

126. *Spurzheim*, medallion, wax, Private Collection

medallions sometimes depict individuals within a narrative or allegorical representation of either a fortunate or deplorable event. The medallions validate the character of David's art and personality promulgated by Republican critics which is summarized in Champfleury's letter to Courbet of 1870: "I seek and find in the history of French art only two men who were resolutely dedicated to—and had full knowledge of—this art that could then be be called more appropriately than it is today republican art or national art. This was Louis David under the Republic, and David d'Angers under the monarchy. . . . David d'Angers achieved this democratic art for which you have an instinct, but which was latent and not realized up to now."[46]

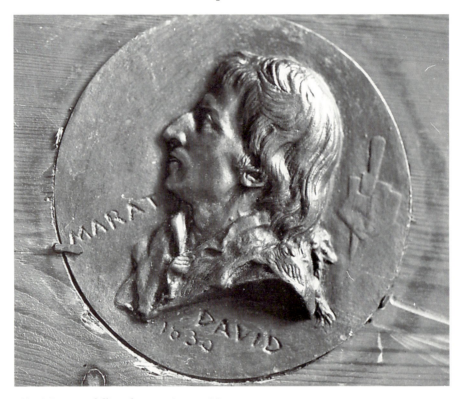

127. *Marat*, medallion, bronze, Angers Museum

A pertinent example is provided by the medal in which David represents the execution of Marshall Ney (fig. 128), an event often discussed by the artist's friends during the July Monarchy.[47] He used the event to question the right and zeal of the State courts to judge political misconduct. He published an account of the event (illustrated with a reproduction of his medal), in which the remorse of one of the members of the squad of executioners is expressed: "The gilded judges of Marshall Ney, richly endowed with power, keep and will keep the most perfect serenity on their deathbeds. It is known, however, that the prosecutor Bellart was so racked by remorse that putrefaction took hold of his body before the end of his miserable existence."[48] David honored the memory of the Sergeants of La Rochelle, who conspired against the government of the Restoration, with the striking image of an axe planted in a chopping block (fig. 129). With the writer Ferdinand de Lasteyrie he planned a monument to these individuals which was never executed because of a failed subscription in 1848 (fig. 130).[49] In another medal he denounced the assassination of the Italian patriots, the Bandiera brothers (fig. 131), a political assassination commented upon by the populist literature that inspired his friends.[50] In his

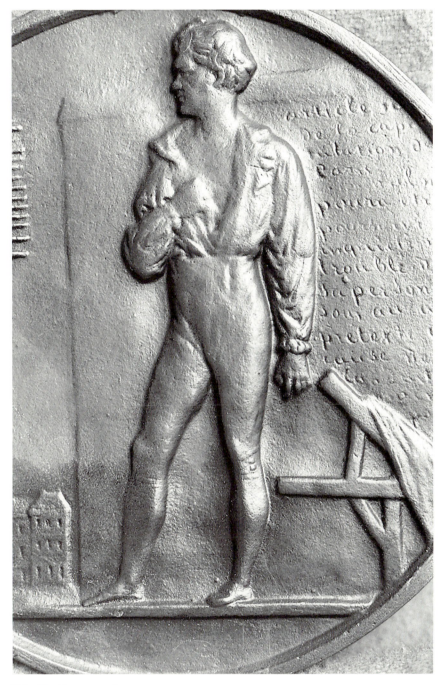

128. *The Execution of Marshall Ney*, medal, bronze, Angers Museum

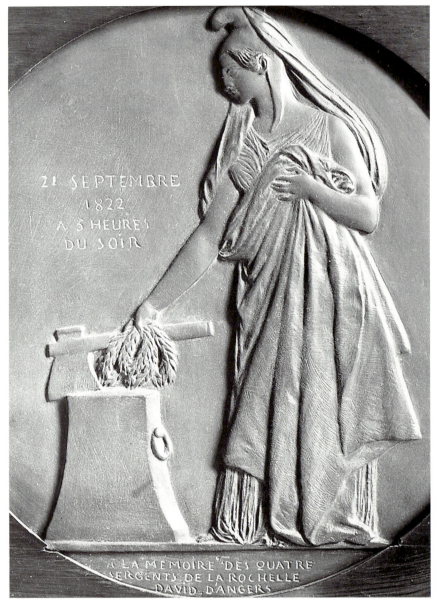

129. *The Four Sergeants of La Rochelle*, medal, bronze, Angers Museum

130. *Project for a Monument to the Sergeants of La Rochelle*, drawing, Private Collection

medals, David was inspired to create powerful images. For example, in one he depicts a figure of *Liberty*—is it Italy liberated or Justice?—which is massive, frontal, and draped, and who lights her torch with the flame of a funerary altar. She is martyred, for her forehead is encircled with a crown of thorns.

This remarkable image that demonstrates the secularization of sacred figures and iconography (one thinks of the humanitarian and revolutionary Christs popular towards the middle of the century)[51] introduces some final remarks which will be concerned again with David's monumental art. The first comment concerns his religious works, a domain that seems at first to be foreign to his preoccupations. In fact, his spiritualist, deist, and evangelist ideas, although strongly anticlerical, are comparable to those of many of his contemporaries during this period. The charac-

131. *The Bandiera Brothers*, medal, bronze, Angers Museum

teristics of his religious ideas can be easily identified through the perceptions offered in a great number of his texts. His ideas are nuanced and, at times, polemical. He seems to be open to the moral severity of Protestantism,[52] and its emphasis on the direct dialogue between man and God. Only one of his religious works will be mentioned, the *Saint Cecilia* (fig. 132), executed in marble for the Cathedral of Angers, where David had already produced a *Calvary* with three figures. The history of the *Saint Cecilia* is obscure. The work originated in a commission given to David by the Prefect of the Seine for the Parisian Church of Saint-Roch and was exhibited in plaster at the Salon of 1822. Done again for the same church and exhibited again in plaster at the Salon of 1834,[53] it was at that time severely criticized and diverted from its first location. David subsequently executed it in marble and offered it to the Cathedral of Angers. We are familiar with this prolonged genesis of nearly fifteen years thanks to a sketch (fig. 133) which refers without doubt to the work of 1822, and through drawings that reveal the diverse ways in which David conceived of religious sculpture during this period.[54] The final state of the *Saint Cecilia* exemplifies David's original approach to Christian art. He had recognized in Gothic sculpture an art "that conveys most profoundly a type of most intimate

132. *Saint Cecilia*, engraving by Leroux, Paris, Bibliothèque nationale

133. *Saint Cecilia*, sketch in clay, Private Collection

conviction."[55] If we compare the *Saint Cecilia* with works of his contemporaries, for example, with Cortot's *Saint Catherine* of 1824 (fig. 134), we find that David created sinuous and fluid effects which express the moral and meditative character of the figure. A biographical dimension is added to this figure since the *Saint Cecilia* is also the portrait of a beloved friend of David's (fig. 135). David created this work at a time when the erudite, classically inspired discourse on religious art expressed a desire to "baptize Greek art." In this discourse, Gothic naturalism was considered aberrant and foreign to what was seen as the stylistic and semiotic continuity of classical art. In fact, the imitative and symbolic characteristics of religious art from antiquity to Raphael were seen as consistent and analogous.[56] David, by privileging the Gothic style, rejected these ideas. By personalizing Saint Cecilia, with her emaciated body, David refines her expression of truth, naïveté, and exquisite emotion—characteristics that a small number of religious sculptors of the period discerned in Gothic sculpture. David's attitude would soon be shared by the medieval archaeologist Didron, for example, who spoke to artists about the art of the Middle Ages. Religious sculptors, contemporaries of David, are today forgotten and neglected and the majority of their works have disappeared. One of these works was noted by critics who unanimously emphasized its novelty[57]—Bion's group surmounting a font, the *Pope Saint Alexander Instituting Holy Water* (fig. 136). This composition was also exhibited at the Salon of 1834. Both Bion and David were more than merely inspired by the fantastic naturalism and freedom of forms that they perceived in Gothic sculpture. Both artists wanted to renew the iconography of Christian art. During this period, for example, David wanted to offer to the Cathedral of Angers a figure of the *Annunciation of the Virgin* (fig. 137), the iconography of which was so uncanonical that critical remarks led him to abandon the project. David, however, stated: "This young girl and the dove, two beings so pure. . . . This did not appear to me to contradict Christian dogma. . . ."[58]

A final group of sculptures will now be examined that could equally be called religious, if the term is used in its broadest sense, according to David's usage in the 1840s. During this period he was also involved with a specific expressive format in sculpture that had previously been foreign to most of his completed sculpted works. This is the "group," a traditional genre of sculpture, indeed, but one which was rediscovered at the beginning of the 1830s for its expanded expressive possibilities. In the renewal of the group one observes a major aspect of the sculptural innovations of the Romantic generation. The breadth and history of this renewal are difficult to reconstruct, however, for most of the works, executed in plaster and never commissioned after their exhibition in the Salons, were short-lived.

The sculpted group, by its nature an assemblage of figures, was an appropriate genre for the expanding ambitions of sculpture. The group also unites the aesthet-

134. Cortot, *Saint Catherine*,
statue, marble, Paris, Church of
Saint Gervais-and-Saint-Protais

ics of painting and sculpture in a closer exchange of respective methods. A painted or sculpted group implies the representation of a narrative or action, and, during David's time, it was thought of as a depiction of history characterized by a dramatic structure.[59] The narrative and its development could either be summarized in a simple action or expressed in multiple actions. The sculpted group, however, "represents" history in a way that differs greatly from the manner in which multiple actions are read in a painting within an enframed space. It differs as well from the unfolding narrative necessitated by the format of the sculpted relief. The group unites in one image the episode—that is, dramatic content—and temporal sequence. Although the image summarizes the episode and in so doing respects the temporal scope of the narrative, the meaning and impact are nevertheless transposed in a paradoxical manner into allegory and symbolism.

135. *Saint Cecilia*, statue, marble, Angers, Cathedral, detail

136. Bion, *The Pope Saint Alexander*, . . . group, plaster, Paris, Church of Saint Eustache

During the Romantic period, the direct presentation of the "thing itself" (as Diderot had put it) that characterizes sculpture also remained a pertinent issue for painters seeking dramatic and monumental effects. An apposite example is provided by Delacroix's *July 28. Liberty Leading the People*, which was reproduced in a contemporary vignette as a sculpted group (fig. 138) (the frame of the painting has been eliminated). This image can be compared with Barre's *Triumph of Liberty* (fig. 139), one of the first examples of a sculpted group with political resonance. Delacroix's painting and Barre's group were both shown at the same Salon in 1831.

137. *The Annunciation of the Virgin*, drawing, Angers Museum

From 1820 to 1840, the sculpted group depicted an unexpected variety of themes. Allusions to observed and familiar events from everyday life, very often of a political and social nature (figs. 140, 141), were combined with allegory. Sometimes, in fact, the entire subject was transposed into allegory. Innovations in imagery and formal arrangements resulted from new ideas concerning the possibilities of the sculpted group. Young sculptors of the 1830s used the group with confidence and with an acute sense of its expressive capacity to convey ideas about nature, man, and history that had previously been largely ignored in sculpture. Barye used the group in his zoological dramas. Like many other sculptors, Etex, in his

138. After Delacroix, *July 28th*, . . . woodcut

139. After Barre, *Triumph of Liberty*, woodcut

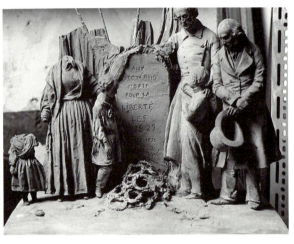

141. Graillon, *Project for a Monument to the Victims of the Revolution of July 1830*, sketch in plaster, Dieppe Museum

140. Chaponnière, *Project for a Monument to the Combatants of the Revolution of July 1830*, sketch in plaster, Musée d'art et d'histoire, Geneva

famous *Cain and his Race Cursed by God* (fig. 142), had been influenced by Neoclassical precedents of the early 19th century which manifested "sublimity" and "terribilità." Typically, these works had been executed in vertical formats with juxtaposed elements placed in pronounced hierarchized structures. Romantic sculptors valued these neoclassical examples as precedents. Thus, in 1830, Foyatier submitted a project in which he proposed to execute in marble, and therefore preserve, Clodion's colossal group, *Scene of a Deluge* (fig. 143), which had been exhibited in plaster at the Salon of 1801. Before its destruction, this group had been barely discernible beneath a portico of the Palais du Luxembourg. Foyatier proposed one of his own works—*Scene of Nero's Burning of Rome*—as a companion piece for Clodion's group and declared that the two groups "seem to have been made for one another."[60] At the end of the 1830s, inspired by the renewal of religious art, Romantic sculptors, who had abandoned the neo-Gothic, became illustrators of the scriptural dramas, historians of the heroic and bloody beginnings of Christianity. If we look at only two works executed by talented artists among the small number of those that have survived, namely Huguenin's *Scene of the Massacre of the Innocents* (fig. 144) and Maindron's *Martyrdom of Saint Margaret* (fig. 145), we see colossal groups characterized by exaggeration in pantomime and expression—qualities typical of this genre. Both were exhibited at the Salon of 1838.

At this moment, David's attitude, vis-a-vis the works of the younger generation of his students, was not entirely positive. He did not blindly endorse subjects and expressive possibilities newly recognized in the genre of the sculpted group. He executed only a few examples and planned several projects which he elucidated in his writings; these works attest to a remarkable imaginative power.

David's writings on sculpture reveal that since the 1820s he had thought about the sculpted group. His first developed response, however, can be seen in the *Monument to General Gobert* (completed in 1847) (see fig. 10) in the cemetery of Père-Lachaise. This outstanding work was singled out by the most exigent critic of sculpture of the 19th century—Rodin.[61] Previously it had been described by certain of David's contemporaries as "the work of a madman."[62] Here again we have a work the genesis of which was long and obscure. In his will, the son of the deceased stipulated that he wanted David to be placed in charge of the monument. He specified that the tomb should include three reliefs and he chose two out of four possible subjects. He wanted the reliefs to be surmounted by an equestrian statue representing his father "at the moment when he was wounded" (fig. 146). This was an unexpected image for funerary sculpture but David executed the program to the letter. We do not know if he had to impose on the Institut de France, Gobert's heir, the narrative that he relied upon for the image.[63] He represented Gobert sliding off his horse when he was killed by a guerilla at the battle of Baylen in Spain in 1808. The monument, characterized by a striking realism, is enhanced by antique and

142. Etex, *Cain and his Race Cursed by God*, group, marble, Lyon Museum

143. Clodion, *Scene of a Deluge*, model in clay, Boston Museum of Fine Arts

modern allusions and combines the Attic stele with compositional elements that recall Géricault. David did not include any reference to resurrection in this tomb. In this powerful confrontation of three figures, one wonders if the murderer and his victim are not united in a single homage, in an all-encompassing evocation of heroism in its broadest sense—both figures were equally devoted to their respective countries. David described this group to one of his correspondents in the following manner: "The general is represented wounded to death on a rearing horse. Beneath, a Spaniard struggles with energy. I was reminded of Spain and of her terrible battle against the foreigner [the Napoleonic invader]."[64]

It is interesting to note that in his writings David gave increasing importance to the group over a period of time as he came to recognize its expressive possibilities. From his meditations concerning the group, he developed an expanded conception of this genre which in turn influenced his figural sculpture. David's statues of *Grands Hommes* which, as we have seen, are distinguished from the "portrait," are thereby enhanced by a more comprehensive depiction of the circumstances of the individual's accomplishments. The *Monument to Bichat* attests to this. This example from Bourg-en-Bresse (figs. 147, 148) is the second of three monumental

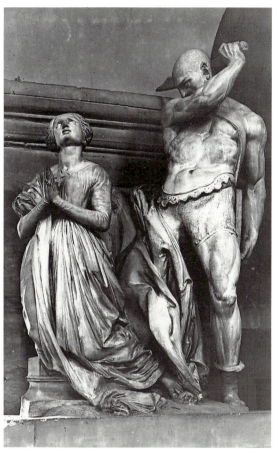

144. Huguenin, *Scene of the Massacre of the Innocents*, group, plaster, Dole Museum

145. Maindron, *Martyrdom of Saint Margaret*, group, plaster, formerly Paris, Church of Saint Marguerite

homages that David paid to the scientist Bichat, whose life and personality fascinated him (the first is in the Pantheon and the third (fig. 149) at the Ecole de Médecine in Paris). It is not surprising that Bichat's writings nurtured David's long and continuous meditations on the corporal organization of man and animate beings, on the phenomenon of the cessation of life, which obsessed him, and on many other questions concerned with physiology. The group in Bourg was completed rapidly in 1842, and David described his vast ambitions for it in several detailed texts. Thus, in a letter to Victor Pavie he wrote: "In the group of Bichat I sought to erect a monument to the science of physiology. Three existences are presented on this pedestal [David refers to the group using the word *pedestal*]: one is dreamlike, vegetative, pure as the dawn of a cloudless day; the other occupies the middle, the summit of this human pyramid. This figure is passionate, devoured by emo-

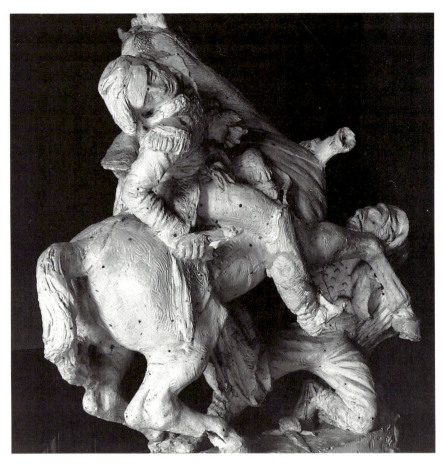

146. *Tomb of General Gobert*, model, plaster, Private Collection

tions; it thinks and consumes; it tries to raise a corner of the veil that hides the mysterious secrets of Creation. Finally, at the base of this pyramid is the dead figure, another obscure, hieroglyphic existence. . . . Here is a trilogy . . . I have used it to display my physiological drama. If I have placed Bichat's hand on the heart of the child, it is because that is where the most ardent seat of life resides. From the first moment my composition presented itself clearly to my mind. Is it not true that a doctor takes man from the cradle, sustains him up until the tomb, and, remaining faithful to his mortal remains, seeks enlightenment there, to illuminate the sublime and miraculous manifestations of life."[65]

David's ideas about the nature of man and his existence led him finally to contemplate an openly religious and humanitarian sculpture. His writings, drawings, and other sources demonstrate that he had entertained these ideas for a very long time and he endeavored to realize them. Several projects can be related to these

147. *Monument to Bichat*, group, bronze, Bourg-en-Bresse

148. *Monument to Bichat*, group, bronze, Bourg-en-Bresse, detail

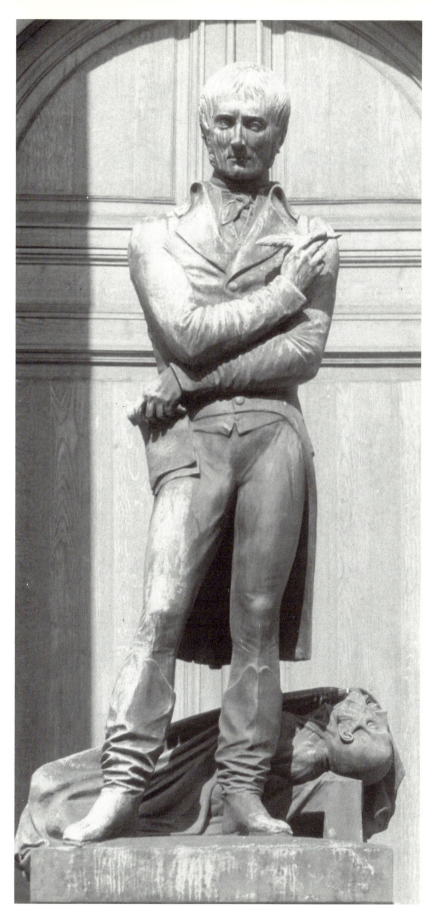

149. *Bichat*, statue, bronze, Paris, Faculté de Médecine

ambitions which continue the work he had undertaken with his *Calvary* and his *Saint Cecilia*. They were realized at the site that, for David, was the true museum, the living museum that he wanted to enrich—the Cathedral of Angers. In the 1840s a series of tense, complicated exchanges, characterized by disappointments and misunderstandings, developed among David (the sculptor who had dared to place Voltaire and Rousseau on the pediment of the Pantheon/Sainte-Geneviève), his Angevin catholic friends, and the diocese. After 1834 David conceived of a *Christ Surrounded by Children* (fig. 150), which he described as "an admirable group in sculpture."[66] In 1836 his idea for this group became clearer and more profound due to a selection of imagery that recalled well-known elements found in Revolutionary culture and prints: " . . . the oldest will be in front of him and will extend their small arms to him, others, younger, will hide in his cloak. On each side one will see a negro and a savage, these two little creatures will crawl on their knees and will direct their gaze towards the face of the great legislator. . . . These children at Christ's feet depict clearly mankind or Christian generations. It is an image of the benefits bestowed by the gentle and generous philosophy of Christ. This is consoling. . . ."[67] It was apparently this project that was on the verge of possible realization in 1848 and then collapsed. Both the bishop and the cathedral lay council rejected it definitively. After 1847 the bishop no longer answered David's letters. In 1848 he offered as an excuse the diminution of his resources and added that he was sorry.[68] However, in Paris during March of the same year, David addressed the voters in the following terms: "The Republic, as I understand it, is a generous and energetic mother who does not want all the members of the great family to be disinherited for the exclusive profit of a part of her children; this is the Religion of Christ, this great and divine Republican who wrote in his own blood on the forehead of humanity, the sublime code—Liberty, Equality, Fraternity."[69] One finds this idea expressed again in a large drawing (fig. 151) that David had been contemplating since the 1830s[70] and which he offered to the Christian-socialist Lamennais several years later. He wrote the following to Lamennais: "For a long time I have tried to compose several principal subjects from the life of Christ. In one, I wanted to represent him seated on the world, writing in his own blood: *Liberty, Equality, Fraternity*, which seems to me the summation of his public ethics. We have faith in His divine charter, we republicans. Our fathers inscribed it on their flags. . . ."[71]

The suffering, Republican Christ was not the only ambitious image that David hoped to realize in a sculpted group, a genre particularly suited to the depiction of humanitarian and social ideas (several painters and sculptors, contemporaries of David, such as Ary Scheffer, Etex, and Flandrin, expressed similar ideas in a number of remarkable works).[72] Throughout his career David dreamed of sculpt-

150. *Christ Surrounded by Children*, drawing, Angers Museum

ing a *Monument to Emancipation* (figs. 152, 153). This project, the history of which remains obscure, occupied a unique position in his reflexions, writings, drawings, and sculpted oeuvre. This group, thus far known only through several drawings and one terracotta sketch,[73] depicts alternatively a slave alone on the bridge of a slave ship or a group of slaves, including a mother and a child. David described the most elaborate of these drawings: "In his right hand he holds his fetish, the souvenir of his country. His wife is dead on the body of a young child, also dead. The crucifix, as well as the whip, are near him. He is also chained around the middle of his body. The jewels that adorn the figures must be indicated, in order to designate the importance of each individual in his country. On the bridge, the name *Rôdeur*, which was the theatre of innumerable heinous crimes, must be written."[74]

151. *Christ Writing on the World*, drawing, Rennes Museum

Depictions of emancipation and the censure of slavery did not attract the attention of the great French artists of the Romantic period, with the exception of Géricault. For the most socially committed artists, the misery of the Whites and the proletariat always came before the misery of the Blacks. Proudhon wrote the following about Courbet's *Stonebreakers*, which he described as an emblem of the enslavement of man by man: "And we speak of liberty, of human dignity! We denounce the slavery of the Blacks whose quality as beasts of burden protects them at least against this excess of poverty! Please God that our proletariats be treated materially as well as the Blacks!"[75]

Throughout his entire career David contemplated at length, and carefully planned, the project for a *Monument to Emancipation* (a project which is little-known today). The project was well-known, however, to one of his closest friends, the Romantic poet Victor Pavie, who was extremely well-informed about David's

152. *Project for a Monument to Emancipation,* drawing, Angers Museum

153. *Project for a Monument to Emancipation,* sketch in clay, Angers Museum

ideas and his art. In 1863 Pavie spoke about the project in the Galerie David at Angers, where the words that were pronounced, evidently carefully chosen, take on a singular significance. The following passage, which refers to remarkably subtle aspects of David's intellectual and artistic development, can serve as a conclusion:

> . . . You are missing his capital work. Is it consoling to tell you that you will search for it elsewhere in vain? A bronze group, consecrated to the censure of slavery, was the dream of his life. He took it everywhere and revealed it to those close to him. At night in the silence of his atelier, he returned to it. One can follow its development through a succession of sketches, drawings, and

models where he outlined it incessantly, always transforming it, never to realize it. A strange problem! How is it that he, with a conception so animated, with a hand so rapid, could never realize in a career of a half-century the child of his predilection and of his choice. . . . It is this choice and this predilection itself that resolves the problem. By identifying with his work, he came to no longer know how to separate himself from it: it lived in him, growing and developing in a creative mode incompatible with the conditions themselves of sculpting; this work was an action . . . you will be surprised that by confronting one of the most eloquent protests with which bronze would have ever resounded, he withdrew in solemn hesitation, allowing hours to pass and no longer counting them! Did he expect with age the necessary sang-froid for the execution of his thought which his ardent autumn could no longer furnish him with? . . . At least he willed this great cause to his students, hoping for nothing better than the posthumous realization of the monument of which he dreamed.[76]

APPENDICES

David and the *Liberty* Statuette

THE STATUETTE of *Liberty* was executed in 1839. The early plaster casts which are 60 cm. high and of certain provenance bear this date. This is the case of the cast given to the Museum of Nantes in December 1839, by the Doctor Ange Guépin. It is remarkable that this cast was apparently publicly exhibited after this date. The mayor of Nantes, communicating to the museum the donor's wishes, called it *Militant Liberty*, specifying that it should be suitably placed in one of rooms of the museum, ". . . a condition that has nothing to do with politics and can be easily fulfilled" (Bibliothèque du musée des Beaux-Arts, Nantes).

David offered the *Liberty* to several of his friends during this period and asked them, occasionally, to reproduce it by casting it. Thus, when he sent a cast to the politician Louis de Potter in Brussels on October 31, 1839, he wrote to him: ". . . Regarding the small statue of Liberty, I made it so it could be purchased by the people, thus it would be a good idea to give it to a caster [in plaster] who will return the model to you when he has finished his cast. Let us hope one day that we will see the statue [word crossed out] the image of Liberty in humble homes. She is a saint who well deserves the most fervent cult . . ." (De Potter Papers, Bibliothèque Royale, Brussels).

Carl Gustav Carus wrote to David from Dresden ". . . that in one of the best newspapers [he read] A Visit to David's Atelier, in which they spoke a great deal about the Liberty statuette that you call your mistress! If you ever have an opportunity to send it to me you will make me very happy." Carus to David, June 5, 1840. See Appendix IV, p. 223. In March 1841, the sculptor Rietschel saw the statuette in Carus' home and described it in these terms: "Die Frieheit steht in theatralischer Stellung, mit freiheitsmüze und kurzem geschürtztem Kleid. Die Idee und die Darstellung ist ganz französische, ja widerwärtig" [Liberty poses in a theatrical stance, with a phrygian cap and an apron-like dress. . . . The idea and the representation is totally French, indeed unpleasantly so], Rietschel to Rauch, Dresden, March 25, 1841. Briefwechsel swischen Rauch und Rietschel, herausgegeben von Karl Eggers, 2 vol., Berlin, 1890-91, vol 2, pp.9–10. On April 15, 1840, the journalist Altaroche sent a manuscript poem to David about the *Liberty* statuette, "yesterday blossoming by your celebrated chisel" (Bibliothèque municipale d'Angers).

Illustrated with an engraving, Altaroche's poem accompanied an advertisement of the publisher Pagnerre dated around 1840. In it, Pagnerre put on sale the *Liberty* statuette in plaster, 60. cm high, with the inscription on the base: "Liberty, Dear Liberty, Fight With Your Defenders." The price was 12 francs. He also offered reductions of busts that David had made of Lamennais, Timon (Cormerin), and the statuette of Carrel. He made provisions for the shipping of *Liberty* to the provinces for 14 francs.

The *Liberty* was produced commercially in plaster after, at least, February 20, 1847. This was the date when the caster in plaster, Auzias, brought it to the Dépôt des Estampes. It was sold, not signed by David, on the Parisian market during the Second Republic, in places such as "the corner of the Boulevard and the Passage du Panorama." In March 1851, David authorized the porcelain manufacturers Ricroch and Cie. and the Association of the Workers in Porcelain at Limoges to execute a series of Liberty-Republic in various sizes, "the smallest one being only 6 thumbs" high. In this version, the inscription "French Republic, February 24, 1848," is written on the base. The figure is depicted leaning on a truncated column above a small altar. This variant with a mason level between the feet of the figure has the following numbers inscribed on the scroll: "89. 1830. 1848." An example of this version, 52 cm. high, is preserved at the Museum Adrien Dubouché at Limoges. It was donated in 1878 by Godefroy. A bronze *Liberty*, leaning on a rifle with a long bayonette, 24. cm high, appears in the published catalogue of the founder Thiébaut in 1867. Sometimes holding a short bayonette, sometimes a long one, Liberty was commercialized in bronze by several founders, Cresson and Thiébaut, for example, in a size approximately 57cm high. According to Ch. Metman, the *Liberty* was edited after 1899 by Bonnet ("La petite sculpture au XIXe siècle. Répertoire des fondeurs du XIXe siècle, . . ." *Archives de l'art français. Documents sur la sculpture française*, vol. 30, Paris, 1989, p. 178). Reductions in bronze and in copper, often rough in execution, were produced during the second half of the 19th century.

APPENDIX II

Rude and the Monuments to Napoleon

THE PROJECT by Claude Noisot, former officer of the Imperial Guard and painter, to erect the *Resurrection of Napoleon* on his country estate at Fixin, Burgundy, a few miles south of Dijon, was conceived earlier than is usually assumed. The monument is Noisot's private response to diverse government and local initiatives for monumental homages to Napoleon. One example among others is provided by the municipality of Dijon in August 1840—a project, later abandoned, to erect a statue to the memory of Napoleon on the public square next to the theater (Archives municipales de Dijon, 1 M XVI). On October 7, 1843, Octave Tournoux the Younger composed a poem "inspired by a account given to him" that described a sketch of the monument. Without describing the sketch, Noisot recorded this fact in one of his sketchbooks where he drew several of his ideas concerning the architectural and sculptural decoration of the park, inaugurated September 19, 1847. One sees among his drawings a project for the placement of a colossal, full-length statue of Napoleon at the summit of a large pyramidal construction in the form of an antique mausoleum inscribed in a hemicycle planted with cypresses. In his Parisian atelier in the spring of 1846, Rude showed to certain individuals the monument in plaster that he eventually executed (Th. Thoré, *Le Salon de 1846,* . . . Paris, 1846, pp. 195–196). After the monument was cast in bronze, Rude opened his atelier to the public in July–August 1847. The liberal press praised the work to the extent that Rude's work helped them question the artistic policy of the state and underscore the artistic failure of the undertaking of Napoleon's tomb that was being built at the Invalides: ". . . Does it now happen in France that the only true, pious, heart-felt monuments, worthy of their vocation, are those that are erected by simple individuals! We have already told our readers about the austere and enduring work that several patriots offered to Godefroy Cavaignac. Yesterday, we praised the noble marble that a son requested for his father from the chisel of Mr. David [Tomb of General Gobert]" (Pr. H. [Prosper Haussard], "Beaux-Arts. Monument funéraire de Napoléon, par M. Rude. Le tombeau de l'Empereur aux Invalides," *Le National*, August 28, 1847).

No document exists that would authorize the historians of Rude to relate the study in plaster representing Napoleon as a gisant preserved at the Musée Noisot

at Fixin to the Fixin program. This study, exhibited at Fixin in the last decades of the 19th century, includes a rectangular base decorated with posts connected with chains, separable from the upper part. The upper part of the study, which depicts only the gisant on the rock, became the model for the execution of several bronzes. Some of these bronzes are unsigned and undated; others, signed and dated 1849, offer slight variations in execution and chiseling. The whole composition, including the gisant and the rectangular base, was cast in bronze in 1898 in one unified piece by Thiébaut who declared it to be one of a kind. This cast is preserved at the museum in Dijon. The plaster in Fixin that served as the model was not known by historians of Rude before the 1890s. This was the period of L. de Fourcaud's work on Rude. He accepted an earlier attribution for the plaster that he identified as the first project for the monument at Fixin ("François Rude. 9th article," *Gazette des Beaux-Arts*, October 1, 1890, p. 338). The bronze was offered to the museum in Dijon by the Dijon Committee which in 1882 had organized the subscription for the erection of a monument to Rude. The remaining funds from the subscription were used to pay for the bronze.

I will argue elsewhere that the sketch at Fixin was made for a different program than that of the monument in the Parc Napoleon. The sketch was not mentioned by the first historians of Rude and it does not appear in the inventory of the estate and art collections recorded after Noisot's death in 1861.

After 1847, Noisot remembered Rude's intentions to create a monument to Napoleon ". . . for twenty years he was working on his monument [in his mind] in order to give it to his native Burgundy" (*La Résurrection de Napoléon . . . Souvenirs par J. Trullard*, Dijon, 1847, n.p.). It is possible that the plaster sketch at Fixin, cast in two pieces made to fit together, can be related to numerous works that were planned or realized in connection with the Parisian competition for Napoleon's tomb which was judged in 1842. Several projects envisaged a sarcophagus supporting a reclining statue. This was a choice that the government did not particularly like because of the statue's realistic nature (since it would have been a portrait). Another reason was the possible competition during the same period for the gisant planned and realized for the funerary monument of the Duke of Orléans. The numerous casts of medieval gisants executed after 1836 for the Musée historique at Versailles, Pradier's gisants for the Royal Chapel at Dreux, as well as the competition for the tomb of Napoleon, and the choice of a reclining statue by the painter Ary Scheffer and the sculptor Henri de Triqueti depicting the Duke of Orléans, ensured the popularity of the gisant in funerary sculpture. Visconti, the architect chosen for Napoleon's tomb, decided that Pradier would execute a reclining Napoleon. Both Visconti and Pradier were chosen outside of the competition, which was consistently denounced as "a lie, derisive and deplorable." Pradier, along with Vis-

conti, thought of a reclining figure of Napoleon in spite of the recommendations of the commission in charge of examining the projects (although the commission was divided in its opinions). Against the views of its secretary, Théophile Gautier, the commission declared: "... no statue, no ornament, no architecture would be able to produce as much expression as the view of the coffin ... the more the sarcophagus permits exactly to imagine the shape of the casket, the greater the effect.... In the church, the tomb; outside, the statue!" ("Rapport à M. le ministre de l'Intérieur, ..." *Moniteur Universel*, January 16, 1842.) On July 10, 1842, Pradier wrote to his marble dealer Henraux: "... I am working on the composition for the monument to Napoleon, and it is I who will do the sculpture; it has been promised to me. I will need the best marble for the Napoleon reclining on his tomb ..." (Custodia Foundation, Institut Néerlandais; J. de Caso, "Remarques sur l'invention de Pradier," *Zeitschrift für Schweizerische Archäeologie und Kunstgeschichte*, 2, 1981, p. 117, note 5; *James Pradier. Correspondance. Textes réunis, classés et annotés par Douglas Siler*, vol. 2, Geneva, 1984, p. 319). This letter was written before Visconti drew his preparatory project for the lay-out of the crypt, a preparatory project that did not include sculpted decoration or a gisant on a sarcophagus. Jean Simon, head archivist at the Assemblée Nationale, kindly helped me find the four drawings by Visconti representing this preparatory project. Signed on September 29, 1842 and approved by Cavé and Duchâtel on November 30 and December 1, 1842, these drawings were attached to the written law of July 1, 1843 (Archives de l'Assemblée Nationale). A tracing corresponding to these drawings is preserved at the Archives nationales (F 21 728). Important artists such as Triqueti, for example, were in favor of the gisant for the tomb (M. Driskel, "By Competition or Administrative Decree? The Contest for the Tomb of Napoleon in 1841," *Art Journal*, vol. 48, Spring 1989, pp. 46–52). Important sculptors would take up the composition with a gisant. For example, in a project that was not submitted to the competition but which was intented to be included, the sculptor Mathieu Justin combined a reclining statue of Napoleon and his emblem, the eagle, with elements of nature in a composition that is reminiscent of the Fixin sketch, "... Like many others, M. Justin believed in the fairness of the competition; he went to work. On a bare rock, the dead Napoleon was lying, his body wrapped in his coat, with a sad and prostrated eagle at his feet ..." (A. H. Delaunay, "Actualités—Souvenirs," *L'Artiste*, October 22, 1843, p. 269).

In the monument at Fixin, Rude and Gautier's ideas meet: "... from the viewpoint of epic and of poetry, it would have been better without any doubt, to have represented the Titan on his rock.... Artists could have done a very simple thing, that is, to make for the giant a tomb fitted to his measurements, that is to say, six to eight feet long, just enough for the coffin, with his reclining statue above it, an

eagle at his head, a dog at his feet, according to heraldry for knights and for kings who had died in captivity. He should have been represented as he was found when they opened his coffin: his narrow shoulders, his thin profile, made more deeply sculptural, his nose pinched by the thin fingers of Death, with his boots and his uniform, his sword and his little military hat beside him. This simple figure executed by a great sculptor, would have made an admirable monument . . ." (cited by Ch. de Lovenjoul, *Histoire des oeuvres de Théophile Gautier*, Paris, 1887, vol. 1, pp. 231–236).

Around 1841, when the projects related to the competition became known, David, apparently thinking of noteworthy sculptors such as Etex, rejected the idea of an effigy of any kind: ". . . Does it not seem to you that the project of representing Napoleon riding on a horse on his tomb, is one of the greatest absurdities. . . . His hat, his sword, a wreath of laurel and his name on the coffin, there you have the only funerary monument worthy of the great man." In 1847, David noted that he had been approached for the execution of the two figures envisaged by Visconti in August 1843 to decorate the entrance of the Invalides' crypt: "Duret knows well that if I had wanted to do the statues that he is executing for the tomb of Napoleon, I could have them, because he did not want him to do them, and I was compelled to write three letters of refusal" (*Les Carnets*, vol. 2, p. 256).

APPENDIX III

David: The Monument to Emancipation

D AVID'S projected *Monument to Emancipation* and its impact on the next generation of artists will be the subject of a later publication. It was unique among the monumental sculptural projects of the 19th century. Jouin offered a summary account of it and underestimated its importance in the context of David's liberal ideas: "But as (David) neared death, his genius experienced a new understanding that he had not yet fully suspected. In addition to the liberty of the people, he perceived the emancipation of man. During the same year, 1854, David appears to have been constantly occupied with his group, *The Abolition of Slavery*. Numerous sketches left by the master attest to the development of his thinking. One recalls the energetic words that this favorite work inspired at Weimar, this work that was always planned and whose sublime eloquence would be the despair of his chisel. He went back to it many times and, as he felt his powers diminishing, David returned with a feverish persistence to the conception of the philosophical and Christian group which he had hoped would be his first claim to glory. One finds hundreds of drawings of the master in which he has sketched a detail of the composition, an isolated figure, the significant idea of a figure, or the general silhouette of the monument. Here we see a young negro, his knees on the ground, who raises his enchained arms, asking the heavens to witness his torture. In another drawing, two slaves look at a dead child with stupor, and the poor beings do not even think of cursing their servitude in the face of these fragile remains which were their hope. In yet another, one sees a robust man with the chains of a prisoner around his hands and feet; slavery has killed him. And always, near the slave, the sculptor places the crucifix. The image of the Redeemer is there in the dust, a dishonored relic that the conqueror of the day has trampled under his feet. David, an artist of ideas, understood that slavery was the negation of Calvary, and that an outrage against the Man/God always preceded the injustice done to man. Thus, the master offered a just homage to Anselme, Pierre Nolasque, Jean de Matha, to the Domenican Las Casas, these glorious defenders of the freedom from slavery in the name of Christ" (Jouin, *David*, vol. 1, p. 492, and *Inventaire*, 1908, p. 362). One can follow the development of this project by citing David's friend and first biographer, Victor

Pavie. In 1863, and again in 1871, Pavie recorded David's ideas concerning this project which the sculptor first expressed in 1829. During the trip they took together to Germany that year, David had stated: "I have always in mind, or rather in my heart, this protest of the human conscience against the most deplorable iniquity of our time, the treatment of the negroes; after ten years of silence and suffering, it must burst forth with a voice of bronze. You see here the group, the enchained slave, his eyes raised to heaven, protector and avenger of the weak. Near him, supine and broken, his wife at whose breast a fragile creature sucks blood rather than milk; at their feet, detached from the broken collar of the negress, the crucifix, the Man/God who died for his brother, whether Black or White. Yes, the monument will be bronze, and when the wind blows, one will be able to hear the chains clanking; the chains will resound" (V. Pavie, *Goëthe et David. (Souvenirs d'un voyage à Weimar)*, Angers, 1874, p. 42–43). This text suggests that David's interest in and preoccupation with issues concerning the fate of the African slaves and the abolition of the slave trade were already well-established by 1819. David, a great admirer and a collector of Géricault, must have been thinking of the *Scène de Naufrage* (the *Raft of the Medusa*), which had been exhibited at the Salon (David could have met Géricault at the end of his Roman stay; there, according to Etex, the painter "communicated his passion to him") (*J. Pradier, sa vie et ses ouvrages*, Paris, 1859, p. 13). In the *Raft*, an African athlete, given a central position in the composition, emblematizes the physical and moral resistance to adversity that for Géricault characterized modern man. In 1819, the efforts of the abolitionists, who were friends of both Géricault and David, were directed against the slave trade that was still encouraged and practiced by the Restoration government in spite of the decisions made by the Allies at the Congress of Vienna. David addressed aspects of the issue of African slavery and the equality of the races in his notes and in several significant works. One finds the African represented in the reliefs of the Monument to Cardinal de Cheverus (*Cheverus Dressing the Wounds of a Sick African*, Mayenne), to Gutenberg (*Europeans Breaking the Chains of the Negroes and Giving Them Books*, Strasbourg), and on the tomb to General Gobert (*Gobert Saving the Lives of French Soldiers Imprisoned by Rebellious Slaves*, Paris, Père-Lachaise). The drawings preserved at Angers related to the project of the *Monument to Emancipation* and the terracotta sketch acquired recently by the museum in Angers (fig. 153) illustrate clearly David's ideas concerning this monument. David recorded these ideas in his notebooks, in which he also copied passages from other texts. ". . . A negro whose neck and arms are adorned with necklaces and bracelets, the sign of power in his country, holds in his hand a small figure of a god from his own country which he contemplates with a melancholy gaze. He is enchained around the waist to the deck

of the ship. One sees on an object the name *Rôdeur*, which was the bloody theater of the slave trade. Near him lies a whip, the instrument of torture for these people, and nearby is a crucifix, symbol of a religion that has done little for the emancipation from the savage egotism of man" (*Les Carnets*, vol. 2, p. 270). Another sculpted sketch that is related to the project for the *Monument to Emancipation* is preserved in the Ménil Collection, Houston.

APPENDIX IV

David and Carus: A Correspondence

SINCE documented personal exchanges between French and German artists
during the first half of the 19th century are scarce, it seemed pertinent to pub-
lish a hitherto unpublished correspondence between David and the doctor, physi-
ologist, and painter, Carl Gustav Carus (1789–1869). This important, though in-
complete, correspondence provides more than mere biographical data; it illumi-
nates the mutual interests of David and Carus in the processes of artistic creation
and in the natural sciences which fascinated Romantic artists. It also documents
and expands our knowledge of David's involvement with the art of Caspar David
Friedrich.

Carus had introduced David to Friedrich when the sculptor and his wife vis-
ited Dresden in November 1834. David recorded the details of his visit to Carus in
his notebooks (*Les Carnets* . . . , 1, 309ff.). As early as 1836 Carus published the
famous remark that David had made concerning Friedrich's paintings: "In solcher
Richtung wird unser Friedrich noch lange der bedeutendste bleiben, so wie er der
erste darin gewesen ist, und ich kann dabei ein schoenes Wort meines Freundes
David nicht verschweigen, welcher als ich ihn bei seinem kurzen Aufenthalte in
Dresden mit den eigenthümlichen Werken Friedrichs bekannt machte, nach
langer Betrachtung ausrief: "Voilà un homme qui a découvert la tragédie du
paysage"—und gewiss jede Zeit hat das Recht eine eigenthümliche ihr gemässe
Richtung ihrer Kunst zu verlangen" (In this way our Friedrich will still remain for
a long time the most eminent one, since he has been the first in this genre, and I
cannot conceal in this respect a beautiful phrase by my friend David, who, during
his short stay in Dresden when I introduced him to the peculiar works by Fried-
rich, exclaimed after a long meditation: "Here is a man who has discovered the
tragedy of landscape"—and certainly every era has the right to demand that its art
take a direction which is peculiarily its own), *Paris und die Rheingegenden: Tagebuch
einer Reise im Jahre 1835*, 2 vols. (Leipzig: G. Fleisher, 1836), 2: 255–256.

Three known Friedrich drawings were in David's collection (V. Huchard,
Cent dessins des Musées d'Angers, Angers, 1982, nos. 39 and 40; A. Sérullaz, "Un
dessin de Caspar David Friedrich," *La Revue du Louvre et des Musées de France* 1,
1975, 55; D. Johnson, "David d'Angers and the Signs of Landscape," *Gazette des*

Beaux-Arts, April 1990, 171–82). Thanks to the correspondence we now know that several of them had been acquired by Carus in 1843 and were subsequently sent to David. The collection of German paintings owned by David, including two by Friedrich, appear to be lost (J. de Caso, "L'Inventaire après décès de David d'Angers," 85–97). In addition, the three paintings by Carus mentioned in the correspondence, apparently replicas he executed himself, were unknown to historians of Carus (M. Prause, *Carl Gustav Carus: Leben und Werke*, Berlin, 1968; E. Meffert, *Carl Gustav Carus: Sein Leben - Seine Anschauung von der Erde*, 2 vols., Stuttgart, 1986). The correspondence between Carus and Régis in 1820 and 1825 mentions several paintings by Carus related to the subject of Schiller's ballad which were presented as companion pieces ("Ein anderes Winterbild habe ich neulich verkauft. S'war das eingeschneite Fenstern des selig verstorbenen Ritters von Toggenburg, das Pendant zu dem Fenster der Klosterjungfrau mit der Lilie"—"I have recently sold another painting on the subject of Winter, I mean the one representing the snow-covered window of the blessed deceased knight von Toggenburg, the companion piece to the one representing the window of the young nun with the lily" (Prause, *Carus: Leben und Werke*, 106).

David's letters are preserved at the Sächssische Landesbibliothek, Dresden. Mr. Stein, head of the manuscript collection, kindly gave me permission to publish them. The syntax, spelling, and punctuation of the original text have been respected, except in cases where they make the text unintelligible. Accents have been normalised.

1 David to Carus
Paris December 12, 1835

My dear and good friend,

A thousand pardons for my long delay in writing you. I have been so burdened with work and affairs of all kinds that the days disappear with a rapidity that frightens me. Do not think that if I have not written you yet this means that I am not extremely grateful for your good and precious painting representing the bridge of Dresden. Emilie and I contemplate it often. It takes us back in our imagination to the beautiful and good country that you live in. And then we think of its author with whom we have spent such interesting moments but of too short duration. Will we see each other again soon? I desire it with all my heart. And if this is an illusion at least it is an extremely agreeable one for me.

A few days after your departure from Paris I left a wooden case with Messieurs Rittner and Goupil containing the bust of Cuvier, a small statue of Monsieur Tieck and many medallions and all the objects you left at our house. There are two medallions in bronze representing Retzsch, one for him and the other for Mlle de (?) and plaster casts that I will ask you to give to him. The bronze statue for Monsieur Tieck and many medallions are in

another case addressed to Monsieur Vogel. Please ask the corresponding agent of these gentlemen where the cases are located.

Monsieur Jourdan has not yet received anything from you and he is very surprised that the translation has not yet reached you since it was sent to you two months ago. He promised to look into this for me.

Monsieur Vavasseur wrote to me that the copies were given precisely to the people to whom they were addressed and that he will write you in a few days and send you Gerdy's work on *hernias*.

Farewell dear friend. Believe in the complete devotion of your heartfelt friend.
David

Please give my respectful greetings to Madame Carus. The bust of Monsieur Tieck will be completed in marble in a few days.

2 *David to Carus*

Paris January 19, 1836

My dear and good friend,

I have just received a letter from Monsieur Jourdan. He apologized to me for having been so late in letting me know about the things I asked him for on your behalf. He had a worthy excuse since he is just convalescing from a long and painful illness that deprived him of rest and of all his faculties for two months. He says that his bookseller cannot imagine that you have not received the copy of your work but he will mail to you another one which will be added to something that he is sending to Professor Prechtl for the surgical academy of Dresden and this package will be shipped in a few days. Nor has he heard anything further about your package. He will ask someone to find out about it from Monsieurs Truttel and Wurtz.

It is very cold here. This has prevented the young draftsman, to whom I introduced you, from being able to climb up the towers of Notre Dame in order to make the drawing that he promised you. But this will be done as soon as the first good weather returns. Nature has a sad and sickly appearance in winter. Winter is a crisis that renders nature as fearsome as a beautiful woman at certain critical moments of her life. It is best to retreat in order to remember the sublime beauty of nature. It is an incomprehensible effect of the imagination- that that which represents the effects of nature is more extraordinary than reality. Certainly matter would not be able to produce such impressions!

Farewell my good friend. All of you be happy. This is the sincere wish of Emilie and myself, and believe in the entire devotion of my heart.

3 *David to Carus*

Paris March 28, 1836

My good and honorable friend,

You have no doubt thought that I have been quite negligent towards you. It has already been a long time since I should have answered you concerning the information that you asked me about. In truth my time passes with an incredible rapidity. This probably

comes from the multitude of different works that are in progress. I believe this is the best system for keeping my inspiration in motion. But it would be quite important to be able to control one's time without harming this inspiration and, among all my reasons for admiring you, this is one of the qualities that struck me about you. You have what Napoléon called the driving motivation, an upright man with a strong base [quarré par la base]. Also, although you have accomplished an enormous number of things for glory what a great future you still have ahead of you.

You will find enclosed a small explanatory note from Messieurs Truttel and Wurtz concerning the book that Monsieur Férussac had left with them to give to you.

Monsieur Flourens told me that the Academy had received the second, third and fourth fascicules of the illustrated plates of your book of comparative anatomy as well as the text that refers to them. He said that he wrote you on behalf of the Academy to thank you in November of the year 1835. If the letter has been lost he will eagerly write you another one.

I will soon send the bust of Monsieur Tieck to Dresden. I do not know if he was pleased with the small statue of him in bronze that Monsieur Vogel was supposed to give him from me.

Your bust is already blocked out in marble. I also hope soon to ask you to give it shelter in your living room.

And Monsieur Friedrich, what great thing is he doing in painting these days? What a genius! I had not yet seen anything as poetic as his works. In Paris we must try to acquire one of his great paintings. This is something that I will ask you to negotiate for me perhaps in the not too distant future.

Farewell dear friend. Be happy and think sometimes of your friends on the rue d'Assas who have devoted to you a very profound and sincere affection.

 David

Give my regards and respects to the ladies. Emilie asks me to remember her to them.

4 *David to Carus*

Paris August 25, 1836

My good and dear friend,

Yesterday I gave your marble bust to the post. The company of Rittner and Goupil kindly took charge of the shipment. I hope that it will reach you within twenty days. Accept it as the testimony of a man who is sincerely attached to you in his heart. If you knew, dear friend, what pleasure it gave me to execute this work. I believed I was still hearing your voice and enjoying those all too short conversations that have left very deep marks in my spirit! Each thought of a distinguished man is a little branch that links our moral existence to his. It is thus that generations are linked by a chain made of genius.

Our domestic happiness has increased. A month ago Emilie gave birth to a healthy girl. Our good Robert is growing a great deal and his kind and likable character makes us very happy.

I always work at a very great pace in order to be able to finish the works that keep me in Paris. After they are finished I will have the opportunity to set to work on our project and spend several days in Dresden. Several months ago I was commissioned to execute two

colossal statues. One was Gutenberg for the city of Strasbourg and the other, for Béziers, is P. Riquet, the inventor of this famous canal that joins the two oceans and is a source of prosperity for the country.

I have also just finished the statue of the young Republican drummer boy who, mortally wounded, was forced by the men from Vendée to cry out "Long live the king!" His only response was to press the tricolor cocade to his heart. This youthful courage caused the Convention to deliberate and to decree that the monument of this heroic child would be placed in the Pantheon. My intention is to give this monument to the nation. This type of work is a prayer of my political religion.

I am also working on the composition of a monument that will be very important to me. It's the tomb of a general killed in Spain. He will be represented on horseback at the moment when he died. This group will be placed on his tomb. There will be four large low reliefs on the pedestal representing the battles in which this general took part. I hope to be able to go to Italy to complete this monument.

Farewell good and very dear friend. Think sometimes of one who is devoted to you with all of his heart.

David

Emilie asks to be remembered and asks you to give her warm greetings to Madame Carus as well as to the Carus daughters. Please give my respects as well to these ladies.

Do not forget to send our greetings to those who kindly sometimes think of us.

5 *Carus to David*

My very dear and highly esteemed friend!

It has been such a long time that our correspondence has been dormant and I would be very unhappy if I were to believe that our friendship were not more awakened than it! However, if the good Lord wanted two men to meet in life and wanted them to recognize that their souls and their hearts understood one another, then it is quite certain that their souls will mutually preserve for life what you French call very aptly by a derivation of the word "soul"—*friendship*. Nonetheless I would be happy if you would write to me soon a few lines in response even if just to prove to me that you have escaped from the flu and that you, your wonderful wife and your dear children are in good health.

As for us, we have also suffered through this epidemic which gave me a terrible amount of work to do. But at present—Thank God! everyone in the house is in good health. Madame Rietschel and her husband were also attacked by the flu and she often asks me about the David family in Paris. When I visit her I find her room decorated with sculptures and low reliefs in plaster.

As for me, I am working now continually on my book on Physiology and at the same time I am preparing the publication of the third edition of my large work on the illnesses of women (Gynaikologie).

With all of this work my painting cannot flourish but nevertheless there is always something about this genre that I attend to, at least inwardly. I don't know if I wrote you that the moonlight view taken from the windows [or "of the windows"] of Monsieur Champin was executed in the spring of 1836 and that this painting was later

taken away by a Russian family. Due to the generosity of the Crown Prince of Prussia, you will soon see in Paris two excellent German paintings to which I direct all of your attention. One is Bendemann's *Jeremias* and the other is *The [Predication] of the Followers of Huss* by Lessing, of Dusseldorf. Please tell me how these paintings were received in Paris! I am sure that you will be astounded by Bendemann's painting! I can tell you that I have never seen anything as great and as worthy in conception and execution since the Sistine Chapel.

If you see Count Baudissin and the Cubières Family please give them my regards and greetings from my family! Please write me about Madame David, our wonderful friend to whom we send our best wishes! Remember me to the men of letters at the Institut who were so friendly to me in Paris and tell us when we will have the pleasure of seeing you all in Dresden? With my true and sincere friendship,

 Your very devoted Carus

Dresden February 21, 1837

6 David to Carus

Paris May 21, 1837

I am profitting from Monsieur de Cubières' trip to write you a few lines, too few unfortunately to satisfy the need I continually feel to converse with you, you whose character and genius I love so much. But what am I to do? Carried away as I am by the torrent of my numerous commitments, I find myself constrained to neglect somewhat my correspondence. However, please believe that my heart does not remain inactive, it narrows the distances, it hovers above all the difficulties caused by the whirlwind of life and friendship finds in the heart an eternal sanctuary.

If you receive French newspapers you have probably seen that the works of German artists have been seen with interest. I have already seen the painting of M. Bendemann in Dusseldorf. The assessment that I made of this young artist is confirmed by the new study that I have just done. In rereading my notes that I took in the atelier of this painter I persist in my judgement. We will speak about this during my next trip to Dresden.

Do not forget to tell Monsieur Rietschel that I wish him complete prosperity and that I hope that he will often have the opportunity to give himself to his art that he feels and understands in such a noble way. I think that the monument that he was working on during my stay in Dresden must be finished. It will produce a beautiful effect and I will be very happy to be able to admire it very soon.

The pediment of the Pantheon whose sketch you have seen is finished. It will be visible to the public for the festivities of July. The statue of Talma is going to be inaugurated at the Théâtre Francais where it will be placed. Since your last trip to Paris I have executed the statue in marble of the young Republican drummer boy who dies pressing the tricolor cocade to his heart. I am currently at work on the statue of Riquet, author of the canal of Languedoc, on Gutenberg for Strasbourg, on Ambroise Paré, surgeon of Charles IX, for Laval, his homeland, on General Beaurepaire, who blew his brains out in order not to accept capitulation after the taking of Verdun, and on two large groups for the customs office of the city of Rouen—one of Navigation and the other of Commerce. All these works

must be finished this year and then I will make travel preparations in order to be able to leave France towards the month of April.

Farewell dear friend. Believe in my feelings of unfailing devotion.

David

Give my respectful regards to the Carus ladies. Emilie asks me to send them her greetings. When a line engraving of the Pantheon pediment has been made I will send you a copy.

7 *Carus to David*
Dresden August 31, 1837

My very dear friend!

I was enchanted with your letter that Monsieur Cubières very kindly brought to me! It has been two years since I had the pleasure of enjoying our evening walks in the moonlight in the streets of Paris! I have often recollected several of our discussions! And the desire to continue them with you leads me thus often to wish for things that are not easily realizable!

Make me happy soon by sending me the engraving of your great work for the Pantheon! I am very interested in seeing it and I admire your energy which allows you to finish so many and such great works.

Rietschel has just finished a statue in plaster of a Nymph after long and assiduous work. It seems to me that it is the most beautiful thing that I have seen him do!—But God only knows if Monsieur de Quandt who commissioned it will allow him to execute it in marble!—Rietschel's wife, my daughter, gave birth to a son on August 28 (Goethe's birthday). This makes me very old as I am now a grandfather. The mother and child are in good health!

A short while ago I sent a letter to the Institut concerning a physiological discovery. I would like very much to know what people such as Monsieur Flourens, Blainville, etc. thought about it.

In addition you have probably read in the newspapers (if news of our little country ever reaches you!) that our king fell ill at Lagbach and that I was obliged immediately to make a trip of 240 leagues to attend to him and to accompany him back here. Because of this I was able to see the Alps again and the grandeur of nature has once again penetrated my heart with this gentle tremor that widens our soul and purifies our spirit! I hope that you will execute your project! Come spend some time with us! We will have so many things to discuss! My entire family and I want to send our greetings to your wonderful wife! Write a few lines soon to your very devoted friend

Carus

8 *Carus to David*

My very dear and highly esteemed friend!

Your letter from the 2nd of this month gave me great pleasure!—how every line reminds me of everything, your being, your engaging and interesting way of speaking, of

expressing your very distinguished thoughts and even the uniqueness of your art! Believe me! In me you have a very faithful friend who will preserve forever the memory of the days he has spent with you!

I have recently spent a great deal of time with Monsieur Coste of Paris. You will soon see him at the Institut and I hope he will speak to you about what we discussed together! This man inspired in me a keen interest in his work on the natural sciences. As for his philosophy, he leans perhaps too much towards the principles of Monsieur Chateaubriand.

My small treatise on the egg of man has not failed (so I have been told) to interest your anatomists and you can tell Monsieur Flourens that in the past few days I have repeated these observations on the ovaries of a three day old infant and I have likewise found the eggs of the following generation fully developed.

I have just finished the third edition of my Manual of Gynecology (in two volumes) and soon the first volume of my new Physiology that I would like very much to make known in France will begin to be printed. However, it will be rather difficult to translate.

What you told me about your works has greatly interested me and I await impatiently the engraving of your great pediment.

My dear Rietschel sends his regards to you. He is busy learning French this winter— and he dreams only of going to France in order to be for once in the center of *great* activity in sculpture since here, as you know, this activity is rather limited!

His cycle of the history of humanity in 12 low reliefs is progressing well. Monsieur Coste has seen two completed reliefs.

Please give my best regards to Madame David, my dear and highly esteemed friend and ask her to remember me warmly! My family and Rietschel's family also send their best regards to yours. His son, my grandson (born on Goethe's birthday on August 28 and named Wolfgang) is becoming very sweet.

This letter will be given to you by two Russian families, that of Monsieur de Soudianko and Monsieur de Borodsna who are going to spend this winter in Paris. These are *very good people*, filled with interest in the arts, especially Monsieur de Soudianko. Please receive them with your usual kindness and give the ladies the pleasure of introducing them to Madame David. They will tell you about our life and will describe to you the place where the busts you gave me are displayed. Take them around a bit in your vast city—and remain always the good friend of your Carus

Dresden October 19, 1837

9 David to Carus

Paris May 1, 1840

When you hear, my dear and very good friend, how sick I have been since the month of December until right now you will excuse me, won't you, for having delayed so long in writing you. I had a very serious and brutal case of pneumonia, terrible to such an extent that I still have a very violent pain in my left lung and the warm weather that has begun to make itself felt has not been able to rid me of it. This annoys me very much and sometimes worries me.

I have, however, returned to my work since I must finish the low reliefs that will deco-

rate the pedestal of the statue of Gutenberg which will be inaugurated in Strasbourg on June 24. The statue has been completed in bronze for quite some time.

I have represented Gutenberg at the moment when he holds the first proof print on which can be read *And there was light*. You know that the bible was printed for the first time in Strasbourg. Why couldn't he have used this phrase in the first prints that he made since it expresses so well the results of his admirable discovery? In the low reliefs I have represented the benefits of printing on the four continents of the world using facts and not allegories. In the composition of this monument I had less in mind the idea of representing the invention of printing than the beneficial effects of its results.

I will be very close to your dear Germany in a few months but yet it will be impossible to extend my journey up to Dresden and this, in truth, makes me very unhappy because I need to see you very much. But it will be necessary for me to return to Paris to finish works that were necessarily delayed because of my long and cruel illness.

I was very deeply touched with gratitude when I received the small painting that you had the kindness to send me. This brought about a benificent interruption to the sadness of my condition. You are fortunate, my dear friend, to be able to give your friends proof of your remembrance of them in such a beautiful language as this. I assure you that in complimenting you on your talent in painting I am not exaggerating because everyone who sees in my home the view of Dresden that you gave me, leaves with a very lofty idea of your talent. Concerning this view of Dresden, I did not dare to give it a pendant. Oh, if I still dared to go to the source there would be a painting by you representing a certain windowsill on which there are dried flowers, a subject inspired, I believe, by a novel of Schiller. This would be an admirable pendant for the first work of your's that I own. But you must find me too demanding. Believe, however, that I would be less demanding of you if you had less talent and felt less friendship for me.

I saw Monsieur Flourens several days ago. I asked him if he had not forgotten something he was to have done for you. He assured me that he had done everything that you had asked him to and he asked me to send you his greetings.

In a few days the statue of Ambroise Paré, one of the great glories of surgery in France, is going to be inaugurated in Laval, his hometown. A new edition of his book has just appeared and an engraving has been made of his statue and of the medallion that I made after an authentic profile of the famous surgeon to be put on the frontispiece of this new publication.

I hope very much that our dear friends in Dresden think of us sometimes. Please don't forget to tell them how dear their memory is to Emilie and to me. Tell them we wish them the very best of all things with all of our soul. Tell my dear Vogel that he will have given me great pleasure if he has remembered the promise he made to send the lithograph of his painting representing the view of his atelier when Monsieur Tieck was posing for his bust.

Remember Emilie and me to Madame Carus and to your entire cherished and interesting family. And believe, my dear and very honorable friend, in all my feelings of profound esteem and devotion and in my sincere and heartfelt friendship.

David

P.S. I was surprised at what you said about my long silence, last summer I wrote to you two different times.

10 Carus to David

Dresden June 5, 1840

My dear friend, you have just finished one of your masterpieces, the statue of the Inventor of printing—and I have just finished and have seen printed the last (3rd) volume of my System of Physiology, a work that I consider the result of 30 years of study and perhaps the most noteworthy of all that I have been able to accomplish for science! How pleasant and useful it would be if we could communicate our ideas to one another in detail, about what we wanted to do, about what we have achieved, and about what we are still not happy with! But you do not come to visit us and I have so little hope at present of going soon to Paris!

Thank God that you have recovered your health!—but it still seems to me that something remains to be desired! Come then! I will try to cure you! Nearby we have excellent spas! But you are too busy. Take care that your art does not become the enemy of your life—since ultimately we need life in order to continue to pronounce well the ideas that God and nature have given us in order to make them grow.

Your idea "And there was light" pleased me very much. However, there are still shadows to be conquered! But this will come with time—

It is like this as well in our science! Light combats darkness and it will vanquish it. I am thinking of writing one of these days to Monsieur Flourens to notify him of the completion of my Physiology, the first two volumes of which have had a very great success in Germany. I would like the Institut to take some notice of it!

You are very kind to still remember my paintings and I will be happy to send you whatever you wish. However, you will have to accept two instead of one. For if you remember there are two paintings, one the window of the beloved virgin, and the other of the dead knight, after Schiller's ballad "The Knight of Tockenburg"[sic]. Tell me how I should send them to you and if I should send them with the frame—if not then you must order a frame for the two paintings just like this one [sketch].

I recently read in one of our best newspapers "A Visit to David's atelier," in which they spoke a great deal about the Liberty statuette that you call your mistress! If you ever have an opportunity to send it to me you will make me very happy.

This spring I became acquainted with one of your travelers from the North, Monsieur Gaimard with his two painters Giraut [sic] (who purchased a sketch from me and from Tiek [sic]) and Lauvergne. If you ever see Monsieur Guimard, he can tell you about my new method of measuring the head and about the scientific basis that I described in the 3rd volume of my Physiology of Cranioscopy!

Farewell then my very dear friend—write me soon about the paintings (believe me, I have *not* had a letter from you during the entire year of 1839). My entire family, thank God, is in good health and they send you their warm greetings. Remember me to your kind and wonderful wife. Be assured of the sincere friendship of your completely devoted

Carus.

Rietschel sends you his greetings! He is thinking of paying you a visit in one or two years. He is presently busy with decorating our new theater with two pediments and with statues of Schiller, Goethe, Mozart and Gluck.

11 David to Carus

June 17, 1840

My worthy and honorable friend,

I was very happy to receive your kind letter. I am happy to learn that you have completed your major work. It is a beautiful monument that you have erected to humanity and to your own glory and what will you do next, because you still have, thank God, many years of life remaining to be an example and to be useful to your fellowmen.

I am very happy that you have responded so generously to the request I had made. You have doubled my hopes. I am going to have two of your interesting productions! A thousand thanks. In this case you can address them, dear friend, to Monsieur Rittner and Goupil, print merchants, 15 Boulevard Montmartre ["near the passage du Panorama," crossed out] in Paris. Send your paintings without frames.

When I return from Strasbourg I will send you the small statue of the Liberty and the sketch of the statue of Gutenberg.

When you send your communication to the Institut everyone will immediately start talking about it because Monsieur Flourens has a profound respect for your works and he will not delay in expressing this respect in an appropriate way.

I am very content to learn that Monsieur Rietschel is still busy with great and noble works. All the better for art because he will leave beautiful examples to emulate.

Emilie, who will never forget your very interesting family, asks me to send her warm regards.

Please give my sincere regards to Madame Carus and believe, dear friend, that you are always present in my thoughts and in my heart.
> David

Paris June 17, 1840

12 David to Carus

Strasbourg June 31, 1840

My good and dear friend,

This letter will be given to you by my friend Carnot, a man who is extremely distinguished by his character and his literary merit. He is the son of our great and immortal Carnot, former Minister of War. He has lived in Germany for many years.

Be kind enough to do for him anything that you would have done for me. I am confident in advance that you will appreciate all of his merit and that meeting him will be very pleasant for you.

I feel very sad being so close to you and not being able to spend a few moments with you but numerous and pressing works force me to return promptly to Paris.

Farewell dear and very good friend and believe in all the most sincere feelings of my heart.
> David

Madame Carnot is accompanying her husband. Please remember Emilie and me to your good and affectionate family.

Strasbourg June 31, 1840

13 David to Carus

Paris January 6, 1841

My dear and honorable friend, I have only been the owner of your two paintings for a few days since I had to go to the company of Rittner and Goupil to ask if they had received a package for me from Dresden. This case had been in their store for a very long time but they didn't know to whom it was addressed. Finally I am happy for I have at my disposal your two very interesting works. They are currently being framed in the way in which you had sketched in your last letter. Looking at these works is going to make me very happy because they are full of feeling and they are the representation of such a touching story. Above all they have been with you a long time. They are two guests who have left the paternal house in order to ["make," crossed out] live in a new home which is not completely unworthy of them. There is a wealth of delightful impressions in the works of art that come from the hand of a man one admires and loves. A thousand thanks.

I have ordered a small case containing two sketches in plaster, one of the Liberty and one of the statue of Gutenberg, to be delivered to Messieurs Rittner and Goupil. You will also find a description of the festivities at Strasbourg for the inauguration of the statue of your famous compatriot and a copy of the Almanach Populaire of 1840 in which I have placed an article on this sculpture.

You would be very obliging, dear friend, if you could send me some notes on Friedrich, your illustrious master. Anything that you would be able to get for me concerning this man I would accept with profound gratitude since he is, as far as I am concerned, the greatest genius among all the landscape painters whose works I know. And add to this his so singular and melancholy character! His very simple life, his very remarkable modesty, everything about him has left an indelible impression on my soul. The moments are few when my memories of him do not come to mind. Without you I would never have known him ["remarkable fact," crossed out]. A unique aspect of this is that you revealed him to me. I truly believe that he is only understood by you in Dresden. In your Germany, as in all other countries, merit conjoined to a modest character is often recognized only after death.

I am very much afraid that the figure of Liberty that I am sending to you will be confiscated by German customs. The rulers of all countries fear it even in painting. They are right because Liberty is the Sword of Damocles suspended continually above their heads. It is the powerful voice of humanity that will be heard one day from one end of the earth to the other. This sun will not leave one part of the earth in shadow while the invigorating rays will spread out over the other part because we have printing.

My very good and dear friend, please give my humble respects to the Carus ladies and remember Emilie to them.

Yours completely in my heart,
David

Please remember me to Monsieur Tieck and to my friend Vogel.

14 David to Carus

Paris March 14, 1843

Dear friend,

Enclosed I am sending you a note of two hundred francs to pay for the small painting and the sketches by our Friedrich.

Thank you very much for your thoughtfulness in sending me also the biographical article that you have written on this great artist. No one but you could have done it ["so," crossed out], worthily, you who have such a lofty feeling for the arts! How deeply I regret not being able to read you in your language in order to understand your learned evaluations of the genius of the master. I will have to have a translation made of your brochure.

It has been only a few months since I have been back in Paris. I have seen again the Pyrenees and Spain with great joy. I still feel a powerful attraction for these sublime countries. It is the sun there, the sun which I need to reanimate my imagination. If ever you have a few months free then come see our southern France. You will see that one can discover there great and noble inspiration ["for," crossed out]. As far as Spain is concerned, nature is savage and energetic there. One cannot imagine it without having seen it.

The Academy is currently busy replacing Monsieur Larrey who has been dead for almost six months. There is a great manipulation among the quite distinguished applicants who are waiting in line, but the one incontestable genius is Doctor Lallemand, dean of the Academy of Montpellier. Two years ago he published a work of the greatest philosophical importance entitled *Des pertes séminales* and he has just completed microscopic research on zoospermes which is expected to cast great light on questions of embryogeny that have been quite obscure up until now. These investigations, brought together in a lecture that the doctor read at the Institut, have contributed largely to accrediting and confirming the thesis of the very enlightening work that Monsieur Serres published on embryogeny. These are works that have created a sensation in the scientific world.

You have no doubt heard of my struggle with the Catholics concerning the figure of Luther that I placed on the low relief of Europe. In order to pacify as much as possible these spirits embittered by religious passions, I have replaced Luther with Montesquieu. Is it possible that religious quarrels could be so exacerbated in our times? This is very sad.

When the monument is lithographed I will send you a copy so that you can have an idea of the composition.

The monument executed in memory of Bichat that I made for his hometown has just been cast in bronze. I have tried to represent the work of this immortal physiologist (*De la vie et de la mort*) in a group. I will try to have a description of it sent to you.

More than two years ago the statue of the great surgeon Ambroise Paré was inaugurated in Laval, his hometown. I am happy to have attempted to render in bronze the features of these two great men.

I am currently executing in marble the colossal bust of Humboldt. For a long time I have wanted to pay homage to this superior and powerful intelligence.

Farewell dear friend. Believe in all my very sincere feelings of friendship and in my limitless devotion to you.

 David

Please give my respects to the ladies and remember Madame David to them. Do not forget to tell my dear Vogel that we think of him often and that we love him with all of our hearts.

I would be obliged if you would acknowledge receipt of the bank note.

15 David to Carus

Paris August 7, 1843

Dear friend,

I did not want to answer your letter sooner because I wanted our friend Monsieur Rietschel to take it to you in person.

I read with very great interest your new ideas on the human skull. Your system, it seems to me, could not be more enlightening. It is unquestionable and most powerfully argued. And this system should simplify in a singular manner the studies of a science so worthy of being seriously investigated by philosophers.

Monsieur Flourens is one of these men who fear that the system of craniology is detrimental to the idea of *free will*. This is a serious matter for the bigots! These men have nothing but prejudices and do not have the noble idea of investigating the wonders of creation. This idea of creation which can lead us to make errors, nonetheless reveals a hidden meaning for many men. But genius unveils this meaning little by little by elevating it to the divine principle with admiration and veneration.

In France there are many of these reactionary bigots who in serving the views of the government which believes bigotry will win the sympathy of the legitimists and the priests, serve their personal ambition as well. Our dear colleague would like to be named Pair of France. This idea stimulates him much more powerfully than scientific truths. He should write to you for you would be able to prove to him with your powerful reasoning that there are men who love the naked truth better than lies covered with decorations and vain titles that are often only awarded by contemptible governments.

Dear friend, you will receive very shortly the bust of Goethe for the library of Dresden. I experienced great joy in working on it. It inspired a multitude of great and noble feelings. I had the great advantage of being able to contemplate the greatest men of the period, these human types, while living, reflecting divinity, these priests that nature sent to explain her sublime enigmas.

I am sending you several engravings and a biography in addition to pieces of paper with signs that will make you think of your friend. You will be seeing a lithograph of Bichat's monument. I assigned myself a very simple program. I thought of the noble mission of the doctor, who takes man from the cradle, supports him up until the tomb and there in the debris of death looks for the mechanism of life. This trilogy interested me, this passionate life that condemns itself to study a life so tender that it does not understand itself. And finally the other that is there, on the ground, formidable mystery of terror.

I have also thought of the number 3, such a respectable number of all beliefs . . . The statue of the young child is the portrait of my dear Robert, perhaps being placed next to a great man will bring him good luck. And thus I have further satisfied a heartfelt need not to separate my life as an artist from all the attachments that provide me with a small world of consolation in the midst of that which offers to my soul only horrible dramas and disappointments.

Farewell my dear friend. Believe in my wishes for your happiness and for that of all those like you and accept the assurance of my eternal devotion.

David d'Angers

1 *David to Carus*
Paris 12 décembre 1835

Mon bon et cher ami

J'ai bien tardé à vous écrire je vous en demande mille pardons je suis tellement en-combré de travaux et d'affaires de toutes espèces que les jours disparaissent avec une rapidité qui m'effraye, ne croyez pas que si je ne vous ai pas déjà écrit, je n'en ai pas moins éprouvé un vif sentiment de reconnaissance pour votre bon et précieux tableau représentant le pont de Dresde, Emilie et moi le contemplons souvent il nous reporte en imagination vers le beau et bon pays que vous habitez. et puis nous pensons à l'auteur avec lequel nous avons passé des instants si intéressants mais de trop courte durée, nous reverrons-nous bientôt? je le désire bien de tout mon coeur si c'est une illusion du moins elle est bien agréable pour moi.

peu de jours après votre départ de Paris j'ai déposé chez Mrs. Rittner et Goupil une caisse contenant le buste de Cuvier une petite statue de Mr. Tieck et beaucoup de médail-lons et tous les objets que vous aviez laissé à la maison, il y a deux médaillons en bronze de Retzsch, l'un pour lui et l'autre pour Mlle de (?) et des plâtres que je vous prierai de lui remettre. dans une autre caisse adressée à Mr Vogel, il y a la statue en bronze pour Mr Tieck et beaucoup de médaillons, veuillez donc vous informer auprès du correspondant de ces messieurs où sont ces caisses.

Mr Jourdan n'a encore rien reçu de vous, et il est très étonné que la traduction ne vous soit pas encore parvenue car elle vous a été expédiée depuis plus de deux mois il m'a promis de prendre des informations à cet égard.

M. Vavasseur m'écrit que les exemplaires ont été exactement remis aux personnes auxquelles ils étaient destinés, qu'il vous écrira sous peu de jours en vous envoyant le travail de Gerdy sur les *hernies*.

adieu cher ami croyez à l'entier dévouement de votre ami de coeur.

David

Veuillez présenter mes respectueux hommages à Madame Carus. Le buste de Mr Tieck sera terminé en marbre sous peu de jours

2 David to Carus

Paris 19 janvier 1836

Mon bon et cher ami

Je reçois à l'instant une lettre de Mr Jourdan il me fait des excuses d'avoir tant tardé à me donner les renseignements que je lui avais demandés pour vous. Son excuse et bien valable car il est à peine en convalescence d'une longue et douloureuse maladie qui l'a privé pendant deux mois de tout [crossed out] repos et de toutes ses facultés. il dit que son libraire ne conçoit pas que vous n'ayez pas reçu l'exemplaire de votre ouvrage mais qu'il va vous en renvoyer un autre qui sera joint à un envoi qu'il adresse à Mr le Professeur Prechlt pour l'académie chirurgicale de Dresde et qui part ces jours ci, il n'a point entendu parler non plus de votre envoi, il va faire prendre des informations chez Mr Truttel et Wurtz.

Le froid est très vif ici, c'est ce qui a empêché le jeune dessinateur, chez lequel je vous ai conduit, de pouvoir monter sur les tours de notre dame pour faire le dessin qu'il vous avait promis, mais cela se fera au premier beau temps qui nous viendra. l'aspect de la nature est triste et maladif dans l'hiver, c'est une crise qui la rend aussi farouche qu'une belle femme dans de certaines circonstances critiques de sa vie, le mieux est de rentrer dans la retraite afin de se rappeler sa sublime beauté et c'est un incompréhensible effet de l'imagination que celui qui nous représente les effets de la nature plus extraordinaires que dans la réalité, certes la matière serait inhabile à produire de pareilles impressions!

Adieu mon bon ami. Soyez tous heureux ce sont les voeux bien sincères d'Emilie et de moi, et croyez à mon entier dévouement de coeur.

David

3 David to Carus

Paris 28 mars 1836

Mon bon et honorable ami

Vous aurez sans doute pensé que j'étais bien négligent à votre égard, il y a déjà bien longtems que j'aurais dû vous avoir répondu sur les renseignements que vous m'avez demandés, en vérité mon temps passe avec une rapidité incroyable, cela vient sans doute de l'immensité d'ouvrages différents que j'ai en train, c'est je crois mon meilleur système pour entretenir l'inspiration, mais ce qui serait bien important ce serait de pouvoir régler son temps sans nuire à cette même inspiration, et c'est parmi tant de motifs d'admiration pour vous, une de ces qualités qui m'a bien vivement frappé en vous. vous avez ce que Napoléon appelait l'esprit de conduite un homme quarré par la base. aussi quoique vous ayez immensément fait pour la gloire quel immense avenir vous avez encore à parcourir!

Vous trouverez ci inclus la petite note explicative de Mrs Trutel et Wurtz sur l'ouvrage que Mr Férussac avait déposé chez eux pour qu'il vous fût remis.

Mr Flourens m'a dit que l'Académie avait reçu les 2eme, 3eme et 4eme livraisons des planches explicatives de votre ouvrage d'anatomie comparée ainsi que le texte qui s'y rapporte, il dit qu'il vous a écrit au nom de l'académie pour vous remercier et cela dans l'année 1835 en 9bre, si la lettre a été égarée il s'empressera de vous en écrire une autre.

Je vais bientôt expédier pour Dresde le buste de Mr Thieck, je ne sais s'il a éprouvé quelque satisfaction de sa petite statue en bronze que Mr Vogel a dû lui remettre de ma part.

Votre buste est déjà ébauché en marbre j'espère aussi bientôt vous demander un azile pour lui dans votre salon.

et Mr Fréderic que fait-il de grand en peinture, actuellement? quel génie! je n'avais encore rien vu de si poétique que ses ouvrages, il faudra que nous tâchions d'avoir à Paris un de ses grands tableaux, c'est une affaire que je vous prierai de me négocier dans un temps qui ne sera peut-être pas long.

Adieu cher ami Soyez heureux et pensez quelques fois à vos amis de la rue d'Assas qui vous ont voué un bien sincère et profond attachement.

David

Présentez mes respects et hommages à ces dames Emilie me charge de la rappeler à leur souvenir

4 *David to Carus*

Paris 25 août 1836

Mon bon et cher ami

Hier j'ai confié au roulage votre buste en marbre, c'est la maison Rittner et Goupil qui a bien voulu se charger de ce soin, il me faut espérer que dans une vingtaine de jours il pourra vous être remis. Recevez le comme un souvenir d'un homme qui vous est bien sincèrement attaché de coeur. Si vous saviez, cher ami, combien j'ai eu de plaisir à m'occuper de cet ouvrage, je croyais encore vous entendre et jouir de ces trop courtes conversations, qui ont laissé des traces bien profondes dans mon esprit! chaque pensée d'un homme distingué est un rameau qui lie notre existence morale à la sienne c'est aussi ainsi que se tiennent les générations, par une chaîne formée par le génie.

Notre bonheur intérieur s'est accru Emilie est accouchée, depuis un mois, d'une fille bien portante. notre bon Robert grandit beaucoup, et son bon et aimable caractère nous rend bien heureux.

Je travaille toujours avec une très grande activité afin de pouvoir terminer les travaux qui me retiennent encore à Paris, et qui après qu'ils seront terminés me donneront la faculté de mettre notre projet à exécution, et passer quelques jours à Dresde. Depuis quelques mois j'ai été chargé de l'exécution de deux statues colossales, l'une Guttemberg pour la ville de Strasbourg, et l'autre pour Béziers, c'est celle de P. Riquet l'inventeur de ce fameux canal qui joint les deux mers et qui est une source de prospérité pour le pays.

Je viens aussi de terminer la statue d'un jeune tambour Républicain, qui blessé mortellement fut sommé par les vendéens de crier vive le Roi, pour toute réponse il pressa la cocarde tricolore sur son coeur. Ce jeune courage fit prendre une délibération par la Convention qui décréta que le monument de cet héroïque enfant serait placé au Panthéon. mon intention est de donner ce monument à la nation. ce genre de travail est une prière de mon culte politique.

Je m'occupe aussi de la composition d'un monument qui sera bien important pour moi. c'est le tombeau d'un général tué en Espagne, il sera représenté à cheval à l'instant où

il reçoit la mort, ce groupe sera placé sur son tombeau. Sur le piédestal il y aura quatre grands bas reliefs représentant les batailles auxquelles ce général a pris part. c'est ce monument que j'espère aller terminer en Italie.

Adieu bon et bien cher ami, pensez quelques fois à celui qui vous est dévoué de tout coeur.
David

Emilie se rappelle à votre bon souvenir et vous prie de dire bien des choses amicales à Madame Carus ainsi qu'à ces demoiselles. Veuillez aussi présenter mes respectueux hommages à ces dames.

N'oubliez pas de nous rappeler au bon souvenir des personnes qui ont la bonté de se souvenir quelques fois de nous.

5 Carus to David

Mon très cher et bien estimé ami!

Il y a un temps si long que notre correspondance a été assoupie que je serais bien malheureux si je devois croire que notre amitié ne serait pas plus éveillée qu'elle! Cependant si le bon Dieu veut que deux hommes se rencontrent dans la vie et qu'ils reconnaissent que leur âme et leur coeur se comprennent allors il est bien sûr que leurs âmes se conserveront mutuellement pour la vie ce que Vous autres nommez très bien par une dérivation du mot "âme" – *l'amitié*.

Du reste Vous ferez toujours bien de me donner néanmoins bientôt quelques lignes de réponse – soit il seulement pour prouver que Vous êtes échappé à la Grippe et que Vous Vous trouvez avec Votre excellente épouse et chers enfans en bonne santé.

Quant à nous, nous avons passé aussi par cette épidémie, qui m'a donné terriblement à faire – mais aprésent Dieu merci! tout le monde se trouve bien dans ma maison. – Aussi Madame Rietschel avec son époux était attaquée par la Grippe mais elle se porte bien aprésent et me rapelle souvent la famille David à Paris quand je fais une visite chez elle et je trouve sa chambre ornée de sculptures et de Bas reliefs en gypse.

Moi je travaille aprésent continuellement à mon ouvrage sur la Physiologie et en même temps je dois publier la troisième édition de mon grand ouvrage sur les maladies des femmes (Gynaikologie).

La peinture ne peut pas prospérer avec cela mais néansmoins il-y-a toujours quelque chose dans ce genre qui m'occupe du moins intérieurement. – Je ne sais pas si je Vous avais écrit que la vue des fenêtres de M. Champin en clair de lune a été exécuté par moi au printemps 1836 et que ce tableau m'a été enlevé plus tard par une famille Russe ? – Vous verrez aprésent par la munificence du Prince Héritier de Prusse deux excellents tableaux allemands à Paris sur lesquels je dirige en avant toute votre attention. – C'est le *Jeremias* par Bendemann et les *Hussiter* par Lessing, à Dusseldorf.

Je Vous prie de me dire comment on a reçu à Paris ces tableaux! – Je suis sûr Vous serez étonné par le tableau de Bendemann! Moi je puis dire, que depuis la Chapelle Sixtine je n'ai rien vu de si grand et si digne dans la conception et l'exécution.

Si Vous voyez le comte Baudissin et la famille Cubières faites je Vous prie, bien des compliments de ma part et de la part de ma famille! – écrivez moi de Madame Votre épouse

notre excellente amie à laquelle nous tous font dire mille choses agréables! – rappellez mon souvenir chez les hommes de lettres de l'Institut qui m'ont fait tant d'amitiés à Paris, et dites nous *quand* nous aurons le plaisir de Vous voir tous à Dresde?

 Avec ma vraie et sincère amitié

 Votre très dévoué

 Carus

Dresde le 21 Février 1837

(Bibliothèque municipale d'Angers, Fonds David)

6 David to Carus

Paris 21 mai 1837

 Je profitte de l'occasion que me procure le voyage de M. de Cubière pour vous écrire quelques lignes, trop peu nombreuses malheureusement pour satisfaire le besoin que j'éprouve continuellement de m'entretenir avec vous, vous dont j'aime tant le caractère et le génie, mais que faire? entraîné, comme je suis, par le torrent de mes nombreuses occupations, je me vois contraint de négliger un peu mes correspondances, cependant croyez bien que le coeur ne reste pas inactif, il rapproche les distances il plane au dessus de toutes les entraves causées par le tourbillon de la vie et l'amitié y trouve un sanctuaire éternel.

 Si vous avez les journaux français vous aurez dû voir que les ouvrages des artistes Allemands ont été vus avec intérêt, j'avais déjà vu à Dusseldorf le tableau de M. Bendeman, le jugement que j'avais porté sur ce jeune artiste se trouve raffermi par la nouvelle étude que je viens d'en faire, en relisant mes notes faites dans l'atelier du Peintre je persiste dans mon jugement. à mon prochain voyage à Dresde nous en causerons.

 Dites bien à Mr Rietschell que je lui souhaite toutes sortes de prospérité et je désire qu'il ait souvent l'occasion d'exercer son art qu'il sent et comprend si noblement. je pense que le monument qu'il était en train d'exécuter lors de mon passage à Dresde, doit être terminé cela doit produire un bel effet et je me réjouis bien de pouvoir sous peu l'admirer.

 Le fronton du Panthéon dont vous avez vu l'esquisse est terminé il sera visible au public pour les fêtes de juillet, la statue de Talma va être inaugurée au théâtre français où elle doit être placée, j'ai fait en marbre depuis votre dernier voyage à Paris, la statue d'un jeune tambour Républicain qui meurt en serrant la cocarde tricolore sur son coeur. J'ai actuellement en train celle de Riquet, auteur du canal du Languedoc, Guttemberg pour Strasbourg, celle d'Ambroise Paré chirurgien de Charles IX, pour Laval sa patrie celle du Gal Beaurepaire qui se brûle la cervelle pour ne pas accepter la capitulation de la prise (sic) de Verdun – deux grands grouppes pour la Douane de la ville Rouen, l'un la Navigation, et l'autre le commerce. tous ces travaux doivent être terminés cette année ensuite je ferai mes préparatifs de voyage pour pouvoir quitter la France vers le mois d'avril.

 Adieu cher ami croyez à tous mes sentiments d'inaltérable dévouement.

 David

présentez mes respectueux hommages à Mesdames Carus Emilie me charge de la rappeler à leur souvenir. Quand on aura fait une gravure aux traits du fronton du Panthéon je vous en ferai parvenir une épreuve

7 *Carus to David*

Dresde le 31 Août 37

Mon très cher ami!

J'ai été bien charmé par la lettre que Mons. Cubières a eu la bonté de m'apporter de Vous! – Il y a deux ans que je jouissais le plaisir de promener avec Vous le soir par le beau clair de lune dans les rues de Paris! – souvent j'ai déjà repassé en mémoire plusieurs de nos discours! et le désir de les continuer avec Vous me portait allors souvent à souhaiter des choses qui ne seront pas si facilement réalisées!

Faites moi bientôt le plaisir de m'envoyer la gravure de Votre grand ouvrage pour le Panthéon! je suis très curieux de la voir et j'admire Votre activité qui Vous laisse finir tant et de si grands travaux.

Rietschel vient d'achever aprésent la statue (en gyps.) d'une Nymphe, après un long et assidu travail – il me semble que c'est la plus belle chose que j'ai vu faite par lui! – mais Dieu sait si Mons. de Quandt qui l'avait commandé le laisse finir en marbre! – Sa femme, ma fille, a été accouchée le 28 Août (jour de naissance de Goethe) d'un fils qui me rend très vieux comme il me fait Grand père. La mère et l'enfant se portent bien! –

Il n'y a pas longtemps que j'ai adressé une lettre à l'Institut sur une découverte physiologique. – Je voudrais bien savoir – quel jugement ont porté là dessus des gens comme Mr Flourens, Blainville, etc.? –

Du reste Vous avez peut-être lu dans les journaux (si toutefois les nouvelles de notre petit pays arrivent jusqu'à chez vous!) que notre Roi était tombé malade à Lagbach, de manière qu'il me fallait faire immmédiatement un voyage de 240 lieues pour le soigner et l'accompagner ici. De cette manière j'ai revu une fois les Alpes – et la grandeur de la nature a de nouveau une fois pénétré mon coeur avec cet [sic] doux frémissement qui élargit notre âme et purifie notre esprit! – Faites que Vous exécutez votre projet! –Venez pour quelque temps chez nous! – nous aurons encore bien des choses à discuter! –toute ma famille de même que moi veulent être rappelée au souvenir de Votre excellente et bonne épouse! –*Donnez* bientôt quelques lignes de Votre main à Votre très dévoué ami

Carus

(Bibliothèque municipale d'Angers, Fonds David)

8 *Carus to David*

Mon très cher et bien estimé Ami!

Votre lettre du 2 de ce mois m'a fait un vif plaisir! – comme chaque ligne me rappelle tout votre être votre manière aimable et intéressante de parler, d'exprimer vos sentiments si distingués et même l'individualité de votre art! – Croyez moi! Vous avez en moi un ami bien fidèle et qui conservera le souvenir des journées qu'il a passé avec Vous pour toujours! –

J'ai été ces jours ici beaucoup avec Mons. Coste de Paris – Vous le verrez bientôt dans l'Institut et j'espère il Vous parlera de ce que nous avons parlé ensemble! – C'est un homme qui m'a inspiré beaucoup d'intérêt sous le rapport de son activité pour les sciences na-

turelles ? – quant à la Philosophie il donne peut être un peu trop dans les principes de M. Chateaubriand. –

Mon petit traité sur l'oeuf de l'homme ne manque pas (comme on me dit) d'avoir intéressé vos anatomistes et Vous pouvez dire à Mons. Flourens que dans ces jours même j'ai réitéré ces observations sur les ovaires d'un enfant de 3 jours, et j'ai trouvé de même les oeufs pour la génération suivante déjà développés. –

Je viens de finir la 3eme Edition de mon Manuel de Gynaicologie (en 2 volumes) et bientôt on commencera à imprimer le 1er vol. de ma nouvelle Physiologie laquelle je voudrais bien rendre connue aussi chez vous – elle sera cependant assez difficile à traduire.

Ce que Vous me dites sur Vos ouvrages m'a vivement intéressé et j'attends avec impatience la gravure de Votre grand fronton.

Mon bon Rietschel Vous fait bien des compliments il s'occupe cet hyver d'apprendre le françois – et ne rêve que de venir une fois chez vous pour être une fois au centre d'une *grande* activité pour la sculpture, car ici Vous savez bien, cette activité est bien bornée! –

Son cyclus de l'histoire de l'humanité en 12 Bas reliefs avance bien – Mr. Coste a vu deux achevé. –

Or recevez bien des compliments pour Madame, ma chère et très estimée amie et priez la de me conserver un bon souvenir! – de même recevez bien de complimens pour Votre famille de la part de la mienne et celle de Rietschel. – Son garçon mon petit fils (né au jour de naissance de Goethe 28 août et nommé Wolfgang) devient très gentil. –

*

Cette lettre Vous sera remise par deux familles Russes celle de Mr de Soudianko et Mr de Borodsna qui vont s'établir pour cet hyver à Paris. Ce sont *de très braves gens* et pleins d'intérêt pour les arts principalement Mr de Soudianko; – ayez la bonté de les recevoir avec Votre bonté connue et procurez à ces Dames le plaisir de faire la connaissance de Madame. – Ils sauront Vous raconter de notre vie – et pourrons Vous décrire l'endroit où les bustes que je tiens de Vous, sont placés. Dirigez les un peu dans votre vaste ville – et restez pour toujours le bon ami de Votre Carus

Dresde le 19 Octbr 1837

9 *David to Carus*
Paris 1 mai 1840

Quand vous saurez, mon cher et bien bon ami, combien j'ai été malade depuis le mois de décembre passé jusqu'à cette époque vous m'excuserez n'est-ce pas d'avoir tant tardé à vous écrire? j'ai eu une fluxion de poitrine qui s'est présentée de la manière la plus grave et la plus brutale, au point qu'il m'est resté encore une douleur très violente au poumon gauche et les chaleurs qui commencent à se faire sentir ne m'en ont pas encore débarrassé, cela m'ennuie beaucoup et m'inquiète parfois.

Actuellement j'ai cependant repris mes travaux car il faut que je termine les bas reliefs qui doivent décorer le piédestal de la statue de Guttemberg dont l'inauguration doit avoir lieu le 24 juin à Strasbourg. La statue est déjà terminée en bronze depuis assez longtemps. J'ai représenté Guttemberg à l'instant où il vient de tirer une première épreuve d'essai sur laquelle on lit *Et la lumière fut.* vous savez que c'est à Strasbourg que la bible a été imprimée pour la première fois, pourquoi dans les essais qu'il aura dû faire n'aurait-il pas pris cette

phrase qui peint bien il me semble les résultats de son admirable découverte? – Dans les bas reliefs j'ai représenté les bienfaits de l'imprimerie dans les quatre parties du monde, par des faits et non par des allégories. dans la composition de ce monument j'ai eu moins en vue l'idée de représenter l'invention de l'imprimerie que les bienfaits de ses résultats.

Je serai bien voisin de votre chère Allemagne dans peu de mois, et cependant il me sera impossible de pousser ma route jusqu'à Dresde, et c'est en vérité ce qui me contrarie beaucoup, car j'ai bien besoin de vous voir, mais il faudra que je revienne à Paris pour terminer des ouvrages qui ont été nécessairement retardés par ma longue et cruelle maladie.

J'ai été bien vivement touché de reconnaissance en recevant le petit tableau que vous avez eu la bonté de m'envoyer, cela a occasionné une trêve bienfaisante à la tristesse de ma situation, vous êtes heureux, mon ami, de pouvoir donner à vos amis des preuves de votre souvenir dans un aussi beau langage que celui là; je vous assure qu'en vous faisant compliment de votre talent dans la peinture, je n'exagère pas car toutes les personnes qui voient chez moi la vue de Dresde, que vous m'avez donné, emportent avec elles une haute idée de votre mérite. à propos de cette vue de Dresde je n'ai pas osé lui donner un pendant, ah si j'osais encore aller puiser à la source, il y a un tableau de vous représentant une certaine fenêtre sur laquelle sont des fleurs desséchées, sujet inspiré, je crois, d'une nouvelle de Schiller. ce serait un admirable pendant au premier ouvrage que je possède de vous! mais vous allez me trouver bien exigeant, croyez cependant que je le serais moins si vous aviez moins de talent et si vous aviez moins d'amitié pour moi.

J'ai vu il y a quelques jours Mr Flourens, je lui ai demandé s'il n'avait pas quelque oubli à se reprocher à votre égard, il m'a assuré qu'il avait fait tout ce que vous lui aviez demandé, et il m'a chargé de le rappeler à votre bon souvenir. On va sous peu de jours inaugurer, à Laval, sa ville natale, la statue d'Ambroise Paré, l'une des grande gloire chirurgicale de notre france, on vient de donner une nouvelle édition de son oeuvre, et l'on a fait graver sa statue, et le médaillon que j'ai fait d'après un profil authentique du célèbre chirurgien, pour mettre à la tête de cette nouvelle publication.

Je désire bien que nos chers amis de Dresde se souviennent quelques fois de nous, veuillez ne pas oublier de leur dire combien leur souvenir nous est cher à Emilie et à moi, dites leur que nous leur souhaitons de toute notre âme toutes sortes de prospérités, dites à mon cher Vogel qu'il m'aurait fait un bien grand plaisir s'il s'était rappelé la promesse qu'il m'avait faite de m'envoyer la lithographie de son tableau représentant la vue de son atelier, lorsque Mr Thieck posait pour son buste.

Ne nous oubliez pas non plus Emilie et moi auprès de Madame Carrus et de toute votre chère et intéressante famille, et croyez, mon cher et bien honorable ami, à tous mes sentiments de profonde estime de dévouement et de sincère amitié de coeur.

David

P.S. Je suis bien étonné de ce que vous me dites à l'égard de mon long silence, l'été dernier je vous ai écrit à deux fois différentes.

10 Carus to David

Dresde 5 Juin 1840

Vous venez, mon très cher et bon ami d'achever un de Vos chef d'oeuvres, la statue de l'Inventeur de l'imprimerie – et moi je viens de finir et de voir imprimer le dernier (3eme)

Volume de mon Système de Physiologie, un ouvrage que je regarde comme un résultat de 30 ans d'études et peut être le plus marquant de tout ce que j'ai pu faire pour la science! –Comme cela seroit donc agréable et utile si nous pourrions communiquer en détail sur nos Idées, sur cela que nous avons voulu – sur ce qui nous a réussi et sur ce dont nous ne sommes pas encore content! – Mais Vous ne venez pas chez nous, et moi j'ai si peu d'espoir aprésent de venir de sitôt chez Vous! –

Dieu soit loué que Votre santé s'est remise! – mais encore il me semble qu'il reste encore quelque chose à désirer! – Venez donc! je tâcherai de Vous guérir – nous avons dans notre voisinage des excellentes sources minérales! mais Vous êtes trop occupé prenez garde que Votre art ne soit pas contraire à Votre vie – car enfin nous en avons besoin pour prononcer encore bien des Idées que Dieu et la nature nous ont donné pour les faire germoglier (sic).

Votre Idée "Et la lumière fut" m'a beaucoup plu – Cependant il y a encore bien de ténèbres à vaincre! – mais cela se fera avec le temps –

C'est ainsi aussi dans notre science! la lumière lutte contre l'obscurité – et elle la vainquera. Je pense d'écrire dans ces jours à Monsieur Flourens pour lui annoncer l'accomplissement de ma Physiologie, dont déjà les deux premiers volumes ont eu un succès très grand en Allemagne. Je voudrais que l'Institut en prenne quelques notices! –

Vous êtes bien bon de Vous rappeller encore de mes tableaux et je me ferai un plaisir de Vous envoyer ce que Vous désirez. Cependant il faut allors que Vous acceptiez deux au lieu d'un; Car si Vous Vous rappellez bien ce sont deux tableaux l'un la fenêtre de la vierge aimée, et l'autre du chevalier mort, d'après la Ballade de Schiller "Der Ritter von Tockenburg (sic)". Dites moi comment je dois Vous les faire parvenir, et si je puis les envoyer avec le cadre – si non allors il faut faire faire un cadre commun – comme cela. [sketch]

J'ai lu dans ces jours dans un de nos meilleurs journaux, "Une visite dans l'atelier de David", où on parle beaucoup d'une statuette de la liberté – que Vous appelez Votre maîtresse! – si Vous avez une foi l'occasion de me la faire parvenir, Vous me feriez bien du plaisir.

J'ai fait ce printems ici la connaissance de vos voyageurs du Nord Mons. Gaimard avec ses deux peintres Giraut (qui a pris ici une esquisse de moi et de Tiek et Lauvergne. Si Vous verrez une fois Mons. Gaimard, il pourra Vous raconter de ma nouvelle manière de mesurer la tête et sur la base scientifique que j'ai donné dans le 3eme volume de ma Physiologie à la Cranioscopie! –

Adieu donc! mon très cher ami – écrivez moi bientôt sur les tableaux (croyez moi je n'ai *pas* eu de lettre de Vous, pendant toute l'année 1839). Toute ma famille se porte, Dieu merci! bien et Vous fait dire bien de choses amicales. Rappellez mon souvenir chez votre bonne et excellente épouse. Soyez sûr de l'amitié sincère de votre tout dévoué

Carus.

Rietschel Vous fait dire bien des choses! Il pense de vous faire une visite dans un ou deux ans. Il est occupé à présent d'orner notre nouveau théâtre de deux frontispices et des statues de Schiller, Goethe, Mozart et Gluck.

(Bibliothèque municipale d'Angers, Fonds David)

11 David to Carus

[17 juin 1840]

Mon digne et honorable ami

J'ai reçu avec une bien vive satisfaction votre bonne lettre, je suis heureux d'apprendre que vous ayez terminé votre grand ouvrage, c'est un beau monument que vous avez élevé à l'humanité et à votre gloire, et que ne ferez-vous pas encore car vous avez encore, Dieu merci, bien des années à rester dans cette vie pour l'exemple et l'utilité de vos semblables.

Je suis bien heureux que vous répondiez d'une manière si généreuse à la demande que je vous avais faite, vous avez doublé mon espérance je vais donc avoir deux de vos intéressantes productions! merci mille fois merci, en ce cas vous pouvez cher ami les adresser tout simplement à *Mr Rittner et Goupil marchand d'estampes 5 Boulevard Montmartre* [près le passage du Panorama, crossed out] à Paris.

Envoyez vos tableaux sans cadre.

Je vais à mon retour de Strasbourg vous envoyer la petite statue de la Liberté et l'esquisse de celle de Guttemberg.

Quand vous enverrez votre communication à l'institut, on en parlera de suite parce que Mr Flourens a pour vos ouvrages une profonde estime, et il s'empressera de l'exprimer convenablement. Je suis bien satisfait de savoir que Mr Rietschel est toujours occupé de grands et nobles travaux tant mieux pour l'art car il laissera de beaux exemples à suivre.

Emilie qui n'oubliera jamais votre intéressante famille me charge de la rappeler à son bon et amical souvenir.

Présentez je vous prie mes respectueux hommages à Madame Carrus, et croyez, cher ami, que vous êtes toujours présent à ma pensée et à mon coeur.

David

Paris 17 juin 1840

12 David to Carus

[Strasbourg 31 juin 1840]

Mon bon et cher ami

Cette lettre vous sera remise par mon ami Carnot homme extrêmement distingué par son caractère et son mérite littéraire; c'est le fils de notre grand et immortel Carnot ancien Ministre de la Guerre, Il a déjà habité l'Allemagne depuis de nombreuses années.

Soyez assez bon pour faire à son égard tout ce que vous auriez fait pour moi, et je suis d'avance assuré que vous apprécierez tout son mérite et que sa connaissance vous sera bien agréable.

J'éprouve un bien vif regret d'être si près de vous et de ne pouvoir aller passer quelques instants auprès de vous mais de nombreux et pressants travaux me forcent de retourner promptement à Paris.

Adieu cher et bien bon ami croyez à tous mes sentiments bien sincères de mon coeur.

David.

[237]

Madame Carnot accompagne son mari Veuillez nous rappeler Emilie et moi au bon et affectueux souvenir de votre famille
Strasbourg
31 juin 1840

13 *David to Carus*
[Paris 6 janvier 1841]

Mon bon et honorable ami

Ce n'est que depuis quelques jours que je suis possesseur de vos deux tableaux, bien m'en a pris d'aller chez M. Rittner et Goupil demander s'ils n'avaient pas reçu de Dresde une caisse pour moi, cette caisse était dans leur magazin depuis fort long-tems ils ne savaient à qui elle était adressée, enfin je suis heureux j'ai à ma disposition vos deux intéressants ouvrages et l'on s'occupe actuellement de l'encadrement dans le goût de celui dont vous m'aviez donné le croquis dans votre dernière lettre. la vue de ces ouvrages va me rendre bien heureux car ils sont pleins de sentiment et ils sont l'exposition d'une histoire si touchante. enfin ils ont été chez vous longtemps ce sont des hôtes qui quittent le toit paternel pour [faire, crossed out] en habiter un qui n'est pas tout à fait indigne d'eux, il y a un monde d'impressions délicieuses dans les ouvrages d'art sortis de la main d'un homme qu'on admire et que l'on aime, merci mille fois merci.

J'ai fait remettre chez Mrs Rittner et Goupil une petite caisse contenant deux esquisses en plâtre, celle de la Liberté et une de la statue de Gutemberg, vous y trouverez aussi une description des fêtes de Strasbourg pour l'inauguration de la statue de votre célèbre compatriote et un exemplaire de l'Almanach Populaire de 1840 dans lequel j'ai fait insérer un article sur la sculpture.

Vous m'obligeriez beaucoup, cher ami, si vous pouviez m'envoyer des notes sur frederich, votre illustre maître. tout ce que vous pourrez me procurer sur cet homme sera reçu par moi avec une profonde reconnaissance car c'est selon moi le plus grand génie parmi les peintres de paysage dont je connais les ouvrages, et puis ce caractère si singulier si mélancolique! cette vie si simple, cette modestie si remarquable tout cela a laissé dans mon âme une trace innéfaçable, il y a peu d'instants où son souvenir ne se présente pas à ma mémoire, sans vous je ne l'aurais pas connu, [chose singulière, crossed out], c'est vous qui me l'avez révélé, je crois en vérité qu'il n'était compris que de vous à Dresde dans votre Allemagne comme dans tous les autres pays le mérite joint à un caractère modeste n'est souvent connu qu'après la mort.

Je crains bien que la figure de la Liberté, que je vous envoye, ne soit saisie par la douane Allemande les souverains de tous les pays la craignent même en peinture, ils ont raison car c'est l'épée de Damoclès suspendue continuellement sur leur tête, c'est la puissante voix de l'humanité qui sera entendue, un jour d'une extrémité du monde à l'autre, ce soleil ne laissera pas une partie du globe dans l'ombre tandis que ses rayons vivifiants se répandront sur l'autre, car nous avons l'imprimerie.

Veuillez mon bien bon et cher ami présenter mon respectueux hommage à Mesdames Carrus et rappeler Emilie à leur bon souvenir.

> tout à vous de coeur
>
> David

Veuillez aussi je vous prie me rappeler à l'honorable souvenir de Mr Tieck et à mon ami Vogel.

Paris 6 janvier 1841

14 David to Carus
Paris 14 mars 1843

Cher ami

Je vous envoye ci inclus un billet de deux cent francs pour solder le petit tableau et les croquis de notre frédrich.

Je vous remercie beaucoup de la bonne pensée que vous avez eu de m'envoyer aussi l'article biographique que vous avez fait de ce grand artiste, personne plus que vous ne pouvait le faire [plus, crossed out] aussi dignement, vous qui avez à un si haut degré le sentiment des arts! combien je regrette de ne pas pouvoir vous lire dans votre langue; afin de comprendre vos savantes appréciations sur le génie du maître. il va falloir que je fasse faire une traduction de votre brochure.

Il y a peu de mois que je suis revenu à Paris. j'ai revu avec un bien grand bonheur les Pyrennées et l'Espagne, et je me sens encore un puissant entraînement vers ces sublimes contrées, c'est du soleil dont j'ai besoin pour ranimer mon imagination. Si jamais vous pouvez, cher ami, disposer de quelques mois venez donc voir notre midi de la france vous verrez que là peuvent se trouver de grandes et nobles inspirations [pour, crossed out] à l'égard de l'Espagne c'est une sauvage et énergique nature dont on ne peut se faire une idée quand on ne l'a pas vue.

On s'occupe actuellement, à l'académie, du remplacement de Mr Larrey, mort depuis à peu près 6 mois, il y a un grand tiraillement par rapport au grand nombre de concurrents bien distingués qui sont sur les rangs, mais celui dont le génie est incontestable c'est le Docteur Lallemand doyen de l'académie de Montpellier, il a fait paraître depuis 2 années un ouvrage de la plus haute portée philosophique, *intitulé des pertes séminales*, et il vient de faire des travaux microscopiques sur les zoospermes qui doit jeter un grand jour sur les questions d'embriogénie encore bien obscures jusqu'à ce jour, ces recherches consignées dans un mémoire que le Docteur a lu à L'institut, viennent donner une grande force de raison à l'ouvrage si lumineux que Mr Serres a fait paraître sur l'embriogénie. Voilà des ouvrages qui ont fait sensation dans le monde savant.

Vous avez sans doute entendu parler de mes luttes avec les catholiques, à l'égard de la figure de luther que j'avais placée dans le bas relief de L'Europe, pour pacifier autant que possible les esprits aigris par les passions religieuse, j'ai remplacé luther par Montesquieu, conçoit-t-on que dans notre époque les querelles religieuses soyent aussi vivaces? c'est bien triste.

Quand le monument sera lithographié je vous en enverrai une épreuve afin que vous puissiez vous faire une idée de la composition.

On vient de couler en bronze le monument à la mémoire de Bichat, que j'ai fait pour sa ville natale, j'ai essayé de rendre dans un groupe l'ouvrage de cet immortel Physiologiste (*de la vie et de la mort*) je tâcherai de vous en faire remettre la description.

Il y a plus de deux ans que l'on a aussi inauguré à Laval (ville natale d'Ambroise Parré la statue de ce grand chirurgien, je suis heureux d'avoir essayé de rendre par le bronze les traits de ces deux grands hommes.

Je m'occupe actuellement de l'exécution en marbre du buste colossal de Humboldt depuis longtemps je désirais rendre cet hommage à cette haute et puissante intelligence.

Adieu cher ami croyez à tous mes sentiments d'amitié bien sincère et de dévouement sans bornes.

 David

Veuillez présenter mes respectueux hommages à ces Dames, au bon souvenir duquel Mme David se rappelle. N'oubliez pas de dire à mon cher Vogel que nous pensons bien souvent à lui et que nous l'aimons de tout coeur.

Vous m'obligerez en voulant bien m'accuser réception du billet.

15 *David to Carus*

Paris 7 août 1843

Cher ami

Je n'ai pas voulu répondre plus tôt à votre lettre parce que je voulais que ma réponse vous fût portée par notre ami Mr Rietschel.

J'ai lu avec un bien vif intérêt vos nouvelles idées sur le crâne humain, votre système me semble on ne peut plus lumineux c'est le positif dans toute sa puissance et ce système doit singulièrement simplifier les études sur une science si digne d'être approfondie par les philosophes.

Mr Flourens est du nombre des hommes qui craignent que le système de cranologie ne nuise à l'idée du libre *arbitre*, c'est chose grave pour les dévots! Ces hommes qui n'ont que des préjugés et non ce noble sentiment d'investigation des merveilles de la création qui même dans ce que nous pouvons croire des erreurs a un sens caché pour beaucoup d'hommes, mais que le génie dévoile peu à peu en reportant vers le divin moteur toute son admiration et sa vénération.

Chez nous il y beaucoup de ces réactionnaires de bigoterie qui en servant le calcul au gouvernement qui pense par là s'attacher les carlistes et les prêtres, servent aussi leur ambition personnelle, notre cher collègue voudrait bien se faire nommer pair de France, cette idée le stimule davantage et bien plus puissamment que les vérités scientifiques. Il doit vous écrire et vous pourrez avec votre puissante raison lui prouver qu'il y a des hommes qui aiment mieux la vérité toute nue que le mensonge couvert de décorations et de vains titres, qui souvent ne sont accordés que par des pouvoirs méprisables.

Sous peu, cher ami, vous allez recevoir le buste de Goethe pour la Bibliothèque de Dresde, j'ai éprouvé un bien grand bonheur à m'occuper de ce travail, il a remué une foule de grandes et nobles sensations, c'est un bien grand avantage que j'ai eu de pouvoir contem-

pler les plus grands hommes de l'époque, de ces types humains, vivants, reflet de la divinité, de (sic) ces prêtres de la nature envoyés par elle pour expliquer ses sublimes énigmes.

Je vous envoie quelques gravures et une biographie enfin quelques morceaux de papier avec des signes qui vous feront penser à votre ami – Vous verrez une lithographie du monument de Bichat, je m'étais donné un programme bien simple, j'ai pensé à la noble mission du médecin, qui prend l'homme au berceau, le soutient jusqu'à la tombe et là dans les débris de la mort va chercher le mécanisme de la vie, cette trilogie m'a intéressé, cette vie ardente qui se condamne à étudier celle si tendre qui ne se comprend pas, et enfin l'autre qui est là à terre mystère formidable de terreur, j'ai aussi pensé au nombre 3 si respectable pour toutes les croyances . . . la statue du jeune enfant est le portrait de mon cher Robert, peut être que d'être ainsi auprès d'un grand homme cela lui portera bonheur, enfin j'ai encore satisfait un besoin de mon coeur qui est de ne pas séparer ma vie d'artiste de toutes les affections qui me font un petit monde de consolations, au milieu de celui qui ne présente à mon âme que drames affreux et déceptions.

Adieu cher ami. Croyez aux voeux que je forme pour votre bonheur et celui de toutes les personnes qui vous ressemblent et recevez l'assurance de mon éternel dévouement.
David d'Angers
(Bibliothèque municipale d'Angers, Fonds David)

NOTES

CHAPTER 1

1. "Yesterday *Le Siècle* published a letter by the sculptor Etex containing the speech he was not able to deliver on the tomb of David (d'Angers). In this speech Etex stimulated and encouraged the disciples of this political figure and made a transparent plea to the political passions of the youthful generation. Today *Le Charivari* ... published a serious article entitled "The young Generation" which explicates the meaning of the speech published in *Le Siècle*.... It praises the young generation who, following David's coffin, showed that they were the faithful friends of the Revolution.... The Prefectoral administration has not yet transmitted to me the legal documents concerning the young people arrested at David's funeral." Prosecutor's Office of the Première Instance Tribunal of the Department of the Seine. Bulletin du Parquet, January 10, 1856, Paris Court. "Disturbances at the funerals of David (d'Angers) and at the courses of Mr Nisard at the Sorbonne," Archives nationales, BB[18] 1552. "As for the political friends of the illustrious defunct who had followed the funeral procession, they could not enter the cemetery to which the police forbade entrance. Journalists, leaders, old comrades of the fight for liberty, none found himself able to bid a final adieu. The same thing happened as had happened to Lamennais, Béranger, and François Arago...." Ph. Audebrand, "David d'Angers et son temps," *Romanciers et Viveurs du XIXe siècle* (Paris, 1904), p. 240. A testimony of the importance of David's art and moral example for young sculptors during the Second Empire can be found in the following statement by Léon Fourquet, an intimate friend of the young Rodin and his assiduous correspondent; he wrote to Rodin in April 1862: "... I also like David, the modern, who supported until his death this noble utopia that any strong and free soul likes to support, *Liberty, Equality*...." Archives of the Rodin Museum.

2. Concerning, for example, the acquisition by the museum in Lille, in 1903, of the terracotta sketches of the four low-reliefs of the Gutenberg monument: "... first bequeathed to the Louvre by Hélène Leferme, daughter of David d'Angers; since we do not have enough room to exhibit them, she agreed with me that I propose to you [to send them to the Museum of Lille]." The Director of National Museums to the Minister of Public Instruction and Fine Arts, March 21, 1903, Archives nationales, F[21] 2265. Acquisition of a bust of Saint-Just in marble from Robert David d'Angers for 5,000 Francs in March 1882. Archives de Paris, VR 105. In 1881, The Louvre turned down the acquisition of this work, in spite of the fact that the letter by Robert David d'Angers offering it was inscribed: "To be bought, if possible" (crossed out) and "important." Archives nationales, F[21] 295.

3. L, Courajod, "Le nu héroïque et académique," *Leçons professées à l'école du Louvre (1887–96) publiées par H. Lemonnier et A. Michel*, vol. 3 (Paris, 1903), p. 397.

4. "Proposition by Mr. David d'Angers adopted by the Committee [of the Interior]." Archives nationales, F[21] 496. *Le Budget des Beaux-Arts de la Ville de Paris* (Paris, 1879), p. 8.

5. Bust of David d'Angers by L. Perrey for the facade of the Luxembourg Museum; decision of February 24, 1886, Archives des Musées Nationaux, S.4.

6. Statue by L. Noël, inaugurated on October 24, 1880. "A cable informs us that during the inauguration ceremony of the [government] Ministers, some drunks mumbled some protests which decency cannot tolerate, such as 'Long life to the Jesuits," and the Ministers have been somewhat jostled by the crowd...."

La Justice (October 25, 1880). Concerning this work see the file preserved at the Archives départementales de Maine-et-Loire, 173 T8.

7. J. de Caso, "L'Inventaire après décès de David d'Angers et quelques remarques," *Gazette des Beaux-Arts* (September 1980), pp. 85–97.

8. Emilie David to Madame Victor Hugo, Paris, July 14, 1857. Archives of the Maison de Victor Hugo, Paris, correspondence, No. 3730.

9. *Collection de portraits des contemporains d'après les médaillons de P. J. David d'Angers sous la direction de P. J. David, P. Delaroche et Henriquel-Dupont par le procédé Collas* (Paris, 1838). The relationship between David and Collas seems to have begun in 1833. David to Collas, Paris, May 1, 1833, Bibliothèque d'art et d'archéologie, Paris, Box 37.

10. Emilie David to Count de Las Cases, December 28, 1863, private collection.

11. L. Aragon, "David d'Angers et l'art national," *La Nouvelle Critique* (May 1956), pp. 158–192.

12. Ch. Blanc, "David d'Angers, 1789 (sic)-1856. Ses médaillons," *Les Artistes de mon temps* (Paris, 1876), pp. 129–144.

13. H. Delaborde, "David d'Angers, ses oeuvres et ses doctrines," *Revue des Deux Mondes* (May 15, 1878), pp. 423–445.

14. See the interesting collection of manuscript poems addressed to David by "populist" writers including Jean Journet, among others, preserved at the Bibliothèque municipale at Angers. The David Papers are catalogued: Mss. 1872 to 1875.

15. Letter by Auguste Girard to David d'Angers, Saint-Denis, April 18, 1848, Bibliothèque municipale, Angers.

16. As early as June 8, 1832, David wrote from Paris to Mickiewicz at the Comité Polonais in Dresden: "My dear good friend, . . . You know without doubt what is happening in France; the future is laden with heavy clouds; only later will we know whether they contain a tempest, or else a beneficient rain. . . ." Paris, Bibliothèque Polonaise.

17. H. Delaborde, "Sculpteurs Modernes. Lorenzo Bartolini," *Revue des Deux Mondes* (September 15, 1855), p. 1235–1268.

18. Delaborde, "David d'Angers," p. 435.

19. J. de Caso, "Sculpture et Monument dans l'art français à l'époque néo-classique," *Still une Ueberlieferung in der Kunst der Abendlandes*, vol. 1 (Berlin, 1967), pp. 190–198.

20. "Le Monument de la place de Reims," *Oeuvres complètes de Diderot*, ed. J. Assézat, vol. 13 (Paris, 1876), p. 30; S. Rocheblave, *Jean-Baptiste Pigalle* (Paris, 1919), pp. 226–232. On the fortune of the statues of Louis XV by Pigalle and Cartellier, and the attempts by the Reims city council in 1848, 1885, 1894, 1900, and 1902 to depose the statue, see Ch. Sarazin, "La Place Royale de Reims," *Travaux de l'Académie nationale de Reims*, vol. 128 (Reims, 1911), pp. 1–159.

21. Voltaire to d'Alembert, June 22, 1770, *The Complete Works of Voltaire, Correspondence,* . . . ed. Th. Besterman, vol. 36 (Banbury, 1975), pp. 272–273.

22. M. de Mopinot, *Eloge historique de Pigalle* (London, 1786), p. 7.

23. P. Patte, *Monuments érigés en France à la gloire de Louis XV* (Paris, 1765), p. 95.

24. F. H. Dowley, "D'Angiviller's 'Grands Hommes' and the Significant Moment," *The Art Bulletin* (December 1957), p. 259–277.

25. Letter by Vleughels, August 24, 1730, cited by A. Roserot, *E. Bouchardon* (Paris, 1910), p. 24.

26. P. de Longuemare, "Les statues de Louis XIV à Caen," *Réunion des Sociétés des Beaux-Arts des départements* (1898), pp. 472–473.

27. J.J. Rousseau, *Discours qui a remporté le Prix à l'Académie de Dijon . . . si le rétablissement des sciences et des arts a contribué à épurer les moeurs*, 2nd ed. (London, 1751), p. 74.

28. D. Diderot, "Pensées détachées sur la peinture," *Oeuvres esthétiques*, ed. P. Vernière (Paris, 1965), p. 769.

29. E. Falconet, *Oeuvres Complètes*, vol. 2 (Paris, 1808), p. 158. Article read at the Academy on June 7, 1760, and published the same year.

30. D. Diderot, "Observations sur la sculpture et sur Bouchardon," 1763, *Oeuvres Complètes*, vol. 13, p. 41.

31. ". . . The soul judges most beautiful that

which it conceives in the shortest span of time.... I believe that [sculpture] should attempt even further to reduce the minimum amount of time that I need in order to form an idea of the object ... rather than expand the maximum of ideas...." "Lettre sur la sculpture...." *Oeuvres philosophiques de F. Hemsterhuis* (Leuwarde, 1846–1850), pp. 18, 45. (Written in 1765 and published in 1769.)

32. O. de Guasco, *De l'usage des statues chez les anciens. Essai historique*, pref. p. vij (sic) (Brussels, 1768).

33. "[Sculpture demands] a very elevated spirituality. Otherwise, it will only produce that striking object that astounds the ape and the savage. This also leads the eye of the amateur himself, sometimes weary from the monotonous whiteness of these large dolls, accurate in all their proportions in length and width, to abdicate its authority." "Salon de 1859," *Oeuvres complètes*, ed. by Cl. Pichois, vol. 2 (Paris, 1976), p. 671.

34. Falconet, *Oeuvres complètes*, vol. 2, p. 158.

35. In an exemplary, political program—the decoration of the pediment of the church of Saint-Genevieve transformed into a Pantheon—the sculptor Moitte, in 1792, under the guidance of Quatremère de Quincy, agreed by contract "to make a model 16 feet long according to the drawing selected by the Direction of the Département de Paris, and to substitute the changes that could be required...." Archives nationales, F[13] 1938. In a note, David jotted down one of the rare observations made by contemporaries concerning Quatremère de Quincy's political activity during the Revolution: "As a poet Chénier was a passioned royalist; he relentlessly conspired underground in the company of Simion (sic), Royer Collard, Quatremer (sic) de Quincy, Pastoret the Elder, and many others; one day as I was asking the latter for a signature of the poet which I needed in order to transcribe it on his medallion, he told me, I do not have any because I burned all the papers which could have endangered our royalist committee at the moment of his arrest. Here is the truthful confession of one of his accomplices." "Notes de souvenirs rétrospectifs," Private collection.

36. *Convention nationale. Discours prononcé par le citoyen David dans la séance du 17 brumaire, l'an deuxième de la République*. See, on these questions, M. Agulhon, *Marianne au combat. L'imagerie et la symbolique républicaines de 1789 à 1880* (Paris, 1979); L. Hunt, "Hercules and the Radical Image in the French Revolution," *Representations*, 1–2. (1983), pp. 97–117. In 1839, David thought the Arc de Triomphe at the Etoile should be crowned with a "statue of the French People, fifty feet high." Mss., private collection. He returned to the same idea in 1842 in the article "Arc de triomphe," *Dictionnaire politique. Encyclopédie du langage* (Paris, 1842), pp. 86–88.

37. R. Campbell has kindly called my attention to this drawing.

38. The program for the statue of Liberty on the Place de la Revolution "compelled the artists to let the roots of the old base remain visible in the middle of the composition of the new base. This former pedestal, on which rested the statue of a tyrant, serving as a support for the statue of Liberty, could have been a striking emblem of the Revolution for our children ..." "Beaux-Arts," *La Décade philosophique*, vol. 6 (An III), p. 537.

39. *Convention nationale. Rapport fait au nom du Comité de salut public sur l'héroïsme des Républicains montant le Vaisseau "Le Vengeur," par Barère, 21 messidor, an II*.

40. "Monuments révolutionnaires," *Revue républicaine*, vol. 3 (1834), p. 155–159. The preceding year, Cavaignac had written about this project in the *Revue*'s prospectus: "If the gratitude of the nations ever erects a statue to the grand city, one will not see the colossus laden with the attributes of that frivolous industry that provides Europe with its fashions made smaller and crowned with roses in memory of the Opera because of the feeble grace and the manners of elegant society. He will hold in his hand the torch which enlightens and enflames Europe, the pike, popular weapon, crowned with the cap of Liberty; he will have for a pedestal the debris of a throne, the pavement of our public squares, and the tricolor flag will serve as a belt around his broad hips."

CHAPTER 2

1. *Lettres de P.J. David d'Angers à son ami le peintre Louis Dupré publiées . . . par Robert David d'Angers* (Paris, 1891). This correspondence dates from 1814 to 1819. One should add to it the letters cited in Jouin's publications on David and three important letters written by David to the painter Abel de Pujol that are preserved at the Custodia Foundation, Institut Néerlandais, Paris. David's training at the Ecole des Beaux-Arts has been studied by F. Chappey, "1811 ou le début des *Trois Glorieuses.* Eléments pour une étude de l'enseignement de la sculpture à l'Ecole des Beaux-Arts au début du 19ᵉ siècle," *Aux Grands Hommes, David D'Angers*, Fondation de Coubertin, Saint-Rémy-lès Chevreuse, 1990, p. 71–99.

2. This lacuna is now partially filled by the publication of the *Correspondance des directeurs de l'Académie de France à Rome*, vol. 2, *Directorat de Suvée, 1795–1807*, ed. by G. Brunel and I. Julia (Rome, 1984), pt. I and II.

3. The terms are borrowed from the published criticism of Canova's *Creugas*, exhibited in Paris in 1803. "Nouvelles. Variétés," *Nouvelles des arts*, vol. 3, no. 1 (1803 [An XII]), pp. 161–164.

4. ". . . If your imagination is so inclined, you should make figures of 'caractère' (I mean figures between twenty and forty years of age) and not youthful figures, before the direction of your career becomes established; and above all, you should draw a great deal. . . ." Dejoux to David, January 10, 1813, published by Jouin, "Lettres inédites d'artistes français," *Nouvelles Archives de l'art français*, vol. 16 (1900), pp. 23–24.

5. "Notice historique sur la vie et les ouvrages de M. Dupaty. . . ." *Recueil de notices historiques. . . .* (Paris, 1834), p. 357.

6. C.P. Landon, *Annales du musée et de l'Ecole moderne des Beaux-Arts . . . Salon de 1812*, vol. 2 (Paris, 1812) p. 95.

7. M. Legrand, *Rude, sa vie, ses oeuvres, son enseignement. Considérations sur la sculpture* (Paris, 1856), p. 83.

8. See above chapter 2, note 1. Letter from David to Roland, Rome, May 23, 1812, pub-lished by P. Vitry, *Bulletin de la Société de l'histoire de l'art français* (Paris, 1929), pp. 109–111. The original letter with a sketch of the figure are preserved in the Louvre, Cabinet des dessins, RF12280 V. When the *Young Shepherd* was exhibited in Paris in 1818, the critical, archaeologically oriented discourse "rectified" the subject matter of *Young Shepherd*. "M. P. J. David's *Young Shepherd*, or rather his *Narcissus* is praised because of the merits of the nude. . . ." T. [Emeric-David], "Exposition des ouvrages à Paris par les pensionnaires de l'Académie de Rome," *Le Moniteur Universel* (July 19, 1818), p. 364.

9. Bibliothèque municipale, Angers, David Papers.

10. Ibid., David Papers

11. "Canova," *Le Siècle de Napoléon*, 1st ser. (Paris, 1844); "Notice on Canova," Mss., 59 p., private collection. A different text was pub-lished by Jouin, *David d'Angers. Sa vie, son oeuvre, ses écrits, ses contemporains*, vol. 2 (Paris, 1878), pp. 146–158.

12. "Lettre sur Thorwaldsen," *Almanach du mois*, vol. 1 (1844), p. 257–264.

13. Fortoul solicited David to collaborate on a collective publication on modern artists and suggested that David write entries on "Houdon, Julien, Pajou, Chaudet, Moitte, Roland (my master), Lemot, Dejoux; this will motivate useful reflections relating to the intellectual movement of our period." Custodia Foundation, Institut Néerlandais, Paris. See, on this point, diverse studies written by David on these sculptors and published by Jouin, *David* vol. 2.

14. "Notice sur la vie et les ouvrages de Roland, statuaire," *Mémoires de la Société Royale des sciences, de l'agriculture et des arts de Lille* (1845), pp. 366–396; "Roland," *L'Artiste* (November 15, 1846), pp. 18–37; *Roland et ses ouvrages* (Paris, 1847).

15. "Notice sur la vie et les ouvrages de Roland," pp. 372–373.

16. September 26, 1844, published by Jouin, "Dernières lettres, . . ." *Nouvelles Archives de l'art français*, vol. 9 (1893), p. 336.

17. *Les Carnets de David d'Angers . . . publiés par A. Bruel*, vol. 1 (Paris, 1958), p. 236.

18. J. de Caso, "Comprendre Pradier," *Statues de chair. Sculptures de James Pradier, 1790–*

1852 (Geneva and Paris, 1985–1986), pp. 13–47, 113–116.

19. City Art Gallery, Birmingham. Writing about this statue, Diderot reminded his readers of the frequently used technique of casting from the live model: "From the live model they cast feet, hands, and shoulders in plaster. . . . This is a means to approximate the truth of nature without much effort; in fact, this technique is more appropriate for an ordinary caster than it is for a skillfull sculptor." *Salon de 1759–1761–1763,* ed. J. Seznec (Paris, 1967), p. 179; *Louis XV, un moment de perfection de l'art français,* no. 79 (Paris, 1974), pp. 86–87.

20. Museum of Valence. This work is not attributed in the first published catalogues of the Museum of Valence. In these catalogues, it is described as a *Sleeping Nymph* and a *Sleeping Woman,* respectively in 1883 and 1899. The catalogue published in 1914 describes it again as a *Sleeping Nymph* and attributes it to Deseine with a note that refers to another catalogue of 1883 according to which "an ancient catalogue of the Valence library (1837) lists it as having been purchased by the State with the name of the author as Desaix."

21. Landon, *Annales du musée,* vol. 2, p. 44.

22. Emeric-David, "Beaux-Arts. Salon. Huitième article," *Le Moniteur Universel* (December 2, 1819), pp. 1523–1524.

23. Emeric-David, *Recherches sur l'art statuaire considéré chez les anciens et chez les modernes. . . .* (Paris, 1805), pp. 43–44.

24. Chateaubriand, "Lettre sur les Tuileries. Au directeur de *L'Artiste,*" *L'Artiste,* vol. 1 (1831), pp. 133–134.

25. Enfantin and Eichthal Papers, Bibliothèque de l'Arsenal Paris. Mss 7826 4.

26. J.N.M. Frémy, *Statues du Pont Louis XVI* (Paris, 1828). On the government's attitudes concerning public statuary, see M. Agulhon's fundamental article, "La *statuomanie* et l'histoire," *Ethnologie française,* vol. 8, nos. 2–3 (1978) pp. 145–172.

27. Mopinot, *Adresse à l'Assemblée nationale* (Paris 1792), p. 11.

28. H. Lechat, "Documents nouveaux sur Clodion. Projet de monument à Condé et à Turenne," *Gazette des Beaux-Arts,* 3rd ser. vol. 12 (1894), pp. 145–166. This long contract is particularly instructive for the precise details it records concerning costumes, emblems, and the attitudes of the figures.

29. David, "Notice sur la vie et les ouvrages de Roland," p. 390.

30. *Explication des ouvrages de peinture, sculpture. . . .* (Paris 1817), No. 808; *Les Vies des hommes illustres de la France continuées par M. Turpin, . . .* vol. 24 (Amsterdam and Paris, 1767), p. 87.

31. *Encyclopédie, ou Dictionnaire raisonné des arts et métiers,* vol. 7 (Paris, 1757), s.v. *Génie.*

32. "Works created by genius constitute a most peculiar type of hallucination; this is the concentration of an idea pushed to an extreme paroxysm. . . . All other faculties of our organization are focused on this hallucination." *Les Carnets,* vol. 2, p. 276. ". . . In my art. . . it was almost always impossible for me to form a plan and to follow it without amelioration or interruption until the end . . . when I begin a composition, I throw a great many marks (traits) on the paper without knowing exactly what will be left of them; and then in this disorder, a mass of mysterious marks (traits) suddenly assume some kind of physiognomic resemblance; then, I establish my idea. . . ." Ibid., vol. 1, p. 416.

33. "In general, in this figure which otherwise displays a facile execution, one finds a slight exaggeration in the dress and the accessories. The elevation of the right arm, starting with the elbow, is too high. Experience shows that the arm throws something more forcefully when it is lowered. The left hip appears well placed. One would wish that the right thigh and leg be slightly brought back in alignment with the base's plinth and that the line they form indicate a slight curve that is found in nature. The coat's folds do not look like folds that flutter. This should be corrected. The boots are a bit heavy." "Observations critiques recueillies sur les modèles des statues destinées à la décoration du pont Louis XVI," Archives nationales, F^{21} 580. On the whole program, see the documents preserved in the Archives nationales, F^{21} 580, F^{17} 1280, and F^{13} 764.

34. "We will say little about the statues for the decoration of the bridge Louis XVI. The kind of sculpture in which the artist is compelled to reproduce costumes which sometimes

are very bizarre, does not manifest art in its perfection." T. [Emeric-David], "Beaux-Arts. Salon," *Le Moniteur Universel* (July 10, 1817).

35. Bibliothèque historique de la Ville de Paris, Michelet Papers, A 3739, published in *Moi, Paris. Centenaire de la mort de Michelet* (Paris, 1975), p. 52.

36. Statuette of Crillon by Brachard, after a drawing by E. Fragonard, 1818, Manufacture nationale, Sèvres.

37. Archives nationales, F^{13} 1244

38. See, for example, the critical reception of the *Nymphe Salmacis* published in *L'Artiste*, vol. 13 (1837), pp. 178–180; Th. Gauthier, *La Presse* (April 8, 1837); and Bosio's obituary by Ch. Guénot, "Le baron Bosio," *L'Artiste*, vol. 32, 2 (1845), pp. 65–66.

39. On the popularity of this theme, see R. Rosenblum's analysis of Broc's *Death of Hyacinth. French Painting 1774–1830: The Age of Revolution* (Paris, Detroit, New-York, 1974–1975), pp. 339–341.

40. "This statue is one of those that words cannot describe. The difficulties the artist had to overcome are incalculable; it was essential that all of its parts be visible, and that because of the subject's age, each one of them be imperceptible, so to speak." Miel, *Essai sur le Salon de 1817* (Paris, 1817), p. 187.

41. *Les Carnets*, vol. 1, p. 47 (written in 1829). Drawn sketches for the *Prometheus* are preserved at the museum at Angers, *Inventaire général des richesses d'art de la France. Province. Monuments civils. Musée d'Angers*, vol. 8 (Paris, 1908), Nos. 306, 307, 335, 336.

42. "Des religions de l'Antiquité et de leurs derniers historiens." (review of F. Creuzer's *Les Religions de l'Antiquité, considérées principalement dans leurs formes symboliques et mythologiques*), *Revue des Deux Mondes* (May 15, 1853), pp. 821–848.

43. Emeric-David, *Jupiter, Recherches sur ce dieu, son culte . . . précédé d'un Essai sur l'esprit de la religion grecque*, vol. 1 (Paris 1833); Walkenaer, "Emeric David," *L'Artiste. Revue de Paris*, 4th ser. (1845); P. L. Jacob, "Notice sur Emeric-David," in T.B. Emeric-David, *Histoire de la peinture au Moyen-Age. . . .* (Paris, 1852), pp. i–xxx.

44. Notes by David, Bibliothèque municipale d'Angers. "Espercieux, Jean-Joseph, sculpteur," in Jouin, *David*, vol. 2, pp. 175–189.

45. Baudelaire, "Exposition universelle. 1855. Beaux-Arts," *Oeuvres complètes*, vol. 2, pp. 583–584.

46. "I have endeavoured to imprint in the hero's features the deep expression of the heart profoundly ulcerated by long and poignant suffering. I tried to give the marble a heart that quivers under the weight of unhappiness; the prolonged duration of extreme suffering renders the body immobile; Ulysses' general attitude expresses this immobility." Undated notes. In another passage: "Everything resides in the type, Ulysses: knowledge, piety, the divine spirit, experience, strength, resistence, the love of one's country, family, finally a circle, the microcosm, the opposite of humanity, of a class, of a fragment of the being . . . assuredly, one cannot be unaware that Ulysses is the archetype of the social life of the Greek." Letter to Leglay, not dated, Douai, Bibliothèque municipale, Bra Papers.

47. J. Reynaud, "Beaux-Arts. Coup d'oeil sur l'Exposition de sculpture," *Revue encyclopédique* (March 1833), pp. 567–597.

48. Ballanche, *Palingénésie sociale*, in *Oeuvres*, . . . vol. 4 (Paris 1833), pp. 154–155.

49. Baudelaire, "Salon de 1859," *Oeuvres complètes*, vol. 2, pp. 669–682. (Unpublished translation by James Norwood Pratt.)

CHAPTER 3

1. F. B. de Mercey, "La sculpture monumentale en province," *Etudes sur les Beaux-Arts depuis les origines jusqu'à nos jours*, vol. 3 (Paris, 1855), pp. 141–185. The term *statuomanie*, often used in the critical discourse at the end of the 19th century, seems to have been coined first by Auguste Barbier as the title of a long poem in which he apologized to the reader for using such a "barbarous title." "Poésie. La statuomanie," *Mercure de France, Revue universelle de la littérature et des beaux-arts* (November 16, 1851).

2. Cl. Petitfrère, "Fêtes et commémorations

en Vendée militaire. 1815–1915," *Annales historiques de la Révolution française* (July–September 1982), pp. 476–490.

3. C.J.M. Darnis, *Les Monuments expiatoires du supplice de Louis XVI et de Marie-Antoinette sous l'Empire et la Restauration, 1812–1830* (Paris, 1981).

4. Drawings preserved at the Museum of Angers (described in *Inventaire*, 1908, No. 74 to 80) and at the Archives départementales de Maine-et-Loire, T 173 22.

5. "Des principaux ouvrages de sculpture élevés en France par souscription," in Jouin, *David*, vol. 2, p. 314.

6. *Le Bric-à-Brac avec son catalogue raisonné*, vol. 2 (Paris, 1853), p. 261. "Beaurepaire, this Leonidas from Angers . . . But how many hindrances one is bound to encounter in our times of miserable struggle! However, it is impossible to annihilate completely the pages of history." David to Guillory the Elder, July 3, 1854, published by A. Lair, "David d'Angers et la statue de Beaurepaire," *Revue de l'Anjou*, vol. 18 (1889), p. 154.

7. [Chanoine Uzureau], "Le monument à Bonchamps à Saint-Florent-le-Vieil," *L'Anjou historique*, vol. 14 (1913), pp. 201–208; vol. 37, p. 246–252; Archives départementales de Maine-et-Loire, T 173 22; R. Chêne-Morinière, *Les Sépultures de Bonchamps* (Cholet, 1974).

8. "I have reported to the King . . . His Majesty who never recalls without emotion the qualities of devotion of this warrior has approved the homage; . . . the King has even expressed the desire that Mr de Bonchamps' last words be engraved on the monument . . . he asked me to let you know that it would be more appropriate (and that he himself would prefer) that the monument be erected in the church rather than on the public square. . . . However, if some obstacle should make this impossible . . . the King would consent to the execution of the first project, with regret. . . ." The Minister of Interior to the Prefect of Maine-et-Loire (letter received on August 3, 1817), Archives départementales de Maine-et-Loire, T 173 22.

9. Meeting of the commission (which convened between October 31, 1818 and April 16,

1819), minutes of the proceedings of the commission, Archives départementales de Maine-et-Loire, T 173 22.

10. Report to the commission by two members on April 26, 1819. Archives départementales de Maine-et-Loire, T 173 22.

11. "When I made the statue of Bonchamps, I wanted to repay my father's debt of gratitude to the extent it was in my power." Notes by Emilie David (copy), Bibliothèque municipale d'Angers, David Papers. B. Fillon, *Lettres écrites de la Vendée à M. Anatole de Montaiglon* (Paris, 1861), p. 99.

12. Bibliothèque municipale d'Angers, David Papers.

13. In this project, begun in 1819, as in the case of the Monument to Bonchamps, the commissioning parties manifest conflicting attitudes about whether the monument should honor the victims on the site where they died, or in a religious, private site, a church or cemetery. See L. de La Sicotière, *Louis de Frotté et les insurrections normandes, 1793–1832* (Paris, 1889), pp. 524–530.

14. See above chapter 3, note 10.

15. M. Shedd, "A Neo-classical Connoissor and his Collection: J.B. Giraud's Museum of Casts at the Place Vendôme," *Gazette des Beaux-Arts* (June 1984), pp. 198–206.

16. *Les Carnets*, vol. 1, p. 18. The text is hardly legible, since the page has been mounted on a binding-strip.

17. Dr. Daillez, "Les restes de Fenelon," *Mémoires de la Société d'émulation de Cambrai*, vol. 47 (1913), pp. 3–36; M. Douay fils, "Le monument de Fenelon et la Société d'émulation de Cambrai," ibid., vol. 40, pp. 15–24.

18. Archives nationales, F^{21} 4360.

19. Louis Belmas to the Prefect of the Department of North, November 20, 1820, Archives nationales, F^{21} 4387.

20. In his model, David modified the pose of Fenelon in an interesting manner: in August 1821, the architect described the whole project to the mayor of Cambrai specifying that "the statue of the prelate . . . is represented half reclining, the Gospel in his hand, looking at heaven." In June 1823, he reminded the mayor that "since [he] had been forced to remove the

pen from Fenelon's hand, I have looked into the life of the prelate for an episode that offers as many resources as possible to the art of statuary; this is why Mr. David, without changing the pose of the figure, represents Fenelon at the moment when he has just torn a page from his book *Maximes des Saints*. Following this explanation, you will judge whether the inscription should allude to this beautiful deed which honors so much Fenelon's character." David's modification, which called attention to Fenelon's submission after his condemnation by the papacy, was eventually not retained. A. Durrieux, "Lettres de David d'Angers au sujet du monument de Fenelon," *Réunion des sociétés des Beaux-Arts des départements*, vol. 9 (1885), pp. 207–214.

21. "Eloge de Fenelon," read at the Academy on August 25, 1774, *Histoire des membres de l'Académie française morts depuis 1700 jusqu'à 1771*, vol. 1 (Paris, 1777–1785), pp. 285–307. "... M. de Boulogne has succeeded in having deleted a print showing the generous deed of the prelate of Cambrai bringing back the peasant's cow. This act of charity was deemed too humble and plebeian. The relief, however, was executed after this drawing..." "Monument de Fenelon," *Le Frondeur* (January 17, 1826).

22. "Histoire. Littérature," *Le Moniteur Universel* (July 8, 1817), pp. 747–748.

23. The most recent precedent, in the 19th century, for a public monument with historiated reliefs, is that erected to Joan of Arc, in Orléans, by Gois the Younger; the model was exhibited at the 1802 Salon. The pedestal is decorated with three very small reliefs which "span Joan of Arc's whole life." A. Leroy fils, "Aux Rédacteurs de la *Décade philosophique*," *La Décade philosophique*. (1802 [An12], pp. 109–113.

24. On Cartellier, see G. Hubert, "L'oeuvre de Pierre Cartellier. Essai de catalogue raisonné," *Gazette des Beaux-Arts* (July-August 1980), pp. 1–44.

25. "The conception of this type of low relief is entirely based on the principles of the Greeks: the figures are separated and treated in a style of flat relief [méplat]; the contours are emphasized in the background; for this reason, they generate a vigorous shadow which makes the figures appear to be drawn with energy; a broad light that is not interrupted by protruding limbs is cast on the figures.... Espercieux is the only sculptor, after Jean Goujon, who understood monumental low relief, and the sculpture of this fountain can be used by sculptors as a model. Brussels, April 21, 1852." "Espercieux," in Jouin, *David*, vol. 2, p. 185. David wrote numerous analyses of relief sculpture in many published and unpublished writings, including an adulatory study of Callamare's art, a study in which, however, he expressed a reservation: "As all the sculptors of his time, Callamare did not dare to address the real issue of the low relief ... he dropped the style of the works that tried to render the illusion of a painting, but he did not go beyond rendering figures in which contours merge progressively into the background in half of their full relief. This is a *juste-milieu* decision, next to worthlessness. In the low reliefs during the First Empire, the draperies are poorly conceived; in their efforts to reveal the nude body underneath, artists arranged folds that look like strings around the body; one does not see the nude under the draperies, rather one sees the contrary.... December 1, 1839." Draft for the article "Notice sur le sculpteur Callamare," *Revue du progrès politique social et littéraire*, 1st ser., vol. 2 (December 1, 1839), pp. 450–459, published again in Jouin, *David*, vol. 2, pp. 122–146.

26. Griffoul-Dorval, *Essai sur la sculpture en bas-relief ou Règles particulières à observer dans la pratique de cet art* (Toulouse, 1821), pp. 11–12.

27. " Mlle de Fauveau's attempts [at sculpture] have caught the jury's attention. The jury has been surprised by the movement her works display and by their merit. If one follows the austere rules dictated by Taste, above all those that apply to the separation of genres, one would have a lot to say about these attempts. However, if one considers them only as attempts, one is bound to see in them something full of spirit and facility. This would be a remarkable début for a man; for a woman, it is something extraordinary." "Note," Archives nationales, O^3 1427. "There is [at the exhibition] a young lady who gave us this year samples of sculpture in an original genre....

Mademoiselle de Fauveau will effect a revolution in the area of art she cultivates." A. Jal, *Esquisses, croquis, pochades, ou tout ce que l'on voudra sur le Salon de 1827* (Paris, 1828), p. 474.

28. Stendhal, "Procès-verbal de la mort du marquis Monaldeschi, escuyer de la Reine de Suède, novembre 1657, par le père Lebel, ministre des Mathurins de Fontainebleau" (Extrait des manuscrits de la bibliothèque Harléienne, No 3. 493). "Musée britannique," *Mélanges d'art* (Paris, 1932), pp. 189–196.

29. Bibliothèque municipale, Angers, David Papers.

30. Th. Gauthier, "Salon de 1834," *La France industrielle* (April 1–2, 1834), p. 22.

31. "[Préault, *La Tuerie*] an arch-fantastic low relief, is indeed the most miserably bizarre . . . vague and confusing sketch ever modelled by an artist half-drunk. . . . Another fantastic relief, the *Malediction of War*, by M. Venot, at least displays some beautiful heads. . . . To begin with, [Préault's] figures are colossal, without proportions, stacked one on top of the other, God knows how. . . . One more time, we invite M. M. Préault and Venot to dispel promptly and firmly the slackness in which they drop off and sleep." Max. Raoul, "Salon de 1834. Sculpture," *Le Cabinet de lecture* (April 24, 1834). It is interesting to note that David approved of Venot's sculpture. In May 1840, when Venot solicited commissions from the government, listing himself as a student of David, David supported his request in these terms: "I especially recommend . . . M. Venot, who has given proof of his talent and of his understanding of monumental sculpture through the remarkable works that he has exhibited several times." Archives nationales, F^{13} 642.

32. *Le Moniteur Universel* (March 12, 1819). The sculptors Ramey, Lesueur, Bridan, Cortot, David, Laitié, and Raggio were asked to sculpt respectively Pascal, Montaigne, Bossuet, Corneille, Racine, Lafontaine, and Montesquieu.

33. For 18th-century examples of monumental homages to the *Grands Hommes* of arts and letters, see J. Colton, *The Parnasse François. Titon du Tillet and the Origins of the Monument to Genius* (New Haven and London, 1979).

34. [Ch. Lafolie], "Completion of the sketch of the statue of Racine," January 7, 1820 (draft of a letter to David, with corrections), Archives nationales, F^{21} 319.

35. "Do not forget that, contrary to our ideas when we were young, Racine is the Romantic of his time," Delacroix to Soulier, May 29, 1858, *Correspondance générale d'Eugène Delacroix*, vol. 4, pub. A. Joubin (Paris, 1938), p. 35.

36. "Compare this Racine so well [because the costume is well executed] and so poorly dressed [because it is in modern costume] [work by Boizot] to this noble statue so filled with tragic thought that the young David dared to make half-dressed; look and judge! A time will come when M. David will dare allow himself to do even more nudes; people will sense that, for the glory of our *Grands Hommes*, not to erect statues to them, than to base them on the model of the *Racine* in the Church of the Sorbonne." Stendhal, "Des Beaux-Arts et du caractère français," *Mélanges d'art*, p. 172.

37. Dated September 24, 1828, Archives nationales, F^{21} 588.

38. C.P. Landon, *Annales*, vol. 2, p. 27; de Caso, "Sculpture and Monument," pp. 197–198. The monument was expected to be "à la goire du Philosophe de la peinture, Nicolas Poussin." A subscription was organized in 1802 by Chaussard, Espercieux, F. Gérard, Harou Le Romain, Landon, Legrand, and Talma, Archives des musées nationaux, N 19.

39. David to Louis Pavie, Paris, December 3, 1832, private collection. Published with modifications and deletions by Jouin, "David d'Angers. Nouvelles lettres," pp. 211–212.

40. Quatremère de Quincy, *Essai sur la nature, le but et les moyens de l'imitation dans les Beaux-Arts* (Paris, 1823), p. 364.

41. A. Etex, *J. Pradier, Etude sur sa vie et ses ouvrages* (Paris, 1859), pp. 17, 33.

CHAPTER 4

1. Villemain, "Souvenirs de la Sorbonne en 1825. Démosthène et le général Foy," *Revue des Deux Mondes* (January 1853), p. 375.

2. *Les Carnets*, vol. 1, p. 110.

3. Ch. Lucas, "Lettre inédite de Léon Vaudoyer. Un concours public en 1826," *La*

Construction moderne 10 (December 8, 1894), p. 110. On December 2, 1825, G.L. Ternaux, a member of the commission for the monument, suggested among other things that Foy "be represented life size, standing on a rather high pedestal, one hand energetically leaning on his sword, the other holding the constitutional *Charte*, and in the attitude of the orator expressing virtue outraged, with his eyes raised to the heavens." The difficulties that arose between Vaudoyer, who was in Rome, and David, and their disagreements on several theoretical points, are alluded to in the long correspondence Vaudoyer exchanged with his father Antoine-Laurent, who supervised the work on the Foy monument. Archives of the Vaudoyer Family. Fontaine, a member with Percier, Lebas, Gros, Gérard, Horace Vernet, Cartellier, and Cortot of the commission in charge of judging the thirty-six projects presented, identified himself in his diary as the author of the article. E., "Architecture.—Concours ouvert pour le monument à élever au général Foy, ... *Revue Encyclopédique*, vol. 30 (May 1826), pp. 580–584. He described the competitors' entries as weak and questioned the type of judgment that submitted the architects to the decision of a composite jury. P.L. Fontaine, *Journal, 1799–1853*, vol. 2 (Paris, 1987), pp. 706–711.

4. First project by Vaudoyer, Carnavalet Museum. *Inventaire*, 1908, Nos. 120, 121.

5. "... M. David d'Angers is eager to receive the applause of the right, the center and the left; ... he is *omnicole* (sic); he has two camps, two flags, friends in three successive governments; finally, and to state it in a more vulgar manner, he stands between the goat and the cauliflower." "Suite des Fourberies de Scapin," *La Liberté. Journal des arts*, 1st Year, No. 7 (September 1832), pp. 109–112. Republished, with variants, in *Journal des artistes* (July 5, 1846). "One wonders if the statue conceived in this manner is in harmony with the reliefs of the pedestal." G. Planche, "Peintres et sculpteurs modernes de la France. David d'Angers," *Revue des Deux Mondes* (March 1, 1856), p. 78.

6. *Les Carnet*, vol. 2, p. 141.

7. "... The low relief in front with the two children is completed and good; the large low relief on the left is not yet fully ready to be executed in stone. For more than three months, two practitioners, one of whom is very old, have been working on it. As far as the two other low reliefs are concerned, the stones have not been touched, and nothing has begun; so, it seems that the general, who has been dead for four years (September 25, 1825) will not be transferred to his monument this year." Archives of the Vaudoyer Family.

8. "... It is surprising, that the idea to represent the funerary ceremony in low relief has only occured to one competitor.... The manner in which he conceived and sketched it does him great honour...." "Bulletin des arts," *Le Globe* (April 13, 1826).

9. *Journée du 30 novembre 1825, ou récit des derniers moments et des funérailles du général Foy* (Paris, 1825), p. 100.

10. M. Agulhon, "Hugo dans le débat politique et social," *La Gloire de Victor Hugo* (Paris, 1985–1986), p. 191.

11. The only sculpted sketch known for the decoration of the monument (the two Geniuses on the facade) is dated 1829 (private collection). Antoine-Laurent Vaudoyer made vague references to the reliefs David reluctantly executed in situ in his correspondence with his son. It is unclear whether Vaudoyer refers to drawings, sculpted sketches, sculpted models, or to the final work. Thus, the sketch dated 1829 is not necessarily the first one made for the decoration of the facade, unless Vaudoyer had a drawing in mind when he writes to his son on October 27, 1827, about "models": "[Madame Foy] has seen the models; she has asked me for a little booth in canvass [to be placed on the site] for [David]'s practionner who is working on the two geniuses. The three other low reliefs will take more time, she said, because M. David wants to make all the heads, portraits of all those who took part in the events he will represent. She told me that the principal statue was undressed, with a simple cloak, and very lifelike...." Archives of the Vaudoyer Family.

12. "People talked, said Béranger, about erecting a tomb. In this, however, one could see how much Manuel and Foy had differed. Everything that we have since called *juste milieu*,

the bankers, above all, were eager to erect a tomb for the general . . . as for Manuel, nearly all these wealthy people refused to contribute, and we ran into a lot of trouble to gather nine or ten thousand francs with a subscription." Cited by P. Thureau-Dangin, *Le Parti libéral sous la Restauration* (Paris 1888), pp. 311–312. David made the medallion for Manuel's tomb.

13. "I asked Mr Lethière, director of the French Academy in Rome, to authorize me to take a trip to Naples, as the students [of the Academy] usually do, in the last months of their tenure. I made the trip in the company of Pallière, Dejuinne, and Picot, and I met again with my old friend Dupré who was *carbonaro* and was privy to the secret of our expedition. . . . Murat, who had been betrayed in a cowardly manner, had just been shot to death. . . . Since our movement had no reasonable purpose any more, we all agreed to withdraw as secretly as possible. At this moment, I saw all these men, who had been so resolute a few days earlier, think henceforth of their self-preservation, and I saw that gathering—which had been so homogenous with feelings about liberty—about to split, each individual became centered on his own survival." "Un récit de J. P. David d'Angers," trans. A. Bruel, *La Table ronde* (October 1959), pp. 124–134.

14. "I have asked nothing until today, and everything favorable and flattering I ever received, I owed to an attentive friend, or to the protection of the government, without any other commitment on my part except my expression of gratitude . . . I will accept all conditions. . . ." March 28, 1828, Bibliothèque historique de la Ville de Paris, C.P. 3405.

15. L. Blanc, *Révolution française. Histoire de dix ans. 1830–1840* (Paris, 1846), vol. 1, p. 226. (First mentioned in the 1844 edition.)

16. *Les Carnets*, vol. 1, p. 365.

17. Ibid., vol. 2, p. 295.

18. "Election of twelve candidates to the office of Mayor and Assistant Mayor, 1846." Mss. Archives de Paris, VD 6 629.

19. Supplement of *Journal de Maine-et-Loire* (June 21, 1834). A. G., "Bulletin moral et politique des élections," *La Nouvelle Minerve. Supplément* (October 29, 1837). Letter by David to the *Gazette de France*, Paris, February

24, 1839, published by C. Callet, "David d'Angers candidat et Napoléon," *Le Mercure de France* (June 1, 1910), pp. 574–575. *A Messieurs les Electeurs du huitième arrondissement de Paris. Séance préparatoire du 17 février 1839* (printed speech), Bibliothèque municipale, Angers, David Papers.

20. "A meeting of reformers [*réformistes*] took place today in an inn at Montrouge under the presidency of David d'Angers (the sculptor). The issue was the election of a district committee; several speeches were delivered. The gathering, which only consisted of approximately sixty adepts, was terminated after two hours, without noise." January 24, 1841, Archives nationales, F^7 3891.

21. A. G., "Bulletin moral et politique des élections," *La Nouvelle Minerve* (October 29 and November 5, 1837), which published again David's proclamation to his electorate: ". . . the righteousness of his mind and the kindness of his heart. He has experienced unhappiness and abandonment . . . his atelier is open without a fee to all young artists. . . ." See also: *Chambre des députés. Elections 1837–1838.*

22. *Revue du progrès politique, social et littéraire.* Founding Act of the Society, Paris, September 19, 1838.

23. Correspondence of E. Arago with Robert David d'Angers, Archives de Paris, 6 AZ 557 1. "Notes rétrospectives," *L'Almanach du peuple* (1851), pp. 39–47.

24. The drawing is inscribed: "Life drawing of Auguste Blanqui when he was hiding at my home in 1840."

25. "Une visite à Levasseur de la Sarthe," *L'Almanach du peuple* (1850), pp. 39–44.

26. *Les Carnets*, vol. 2. pp. 448–449.

27. Ibid., vol. 1, p. 230.

28. "I have asked Mr. Bosio. . . . The monarch, depicted as a legislator, is seated adorned with regal insignia; with one hand he holds his scepter, with the other he holds the fundamental law he gives to his people. Three low reliefs . . . on one side one sees the successor of sixty kings, preserving the majesty of his rank and of his house in the midst of exile and adversity; with noble pride, he rejects the insolent offers of the usurper of the throne. On the other side, [one sees] the entry of Louis le Désiré in the

Capital ... finally, the prince, liberator of Spain, lays the palm of victory at the feet of the monarch triumphing over the last efforts of the Revolution." Chabrol, Report to M.M. the members composing the municipal council of the city of Paris, July 15, 1825, Archives nationales, BB[17] A 40–44.

29. Guizot, *Mémoires pour servir à l'histoire de mon temps*, vol. 2 (Paris, 1872), p. 69.

30. "There would be real prejudice towards the administration if a new artist should be introduced; he could only modify this monument according to his personal ideas. Contrary to this, M. Huvé would suggest none of his ideas and would limit himself to execute those which would be given to him by the administration." La Rochefoucault to Martignac, May 25, 1828, Archives nationales, F[21] 577.

31. "David said that he would not enter the competition for the pediment of the Madeleine because some of his students were able to do better sketches than he." Rude to Moyne, Paris, February 26, 1832, Custodia Foundation, Institut Néerlandais, Paris.

32. On the Pantheon, see M. Ozouf, "Le Panthéon. L'Ecole normale des morts," *Les Lieux de mémoire*, vol. 1, pub. by P. Nora (Paris, 1984), pp. 139–166; *Le Panthéon, Symbole des révolutions* (Paris-Montréal, 1989).

33. Guizot, *Mémoires*, vol. 2, pp. 71–73.

34. Report from the Direction des Bâtiments Civils to Thiers, April 18, 1833, Archives nationales, F[13] 1145.

35. Memo by Gaulle, Archives nationales, F[21] 843.

36. Drawing with captions, signed: "Baltard, May, 1821," Archives nationales, Versement de l'Architecture, LI 20.

37. Archives nationales, F[13] 1145.

38. See de Caso, "Le romantisme," pp. 100–101, note 23, fig. 87.

39. "... Since the inscription 'To the Grands Hommes' should be the basis of the program of the low relief to be executed ... I have (according to your suggestions) [in the margin] decided that the program will be as follows: In the center, *Motherland* [La Patrie] raised on a platform, to her right is *History* which records the names of the Grands Hommes and *Liberty* which plaits the wreaths which *Motherland* is handing. On each side, there will be groups of Grands Hommes who have distinguished themselves in the sciences, the letters, the arts, and on the battlefield...." Guizot, to David (draft), July 30, 1831, Archives nationales, F[21] 528.

40. Letters from Lafayette to Montalivet regarding the honorific inscriptions concerning Foy, Manuel, and "Bories and his companions," November 5 and 15, 1830, Archives nationales, F[21] 578. This commission was appointed by the decree of August 27, 1830. It comprised among others, Lafayette, Maréchal Jourdan, and Béranger, and was asked to prepare the draft of a bill regulating the conditions and forms of the homages to be conferred in the Pantheon to the July combatants. This commission was distinct from the Commission des récompenses des combattants de Juillet, formed by decree on August 26, 1830. *Nouveau Journal de Paris* (August 29, 1830). In one of his last discourses to the National Assembly, when the question of the homages to be awarded to Larochefoucauld-Liancourt, Manuel, Foy, and Benjamin Constant was debated, Lafayette alluded to the role he played in the first days of the July Revolution. He was influential in deterring the popular initiative in its attempt to carry busts of Foy and Manuel on order to display them in the Pantheon. He also alluded to his role in the Commission des récompenses: "This commission ... drew up a project which was taken to M. Guizot.... He took it upon himself to submit it to the Chamber; the project was to be engraved in gold letters on the walls of the Pantheon; it was preceded by a short and simple preamble in which several names were mentioned, notably one name dear to the friends of Liberty, that of Bories [one of the Sergeants of La Rochelle]...." "Chambre des députés. Séance du samedi 26 février 1832," *Le Moniteur Universel* (February 26, 1832). In May 1831, the government initiated a competition for a monument to be erected in the Pantheon to the memory of the victims of the July Revolution. The Classe des Beaux-Arts at the Institut was approached. A commission comprising Gros, Guérin, Garnier, Cortot, Roman, Ramey the Elder, Percier, Lebas, and Leclère was formed to prepare the program for

"a sculpted monument in which architecture could be represented to a greater or lesser degree." The winner would be decided through a competition. On May 14, 1831, the Académie des Beaux-Arts discussed the project submitted by the commission, approved it, and forwarded it to the government. The report concluded that ". . . each artist individually represented in the competition [should] remain master of his thought . . ." and that the commission could not specify what subject should be represented, ". . . the Académie cannot or must not impose on the competitors the idea it would have adopted; on the contrary, it must encourage the liberty of invention as much as possible. . . ." The Académie, however, prescribed dimensions for the monument: 4 m. 1/2 for its width, 3 for its depth, and 8 1/2 for its height. The monument was to be placed "in the interior of the Pantheon, beyond the steps that are in front of the hemicycle, under the center of the oval vault." Finally, the commission suggested that ". . . the Minister be made aware of the opportunity of an analogous decoration in the space between the pilasters of the hemicycle against which the monument would stand; this would complete it and ensure its all-encompassing effect." Archives de l'Institut de France.

41. Letter to Mercier, Paris, August 31, 1838, incorrectly transcribed by Jouin, "Nouvelles lettres de David," p. 241, and published again by A. Joubert, "Lettres inédites de David d'Angers," *Revue de l'Anjou* (1879), p. 149 (with a misreading in the paragraph in question). The original letter reads: "Je vous avais." Bibliothèque municipale, Angers.

42. "You honored me by coming to my place to see the sketch for the pediment of the Pantheon which is now finished. I would be grateful if you would see that I receive a first installment on the payment. . . ." David to the Minister of Commerce and Public Works, Paris, September 18, 1833, Archives nationales, F^{21} 578. The price for the execution of the work was determined in a decree on August 19, 1833; the first installment was paid on September 30, 1833. Ibid. On August 12, 1834, David wrote to his practitioner Le Goupil to secure his services. Custodia Foundation, Institut Néerlandais, Paris.

43. Bibliothèque municipale, Angers, David Papers.

44. See the description of the project by David in Jouin, *David*, vol. 2, p. 117.

45. Bibliothèque municipale, Angers, David Papers.

46. Jouin, *David*, vol. 1, p. 336.

47. "Nouvelles diverses," *La Quotidienne* (July 26, 1837).

48. N. McWilliam, "David d'Angers and the Pantheon Commission: Politics and Public Works under the July Monarchy," *Art History* 5, 4 (December 1982), pp. 426–446.

49. ". . . without any doubt he will want to suggest to me that I make some changes with certain figures. If he should propose such a cowardly act, I will respond to him as a man with convictions should do. . . ." David to an anonymous correspondent, July 27, 1837, Archives de Paris, 4 AZ1131. A parody of excerpts of the conversation between David and Montalivet was published the following day, July 27, 1837, in *Le Charivari*, "Le Président du Conseil et M. David le sculpteur," pp. 3–4. On July 29, the same journal published a caricature of the pediment under the title: *Facsimile of the Panthéon Pediment, re-examined, corrected and considerably disfigured by order of the Authority, to be substituted for "Anarchy," composition by M. David, which was to be inaugurated today, July 29* (fig. 87). The inscription on the monument's frieze reads: *To the Great Jokers The Grateful Shopkeepers* (Aux Grands Blagueurs L'Epicerie Reconnaissante).

50. Bibliothèque municipale, Angers, David Papers.

51. Proudhon, *Du principe de l'art et de sa destination sociale* (Paris, 1865), pp. 134–144.

52. L. Veuillot, *Mélanges religieux, historiques, politiques et littéraires*, 2nd Ser., vol. 6 (Paris, 1861), pp. 44–45.

53. "One reads in *L'Univers religieux*: . . . Some people claim that Fenelon is included in the groups, I confess that I could not find him; he must have been hidden in the background; this is half an expediency on David's behalf; he understood that the saint archbishop could hardly be found in the company that is given to him. . . ." "Chronique," *L'Europe* (September 6, 1837).

54. "... This is the one that is exactly reproduced...." Notes by Emilie David, Bibliothèque municipale, Angers, David Papers.

55. *Inventaire*, 1908, Nos. 213 to 224, 647.

56. "... One could reproach the artist for submitting to the program in which the July Government imposed the figure of Bonaparte...." A. Pothey, "David d'Angers," *Le Voltaire* (October 21, 1880).

57. *Les Carnets*, vol. 1, pp. 178, 281.

58. Ibid., p. 167.

59. Ibid., p. 170.

60. Ibid., p. 203; vol. 2, p. 426.

61. "At the sight of the great scandal that has just erupted right where we stand, and which exposes itself in broad daylight on our holy hill; in the presence of these more than profane emblems which have replaced the radiant Cross of Jesus Christ; in front of the crowned images of impious, licentious, and corruptive writers ... the faith of the Motherland shouts in pain; the moanings and tears of the clergy, of the pious faithful, of all Christians must answer to it. May this expiation suffice to the heaven!" Mrg de Quélen, *Circulaire. A l'occasion du fronton du Panthéon* (Paris, 1837). *Deux mots en faveur de Mrg l'archevêque de Paris* (Paris, 1837). On the critical reception of the pediment, see Mc William.

62. *Les Carnets*, vol. 1, pp. 181–182.

CHAPTER 5

1. There is little to add to the catalogue of David's oeuvre as published by Jouin in 1878. "Oeuvre sculpté et dessiné de David d'Angers," in Jouin, *David*, vol. 2, pp. 457–529. Jouin completed it in the two volumes of the *Inventaire*, vol. 3 (1885) and vol. 8 (1908) that describe the museum at Angers.

2. The program established in 1828 included (for David) half of the trophies, Fames, and acroterial statues, and three reliefs: *Spain Delivered by Mrg le Dauphin*, *The Taking of Trocadero*, and *The Return to France of the Spanish Army*. "Delibérations du conseil municipal de Marseille, meeting of August 31, 1831," Archives municipales, Marseille, 32 M. On the history of the Arc, see P. Parrocel, "L'Arc de

triomphe de la porte d'Aix à Marseille," *Réunion des Sociétés des Beaux-Arts des départements* (1898), pp. 841–855. The models of David's reliefs were shipped to Marseille by David's widow. The mayor of Marseille to Emilie David, December 1, 1856, Bibliothèque municipale, Angers, David Papers. Under the Second Republic, since the municipality of Marseille was thinking of commemorating the advent of the regime with a monument, David proposed the erection of a colossal Liberty standing on steps at the summit of the Arc; she would be "leaning on a rifle and holding a branch of an olive tree in her right hand...." Letter by David to an unknown correspondent, draft, ibid.

3. "The Departure. The Directory is represented in all Its Majesty and surrounded with the might that is proper to the government of a grand nation. The President is standing and orders an army general, showing him Liberty, to avenge her from the tyrants who want to threaten her rights; Justice promises her protection and arms her with her sword; Victory shows her laurel leaves, and the recruits pay marked attention to the General by striking their shields; several episodes enrich the scene; Women on their knees at the feet of Liberty seem to beg her to bring back their husbands and sons; and others hurry to give them weapons in order to run and save the Fatherland. The Return...." "Subjects of the two low reliefs proposed by citizen Moitte, for the circular segment of the Palace," Archives nationales, F^{21} 586. Engraved in C.P. Landon, *Annales*, vol. 12, pp. 97–100, plates 45–47.

4. *Les Carnets*, vol. 2, p. 280.

5. Ibid., vol. 1, p. 131.

6. D. P. G. H. D. S (Humbert de Superville), *Essai sur les signes inconditionnels dans l'art* (Leiden, 1827 [1827–1832]). David's letter to Humbert de Superville is not dated. Royal Library, Department of Manuscripts, The Hague. Jouin seems to have rewritten the draft of the letter he published and reported a date: 1832. *David*, vol. 2, pp. 371–373.

7. "I have been given a newspaper titled *L'Enquête sociale*, of June 10, 1846, in which is inserted a biography of Gerbert by M. Pierre Dubois. Reading this biography made me de-

cide the choice of the subjects for the low reliefs which will decorate the pedestal. When the monks meet the young shepherd Gerbert; the education of the young prince Robert; finally when [Gerbert] busies himself with the composition of his clock. . . ." David to the mayor of Aurillac, Paris, July 30, 1846, Archives communales d'Aurillac, I M 19.

8. *Complainte sur Gerbert [Sylvestre II] à l'occasion de l'inauguration de sa statue à Aurillac, sa patrie, le 16 octobre 1851.*

9. de Caso, "L'Inventaire après décès de David d'Angers," p. 94. "You are very kind to still remember my paintings and I will be happy to send you whatever you wish. However, you will have to accept two instead of one. For if you remember there are two paintings, one of the window of the beloved virgin, and the other of the dead knight, after Schiller's ballad The Knight of Tockenburg [sic]. Tell me how I should send them to you and if I should send them with their frames—if not then you must order a frame for the two paintings just like this one [sketch in the letter]. . . ." Carus to David, Dresden, June 5, 1840, Bibliothèque municipale, Angers, David Papers. See Appendix IV.

10. *Les Carnets*, vol. 1, p. 123.

11. P. Mérimée, "Beaux-Arts. Tombeau de l'amiral Dumont d'Urville," *Le Constitutionnel* (November 12, 1844). A critic saw in this work "the billboard of a circus" and violently attacked the architect, the sculptor, and Mérimée. E. Bergounioux, "About the necessity to put an end to falsity, puerility and circus in the arts," *Journal des Artistes* (November 17, 1844), pp. 388–389.

12. *Les Carnets*, vol. 2, p. 439.

13. Ibid., vol. 1, p. 366.

14. "Have you ever thought of visiting our museum by moonlight? This should produce a very curious effect—all these portraits of *grands hommes*, this plastic immobility compressed in one corner of our province of Anjou. One day [word crossed out] (one) night, in my studio, I have written some feverish impressions of the [crossed out, illegible], as the night came to lighten the statue of my poor little Barra; if I dare, one day, I will send you this manuscript and some others which are written to you in the form of letters." To Victor Pavie, Paris, August

12, 1850, private collection, published with modifications by Jouin, *David d'Angers et ses relations littéraires*, p. 291. This manuscript, which expands notes dating from 1831 and included in the *Carnets*, (vol. 1, pp. 181–182) is forty-six pages long. Private collection. In his will, David bequeathed to Victor Pavie "all [his] unbound manuscripts. . . ." de Caso, "L'Inventaire," p. 97.

15. "Quelques notes écrites sur les bords du Rhin," *Bulletin de la Société industrielle d'Angers* (1846), pp. 291–294. For the harsh reactions of David's contemporaries to his published writings, see, among other comments, "M. P.-J. David d'Angers, statuaire, écrivain politique, philosophe et moraliste," *Journal des artistes*, vol. 1 (1847), pp. 46–47, 56–58.

16. "M. Théophile Bra, Half-Mad sculptor, ex-inmate of the [mental hospital] at Charenton, has sent a lithographed letter to all the artists, students, professors, old, young, and of all kinds, numbering two or three thousand, to invite them in his name to assemble on August 23 in the grand concert hall of Mr. Dedreux, Taitbout street, No 9 . . . the purpose of this invitation (said the letter I received) is to collect signatures for a petition [written without doubt by Bra] to be presented to the Chamber of Representatives in order to ensure for each artist a portion of the Glory they are entitled to and of which they have been deprived for fifteen years . . . the meeting was adjourned in the midst of laughter before the orator Bra could say a single word." Correspondence of Antoine-Laurent Vaudoyer and Léon Vaudoyer, September 1, 1830, Archives of the Vaudoyer Family.

17. Bra Papers, Bibliothèque municipale, Douai. A. Bigotte, "La sculpture Bra. Eléments d'approche," *Amis de Douai*, vol. 9, no. 2 (April–May 1983), pp. 20–27.

18. "Sunday I went to the sculptor Bra's place; there I saw the most beautiful masterpiece that exists. . . . There, I conceived the most beautiful book, a small volume of which *Louis Lambert* could be the preface, a work titled *Séraphita*." Paris, November 20–24, 1833, Balzac, *Lettres à Madame Hanska*, . . . vol. 1, pub. R. Pierrot (Paris, 1967), pp. 127–128.

19. T. [Théophile Thoré], "De la phrénologie dans ses rapports avec l'art," *L'Artiste*, vol. 6

(1833), pp. 122–125, 259–261. David was a member of the Société phrénologique when it was created in 1831. Archives nationales, F^{17} 3038.

20. Bra Papers, Bibliothèque municipale, Douai.

21. Stendhal, *Vie de Henry Brulard*, Mss., Bibliothèque municipale, Grenoble.

22. Bibliothèque nationale, Mss., n.a.f. 24609 395 Vo.

23. *Les Carnets*, vol. 1, p. 271.

24. The museum at Angers alone preserves more than three thousand drawings. Jouin described approximately one thousand of these in the *Inventaire*, vol. 8.

25. "Dialogue between two dead, seated on their coffin, the victim and the assassin; the victim has a dagger in the heart, the assassin has a rope around his neck." *Les Carnets*, vol. 1, p. 209.

26. Bibliothèque municipale, Angers, David Papers. David used these notes, with variants (. . . Liberty, dressed in a worker's overall . . .), in "Arc de Triomphe," *Dictionnaire politique. Encyclopédie du langage. . . .* (Paris, 1842).

27. "Des principaux ouvrages de sculpture élevés en France par souscription," cited by Jouin, *David*, vol. 2, pp. 310–315.

28. ". . . You should know that since [the commission of the] Pantheon pediment, I have not been paid for any work, and that all the monuments I made for the provincial towns have been made as gifts; this has caused me considerable financial problems. . . ." David to H. Fortoul, August 11, 1843, Archives nationales, 246 AP 14. ". . . M. David's personal assets were not even sufficent for his widow to be able to recover her own contributions . . . the bequests in David's will have been taken from the assets—certainly not to be counted in the millions—of his widow. . . ." E. David to C. Berru, February 15, 1857, Bibliothèque municipale, Angers, David Papers.

29. *Les Carnets*, vol. 1, p. 227. David's text was published with variants in *Revue du progrès* and *Almanach populaire* in 1840: "If one wanted to erect a monument to Bonaparte, this parricide son of the Revolution, one should represent him with his crossed arms on the top of a mountain made of corpses, canons, flags, and

broken wagons; [Bonaparte] amassed all this debris so that he could distribute thrones to each member of his family. At the bottom of the mountain, one would sculpt the soldiers of the Republic; they would threaten him with their gestures, and curse him." It was cited in the context *in extenso* of the article from which it was extracted. "D'un statuaire professeur à l'Ecole des Beaux-Arts et Membre de l'Institut, enseignant son art à la multitude," *Journal des Artistes*, (November 17, 1844), pp. 385–387; (December 15, 1844), pp. 427–432; and again, in excerpts (December 22, 1844), p. 443; (June 20, 1847); and (July 25, 1847), p. 40. It was translated in *Blätter für literarishe Unterhaltung* (February 5 and 6, 1840), Nos. 36 and 37, pp. 140–143, 145–147.

30. Bibliothéque municipale d'Angers, fonds David.

31. ". . . You certainly know that, when I was heard by the commission, I always fought the idea of an underground crypt; however, when I saw your beautiful monument, I felt deeply touched and moved by its mysterious and grandiose character." Ingres to Visconti (copy), May 17, 1848, Archives nationales, F^{21} 729. David seems to have approved of Bidon's (and Lanno's) second project submitted to the competition. It consisted of a "colossal eagle in bronze placed and hanging in the dome's space; it holds in its claws the cenotaph in which one will place the coffin brought back from Saint-Helena. . . ." Archives nationales, AJ52 493.

32. *Les Carnets*, vol. 2, p. 94.

33. Ibid., p. 263. See Appendix II: Rude and the Monuments to Napoleon.

34. Jouin, *David*, vol. 1, pp. 307–309. D. Johnson, "David d'Angers and the Signs of Landscape," *Gazette des Beaux-Arts* (April 1990), pp. 171–182.

35. G. Schadow, *Polyclet, oder, Von den Maassen des Menschen nach dem geschlecht und alten* (Berlin) 1834 (1909 edition) plates 4 to 15.

36. To Victor Pavie, Montpellier, November 5, 1838, published by Jouin, *David d'Angers et ses relations littéraires*, pp. 147–148. A variant of this text exists in *Les Carnets*, vol. 2, p. 35.

37. *Les Carnets*, vol. 2, p. 187.

38. "Salon de 1865," *Salons de W. Burger*, vol. 1 (Paris, 1870), pp. 259–260.

39. "Le Monument de la Révolution," *J. Michelet, Oeuvres complètes*, ed. P. Viallaneix, vol. 16, *1851–1854* (Paris, 1980), pp. 41–42. E. Fauquet, "J. Michelet et l'histoire de l'architecture républicaine," *Gazette des Beaux-Arts* (February 1984), p. 76.

40. *Les Carnets*, vol. 1, pp. 198–199.

41. J. Holderbaum, "Portrait Sculpture," *The Romantics to Rodin*, ed. P. Fusco and H. W. Janson (Los Angeles, 1980), pp. 39–42.

42. *Les Carnets*, vol. 1, p. 370. Bruel's reading of the original text is faulty.

43. Ibid., p. 65.

44. To François Grille, Paris, January 21, 1847, cited by Jouin, *Nouvelles lettres*, pp. 339–340. To Victor Hugo, Marseille, June 9, 1835, cited by Jouin, Ibid., pp. 223–227. It was published again in "Lettre sur les arts," *Revue du progrès politique....* (April 1, 1839) and "Récompenses nationales," *Dictionnaire politique*, pp. 808–810.

45. See Appendix I: David and the *Liberty* Statuette.

46. "Lettre confidentielle à mon ami Courbet," *Le Diable, journal hebdomadaire* (July 30, 1870), No. 24, pp. 2–3.

47. A. A. J. Rouval, *Vie du maréchal Ney* (Paris, 1833); Maurice-Alhoy, "Le Luxembourg en 1815, ou la dernière nuit du maréchal Ney," *Paris révolutionnaire*, vol. 1 (Paris, 1833), pp. 281–307.

48. "La rive gauche de la Seine," *Almanach populaire de la France* (Paris, 1847 [1846]), pp. 49–53. A first version of this text was written as early as 1830–1831. *Les Carnets*, vol. 1, pp. 101–104. This passage was cited in numerous articles written against David, for example: "M. P. J. David d'Angers, statuaire, écrivain politique, philosophe et moraliste (fin)," *Journal des Artistes* (January 31, 1847), pp. 56–58.

49. "A subscription is opened to erect a monument to the Four Sergeants of La Rochelle. The president of the commission is M. Guinard, Major General of the Garde Nationale of Paris; the secretary is Mr. Dumoulin; M. David (d'Angers) is in charge of the monument. The banker of the subscription is Mr. Goudchaux, 41, rue de Provence." "Nouvelles diverses," *La Réforme* (March 24, 1848).

50. Alex. Weill, "Les frères Bandiera," *Almanach du mois*, vol. 2 (1844), pp. 158–160.

51. F. P. Bowman, *Le Christ romantique* (Geneva, 1975).

52. "I was less happy with David the sculptor; I have met him recently; he saddened me with his ridiculous ideas about the superiority of Protestantism." Montalembert to Lamennais, Paris, March 6, 1833, F. de Lammenais, *Correspondance générale*, ed. L. Le Guillou, vol. 5 (Paris, 1974), p. 703.

53. Criticism published following the exhibition of the plaster of *Sainte Cécile* at the 1833 Salon does not help in identifying this plaster with certainty as the model for the work in marble eventually sent by David to Angers. The various descriptions conflict, although they all allude to David's use of a "Gothic" style, "... the long tunic that comes down beneath the feet...." *Lettres sur le Salon de 1834* (Paris, 1834), p. 353. "Mr David has not even given to his drapery the length necessary to cover the legs of Sainte-Cécile." G. Laviron, *Le Salon de 1834* (Paris, 1834), p. 143. The first lithograph of the work, by Leroux, dated 1836, shows the final work standing on a corbel drawn by David.

54. *Inventaire*, 1908, Nos.199–208.

55. *Les Carnets*, vol. 1, p. 390.

56. Raoul-Rochette, *Discours sur l'origine, le développement et le caractère des types imitatifs qui constituent l'art du christianisme* (Paris, 1834).

57. For example, T. Thoré: "This is also a symbol. The artist has chosen the subject of the consecration of water.... Young sculptors think that, following such beginnings, you cannot pull back. Society orders you to advance with it. Not only must one translate the social feelings of another age, your masterpieces must reveal [to society] the social feeling of the future." "Le Salon," *Revue républicaine*, vol. 1 (1834), p. 129.

58. This project is described in a series of letters exchanged in 1838 between David and Victor Pavie. *David d'Angers et ses relations littéraires*, pp. 132, 134–136, 141.

59. "One can compare the antique tragedy to the sculpted group; the figures correspond to characters of the drama; the group corresponds to the action ... such a tableau [the Romantic drama] will not be as clearly circumscribed as a

sculpted group is, since it is, so to speak, a fragment of perspective of the Universe...." (The French translation is a free translation.) A. W. Schlegel, *Cours de littérature dramatique*, vol. 2 (Paris-Geneva, 1814), p. 330.

60. Foyatier to M. de Sémonville, Paris, March 9, 1830, Archives de Paris, AZ315 3.

61. "David d'Angers, with his hollow models, had ideas, intelligence, a sense for composition; however, he created more as a poet and an historian rather than as a sculptor.... The tombs of General Foy and General Gobert are absolutely beautiful." Dujardin-Beaumetz, *Entretiens avec Rodin* (Paris, 1913), p. 108.

62. "Actualités. Souvenirs," *Journal des Artistes*, vol. 1 (1847), p. 64. See, by contrast, the warm reception reserved to the work by the liberal press, Pr. H. [Haussard], "Le monument du général Gobert, par David (d'Angers)," *Le National* (August 16, 1847).

63. Jouin, *David*, vol. 1, p. 410.

64. David to X. (A. Deville), Paris, June 19, 1847, cited by Jouin, ibid., vol. 2, p. 435.

65. David to Victor Pavie, Paris, May 27, 1842, cited by Jouin, *David d'Angers et ses relations littéraires*, p. 197. David formulated his final program in a letter dated August 7, 1839, to an unknown correspondent: "As soon as I was asked to work on the statue of Bichat, the program of the composition of the statue came immediately to my mind; here it is: Bichat is seated, holding a pen.... Today, I find the confirmation of my program in one passage of a biography of Bichat...." Bibliothèque Doucet, Box 37.

66. *Les Carnets*, vol. 1. p. 338.

67. Ibid., p. 391.

68. "I was expressing to you, Monseigneur, all the joy I will feel if I should be able to dedicate my working time to our dear [province of] Anjou and how much I will enjoy the opportunity you so graciously offered me of realizing a project cherished for a long time: the representation of a Christ and of Mary, these two beautiful personifications of Christianity." David to the Bishop of Angers, March 4, 1847, Archives diocésaines, Angers, G. 21. "I am sending you the letter I have just written to our Bishop at Angers; at least I am sure this

one will reach him. That he did not receive my first letter is something incomprehensible to me; at any rate, I hope nothing will now prevent these gentlemen from making a definitive decision concerning the statue of Christ and that of the Virgin," to Victor Pavie, Paris, March 4, 1847, private collection. "The lay administrators of the cathedral have asked me to be their interpreter and to express to you their regrets: Two years ago, you most generously offered your talent to have a monument placed in the church of Saint Mauricius, that the church could legitimately be proud of.... As things stand, the administrators have learned that your numerous commitments have not allowed you to busy yourself realizing your project, and that the marble had not been bought yet.... As for me, who only hold the pen in this matter, I remain yours...." The Bishop of Angers to David, December 31, 1848 (copy), Archives diocésaines, Angers.

69. Paris, March 27, 1848, Custodia Foundation, Institut Néerlandais, Paris.

70. "Painting of a Christ, seated on the orb, and writing with his finger dipped in blood, *Liberty*, *Equality*; He will be very thin, with that noble thinness that comes from the soul that consumes the heart; he will be melancholy, because this is the expression of all the men who love humanity and who work to improve its fate; he will be crowned with thorns and the blood will run from his wounds; this blood will spread over the world." *Les Carnets*, vol. 1, p. 285.

71. David to Lamennais, Paris, March 3, 1838, in Jouin, *David d'Angers et ses relations littéraires*, p. 135.

72. M. Driskel, "Painting, Piety and Politics in 1848: Hippolyte Flandrin's Emblem of Equality at Nîmes," *The Art Bulletin* (June 1984), pp. 270–285.

73. *Inventaire*, 1908, p. 362, Nos. 877 to 891.

74. Ibid., No. 890.

75. Proudhon, *Du principe de l'art*, p. 240.

76. V. Pavie, *Inauguration du buste de David d'Angers dans la galerie de sculpture du musée, le 2 mars 1863* (Angers, 1863), pp. 50–67.

BIBLIOGRAPHY

Collection de portraits des contemporains d'après les médaillons de P. J. David d'Angers sous la direction de P. J. David, P. Delaroche et Henriquel-Dupont par le procédé Collas. Paris, 1838.

Esquiros, A. "Intérieurs d'ateliers. P. J. David." *L'Artiste*, 3rd ser. (March 17 and 22, 1844), pp. 169–171, 184–187.

[Carnot,] H., "David d'Angers." *Magasin pittoresque*, vol. 24 (July 1856), pp. 233–238.

Oeuvres complètes de P. J. David d'Angers, Statuaire . . . lithographiées par E. Marc. Paris, 1856.

Halévy, F. *Notice sur la vie et les ouvrages de M. Pierre-Jean David (d'Angers) . . . lue dans la séance. . . .* Paris, 1857.

David, R., and E. About. *Les Médaillons de David d'Angers. Album photographique.* Paris, 1867.

Jouin, H. *David d'Angers, Sa vie, son oeuvre, ses écrits, ses contemporains.* 2 vols. Paris, 1878–1885.

Inventaire général des richesses d'art de la France. Province. Monuments civils. Musée d'Angers, vol. 3. Paris, 1885; vol. 8. Paris, 1908.

David d'Angers, R. *Un statuaire républicain. David d'Angers, sa vie, ses oeuvres.* Paris, 1891.

Jouin, H., ed. "Nouvelles lettres du Maître et de ses contemporains" and "Dernières lettres de David d'Angers et de ses contemporains." *Nouvelles Archives de l'art français,* 3rd ser., vol. 9. Paris, 1893, pp. 169–301, 302–362.

Jouin, H., ed. "Lettres inédites d'artistes français du XIXe siècle." *Nouvelles Archives de l'art français,* 3rd ser., vol. 16. Paris, 1900.

Jouin, H., ed. *Les Tragiques Grecs, cent dessins par David d'Angers.* Paris, 1903.

Lami, S. *Dictionnaire des sculpteurs de l'Ecole française au XIXe siècle,* vol. 2. Paris, 1916.

Chesneau, G. and Ch. Metzger. *Ville d'Angers. Musée des Beaux-Arts. Les oeuvres de David d'Angers.* Angers, 1934.

Aragon, L. "David d'Angers et l'art national." *La Nouvelle Critique* (May 1956), pp. 158–192.

Les Carnets de David d'Angers, publiés . . . par A. Bruel, 2 vols. Paris, 1958.

de Caso, J. "David d'Anger's *Portable Tieck*," *The Register of the Museum of Art. The University of Kansas* (December 1963), pp. 2–13.

David d'Angers, 1788–1856. Hôtel de la Monnaie. Paris, 1966.

Schatzmann, P. E. *David d'Angers. Profils de l'Europe*. Geneva, 1973.

de Caso, J. "L'Inventaire après décès de David d'Angers et quelques remarques." *Gazette des Beaux-Arts* (September 1980), pp. 85–97.

Holderbaum, J. "Pierre-Jean David d'Angers." *The Romantics to Rodin*. Ed. P. Fusco and H. W. Janson. Los Angeles, 1980.

McWilliam, N. "David d'Angers and the Pantheon Commission: Politics and Public Works under the July Monarchy." *Art History*, vol. 5, No. 4 (December 1982), pp. 426–446.

de Caso, J. "Le Romantisme de David d'Angers." *La Scultura nel XIX Secolo*, Acts of the XXIVth International Congress of Art History, vol. 6. Ed. H. W. Janson. Bologne, 1984, pp. 87–102.

Coifard, J. L. *Pierre-Jean David d'Angers, "Sculpteur d'histoire," l'Angevin, le Républicain (1788–1856)*. [Angers], 1985.

Lindsay, S. *David d'Angers' Monument to Bonchamps: A Tomb Project in Context*. Ann Arbor, Mich.: University Microfilm, 1987.

de Caso, J. *David d'Angers: l'avenir de la mémoire. Etude sur l'art signalétique à l'époque romantique*. Paris, 1988.

Huchard, V. *Galerie David d'Angers, musées d'Angers*, 2nd ed. Angers, 1989.

Johnson, D. "David d'Angers and the Signs of Landscape." *Gazette des Beaux-Arts* (April 1990), pp. 171–182.

de Caso, J. "Romanticism and Sculpture." *Studies in Art History. Faculty of Letters, The University of Tokyo*, no. 6 (1990), pp. 211–229.

de Caso, J. "A Philological Imposture, Henri Jouin Interpreter of David d'Angers." *The Art Bulletin* (June 1991), pp. 309–312.

Huchard, A., I. Leroy-Jay Lemaistre, A. Le Normand-Romain, F. Chappey, P. Grémont-Gervaise. *Aux Grands Hommes, David d'Angers*. Fondation de Coubertin. Saint-Rémy-lès-Chevreuse, 1990.

INDEX

abolitionism, 212. See also slavery, *Project for a Monument to Emancipation* under David d'Angers
academicians, 32, 56. See also French Academy
academic works. See *envois*
Academy of Sciences, 217, 219, 220, 221, 223
Agulhon, M., 245n.36, 247n.26, 252n.10
Alavoine, 50
d'Alembert, 19, 77, 244n.21
Alexander, 24, 48, 70
Algardi, 86
allegory, 19, 33, 50, 60, 66, 114, 115, 118, 125, 131, 163, 164, 175, 184, 187, 219; with historical figures, 131; moral, 72; political, 72
Allegrain, 25
anatomy, 32, 38, 43, 50, 70, 79, 100; David's adherence to theory of, 70; treatises on, 217, 221. See also Carus
Andromaque, 89
d'Angiviller, 20, 45, 46
Angoulême, Duke of, 108, 114
animal sculpture, 163, 187
Annales, 41
Anselme, 211
anthropometric theories, 146; medieval, 183
antique models, 41, 118, 146, 166, 189–190, 207
antiquity, 44, 133; epics of, 60; heritage of, 40; heros of, 12, 55; myths of, 55
Arago, E., 112, 253n.23
Arago, F., 243n.1
Aragon, L., 11, 244n.11
Arc de Triomphe, Marseille, 137
Archbishop of Paris, 118
archaeology, 41, 44, 55, 70, 119, 146
architects, 29, 121, 257n.16; and control of sculptural programs, 26, 75, 78, 97–99, 116, 251n.3; relation to sculptors of, 44, 77, 90, 97–99, 252n.11
architectural sculpture, 21–22, 26, 50, 73, 82
architecture, landscape, 30, 91, 207; public, 44, 91, 118

d'Argout, 120
Aristotle, 60
art criticism, 36, 39–40, 57, 82–83, 140, 147, 180. See also critics
art industrialists, 8
art market, 8, 19, 206; modification of, 84. See also private patronage
artistic education, impact of Academy on, 32–36
aspective vision, 147–148
Assyrian sculpture, 150
Attic style, in sculpture, 80
Audebrand, Ph., 243n.1
Aumale, Duke of, 121
Autichamp, Count of, 65
Auzias, 206

Bailly, 123, 130
Ballanche, 59, 76, 248n.48
Baltard The Elder, 118, 254n.36; *Project for a Pediment for the Church of Saint-Geneviève*, **120**
Balzac, 152, 257n.18; *Louis Lambert*, 257n.18; *Séraphita*, 257n.18
Bandiera brothers, 176
Barbedienne, 8
Barbier, A., 248n.1
Barère de Vieuzac, 245n.39; *Le Vengeur*, 245n.39
Barra, 128, 257n.14
Barre, 186; *Triumph of Liberty*, **188**
barricades, 110
Barry, Mme du, 41
Barthe, Félix, 112
Bartolini, 15, 244n.17
Barye, 8, 56, 59, 117, 163, 187
Baudelaire, 15, 25, 56, 248n.49
de Bay The Elder, 117. See also Debay
Bayard, 70
Beaurepaire, 64, 248n.6
beauty, formal idea of, 53
Bellart, 176

phrygian cap, 205. See also Republican imagery

physiognomy, 16, 32, 53, 70, 79, 90, 133, 134, 135, 139, 140, 147, 172, 173

physiology, 38, 107, 146, 164, 191–192, 214, 218, 220–221, 223, 226. See also Carus

Picot, 108, 253n.13

pictorial illusionism, 73, 136. See also imitation, mimesis

picturesque effects, 73, 83, 104, 149

Pigalle, 244nn.20, 22; *Monument to Louis XV*, 19, **20, 21**, 244n.20; *Voltaire*, 20, **23**

Planche, 90, 99, 147, 252n.5

plaster casts, public exhibition of, 205; production of, 206

Poitevin, Auguste, 157; *Le Vengeur*, **160**

political banquets, 110

political clubs, 12

political sculpture, editions of, 173

polychromy, 149

popular culture, 29, 77–78, 95, 125, 127, 136, 142, 173, 176

populist art, 29–30, 123, 149, 167–68, 205

porcelain manufacturers, 206

portable sculpture, 29, 82

portrait sculptors, 169

portraits, 86, 104, 107, 131, 139, 153, 169, 208; as antithesis to statue, 104, 190; female, 41; gallery of, 97, 125, 127

portraiture, 50, 70, 169, 183, 226, 228, 259n.41; idealization in, 168; paradoxical elements of, 168; profile view in, 49, 79, 105, 173, 210, 222

Postel, 22

Pothey, A., 256n.56

de Potter, Louis, 205

Poussin, 91, 128

Pradier, 8, 32, 34, 38, 39, 56, 58, 208, 246n.18; *Bacchante*, 34, **40**, 41, 43

Pratt, J. N., 248n.49

press, 95, 123, 173, 219; liberal, 112, 207; opposition, 4, 97; periodical, 84; republican, 3

Préault, 56, 59, 82, 84, 135, 166, 251n.31; *Tuerie*, 85, **85**

primitive art, 150

printing, invention of, 222–223. See also *Gutenberg Monument* under David d'Angers

prints, 95; anonymous, 78; revolutionary, 196

private patronage, 40, 62, 159, 161, 189, 207, 220

private sculpture, 24, 82, 100, 161, 168, 169, 173, 207

Prix de Rome, 32, 56, 81, 86, 97; winners of, 33–34

projects, unrealized, 62, 86, 156, 160, 196

proletariat, 198

proportions, 137, 157; canon of, 41, 70, 72, 143, 146, 164; distortion of, 147

Protestantism, 180

Protestants, prosecution of, 161

Proudhon, 125, 198, 255n.51, 260n.75

provinces, 67, 90; autonomy of, 64; programs for, 63, 87. See also commissions

public art, 39; David's commitment to, 135; impact of political on, 31. See also public sculpture

public cult, 76

public sculpture, 16, 25, 29, 44, 62, 73, 75, 86, 95, 100, 114, 118, 131, 161, 164, 168, 173, 219; and collective experience, 157; failure of, 159; political function of, 95

Puget, 84, 86

de Pujol, A., 246n.1

Quatremère de Quincy, 26, 29, 33, 36, 94, 118, 245n.35, 251n.40

de Quélen, 256n.61

Quintus Curcius, 30

Racine, 60, 87, 251n.32

Raggi, 251n.32

Ramey the Elder, 45, 70, 72, 136, 251n.32, 254n.40

Ramus, 86

Raoul, Max, 251n.31

Raoul-Rochette, 259n.56

Raphael, 183

realism, 75, 150, 156, 163, 189, 208; in subject matter, 187. See also Courbet

recomposition, of the nude, 99–100. See also nudity

Récamier, Mme., 119

reductions, in bronze and copper, 206

relief sculpture, 32, 50, 63, 66, 70, 72, 77, 78, 85, 95, 97, 104, 107, 108, 118, 121, 136, 143, 150, 161, 184, 189, 212; as akin to writing, 72; of battles, 146–147; as collective ex-voto, 79; conceptions of, 81, 86; flatness in, 72–73, 350n25; flowering of, 84; high relief, 72; historiated, 80, 108,

114, 135, 142, 146, 250n.23; innovations in, 149; low, 72–73, 81, 85, 218, 221–222, 226; perspective in, 136; as populist, 123; transformation of, 80–84, 135. See also méplat

"relief-painting," as portable object, 82

religion, 75–76, 153. See also expiatory monuments

religious art, 116, 119, 153, 179, 180, 183, 192, 196; discourse on, 183; renewal of, 189

Renaissance perspective, 81, denial of, 136, 147

Renan, 55

Republican imagery, 12, 26, 29, 118, 121, 123–125, 131, 136, 157, 166–168, 175, 205, 218–219, 223–224, 245n.36, 254n.40. See also populist art

republicanism, 110, 112, 124, 196; debate on, 3

Revolutionary culture, 196

Reynaud, J., 57, 60, 248n.47

"Réformistes," 253n.20

Ricroch and Cie., 206

Rienzi, 36

Rietschel, 205

Robespierre, 27, 131, 134, 166

Rocheblave, S., 244n.20

Rodin, 11, 189, 243n.1

Roguier, 45, 48; *Duquesne*, **49**

Roland, 36, 44, 46, 80, 246n.8, 246nn.13, 14, and 15; *Grand Condé*, **49**

Roman, 254n.40

Roman relief, 150

Roman sojourn, 32, 39, 43, 108, 212

Roman works. See *envois*

Romanesque sculpture, 150

Romantic criticism. See art criticism

Romantic generation, innovations of, 183

Romantic period, 41, 48, 152, 186, 198; poetry of, 156; sculpture of, 31, 34, 50, 56, 58, 161, 189, 196, 208; visual arts during, 31, 150, 153, 156, 198, 214; writers of, 107

Romanticism, 53, 55, 77, 83, 86, 90, 124, critical discourse on, 82, 152; social, 40; and ideas about sculpture, 31–32, 82

Rosenblum, R., 248n.39

Roserot, A., 244n.25

Rousseau, J. J., 23, 118, 125, 130, 244n.27

Rouval, A. J. J., 259n.47

Royer-Collard, 245n.35

Rude, 8, 34, 38, 58, 135, 161, 207, 246n.7, 254n.31; *Aristeus Mourning the Loss of his Bees*, 34, **35**; *The Resurrection of Napoleon*, **163**

sacred figures, secularization of, 179

Saint-Hilaire, Geoffroy, 135, 138

Saint-Just, 157

de Saint-Pierre, Bernardin, 164

de Saint-Pierre, Eustache, 135

Saint-Simonianism, 44, 153

Salon criticism. See art criticism

Salons *livrets*, 56, 85

Sarazin, Ch., 244n.20.

sarcophagus. See funerary sculpture

Schadow, G., 258n.35

Scheffer, Ary, 196, 208

Schiller, 257n.9

Schlegel, A. W., 259n.59

scriptural dramas, as theme for sculpture, 189

sculpted group, 55, 80, 183–184, 186–187, 189, 196; dramatic structure of, 184

sculptors, interdependence of, 25

sculpture, accessories in, 36; collaborative nature of, 25; discourse on, 15, 22–24, 30, 50, 60, 86, 164; dramatic effects of, 184, 186; humanitarian aspirations of, 60; instantaneous communication of, 49–50, 136; political uses of, 12, 25; sources for, 24, 150; transformations in, 56; uses of, 19, 25, 60, 152

Segrais, 22

self-portrait, 19. See also portraits

de Sémonville, M., 260n.60

sensualism. See eroticism

sepulchral monuments. See funerary sculpture

serialization, 11. See also commercial production

Shedd, M., 249n.15

Sieyès, 134

signature, 19, 173

significant moment, 45–46, 48, 63, 78, 83

signs, 40, 50, 53, 104, 136, 139; non-figurative, 153; statue as, 25, 44

silhouette, 50

Siméon, 245n.35

Simon the Pharisee, 117

site, 50; importance of, 28–29, 44; as scenographic, 114; materiality of, 161; in nature, 91, 137

sketch, Romantic valorization of, 83